IN THE BEGINNING WAS MERZ – FROM KURT SCHWITTERS TO THE PRESENT DAY

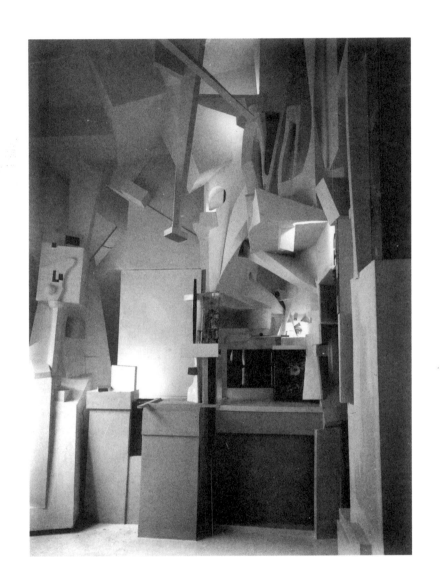

IN THE BEGINNING WAS MERZ – FROM KURT SCHWITTERS TO THE PRESENT DAY

EDITED BY
SUSANNE MEYER-BÜSER
AND KARIN ORCHARD

MERZ

HATJE CANTZ PUBLISHERS

LENDERS

MUSEUMS AND GALLERIES

Armitt Library and Museum, Ambleside
Stedelijk Museum Amsterdam
Öffentliche Kunstsammlung Basel,
 Kupferstichkabinett
Stiftung Museum Schloss Moyland – Sammlung
 van der Grinten, Bedburg-Hau
Bauhaus-Archiv, Museum für Gestaltung, Berlin
Galerie Brusberg, Berlin
Galerie Klosterfelde, Berlin
Galerie Kuckei + Kuckei, Berlin
Staatliche Museen zu Berlin, Kupferstichkabinett
Staatliche Museen zu Berlin, Neue Nationalgalerie
Galerie Kornfeld, Bern
Indiana University Art Museum, Bloomington
ART KIOSK, Brussels
Gallery Maurice Keitelmann, Brussels
Cleveland Museum of Art
Museum am Ostwall, Dortmund
Staatliche Kunstsammlungen Dresden,
 Kupferstichkabinett
Galerie Konrad Fischer, Düsseldorf
Kunstsammlung Nordrhein-Westfalen, Düsseldorf
Deutsche Bank AG, Frankfurt/Main
Museum für moderne Kunst, Frankfurt am Main
Cabinet des estampes, Geneva
Galerie Jan Krugier, Ditesheim & Cie, Geneva
Kestner-Museum, Hanover
Sprengel Museum Hannover
Sprengel Museum Hannover, Sammlung
 Nord/LB in der Niedersächsischen
 Sparkassenstiftung
Stadtbibliothek Hannover
Abbot Hall Art Gallery, Kendal
Luis Campaña Galerie , Cologne
Galerie Gmurzynska, Cologne
Museum Ludwig, Cologne
Fondazione Marguerite Arp, Locarno
Pinacoteca Casa Rusca, Locarno
Muzeum Sztuki, Łódź
Grosvenor Gallery, London
The Mayor Gallery, London
Tate Modern, London
Victoria and Albert Museum, London
Wilhelm-Hack-Museum, Ludwigshafen
Galleria Blu, Milan
Museo Vostell Malpartida
Städtisches Museum Abteiberg Mönchengladbach,
 Mönchengladbacher Sparkassenstiftung für
 Kunst und Wissenschaft
Staatliche Graphische Sammlung München
Yale University Art Gallery, New Haven
Gorney Bravin Lee Gallery, New York
Michael Rosenfeld Gallery, New York

Spencer Collection, New York Public Library
Joan Washburn Gallery, New York
Solomon R. Guggenheim Museum,
 New York
Whitney Museum of American Art,
 New York
Kröller-Müller Museum, Otterlo
Musée national d'art moderne,
 Centre Georges Pompidou, Paris
Archiv Baumeister, Stuttgart
Staatsgalerie Stuttgart
Staatsgalerie Stuttgart, Archiv Sohm
Kunstmuseum Liechtenstein, Vaduz
Kerstin Engholm Galerie, Vienna
Museum moderner Kunst Wien, Stiftung Ludwig
Kunsthaus Zürich
Kunsthaus Zug, Stiftung Sammlung Kamm

PRIVATE LENDERS

Armand and Corice Arman
Collection Timothy Baum, New York
Collection von Bergmann
Lisa Breimer
Collection Calmarini, Milan
Dr. & Mrs. M. Michael Eisenberg
Collection Feelisch, Remscheid
Flick Collection
Maria Gilissen
Carroll Janis, New York
Collection Stella and Joe Kattan
Klaus Lieckfeld, Hamburg
Konrad Losch
Ron and Ann Pizzuti, Columbus (Ohio)
Nicola del Roscio, Rome
Collection Maria and Walter Schnepel, Bremen
Kurt Schwitters Estate
Sherwin N. A. G., Leeds
Krimhild and Jürgen Sparr, Kronberg/Ts.
Helmut F. Stern
Ute Thio, Mannheim
Angela Thomas Schmid
Philippe Woog
Franz-Josef Wrede
Richard S. Zeisler Collection, New York

and numerous other lenders who prefer to remain
anonymous.

CONTENTS

PREFACE

To this day – even to the public with a real interest in art – Kurt Schwitters' work is not as well known as it should be in view of its outstanding importance for the visual arts during the second half of the 20th century.

Is this due to the many-faceted nature of his work, is it due to its at times provocative differentness?

The exhibition *In the Beginning was MERZ – from Kurt Schwitters to the Present Day* may provide the answer, for it presents the work of Kurt Schwitters in a dialogue with works from Pop Art, Nouveau Réalisme, Fluxus, concrete poetry, to name but a few – art movements that have all been crucially influenced by Schwitters' work.

This exhibition is important in that it presents a comprehensive retrospective of the work of Kurt Schwitters, at the same time showing its influence on art as it subsequently developed in the 20th century. It is fitting that it should take place within the context of a world exhibition – and will, I sincerely hope, raise Schwitters in the eyes of the general public to the status that art history has long recognised as his rightful due.

Dr. Michael Naumann
State Minister for Culture and Media, Federal Chancellery, Berlin

PREFACE

For its part in the cultural programme of this world exhibition, the Sprengel Museum Hannover is focusing on the artist Kurt Schwitters with a major exhibition of his work, which in itself has links, if one will, to EXPO 2000: the newly built 'EXPO town' – in effect a collage of the most diverse presentations and contributions – is juxtaposed with a world of everyday found objects. After all, with his invention of Merz, Schwitters never denied the close association of art and economics.

But more importantly, space is being given to an artist who worked with almost all artistic materials imaginable and who, more than any other artist pursued and lived the idea of the *Gesamtkunstwerk* – space for a comprehensive overview of his multi-disciplinary work. Poetry, typography, collage, assemblage, drawing, the ambivalence of his representational paintings produced concurrently with his abstract works, and not least the *Ursonate*: seen in conjunction with each other these works demonstrate how strong this one-man art movement was. "The style, that is the person". This statement by Ludwig Wittgenstein applies perfectly to Kurt Schwitters and his "total Merz vision of the world".

The particular quality of this exhibition owes much to the fact that as well as presenting a comprehensive retrospective of Schwitters' work and highlighting artists from the generation after his, who were influenced by the "friendly bugbear of the bourgeoisie", it also presents commissions by younger artists who in their own way have taken forward Schwitters' idea of a *Gesamtkunstwerk*. For they show all too well that Schwitters' artistic stance has lost nothing of its actuality and modernity.

Thus Schwitters' declared intention in his work – "to create connections, preferably between all the different things in this world" – lives on and is extended as far as the world exhibition.

The long period during which Kurt Schwitters was relegated to a marginal position in the history of Classical Modernism has at last come conclusively to an end. In this exhibition the world will be able to discover the city's most striking son.

Tom Stromberg
Artistic Director of the Cultural and Events Programme for EXPO 2000.

PREFACE

Looking to the future does not prevent us also looking to the past. If anything, the two complement each other. The best evidence of this is the project *In the Beginning was MERZ – from Kurt Schwitters to the Present Day* which the Sprengel Museum Hannover is presenting during the world exhibition as part of the EXPO 2000 cultural programme.

This exhibition will introduce even the people of Hanover to a different side of this very special son of their city. Those who persist in regarding Schwitters as a kind of "Dada clown", as an amusing but ultimately lightweight footnote to art history, will at last have to hold their peace. Indeed this exhibition will show very clearly why Per Kirkeby described his colleague Kurt Schwitters as the "most neglected artist of this century".

Walking through the exhibition *In the Beginning was MERZ* the visitor will find many aspects of his work emerging in a clearer light. Schwitters' early drawings, seen here for the first time, and his representational paintings refute the enduring cliché of the "debris artist". The Merz collages and assemblages, like the reconstruction of the *Merzbau* itself display the artist's outstanding compositional skill – for however witty a work might be, his main concern was always the combined organic effect of the most diverse elements. A combined effect that by definition led him to work in other media such as typography or literature, both of which are also represented in this exhibition. A combined effect that ultimately sheds a very particular light on the classic question of the border between life and art.

Hanover's artistic standing in the 1920s and 30s would never have come about without Schwitters' numerous contacts to the major international art centres of the time. Even after his death others continued to draw on Schwitters for their creative energy.

Leading artists cite Schwitters as their inspiration, from visual artists like Robert Rauschenberg, Joseph Beuys and Nam June Paik, to poets like Ernst Jandl and Gerhard Rühm; this is amply demonstrated in the exhibition by means of specific exhibits. In addition, the Merz artist continues to exercise an undiminished influence on outstanding artists of the younger generation. The Sprengel Museum Hannover has set aside one part of the building for artists such as Christoph Büchel, John Bock and Laura Kikauka to create 'walk-in collages' conceived specially for this exhibition: works that today adopt a multi-genre approach as a matter of course, an approach that has its origins not least in the work of a Hanoverian called Kurt Schwitters, who defied his detractors and resolutely pursued his wholly individual vision of a *Gesamtkunstwerk*.

It was precisely this forward-looking aspect of Kurt Schwitters' work that prompted the Niedersächsische Sparkassenstiftung to sponsor the exhibition. Thus the Niedersächsische Sparkassenstiftung have been glad to sponsor this exhibition, together with the members of the Sparkassen-Finanzgruppe, namely the Deutsche Sparkassen- und Giroverband, VGH Versicherungen, the Norddeutsche Landesbank and the Stadtsparkasse Hannover.

We hope and trust that the Schwitters project will strike a chord with the people of Hanover and its international visitors alike, and that the many-faceted expressive powers of the Merz artist may become better known both at home and abroad.

Klaus Rathert
President of the Niedersächsische Sparkassenstiftung.

FOREWORD

Kurt Schwitters himself at one time pondered the problem of putting on a major art exhibition (of course knowing nothing at the time of our exhibition in his honour) in competition with a world exhibition. In 1936, on the Island of Hjertöya in Norway, in his text 'Ich sitze hier mit Erika' (Here I sit with Erica) he wrote:

"I wanted to write about colour.
Not about an art exhibition, although the main topic there is colour, no, let that also be far from my thoughts. A world exhibition, that would suit Hjertöya, not just an art exhibition. Art wouldn't lure people from other parts of the world to come to Hjertöya, for you only go to openings on Sunday mornings after church, because you don't want the others to be part of it without you. So it is a burden if there are too many art exhibitions, even a useless burden, whereas a world exhibition with the usual pleasure grounds, *fontaine lumineuse*, glass-house and fireworks would immensely enliven trade. The only visitors to an art exhibition in Hjertöya would be oxen, cows, geese, turkeys, chickens and pigs, the sort of folk that don't generally go to art exhibitions. No, the regular attenders at openings of art exhibitions, they're society folk."

Kurt Schwitters, that will-o'-the-wisp and inventor of MERZ, the Hanoverian Dadaist *per se* and champion of inspired folly in art and literature, concerned himself – amongst many other things – with the contradictory nature of major official events. The ideas that he was toying with so thoughtfully in 1936, the year before he emigrated to Norway – the notion of a world exhibition on a small, remote island with only two inhabitants, which he then plays off against his own position, as an artist only able to dream of the position of a dictator able to put on a world exhibition – this is the paradigm for what has become reality in Hanover in the year 2000. While the world exhibition, transferred from its imaginary location in the Norwegian wilderness to the North German plain, has become reality, at the same time a major exhibition focuses on Kurt Schwitters and his influence on the art of the 20th century. Meanwhile Kurt Schwitters, after the loneliness and isolation of exile in Norway and England and his premature death in 1948, has become an international artist in the public eye. Major exhibitions, notably the exhibition by Werner Schmalenbach in Hanover in 1956, the exhibitions by John Elderfield in New York in 1985 and in Hanover in 1986, and finally the exhibition by Serge Lemoine in Paris in 1994, have put the inventor of MERZ on the agenda in any discussion of modernism. Today Kurt Schwitters is regarded as a leading exponent of modernism in 20th-century art. So, as the new century dawns, we are moved to reflect on his role and his influence on the art of the past century.

The initiative for this exhibition came from the Sprengel Museum Hannover, where the work of the Kurt Schwitters Archive has been at the heart of international research into the artist and his work for years. In autumn 2000, while the exhibition is still running, the first volume of the *Catalogue Raisonné* of Schwitters' work will be presented. Following this, over the years the subsequent volumes of the *Catalogue raisonné* will aim to present Kurt Schwitters' œuvre as comprehensively as possible.

In Germany it is not only in Hanover that Kurt Schwitters is valued and that this exhibition excites interest. This is readily evident in the cooperation that has led to the subsequent tour of the exhibition. Two leading German art institutions, the Kunstsammlung Nordrhein-Westfalen in Düsseldorf and the Haus der Kunst in Munich, have joined forces with the Sprengel Museum Hannover and together we are glad to seize this opportunity to reconsider Schwitters' position and update our view. The initial incentive for the exhibition came from the two curators, Susanne Meyer-Büser and Karin Orchard; however, without the Schwitters family, Frau Lola Schwitters and Herr Bengt Schwitters, and their generous support for all aspects of the projects, this exhibition would never have been possible. The project in Hanover and beyond has received large-scale, wide-ranging support from EXPO 2000 and from the Niedersächsische Sparkassenstiftung, the Deutscher Sparkassen- und Giroverband, the Norddeutsche Landesbank, the Stadtsparkasse Hannover and the VGH Versicherungen. In Hanover itself the exhibition has received the widest possible publicity through our partners in broadcasting, the NDR and Hallo Niedersachsen. We should also like to thank the artists of the group tomato, whose have designed the catalogue as their contribution to the exhibition. Our particular gratitude for their work in the preparations for this exhibition goes to the teams in the other participating institutions, led by Anette Kruszynski in Düsseldorf and Hubertus Gaßner in Munich.

We are especially honoured that the State Minister for Culture and Media, Dr. Michael Naumann is the patron of our exhibition.

Finally, however, we ought to reveal to all those who have worked on the exhibition and supported the project, that it was actually Kurt Schwitters himself who devised the instructions for the scenario of the world exhibition in Hanover. In 1936 he already knew precisely how it could be:
"You simply collect together objects from all over the world in the place where the world exhibition is planned; the press, whose power cannot be overestimated, draws attention to the future world exhibition, be it in Chicago, or in Hjertöya, then the usual spiel is served up and everyone who is anyone spends their holidays at the world exhibition. Hotels sprout from the ground, are over-booked and charge top prices. In the mornings business is done, trade flourishes, and in the evenings there is dancing. Gentlemen, is it then not immaterial where this world exhibition takes place? As long as there is room for swings of hitherto unimagined dimensions, for a lunar park, for a water slide, a *fontaine lumineuse*, fireworks etc., etc., then a world exhibition may be held in that place."

Ulrich Krempel
Sprengel Museum Hannover

Armin Zweite
Kunstsammlung Nordrhein-Westfalen, Düsseldorf

Christoph Vitali
Haus der Kunst München

INTRODUCTION

"I know that I am an important factor in the development of art and will remain important for all time. I say this with such emphasis, so that later on people will not say: 'The poor man had no idea how important he was.' No, I am not stupid and I am not shy either. I know very well that for me and all the other important personalities of the abstract movement the great time is yet to come when we will influence a whole generation, only I fear I will not experience it personally." (Kurt Schwitters, 'Ich und meine Ziele', 1931)

The importance of the Hanover artist Kurt Schwitters (1887–1948) for the art of the 20th century was indeed long underestimated. It is only more recently that there have been numerous exhibitions on individual themes and periods in his art and two major retrospective touring exhibitions: 1985/86 in New York, London and Hanover, and 1994/95 in Paris, Valencia and Grenoble. These exhibitions were the first documentations of the full range of Schwitters' output, and included his typographical, representational, literary and architectural works, all of which were shown on an equal footing with his collages and assemblages. The retrospective in the Sprengel Museum Hannover in 1986, to mark what would have been his 99th birthday, was the last comprehensive presentation of his work in Hanover. In Düsseldorf his work was last seen in the Städtische Kunsthalle in 1971, and in Munich there has never been a solo exhibition of Schwitters' work.

In view of these past retrospectives, any new comprehensive presentation of the artist's œuvre must clearly be different from what has gone before. Thus *In the beginning was MERZ – from Kurt Schwitters to the Present Day* will provide some unusual, surprising insights into the work of this Hanover artist, at the same time it will also trace the progress of his ideas as they have been taken up and continuously developed since the 1950s. Therefore, besides focusing on the artist's main works, his assemblages from the early 1920s – few in number and extremely problematic in terms of their conservation – this new selection from Schwitters' œuvre presents works that have as yet only very rarely been shown or, in some cases, not at all. The Kurt Schwitters Archive in the Sprengel Museum Hannover, where work is under way on a *Catalogue Raisonné* of Schwitters' work, offers ideal conditions for a 'fresh' selection of this kind, since here information is to be had on works and their owners that could not be included in earlier retrospectives. Furthermore, the Sprengel Museum Hannover is also able to draw on the Estate of the Schwitters Family which is on extended loan to the Museum, providing the selectors with yet more choice.

Thus our project presents the full-range of Schwitters' complex personality with over 250 works from all areas of his output: hitherto unexhibited drawings and paintings from his early period, assemblages and collages from his classical Merz time, sculptures that have survived from his late period, the reconstruction of the *Merzbau* as it was in 1933, the representational paintings that Schwitters produced throughout his life in parallel with his abstract works, typographical works, literary works, and documents relating to unrealised projects.

Kurt Schwitters regarded himself as a 'total artist', his complex output embraces a whole number of different media and fields: of prime importance in his work with traditional pictorial media was his innovative and consistent exploration of collage and assemblage. Yet he applied his artistic theories with equal interest and commitment to sculpture, architecture, typography, literature, drama, the stage, music and performance – and called the result "MERZ art". In addition to this he left behind an extensive body of painting that grew out of his representational beginnings, and which he produced in parallel with his so-called 'abstract' works. His enduring aim was to remove the boundary between the various art forms and everyday life, and to replace this with his notion of a "total Merz vision of the world", inter-linking all its constituent parts. "Without Duchamp and Schwitters no Neo-Dada, without Neo-Dada no Pop Art and its consequences" – Heinz Ohff's apodictic statement from 1968 leaves us in no doubt as to Schwitters' importance for the visual arts in the second half of the 20th century. In the 1950s and 60s art-critics and artists alike regarded Schwitters as one of the founding fathers of modernism. Writing on collage, the influential critic Clement Greenberg named Schwitters along with Pablo Picasso and Georges Braque as one of the most important exponents of this "most succinct and direct single clue to the aesthetic of genuinely modern art".

The extent of Schwitters' influence on art in the second half of the 20th century is shown in this exhibition in works by exponents of Abstract Expressionism, British and American Pop Art, Neo-Dada, Nouveau Réalisme and Fluxus – by artists such as Robert Rauschenberg, Louise Nevelson, Cy Twombly, Daniel Spoerri, Dieter Roth and Joseph Beuys. All these artists have been inspired by Schwitters' practice of montage and his hope of uniting art and life.

The rediscovery of Dada and the work of Kurt Schwitters first occurred in the United States in the 1950s. As early as 1948, shortly after the death of Schwitters, the first solo exhibition of his work took place in the Pinacotheca Gallery in New York; this was soon followed by the overview exhibition on collage in the Museum of Modern Art, where the Hanover artist occupied a prominent position with a large number of works. In the early 1920s Katherine Dreier had already included his works in numerous group shows put on by the Societé Anonyme. In 1952, 1956 and 1959 the Sidney Janis Gallery, a leading avant-garde gallery in New York presented his work in solo exhibitions. Major international art events such as documenta in Kassel in 1995, the world exhibition in Brussels in 1958, the Venice Biennale in 1960 and the São Paulo Biennale in 1960 all provided opportunities for younger artists to become acquainted with Kurt Schwitters' work.

It was above all due to Robert Motherwell, himself an artist and an experienced critic, that Schwitters acquired the aura of the 'founding father' of modern collage. In 1951 Motherwell edited *The Dada Painters and Poets: An Anthology*. This was the first wide-ranging publication in English on Dada, and in it Kurt Schwitters occupies a prominent position. It seems fair to assume that this volume, which contained texts and numerous illustrations relating to Schwitters' collages and his *Merzbau*, must have had a decisive influence on the direction taken by the young American exponents of Abstract Expressionism and Junk Art in their

paintings and installations. In his own contribution to the evolution of the paper collage since the mid-1940s, Motherwell was striving, like Schwitters, for an aesthetic solution to problems of form. When Robert Rauschenberg first saw Schwitters' works, he had the feeling that "he had done all this just for me". A direct line leads from Schwitters to the early Happenings and environments by Allan Kaprow, Jim Dine and Claes Oldenburg.

In Europe in 1944, while Schwitters was still alive, his first solo exhibition took place in the Modern Art Gallery in London. The young Eduardo Paolozzi found his visit to the exhibition both unsettling and stimulating. Impressed by the collages made from scraps and waste materials, he himself started to produce paper collages from bits of newspaper, which he collected together in his series of *Scrapbooks* from 1944 to 1946 and in the *Popular Images* in the *Bunk* series in 1947. In 1952 the *Bunk* series was shown for the first time by the Independent Group in an epidiascope lecture. This lecture was to have a decisive effect on the evolution of Pop Art in Britain.

In 1960 the Nouveaux Réalistes first came together as a group which included Raymond Hains, Arman, and Daniel Spoerri amongst its members. Their décollages were made from torn-down posters that were presented partly as they were and partly treated in various ways. Their work took as its starting point found fragments of reality from the every-day world and the world of the media, which some of the group's members had been using since as long ago as 1954. In 1958 it was Jacques Villeglé who said that Schwitters had shown them that "any element of our everyday world could be used as a means of painterly expression, including torn down posters".

For the artists of the 1960s who felt drawn to Fluxus, Happenings and Action Art, Schwitters' notion of his "total Merz vision of the world" was a source of inspiration for their own activities. Joseph Beuys, in particular, greatly admired Schwitters. In his early days he produced collages and assemblages that were clearly influenced by the latter's style. Besides using inconsequential, shabby found materials, in his *Plastic Pictures* after 1947 Beuys, like Schwitters, also set great store by the aesthetic effect of the intrinsic colour of the found objects. Similarly, the acoustic component of Beuys' Action *Der Chef* of 1964 would be unthinkable without his having intimate knowledge of the *Ursonate*.

Schwitters also left his mark on the literary world. His love of experiment and the range of his work were valued above all by Gerhard Rühm and Ernst Jandl. Rühm, a founding-member of the Vienna Group, was an early exponent of concrete and visual poetry; he used text-montage, phonetic materials and the intrinsic dynamics of words themselves, always striving for what Schwitters himself had described as the "art of abstract poetry". This tendency is still alive today in the work of sound poets such as Jaap Blonk.

Like Schwitters and other modernist artists, many contemporary artists today feel they are operating somewhere on the boundary between art and life. They either consciously combine genres or simply ignore the existence of different categories. While collage artists from Paolozzi to Rauschenberg have cited Kurt Schwitters as their role model, the principles of collage have long become public property as far as the younger generation of artists today is concerned. With unlimited possibilities in terms of form and style, contemporary artists are nevertheless once again exploring the question of borders and boundaries in art. The dismissal of traditional attitudes to art and the combining of all available materials – independent of their defined value – as well as the incursion into all kinds of virtual and real worlds are themes that not only occupied exhibitions such as documenta X, but which by and large shaped the art of the 1990s.

For the exhibition *In the Beginning was MERZ – from Kurt Schwitters to the Present Day*, a number of contemporary artists, who broadly speaking find themselves drawing on Schwitters' artistic and intellectual property, were invited to create new works for the project. These new works were also to take collage – including walk-in collage – as their starting point. Studios and workshops, caves, cells, cocoons, niches and other environments and installations lead the way. These new pieces by John Bock, Christoph Büchel, Laura Kikauka, Nana Petzet, Lois Renner, Gregor Schneider, Jessica Stockholder, the groups gelatin + d.moises and tomato demonstrate the progress of the idea of the *Gesamtkunstwerk*, as developed by Schwitters in the inter-war years. Seeing the works of the founding-father Schwitters side by side with collages, sculptures and installations by other artists, and visually pacing out a time-span of eighty years, cannot fail to enrich the perceptual experience of the viewer. Thus it bears repeating that our project both presents a retrospective of the work of Kurt Schwitters and traces the influence of his *Merzbau* and collages. And we trust that this juxtaposition of historical and contemporary positions is indeed in the spirit of Schwitters' own approach, for as early as 1931, he was already exhorting critics and exhibitions-makers: "But if you people of the future want to do something to make me particularly happy, then try to recognise the important artists of your own time. That is more important for you and would be a greater joy for me, than if you discover me at a time when I have already long been discovered." (Kurt Schwitters, 'Ich und meine Ziele', 1931).

Susanne Meyer-Büser
Karin Orchard

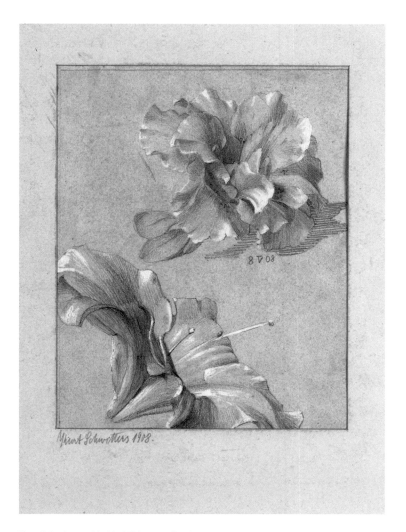

Kurt Schwitters, *Untitled (Blossom Studies)*, 1908 (cat. no. 1

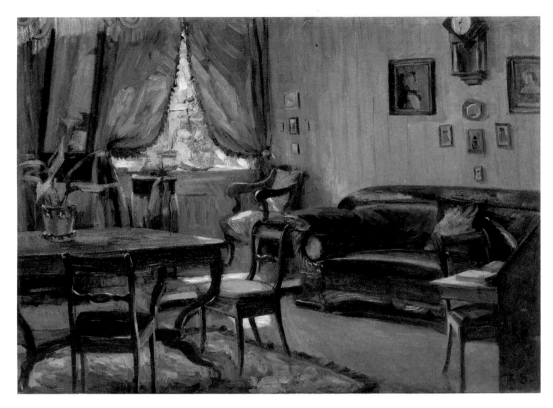

Kurt Schwitters, *Untitled (Interior),* ca. 1910 (cat. no. 2)

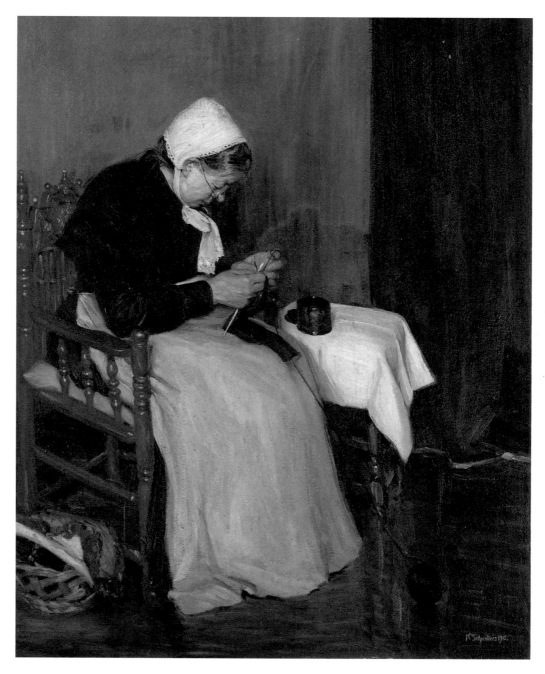

Kurt Schwitters, *Old Woman Knitting*, 1915 (cat. no. 6)

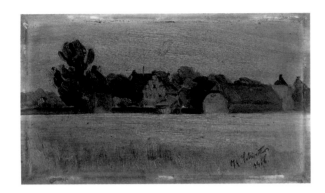

Kurt Schwitters, *Untitled (Landscape and Farmstead in Opherdicke, Westphalia)*, 1916 (cat. no. 8)

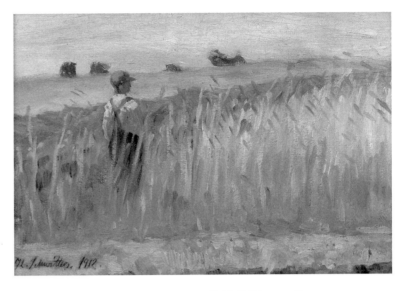

Kurt Schwitters, *Untitled (Farmer on a Wheat Field)*, 1912 (cat. no. 3)

Kurt Schwitters, *A S Landscape 1. Midsummer,* 1914/16 (cat. no. 5)

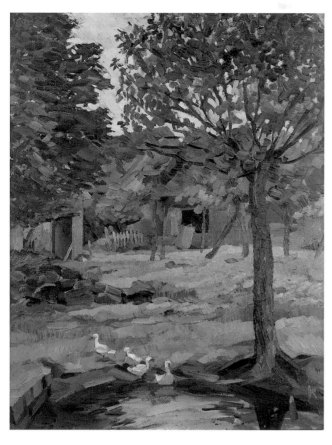

Kurt Schwitters, *Farmstead with Geese,* ca. 1913 (cat. no. 4)

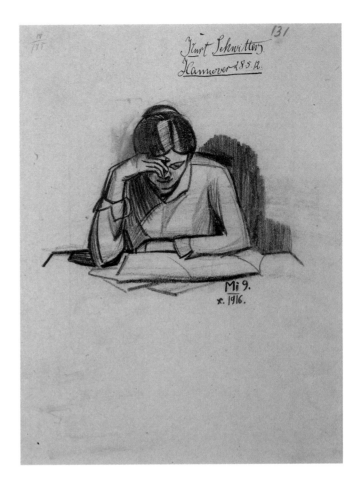

Kurt Schwitters, *Untitled (Woman Reading)*, 1916 (cat. no. 9)

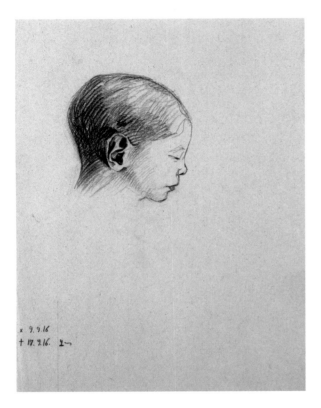

Kurt Schwitters, *Untitled (Gerd Schwitters, Study of Head 1)*, 1916
(cat. no. 10)

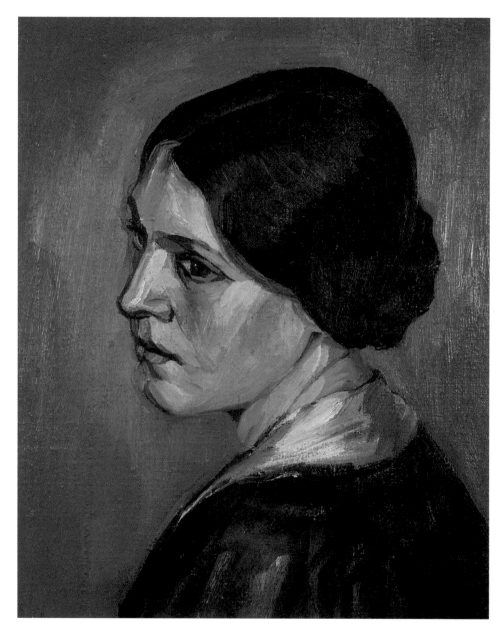

Kurt Schwitters, *Untitled (Portrait of Helma Schwitters)*, 1916 (cat. no. 7)

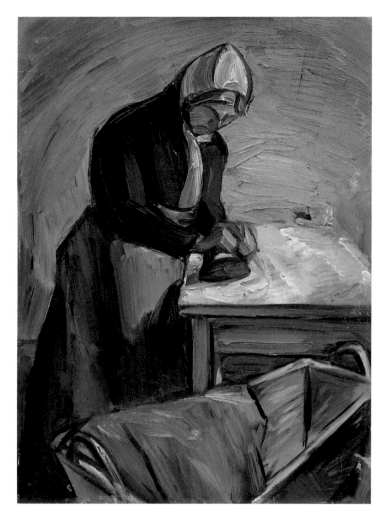

Kurt Schwitters, *The Ironer,* 1917 (cat. no. 11)

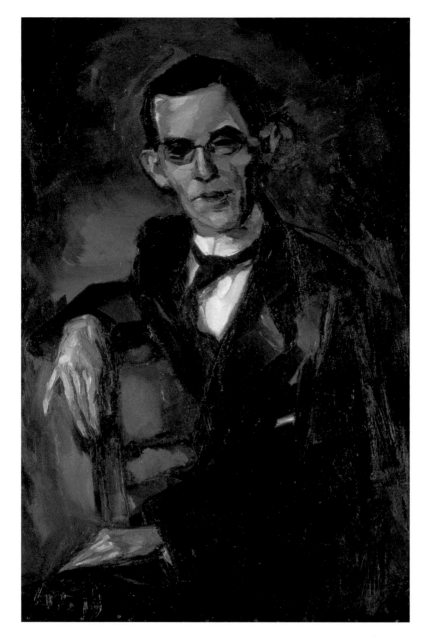

Kurt Schwitters, *Untitled (Portrait of the Bookseller Julius Beeck),* 1919 (cat. no. 28)

Kurt Schwitters, *Untitled (Farmstead and Path near Vrestorf),* 1919 (cat. no. 29)

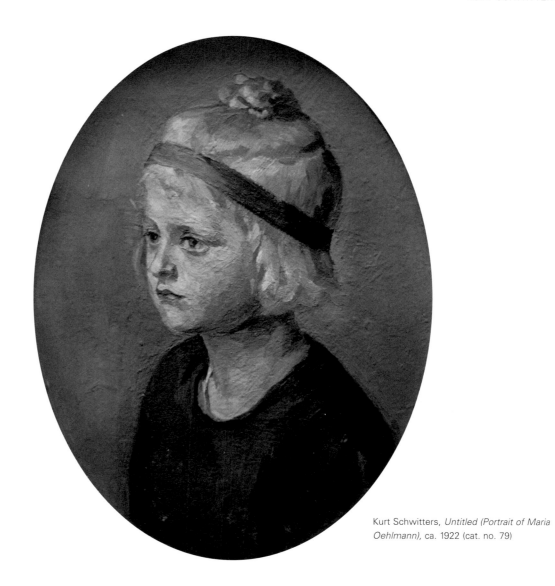

Kurt Schwitters, *Untitled (Portrait of Maria Oehlmann)*, ca. 1922 (cat. no. 79)

Kurt Schwitters, *Z 14 Factory Yard.*, 1918
(cat. no. 15)

Kurt Schwitters, *Z 15 Church and Houses*, 1918
(cat. no. 16)

Kurt Schwitters, *Z 130 Abstract Drawing,*
1918 (cat. no. 17)

Kurt Schwitters, *Z 81 (?) Factory,* 1918 (cat. no. 20)

Kurt Schwitters, *Z 40, Canal (2),* 1918 (cat. no. 18)

Kurt Schwitters, *Z 71, The Lonely One. (2),* 1918 (cat. no. 19)

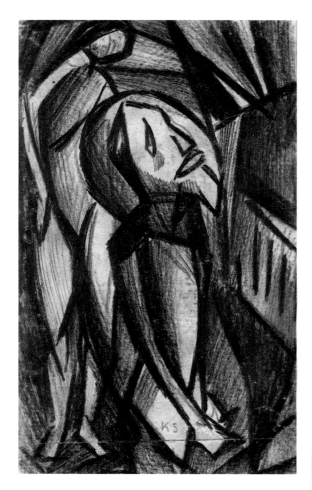

Kurt Schwitters, *Z 122 The Temptation of St. Anthony.*, 1918
(cat. no. 22)

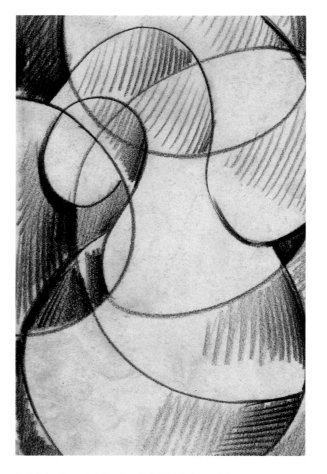

Kurt Schwitters, *Abstraction 150*, 1918 (cat. no. 21)

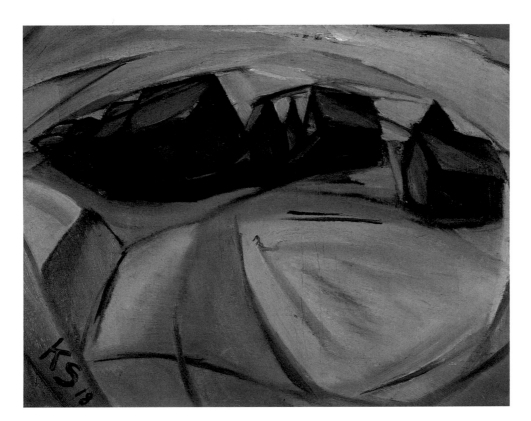

Kurt Schwitters, *Snowcovered Houses,* 1918 (cat. no. 13)

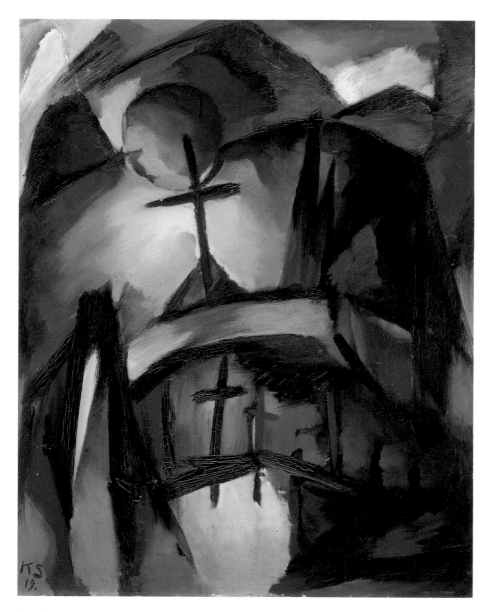

Kurt Schwitters, *Mountain Graveyard (Abstraction),* 1919 (cat. no. 27)

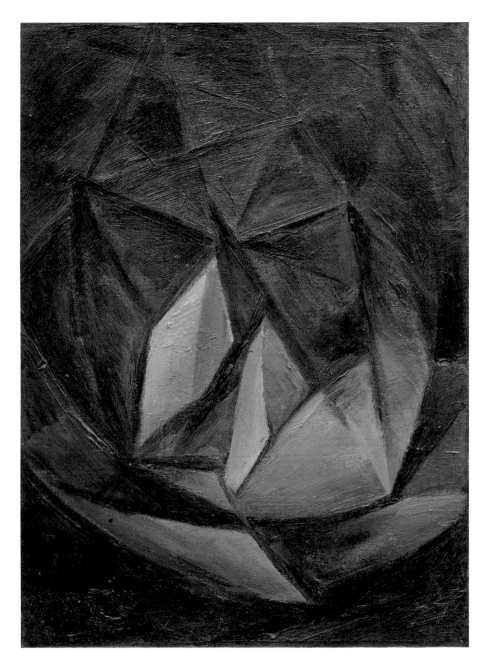

Kurt Schwitters, *Abstraction No 16 (Sleeping Crystal),* 1918 (cat. no. 12)

Kurt Schwitters, *Untitled (Lithograph, with Rivet Holes),* 1919 (cat. ro. 37)

Kurt Schwitters, *Untitled (2 Circles, from: Das Kestnerbuch),* 1919
(cat. no. 36)

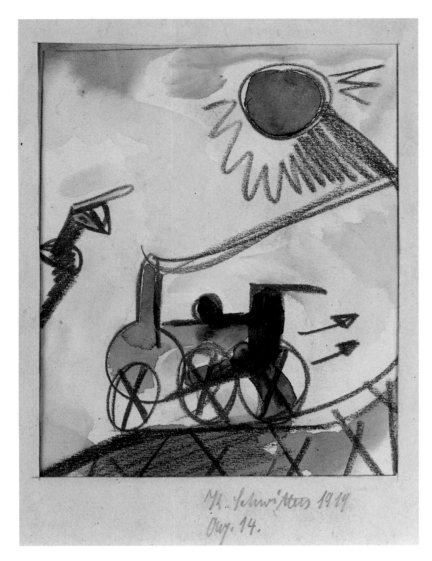

Kurt Schwitters, *Aq. 14. (Locomotive Backwards.),* 1919 (cat. no. 33)

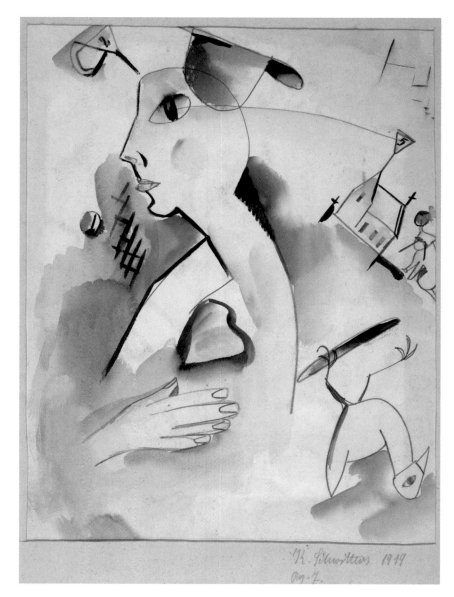

Kurt Schwitters, *Aq. 7. (Mann schaaft Lilablau),* 1919 (cat. no. 32)

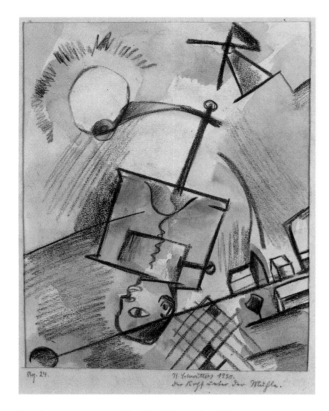

Kurt Schwitters, *Aq. 24. The Head Below the Mill.*, 1919–1920
(cat. no. 38)

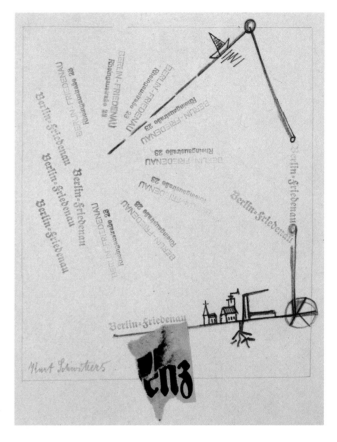

Kurt Schwitters, *Untitled (Berlin–Friedenau),* 1919 (cat. no. 34)

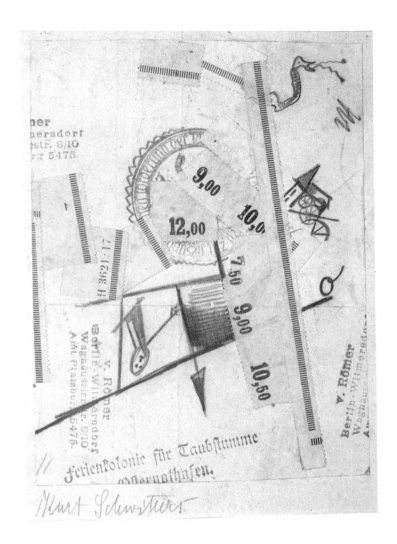

Kurt Schwitters, *Untitled (Holiday Camp for Deaf Mutes),* 1919 (cat. no. 35)

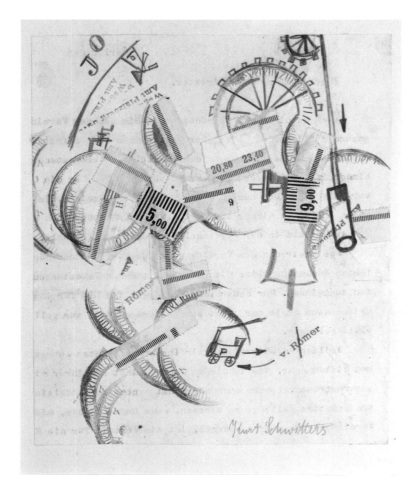

Kurt Schwitters, *Untitled (With Red 4),* 1919 (cat. no. 30)

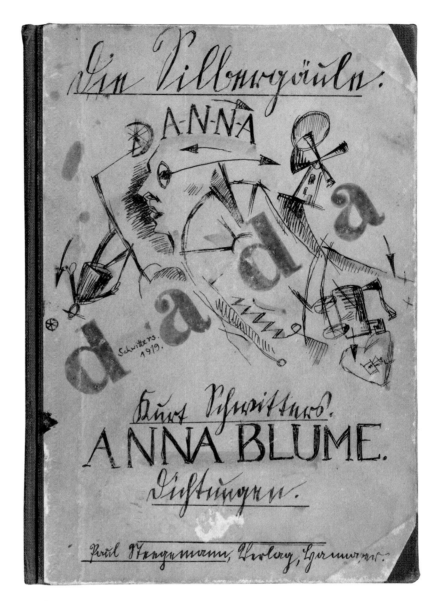

Kurt Schwitters, *Anna Blume, Dichtungen (Draft of Title Page),* 1919 (cat. no. 31)

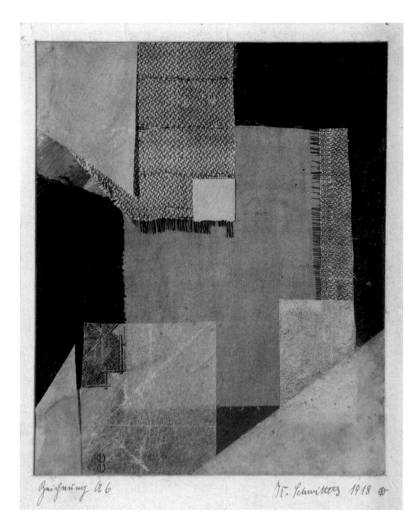

Kurt Schwitters, *Drawing A 6,* 1918 (cat. no. 14)

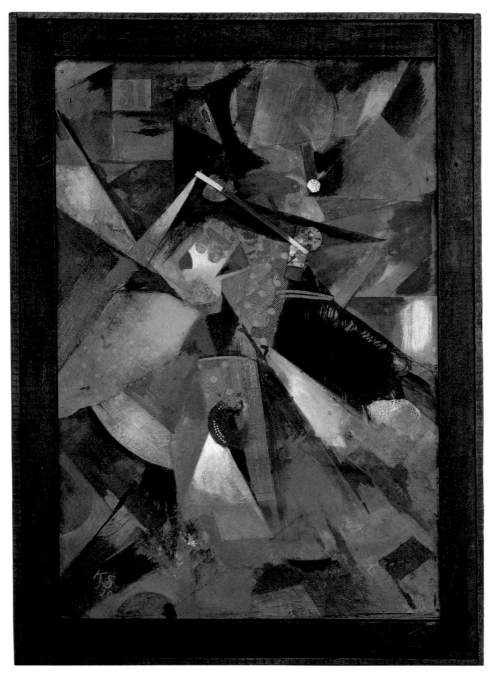

Kurt Schwitters, *Merzpicture Thirty-One,* 1920 (cat. no. 40)

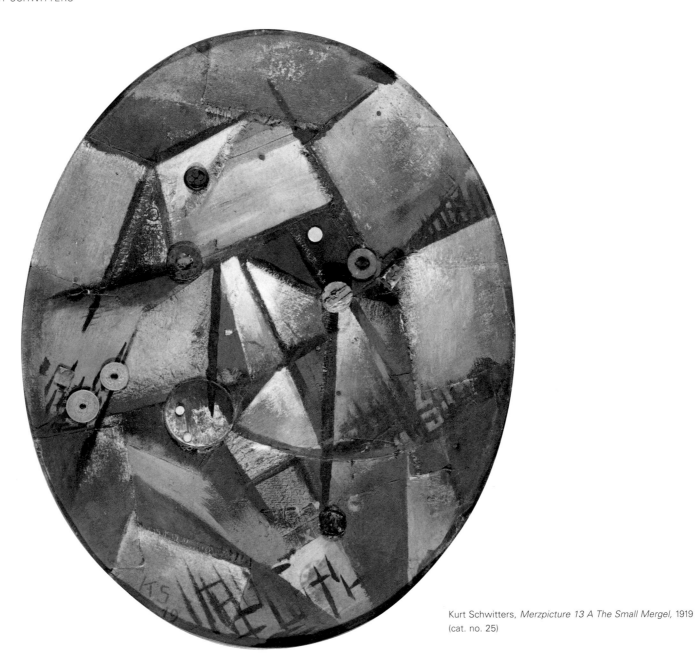

Kurt Schwitters, *Merzpicture 13 A The Small Mergel,* 1919
(cat. no. 25)

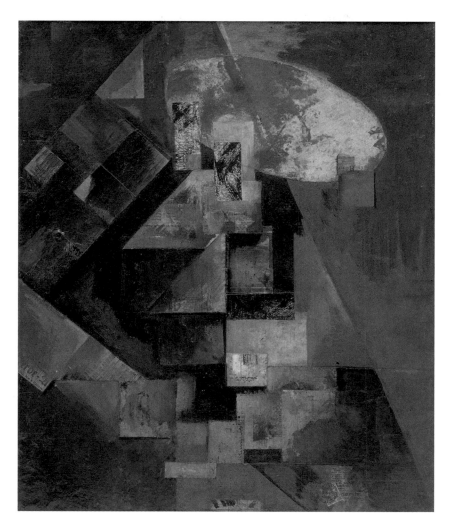

Kurt Schwitters, *Merzpicture 1 B Picture with Red Cross,* 1919 (cat. no. 23)

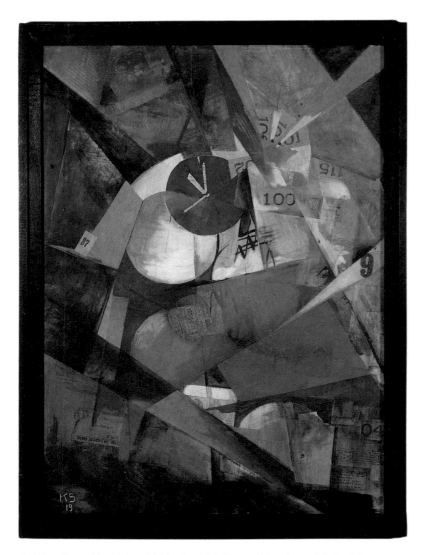

Kurt Schwitters, *Merzpicture 9 b The Great Ich Picture / Merzpicture K 7 (?)*, 1919
(cat. no. 24)

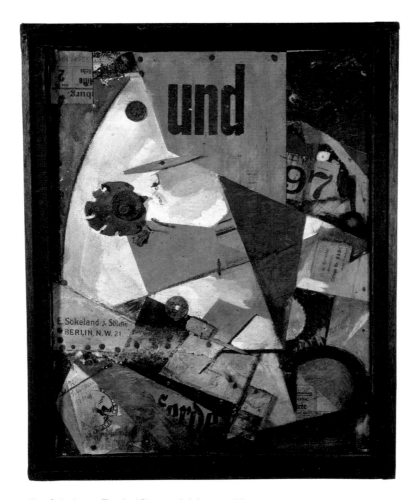

Kurt Schwitters, *The And Picture,* 1919 (cat. no. 26)

Kurt Schwitters, *Mz. 57. (Pink.)*, 1920 (cat. no. 44)

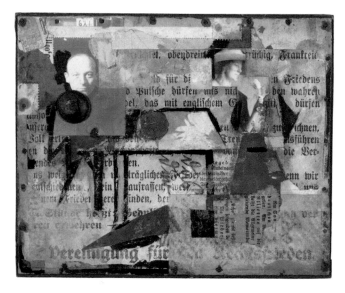

Kurt Schwitters, *The Bäumer Picture*, 1920 (cat. no. 41)

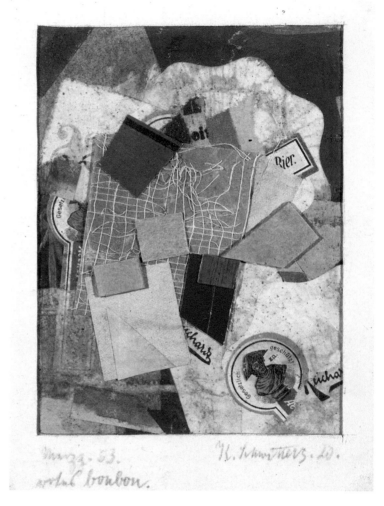

Kurt Schwitters, *Merzz. 53. Red Bonbon.,* 1920 (cat. no. 43)

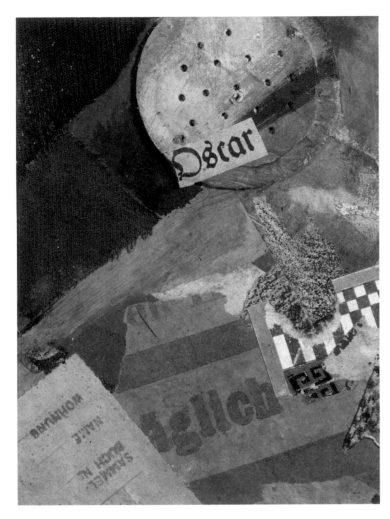

Kurt Schwitters, *Mz 150 Oskar.*, 1920 (cat. no. 47)

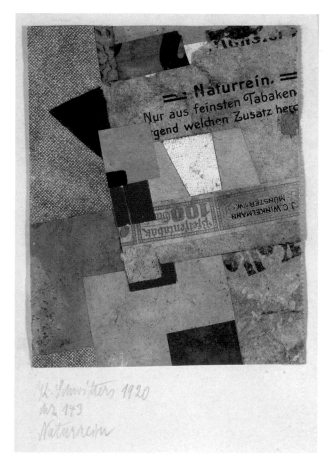

Kurt Schwitters, *Mz 143 Unadulterated,* 1920 (cat. no. 53)

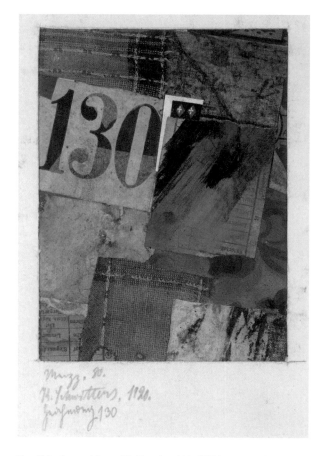

Kurt Schwitters, *Merzz. 80. Drawing 130,* 1920 (cat. no. 46)

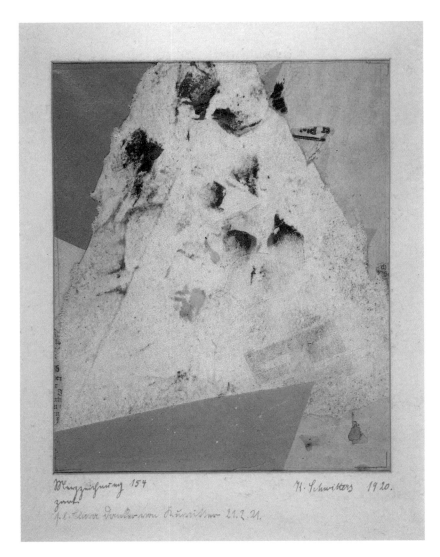

Kurt Schwitters, *Merzdrawing 154 Tender.*, 1920 (cat. no. 48)

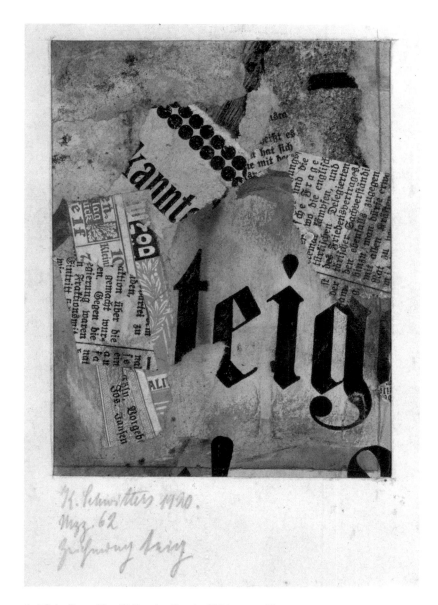

Kurt Schwitters, *Mzz. 62 Drawing Dough,* 920 (cat. ro. 45)

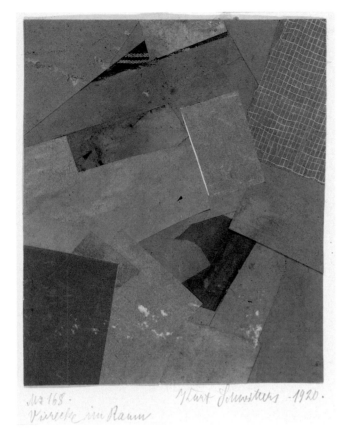

Kurt Schwitters, *Mz 168. Squares in Space,* 1920 (cat. no. 49)

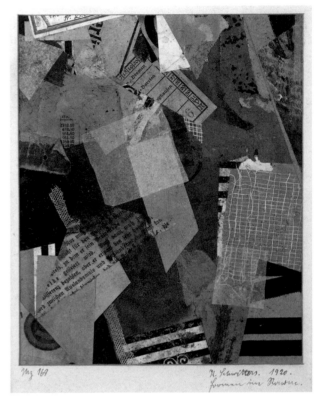

Kurt Schwitters, *Mz 169 Shapes in Space,* 1920 (cat. no. 50)

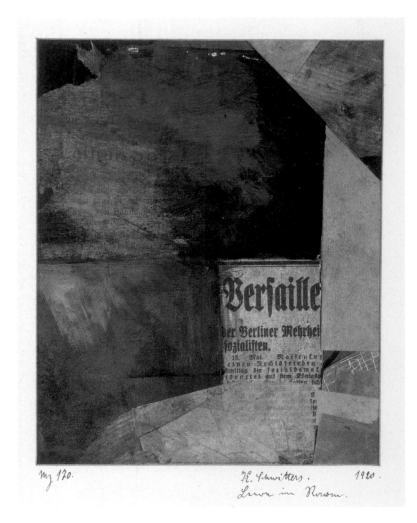

Kurt Schwitters, *Mz 170. Voids in Space.,* 1920 (cat. no. 51)

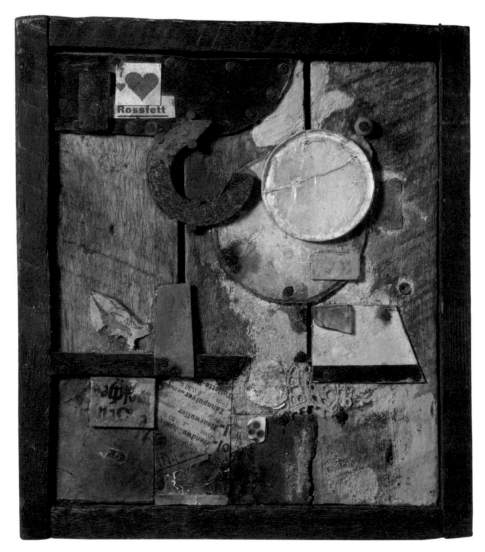

Kurt Schwitters, *Untitled (Merzpicture Horse Grease),* ca. 1920 (cat. no. 42)

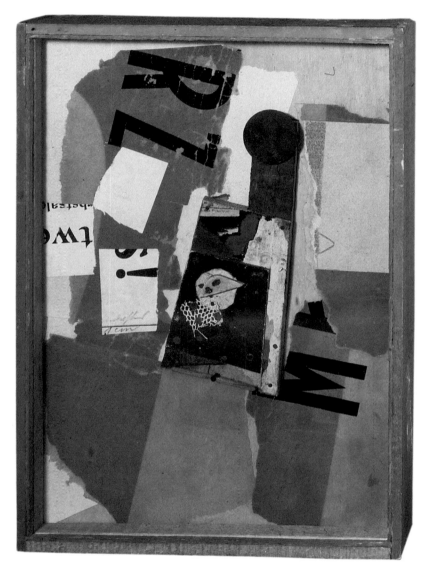

Kurt Schwitters, *Untitled (Merz),* 1919–1923 (cat. no. 39)

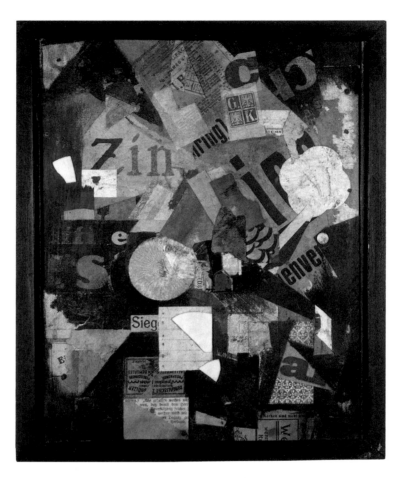

Kurt Schwitters, *Victory Picture,* 1920/25 (cat. no. 57)

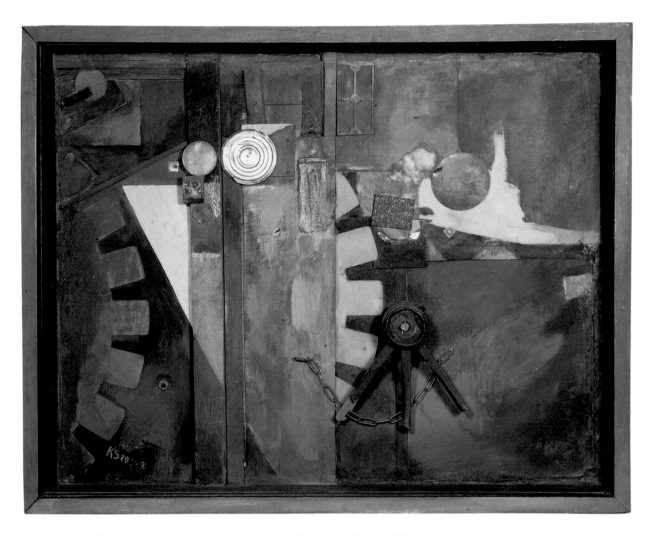

Kurt Schwitters, *Merzpicture 29 A. Picture with Turning Wheel,* 1920 and 1940 (cat. no. 55)

Kurt Schwitters, *Merzpicture 35 A,* 1921 (cat. no. 58)

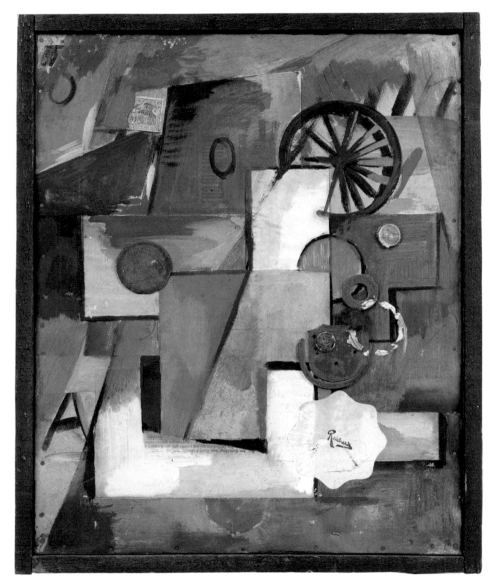

Kurt Schwitters, *Untitled (Dein treufrischer),* 1921 (cat. no. €0)

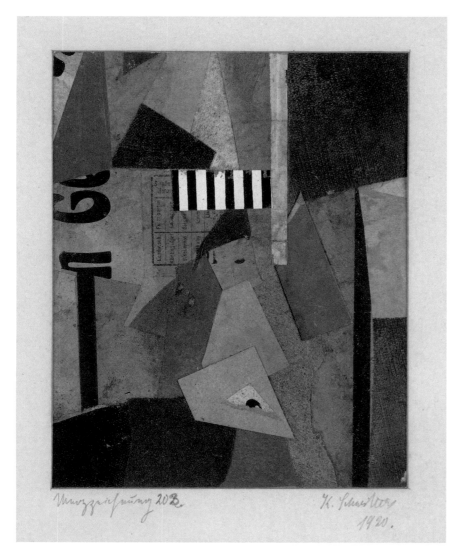

Kurt Schwitters, *Merzdrawing 203.*, 1920 (cat. no. 52)

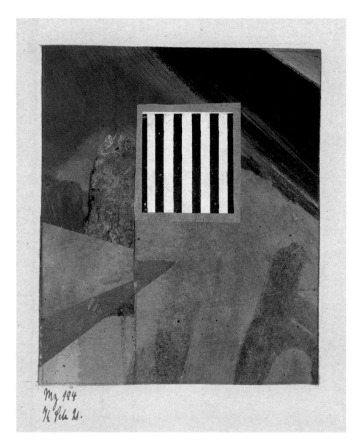

Kurt Schwitters, *Mz 194,* 1921 (cat. no. 61)

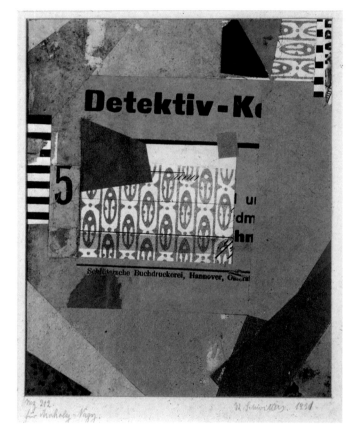

Kurt Schwitters, *Mz 212. For Moholy-Nagy.,* 1921 (cat. no. 62)

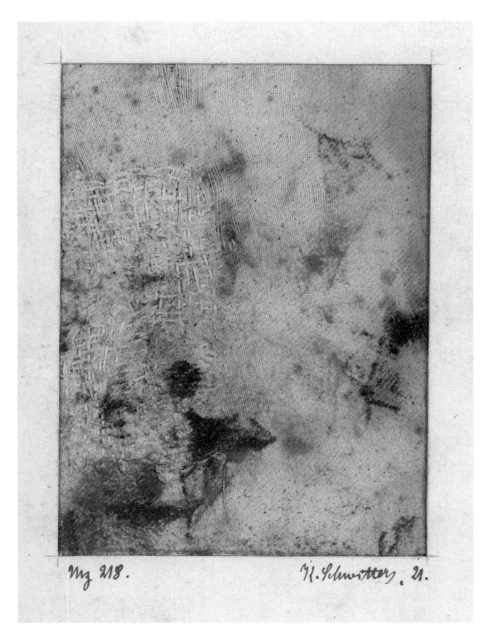

Kurt Schwitters, *Mz 218.*, 1921 (cat. no. 63)

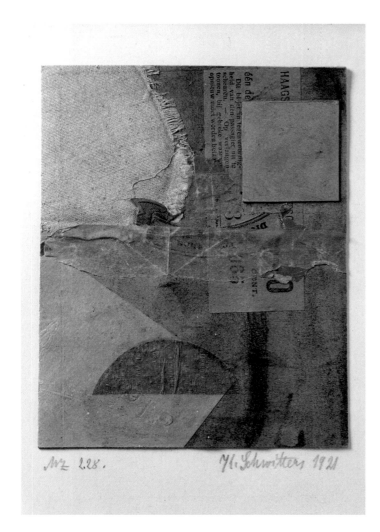

Kurt Schwitters, *Mz 228.*, 1921 (cat. no. 65)

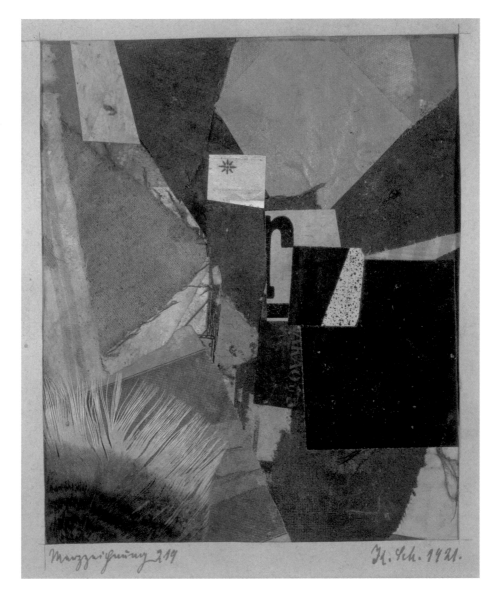

Kurt Schwitters, *Merzdrawing 219,* 1921 (cat. no. 64)

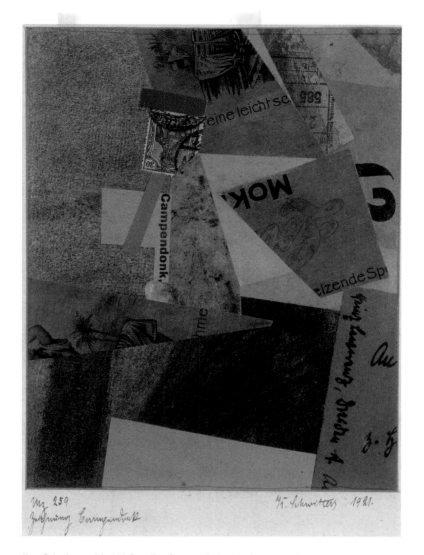

Kurt Schwitters, *Mz 259 Drawing Campendonk,* 1921 (cat. no. 66)

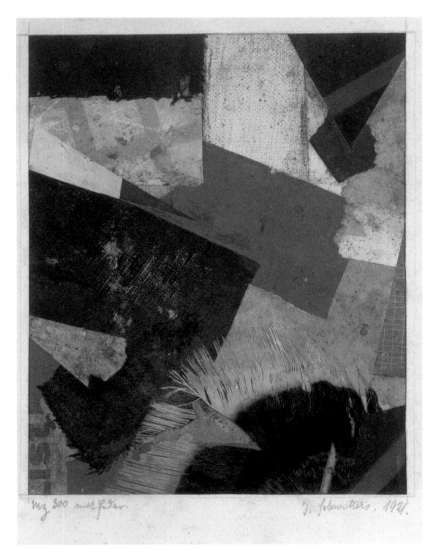

Kurt Schwitters, *Mz 300 With Feather.,* 1921 (cat. no. 68)

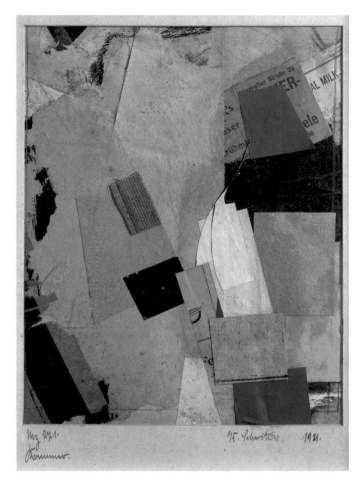

Kurt Schwitters, *Mz 271. Cupboard.*, 1921 (cat. no. 67)

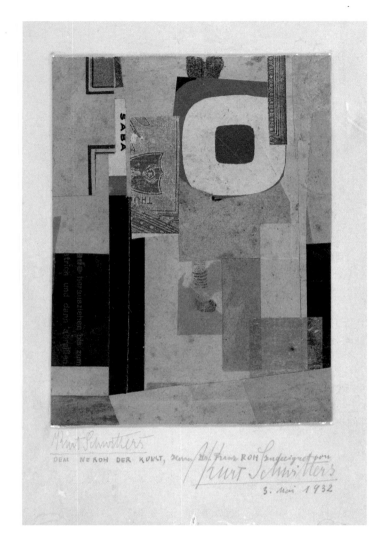

Kurt Schwitters, *(SABA) To the NeROH of Art,* 1926/28 (cat. no. 106)

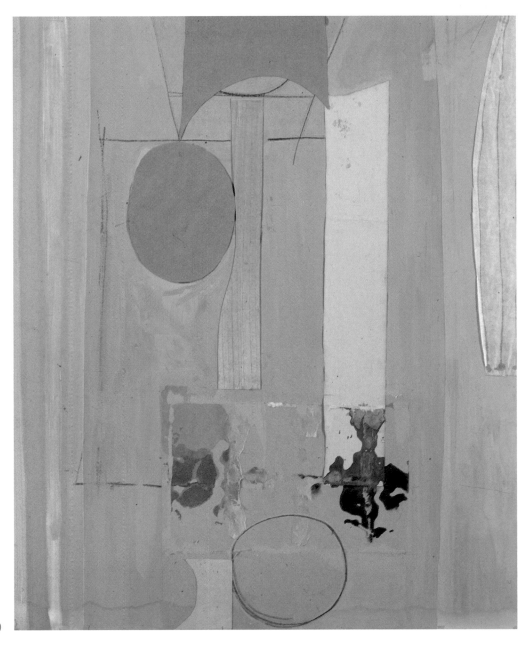

Robert Motherwell, *Mallarmé's Swan*, 1944 (cat. no. 299)

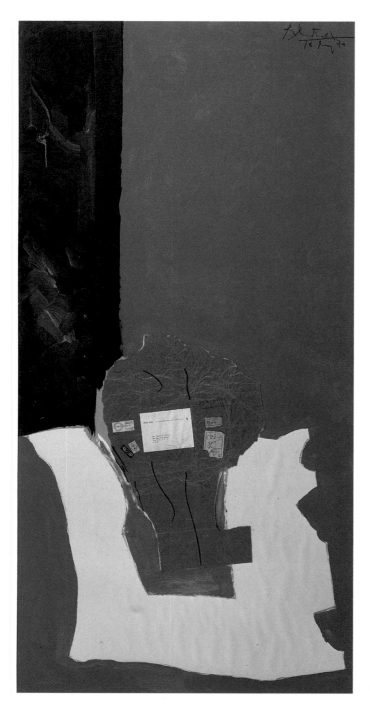

Robert Motherwell, *Pierre Berès,* 1974 (cat. no. 300)

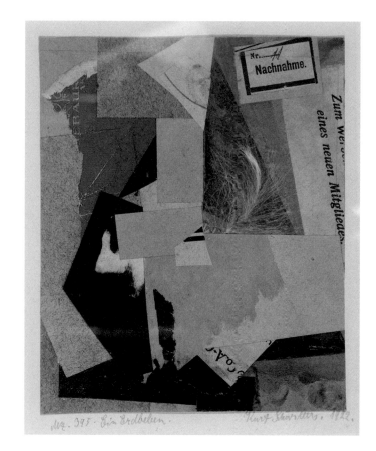

Kurt Schwitters, *Mz. 395. An Earthquake.*, 1922 (cat. no. 71)

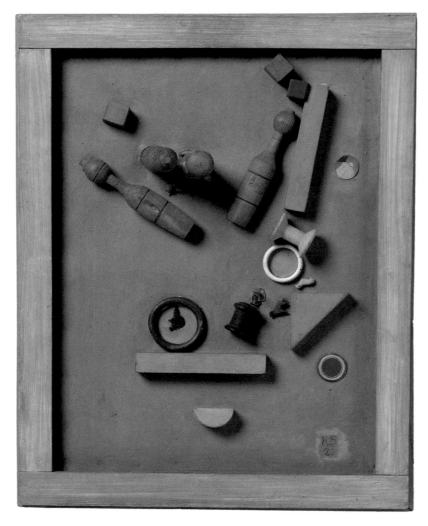

Kurt Schwitters, *Merzpicture 46 A. The Bowling Picture*, 1921 (cat. no. 59)

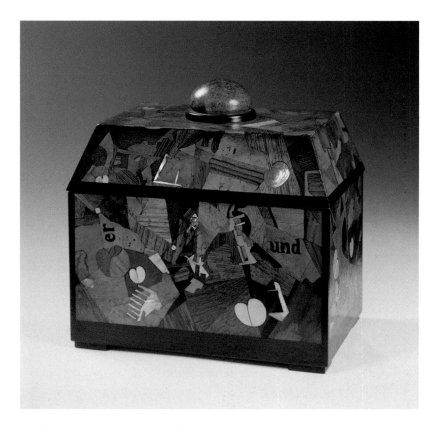

Kurt Schwitters, *Untitled (Inlaid Box SK / P for Sophie and Paul Erich Küppers),* 1921
(cat. no. 69)

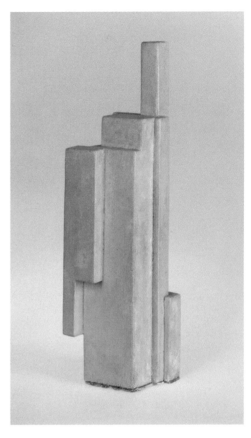

Kurt Schwitters, *Untitled (Vertical),* 1923 (cat. no. 85)

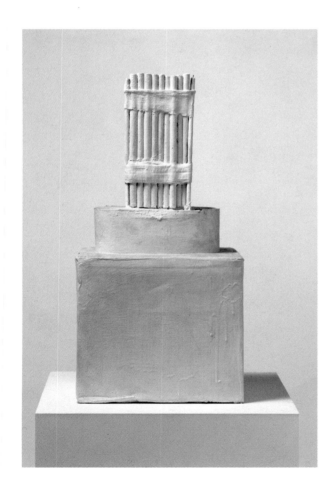

Cy Twombly, *Untitled. Rome 1959 (Cast Rome 1985)* (cat. no. 337)

CY TWOMBLY

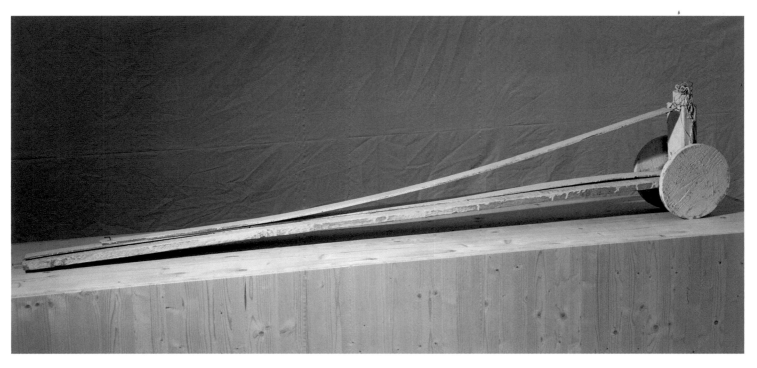

Cy Twombly, *Untitled. Zurich 1978 (Cast Zurich 1991)* (cat. no. 336)

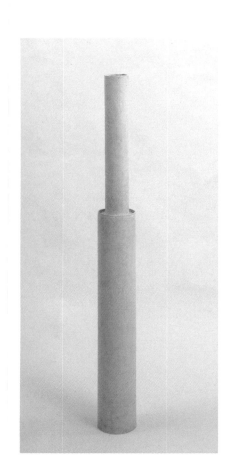

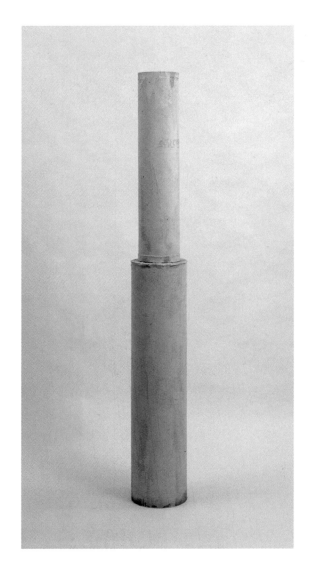

Cy Twombly, *Untitled. Rome 1977*
(cat. no. 335)

Cy Twombly, *Untitled. Rome 1977* (cat. no. 334)

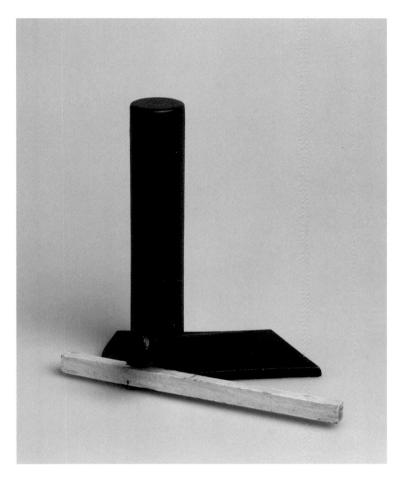

Kurt Schwitters, *Untitled (Small Black Column),* 1922/24 (cat. no. 78)

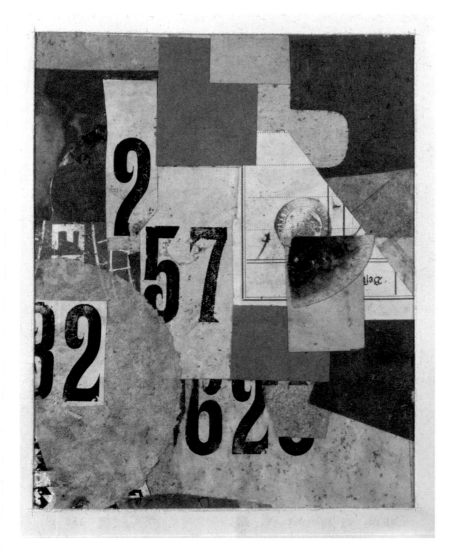

Kurt Schwitters, *Mz 426 Figures,* 1922 (cat. no. 74)

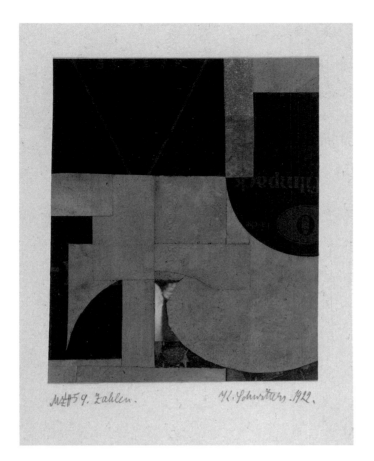

Kurt Schwitters, *Mz 459. Figures.*, 1922 (cat. no 75)

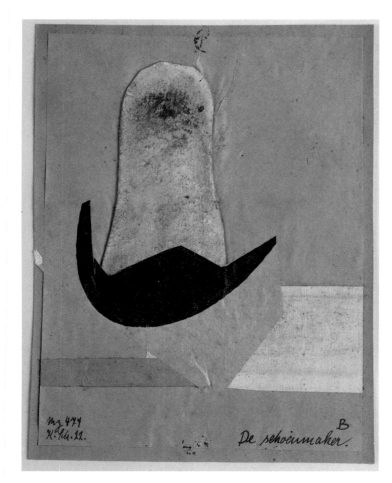

Kurt Schwitters, *Mz 474 The Shoemaker.*, 1922 (cat. no. 76)

Kurt Schwitters, *i-Drawing*, 1920 (cat. no. 56)

Kurt Schwitters, *Drawing I 8 Lever 1*, 1920 (cat. no. 54)

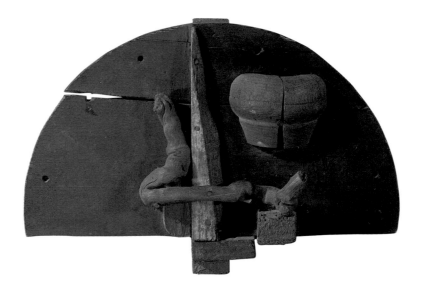

Kurt Schwitters, *Untitled (Wooden Construction)*, 1923 (cat. no. 80)

Kurt Schwitters, *Mz 425. Not so Cheap at All.*, 1922
(cat. no. 73)

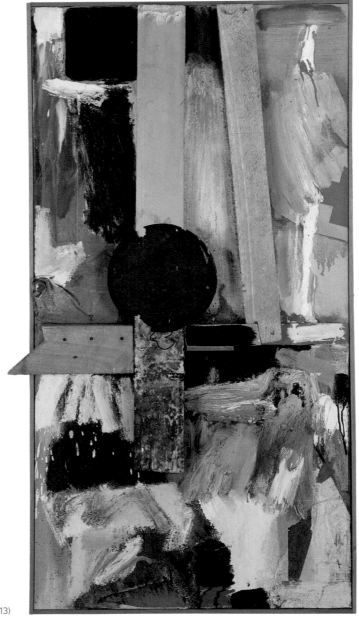

Robert Rauschenberg, *Diplomat,* 1960 (cat. no. 313)

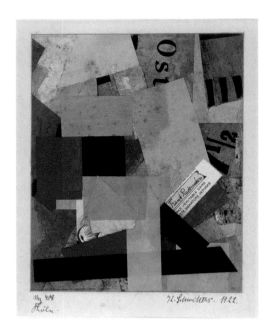

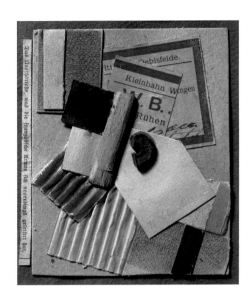

Kurt Schwitters, *Merzpicture 435,* 1922? (cat. no. 70)

Kurt Schwitters, *Mz 408 Cologne.,* 1922 (cat. no. 72)

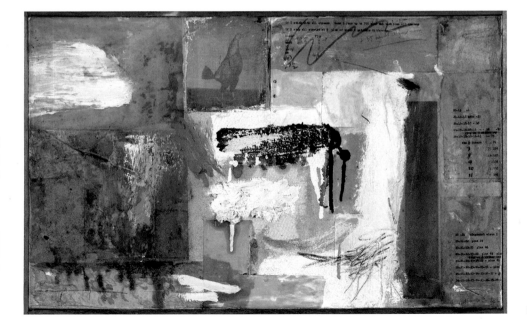

Robert Rauschenberg, *Untitled,* 1957 (cat. no. 312)

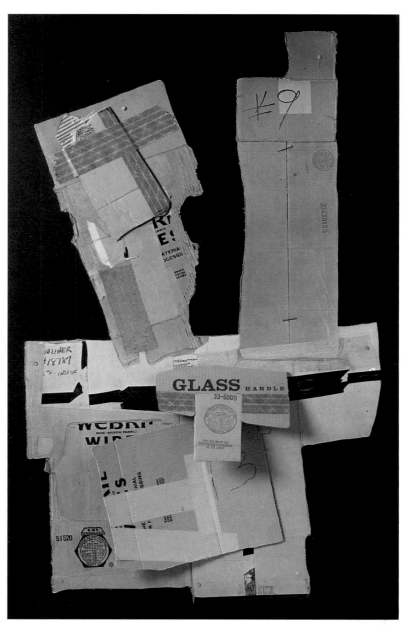

Robert Rauschenberg, *Cardbird II*, 1971 (cat. no. 315)

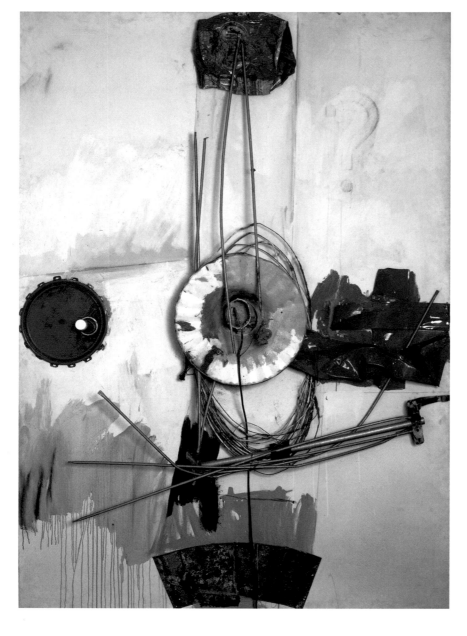

Robert Rauschenberg, *Navigator,* 1962 (cat. no. 314)

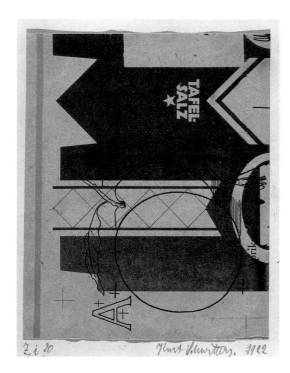

Kurt Schwitters, *Z. i. 20 Table Salt,* 1922 (cat. no. 77)

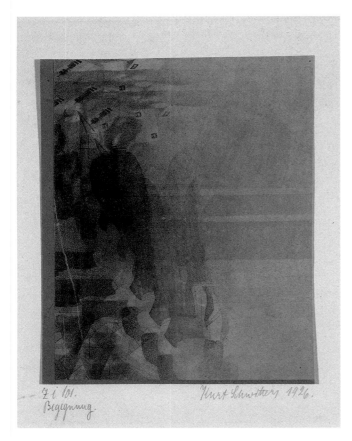

Kurt Schwitters, *Zi 101. Encounter.,* 1926 (cat. no. 104)

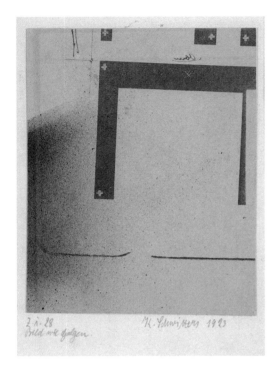

Kurt Schwitters, *Z. i. 28 Picture like Gallows.*, 1923
(cat. no. 84)

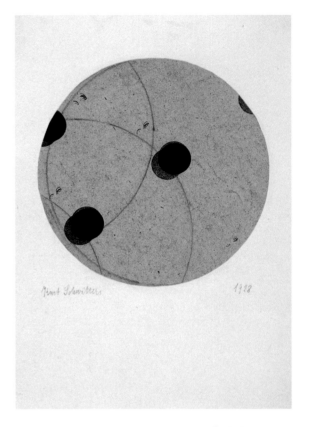

Kurt Schwitters, *Untitled (formerly: i-drawing 'Circles')*, 1928
(cat. no. 111)

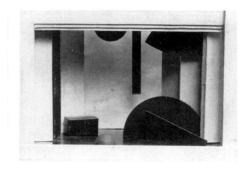

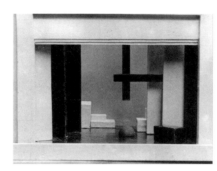

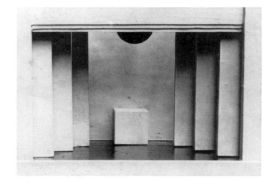

Kurt Schwitters, *Photographs of the original model of the Merz Normal Stage,* ca. 1924 (cat. no. 235)

Kurt Schwitters, *Merz 1924, 1st Relief with Cross and Sphere,* 1924
(cat. no. 90)

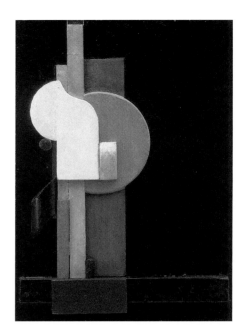

Kurt Schwitters, *Merz 1926,3. Cicero,* 1926
(cat. no. 99)

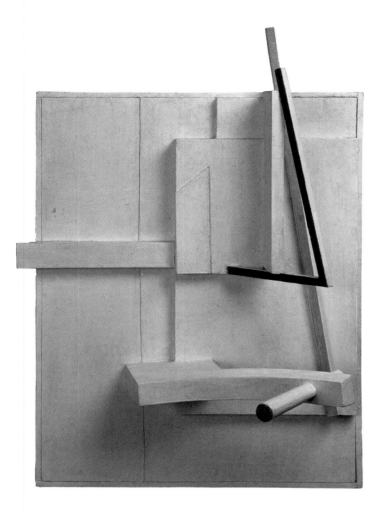

Kurt Schwitters, *1st White Relief,* 1924/27 (cat. no. 93)

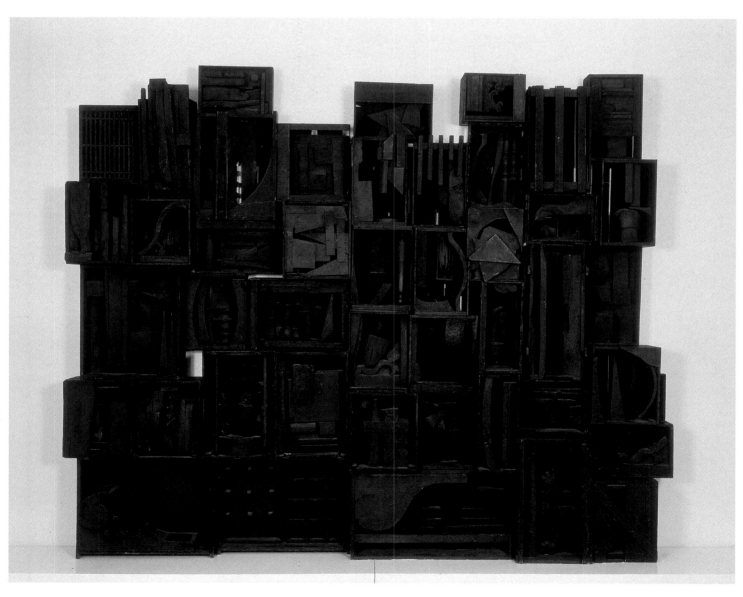

Louise Nevelson, *Sky Cathedral III,* 1959 (cat. no. 302)

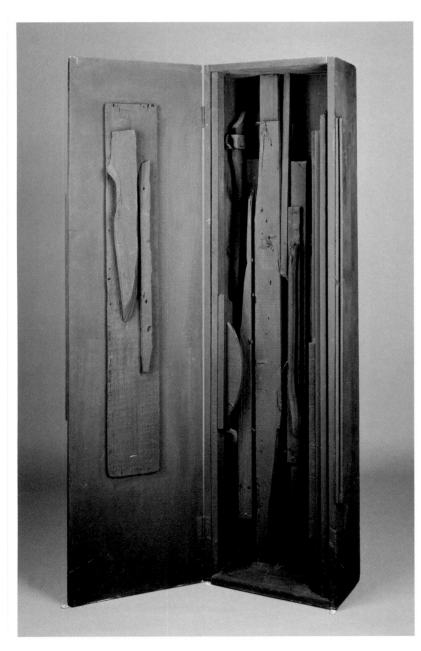

Louise Nevelson, *World Garden IV,* 1959 (cat. no. 303)

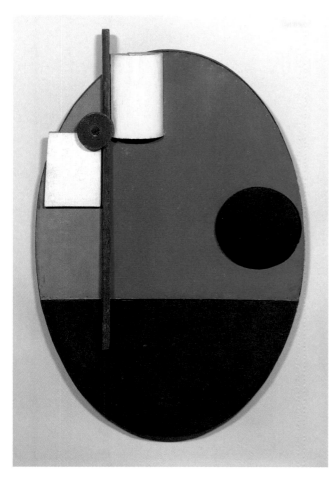

Kurt Schwitters, *Untitled (Oval Construction),* ca. 1925 (cat. no. 94)

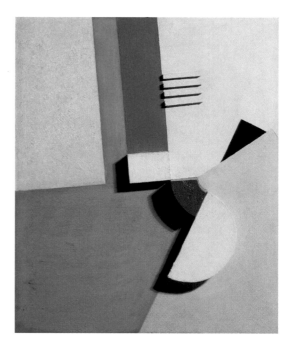

Kurt Schwitters, *Relief with Red Segment,* ca. 1926 (cat no. 96)

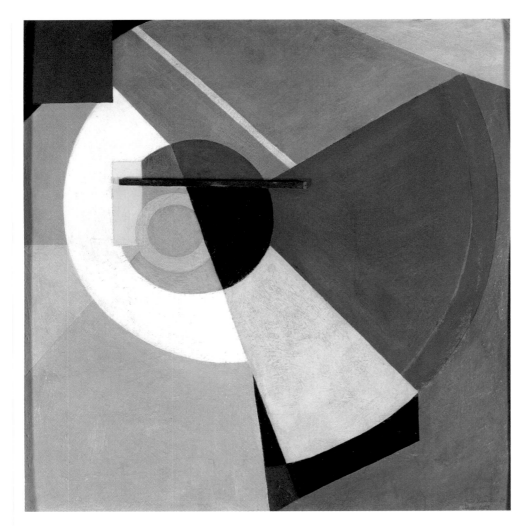

Kurt Schwitters, *Merz 1003. Peacock's Tail,* 1924 (cat. no. 88)

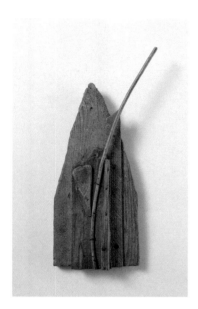

Kurt Schwitters, *Cathedral,* 1926
(cat. no. 97)

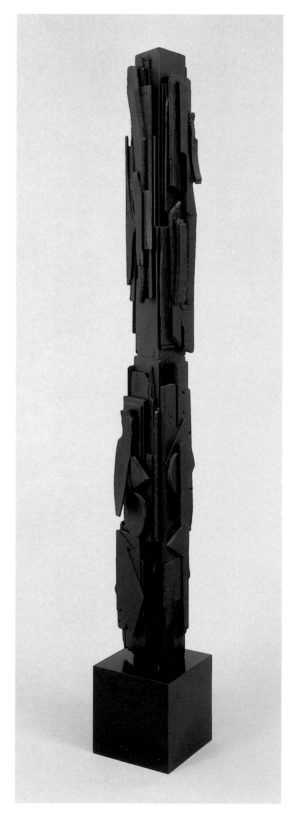

Louise Nevelson, *Pan Forest Column XIX,* 1959
(cat. no. 301)

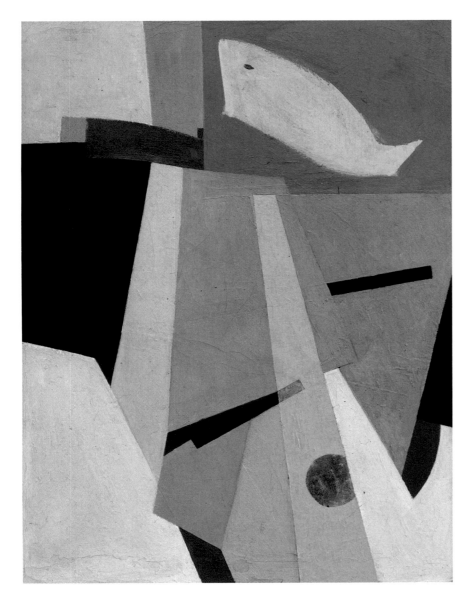

Kurt Schwitters, *Untitled (Picture with Whale)*, 1924 (cat. no. 89)

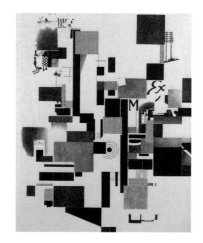

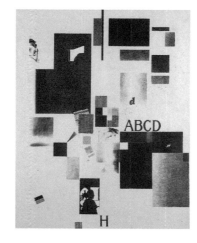

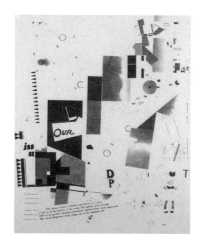

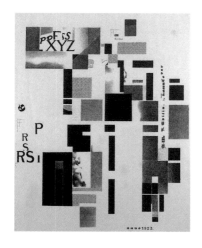

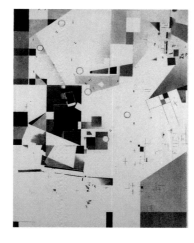

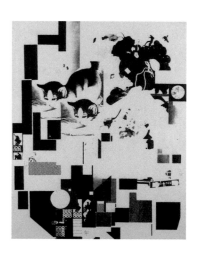

Kurt Schwitters, *Merz 3. Merz Portfolio.*, 1923
(cat. no. 83)

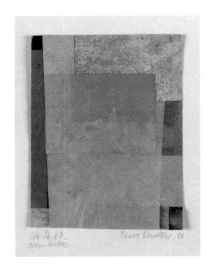

Kurt Schwitters, *Mz 26, 63. absolutely nothing.*, 1926 (cat. no. 103)

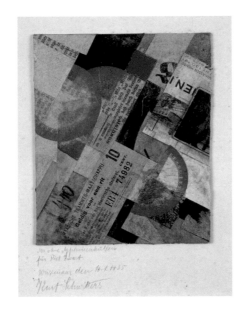

Kurt Schwitters, *Mz without Orangeskins,* 1923/25 (cat. no. 86)

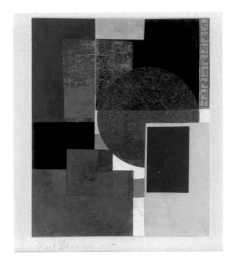

Kurt Schwitters, *Untitled (5 So Mo Die)*, 1925 (cat. no. 95)

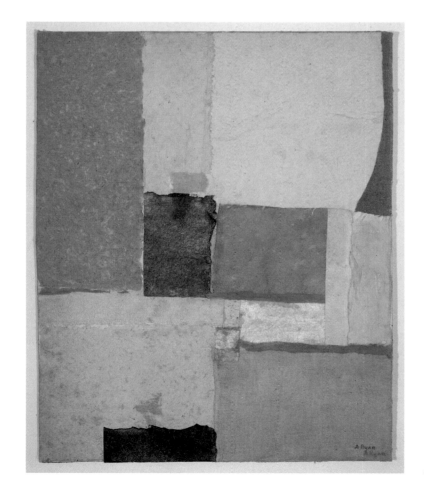

Anne Ryan, *Untitled (# 516),* 1949 (cat. no. 326)

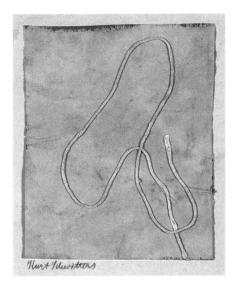

Kurt Schwitters, *Untitled (With Thread)*, 1923/26
(cat. no. 87)

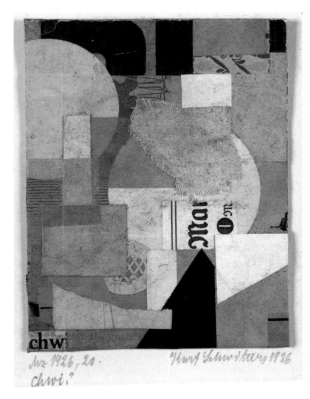

Kurt Schwitters, *Mz 1926,20. chwi.*, 1926 (cat. no. 100)

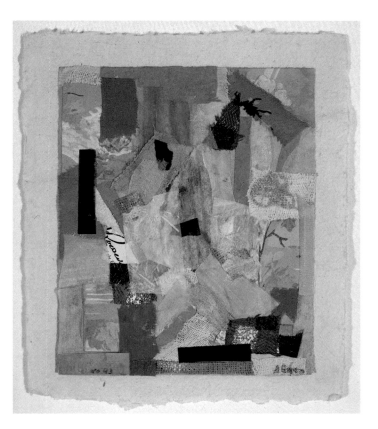

Anne Ryan, *Untitled (# 43),* 1948 (cat. no. 323)

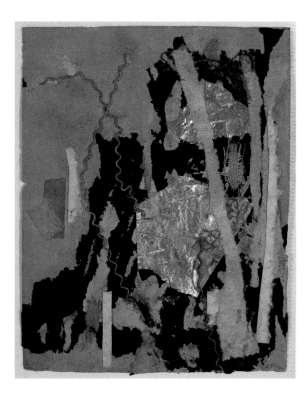

Anne Ryan, *Untitled (# 234),* 1949 (cat. no. 325)

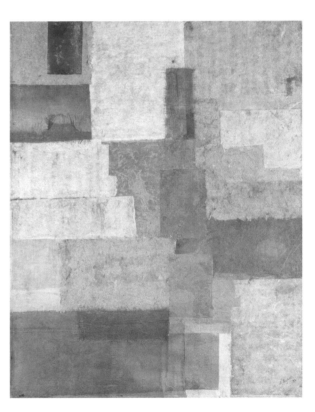

Anne Ryan, *Untitled,* 1952 (cat. no. 327)

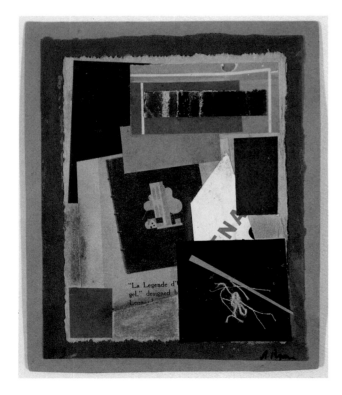

Anne Ryan, *Untitled (# 3),* 1949 (cat. no. 324)

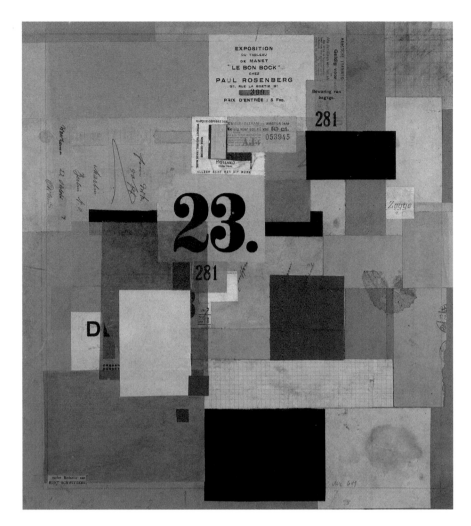

Kurt Schwitters, *Mz 601,* 1923 (cat. no. 81)

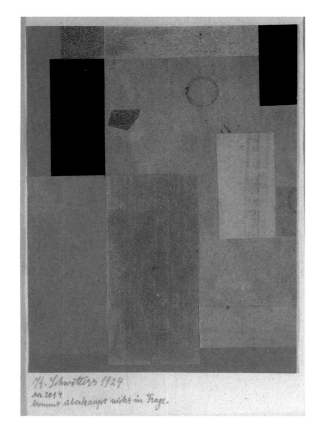

Kurt Schwitters, *Mz 2014 completely out of the question.*, 1924
(cat. no. 91)

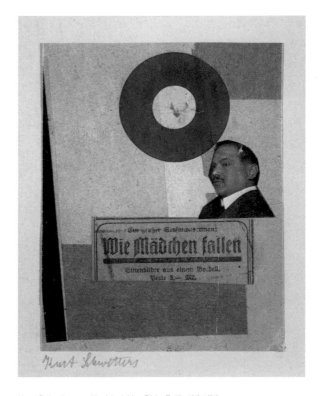

Kurt Schwitters, *Untitled (As Girls Fall)*, 1924/26
(cat. no. 92)

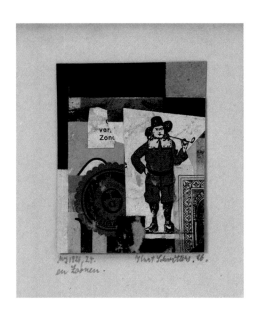

Kurt Schwitters, *Mz 1926,24. en Zoonen.*, 1926
(cat. no. 101)

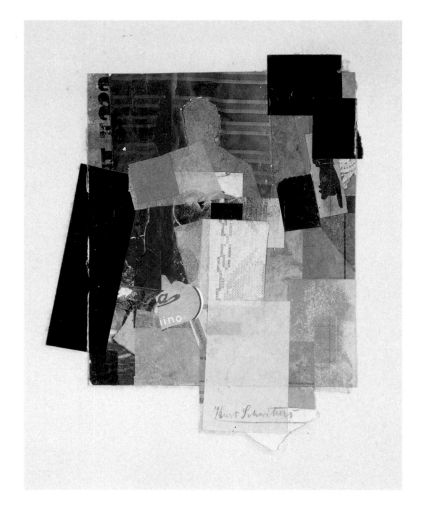

Kurt Schwitters, *Mz 1926,2. self above. for Janssen 1936,* 1926 (cat. no. 98)

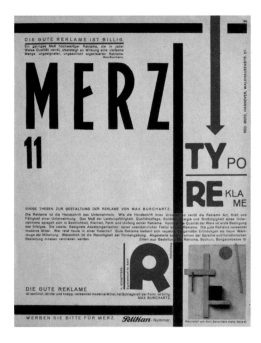

Kurt Schwitters, *Merz 11 Type-set text advertisement (Pelikan Number)*, 1924 (cat. no. 233)

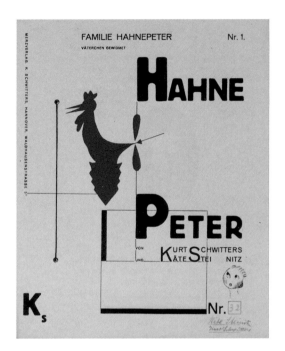

Kurt Schwitters, *Hahne Peter (Merz 12)*, 1924 (cat. no. 234)

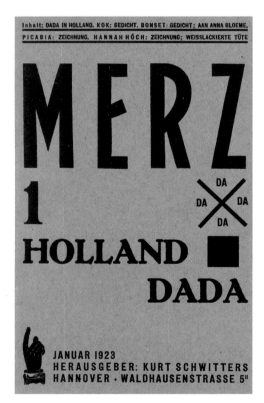

Kurt Schwitters, *Merz 1 Holland Dada*, 1923 (cat. no. 232)

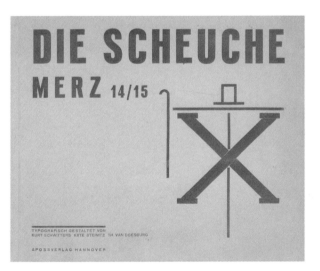

Kurt Schwitters, *The Scarecrow (Merz 14/15)*, 1925 (cat. no. 239)

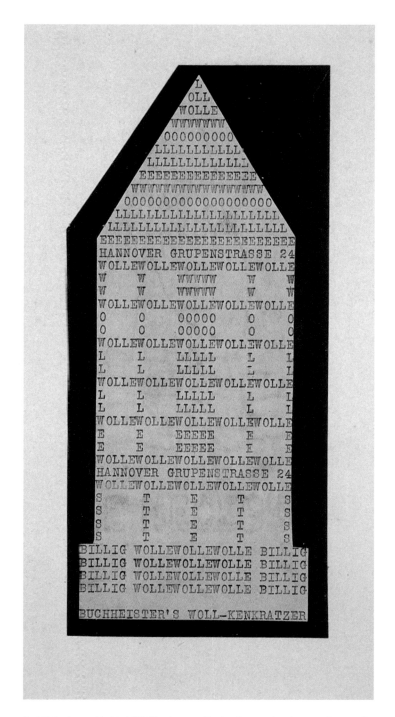

Kurt Schwitters, *Untitled (Woll-kenkratzer, Design for an advertisement for a craft shop, the Handarbeitshaus Buchheister)* , 1926/28 (cat. no. 105)

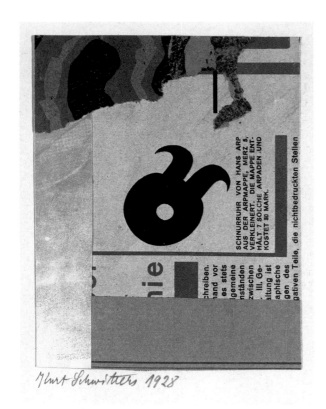

Kurt Schwitters, *Untitled (Schnurruhr von Hans Arp)*, 1928
(cat. no. 108)

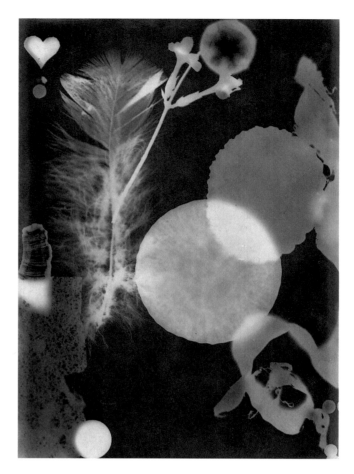

Kurt Schwitters, *Untitled (Photogram I)*, 1928 (cat. no. 109)

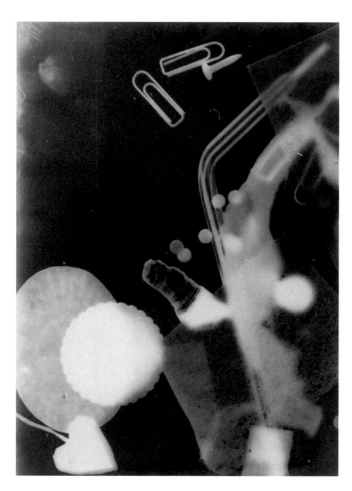

Kurt Schwitters, *Untitled (Photogram II)*, 1928 (cat. no. 110)

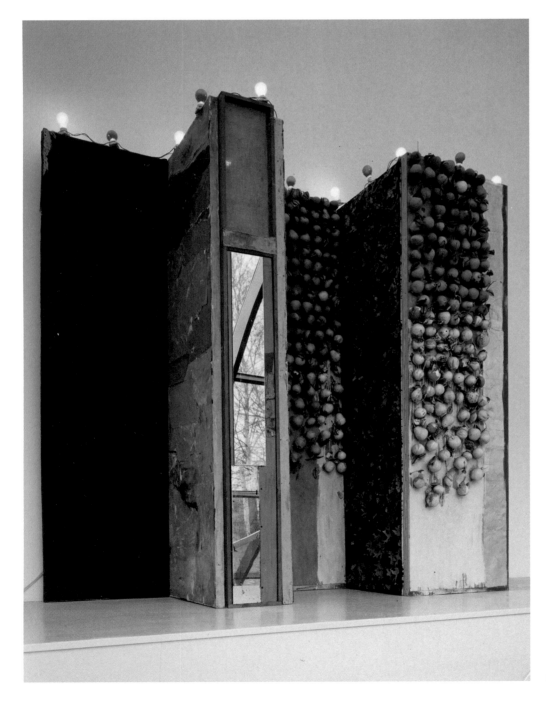

Allan Kaprow, *Kiosk*, 1957–1959 (cat. no. 291)

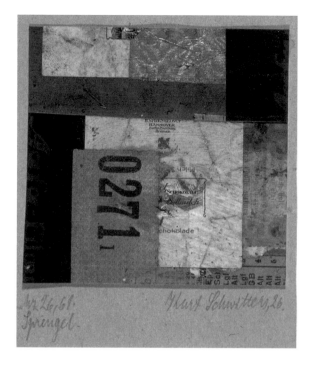

Kurt Schwitters, *1926,61. Sprengel.,* 1926 (cat. no. 102)

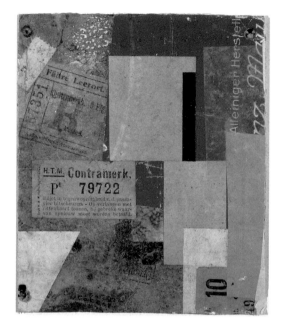

Kurt Schwitters, *Untitled (Contramerk.),* 1923 (cat. no. 82)

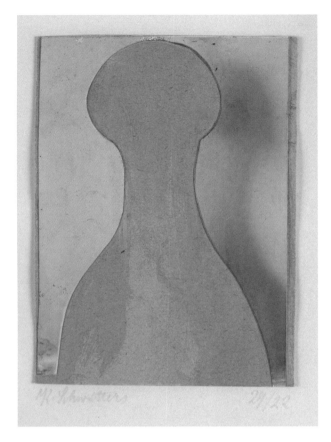

Kurt Schwitters, *29/22 (Shadow of Nothingness)*, 1929 (cat. no. 113)

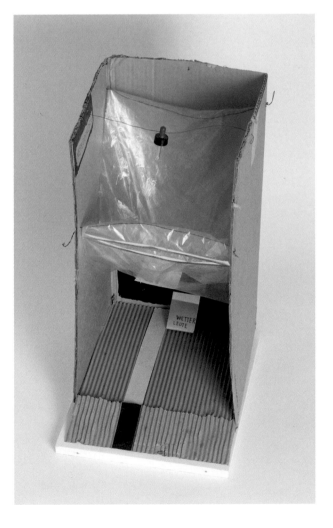

Allan Kaprow, *Meteorology*, 1972 (cat. no. 292)

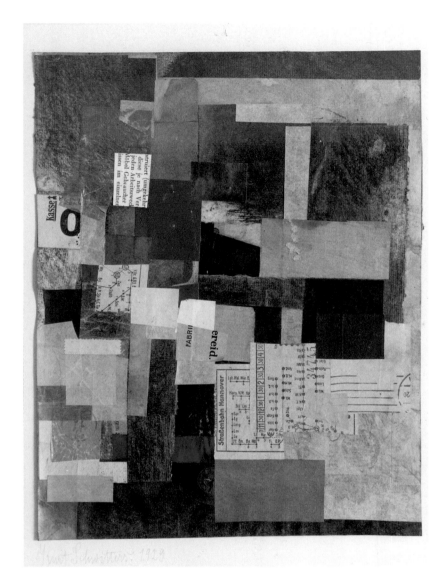

Kurt Schwitters, *Untitled (ereid.),* 1929 (cat. no. 114)

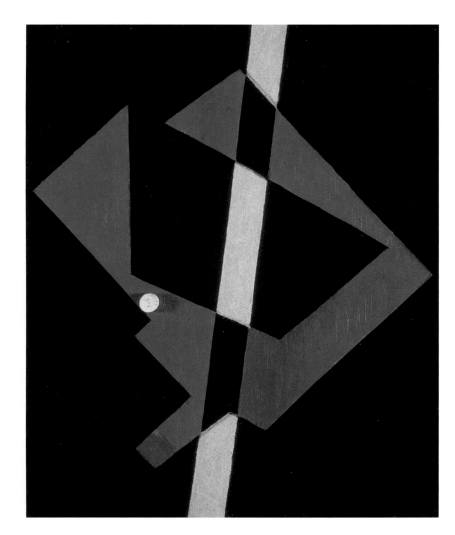

Kurt Schwitters, *That is the Spring for Hans Arp,* 1930 (cat. no. 117)

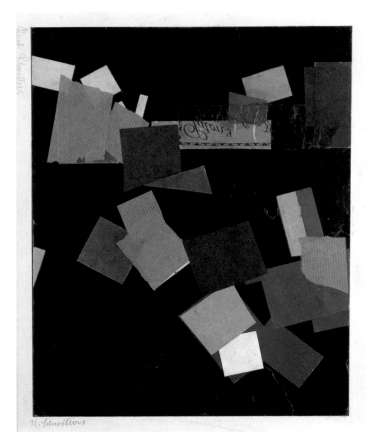

Kurt Schwitters, *Untitled (Black Merzdrawing),* 1928 (cat. no. 107)

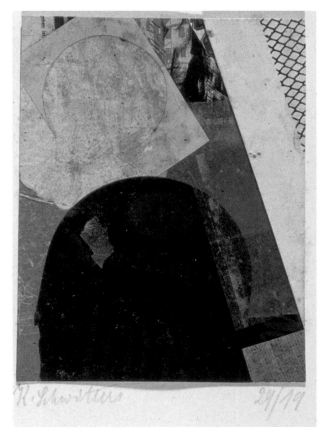

Kurt Schwitters, *29/19,* 1929 (cat. no. 112)

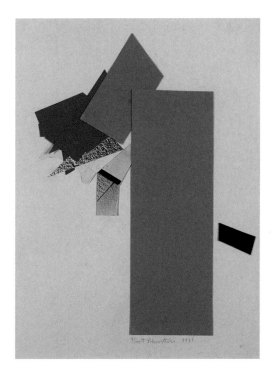

Kurt Schwitters, *Untitled (red, grey, black)*, 1931
(cat. no. 129)

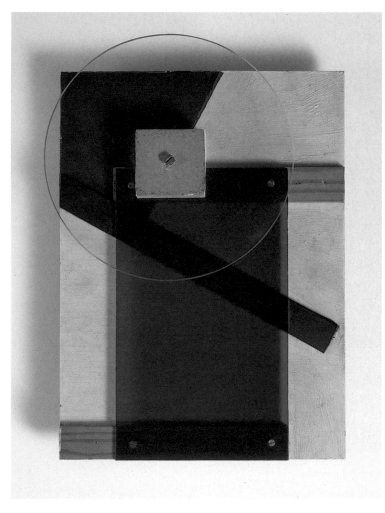

Kurt Schwitters, *Untitled (Picture with Rotatable Glass Disc)*, 1930 (ca. no. 118)

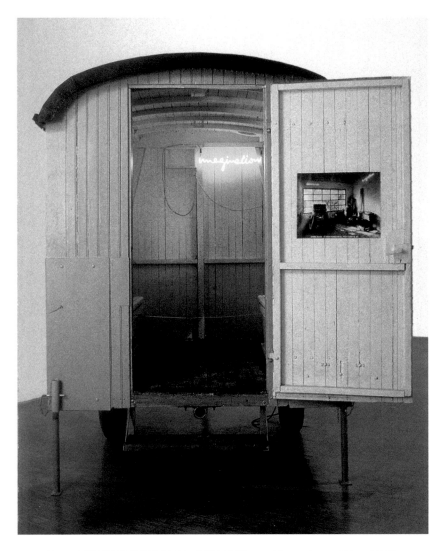

Robert Filliou, *PERMANENT CREATION – TOOL SHED – mobile version –*, 1969 and 1984
(cat. no. 281)

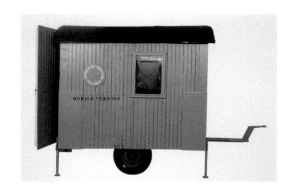

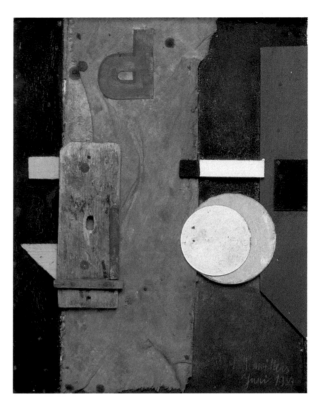

Kurt Schwitters, *Merzpicture P rose,* 1930 (cat. no. 116)

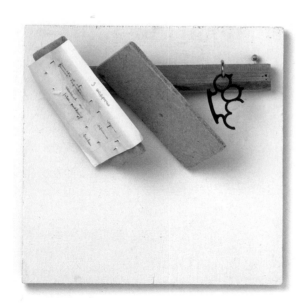

Robert Filliou, *3 Weapons,* 1968–1970 (cat. no. 278)

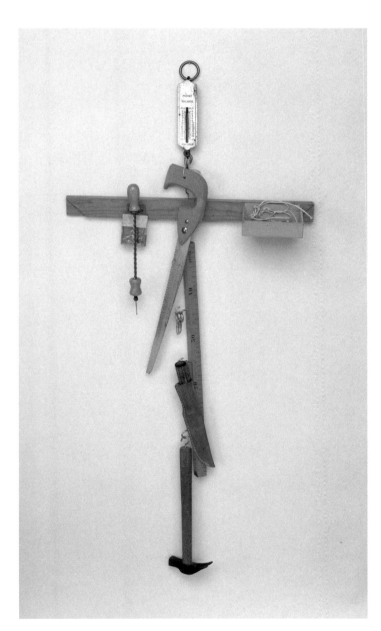

Robert Filliou, *Tool Cross,* 1969 (cat. no. 276)

Robert Filliou, *Research on Filmmaking,* 1970 (cat. no. 282)

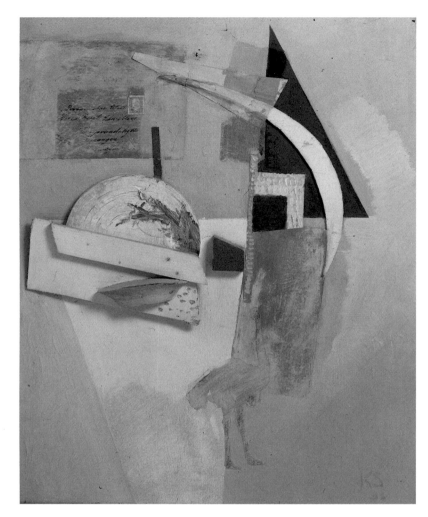

Kurt Schwitters, *Half-Moon Ugelvik*, 1930, 1931 and 1933 (cat. no. 124)

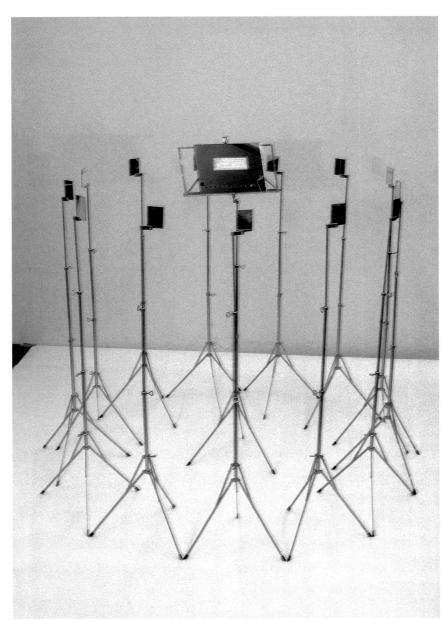

Robert Filliou, *Telephatic Music No. 20,* 1982 (cat. rc. 283)

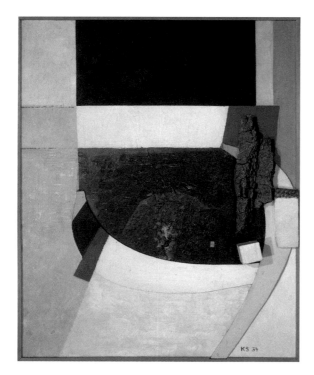

Kurt Schwitters, *Merzpicture 1933, 2 "Umschuldung"*, 1932–1934
(cat. no. 133)

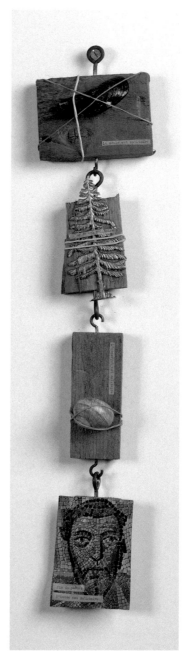

Robert Filliou, *Suspense Poem (L'Homme est solitaire)*, 1961
(cat. no. 277)

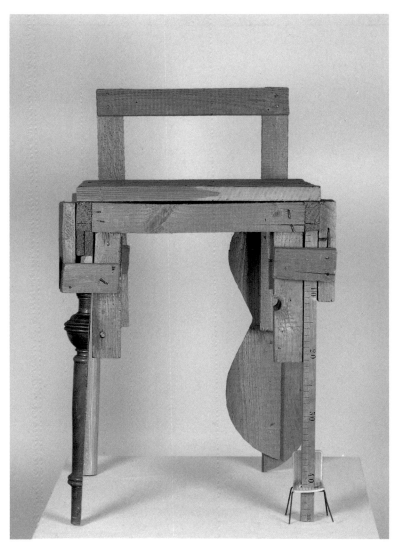

Robert Filliou, *Chair,* 1969 (cat. no. 280)

Kurt Schwitters, *Monument to the Father of the Artist,* 1931/35
(cat. no. 130)

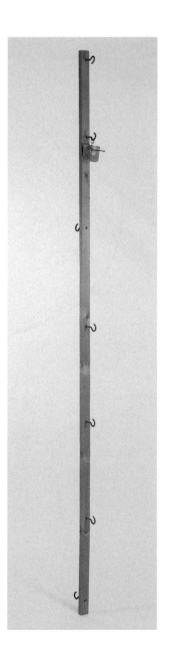

Robert Filliou, *Object without Object,*
1969 (cat. no. 279)

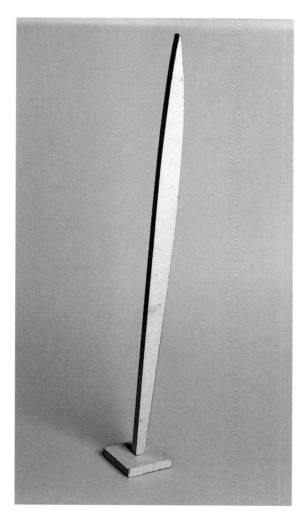

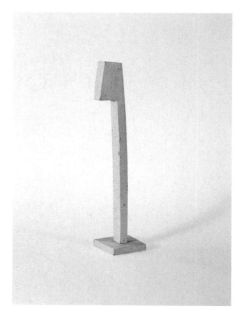

Kurt Schwitters, *Slim Angle,* ca. 1930
(cat. no. 126)

Kurt Schwitters, *Sword,* ca. 1930 (cat. no. 127)

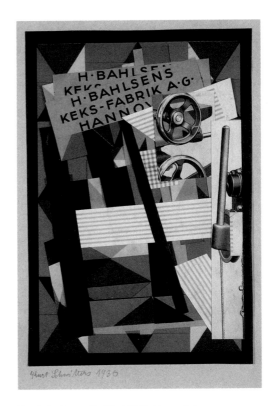

Kurt Schwitters, *Untitled (H. Bahlsens Keks-Fabrik A.G.),* 1930 (cat. no. 122)

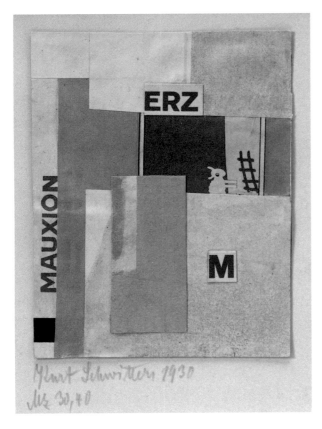

Kurt Schwitters, *Mz 30,40,* 1930 (cat. no. 121)

George Brecht, *Variation on Blair (ca. 1959)*
and Koan (1958), 1958/59 (cat. no. 270)

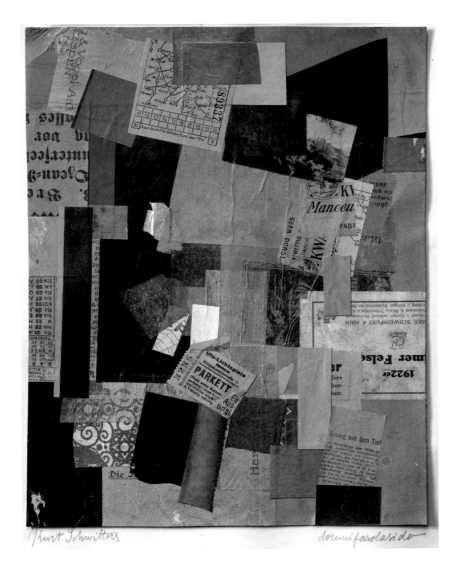

Kurt Schwitters, *doremifasolasido,* ca. 1930 (cat. no. 125)

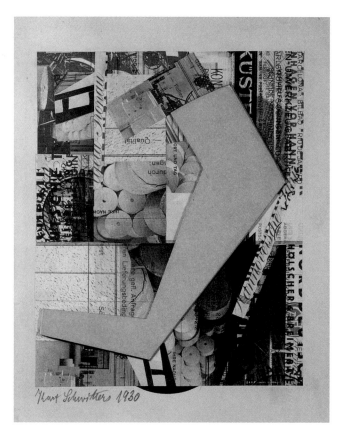

Kurt Schwitters, *Untitled (With Yellow Form),* 1930 (cat. no. 123)

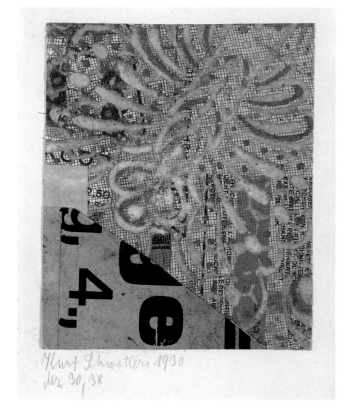

Kurt Schwitters, *Mz 30,38,* 1930 (cat. no. 120)

Marcel Broodthaers, *La clef de l'horloge,* 1957
(cat. no. 271)

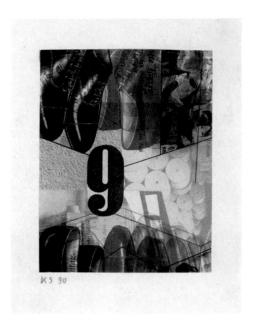

Kurt Schwitters, *Untitled (9),* 1930 (cat. no. 119)

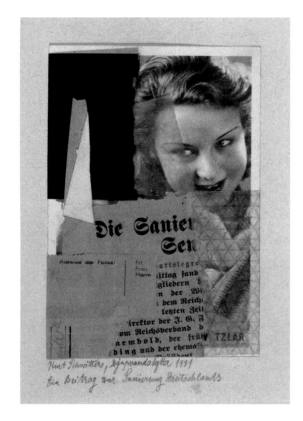

Kurt Schwitters, *A Contribution to the Refurbishment of Germany,* 1931 (cat. no. 128)

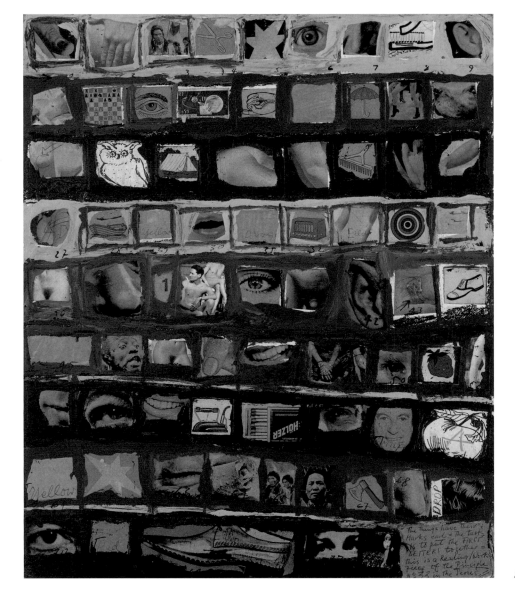

Arthur Køpcke, *Reading Piece No. 33,* 1964 (cat. no. 296)

Arthur Køpcke, *What's the Time,* 1969 (cat. no. 298)

Arthur Køpcke, *Continue ...,* 1958–1964 (cat. no. 295)

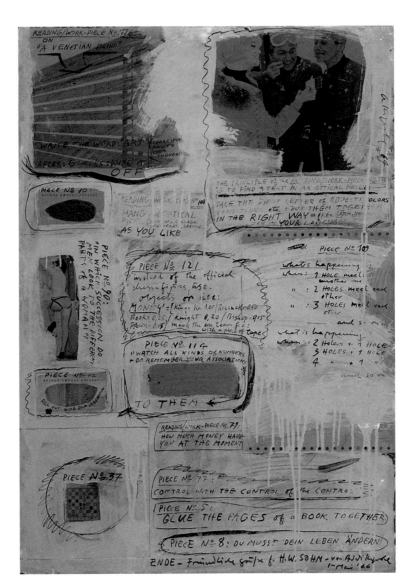

Arthur Køpcke, *Reading / Work Pieces*, 1964 (cat. no. 297)

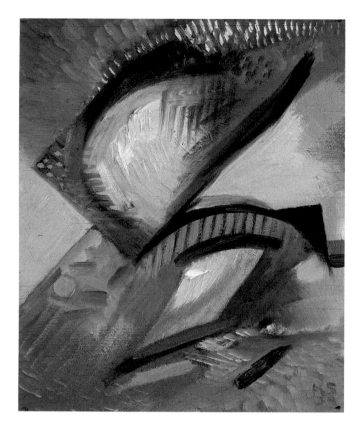

Kurt Schwitters, *Untitled (Zig-Zag)*, 1939 (cat. no. 158)

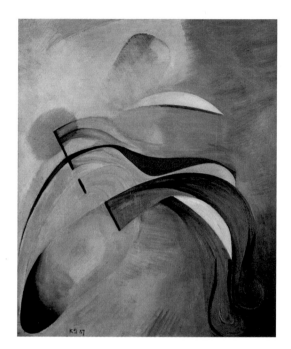

Kurt Schwitters, *Red Line*, 1937 (cat. no. 142)

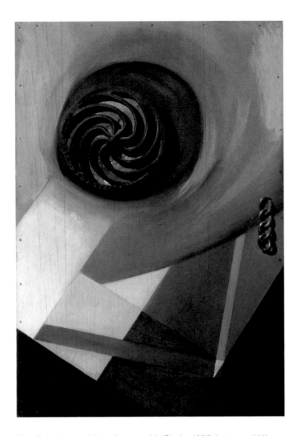

Kurt Schwitters, *Merzpicture with Chain*, 1937 (cat. no. 141)

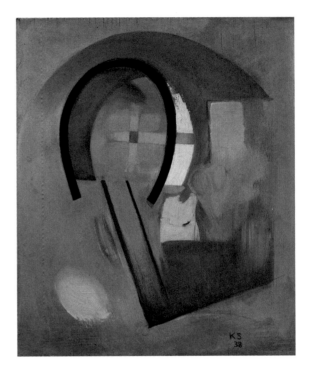

Kurt Schwitters, *Untitled (The Horse Shoe Picture)*, 1938
(cat. no. 153)

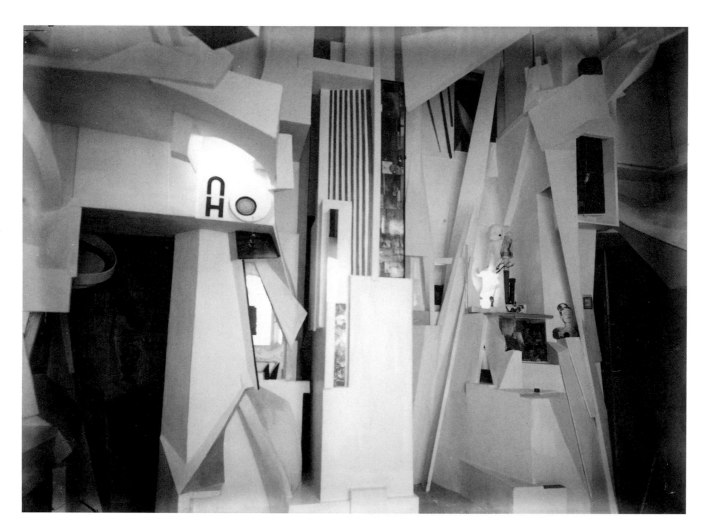

Kurt Schwitters, *Merzbau,* state ca. 1933, destroyed (cat. no. 134)

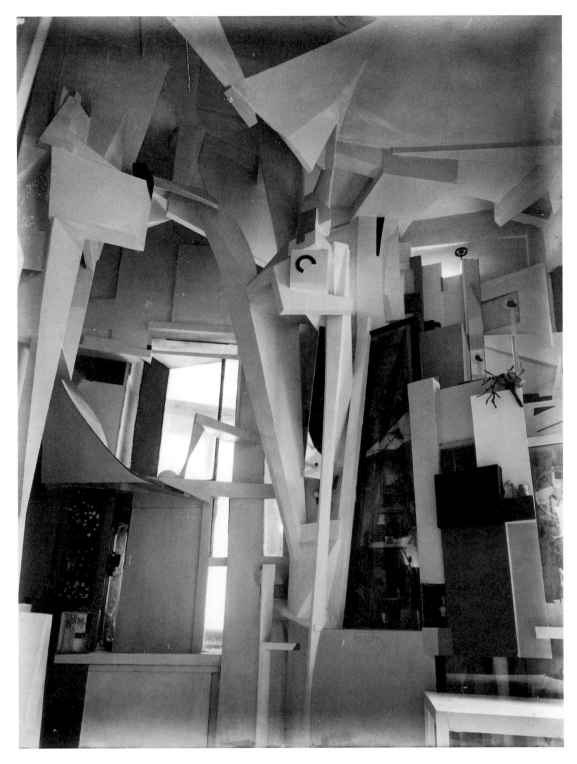

Kurt Schwitters, *Merzbau,* state ca. 1933, destroyed (cat. no 134)

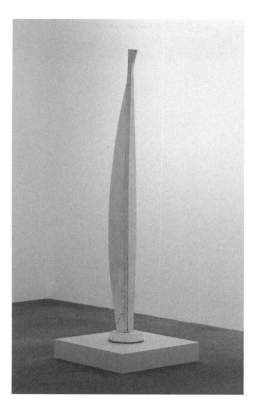

Kurt Schwitters, *Untitled (Narrow Merz Column)*, 1936
(cat. no. 138)

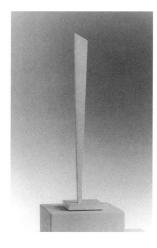

Kurt Schwitters, *The Sword
of the German Spirit*, 1935
(cat. no. 136)

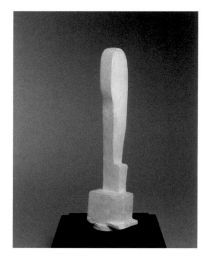

Kurt Schwitters, *Untitled*, 1934
(cat. no. 135)

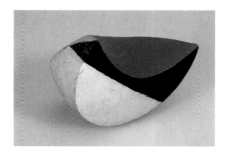

Kurt Schwitters, *Untitled (Coloured Half-Moon),* 1937/40 (cat. no. 151)

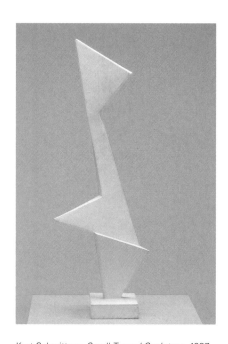

Kurt Schwitters, *Small Turned Sculpture,* 1937 (cat. no. 145)

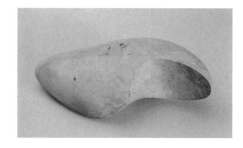

Kurt Schwitters, *Untitled (For the Hand),* 1937/40 (cat. no. 150)

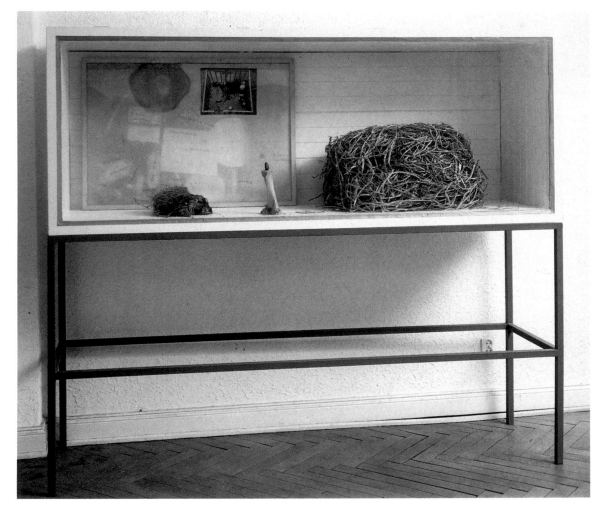

Joseph Beuys, *Showcase with Potato Vine and Fluxus Dust Picture*, 1962 and 1982 (cat. no. 267)

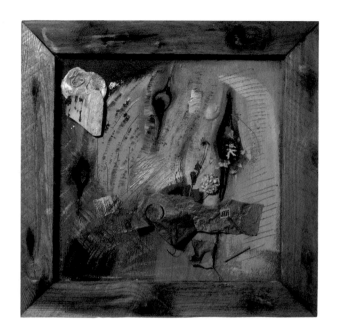

Kurt Schwitters, *Untitled (Merzpicture Alf),* 1939 (cat. no. 157)

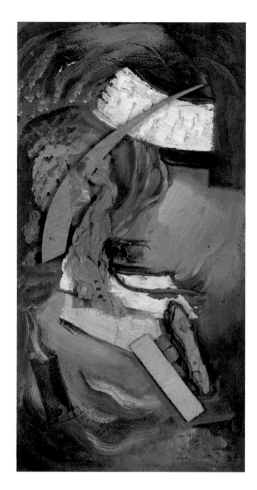

Kurt Schwitters, *Untitled (Merzpicture with Algae),*
1938 (cat. no. 152)

Kurt Schwitters, *Untitled (Silvery),* 1939
(cat. no. 159)

Kurt Schwitters, *Untitled (Union),* 1937/38
(cat. no. 148)

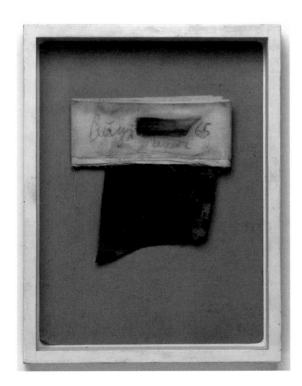

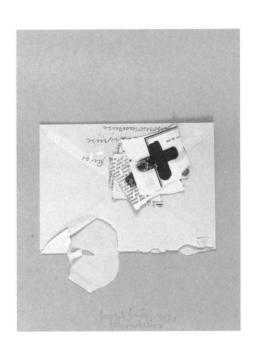

Joseph Beuys, *Brown Cross,* 1960 (cat. no. 263)

Joseph Beuys, *Knife,* 1965 (cat. no. 268)

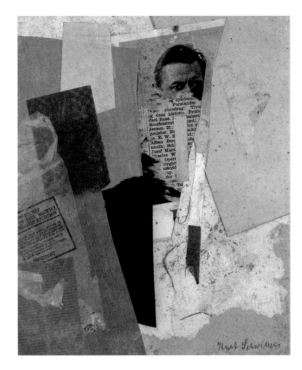

Kurt Schwitters, *Unt.tled (With an early portrait of Kurt Schwitters)*, 1937/38 (cat. no. 149)

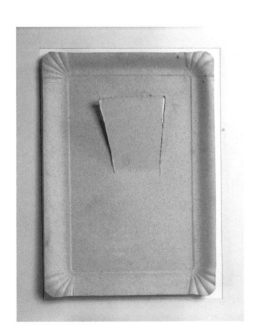

Joseph Beuys, *Woodpecker Picture*, 1961
(cat. no. 264)

Joseph Beuys, *List of Names*, 1963
(cat. no. 266)

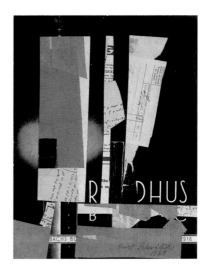

Kurt Schwitters, *Untitled (R DHUS)*, 1938
(cat. no. 154)

Kurt Schwitters, *Untitled (With Piece of Apple and Green Leaves)*,
1936 (cat. no. 137)

Joseph Beuys, *Chalice,* 1962 (cat. no. 265)

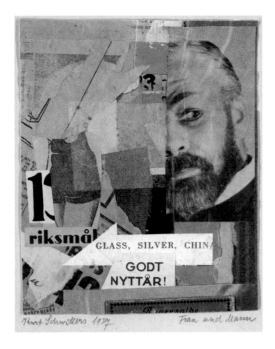

Kurt Schwitters, *Woman and Man,* 1937 (cat. no. 143)

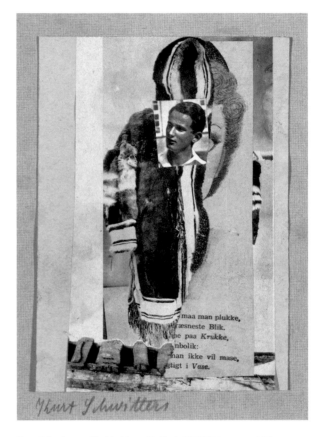

Kurt Schwitters, *Untitled (paa Krukke),* 1936/39 (cat. no. 140)

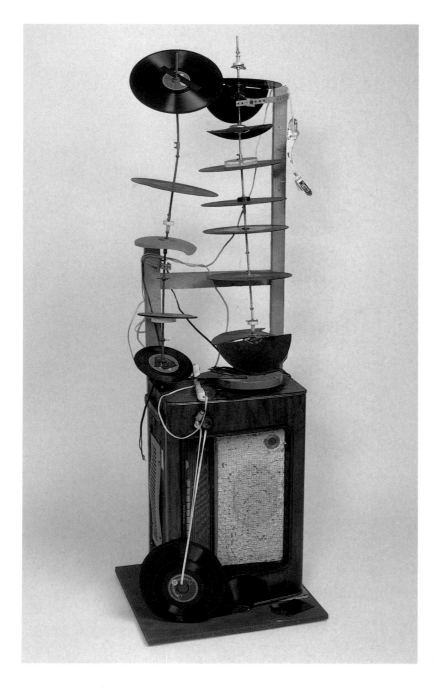

Nam June Paik, *Gramophone Record Shashlik*, 1963 (cat. no. 304)

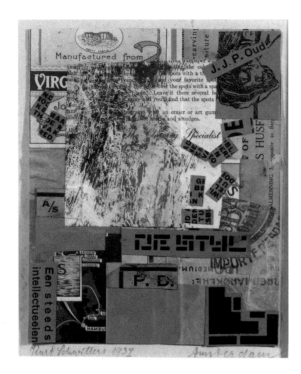

Kurt Schwitters, *Amsterdam*, 1937 (cat. no. 144)

Dieter Roth, *Dumb Relief (first Cubist violin)*, 1984–1988
(cat. no. 321)

Dieter Roth, *Table Mats,* 1988/89 (cat. no. 322)

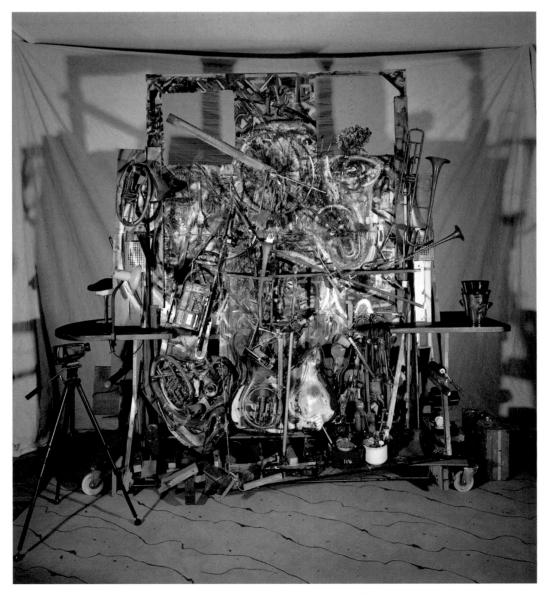

Dieter Roth, *Bar Nr. 1, Basel – Toulouse – Holderbank – Wien [Vienna]*, 1983–1997 (cat. no. 320)

Kurt Schwitters, *Untitled (Alpine Landscape?),* 1932 (cat. no. 131)

Kurt Schwitters, *Nervi, Spring Morning,* 1932 (cat. no. 132)

Kurt Schwitters, *Landscape with Snowfield: Opplusegga,* 1936 (cat. no. 139)

Kurt Schwitters, *Untitled (Harbour in the Fjord),* 1937
(cat. no. 146)

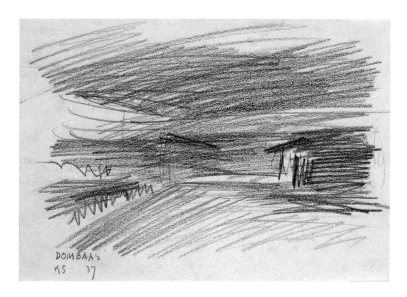

Kurt Schwitters, *Dombaas,* 1937 (cat. no. 147)

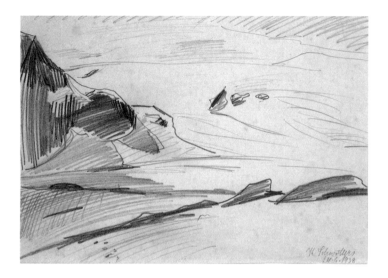

Kurt Schwitters, *Untitled (Norwegian Mountain Landscape)*, 1938 (cat. no. 156)

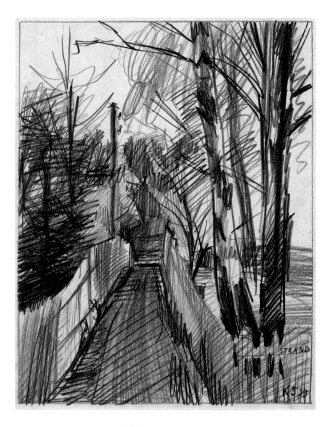

Kurt Schwitters, *Beach*, 1939 (cat. no. 161)

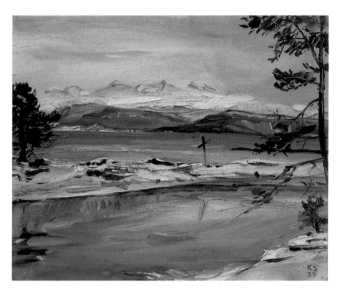

Kurt Schwitters, *Hjertö Cross,* 1939 (cat. no. 160)

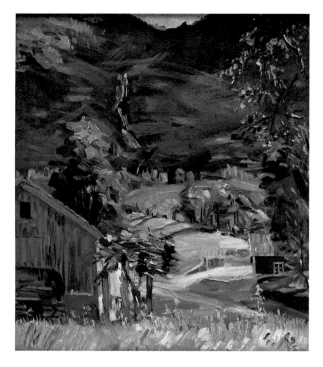

Kurt Schwitters, *Waterfall near Olden,* 1938 (cat. no. 155)

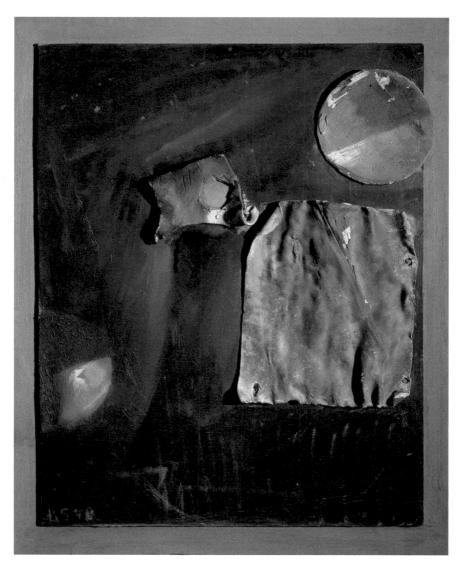

Kurt Schwitters, *Untitled (Very Dark Picture),* 1940 (cat. no. 162)

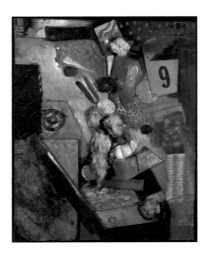

Kurt Schwitters, *Untitled (Merzpicture 9)*,
1943 (cat. no. 175)

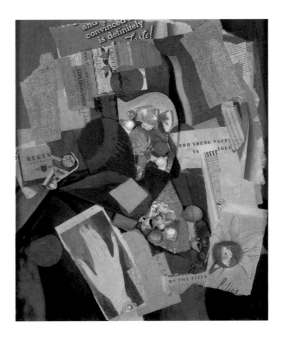

Kurt Schwitters, *PEN (For Young Faces)*, 1941 (cat. no. 167)

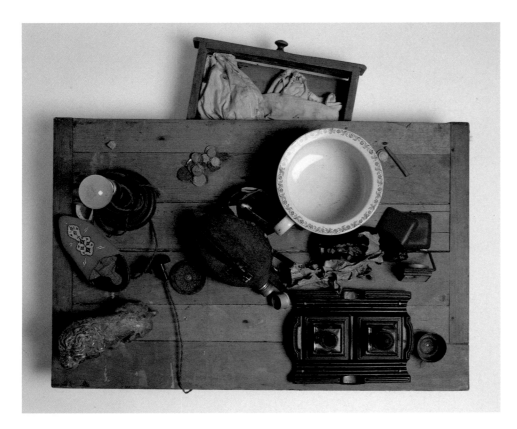

Daniel Spoerri, *Le réveil du Lion*, 1961 (cat. no. 330)

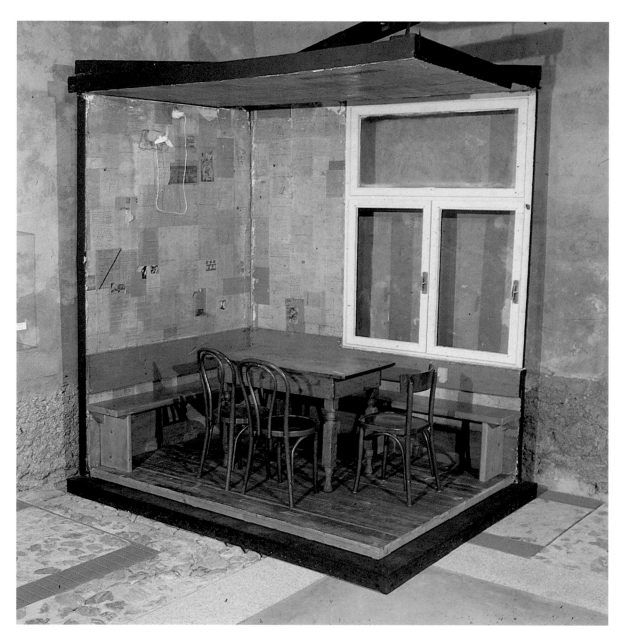

Daniel Spoerri, *Le coin du restaurant Spoerri,* 1968 (cat. no. 331)

Kurt Schwitters, *Untitled (Picture with Ring and Frame)*, 1941
(cat. no. 166)

Kurt Schwitters, *stillife with penny,* 1941 (cat. no. 168)

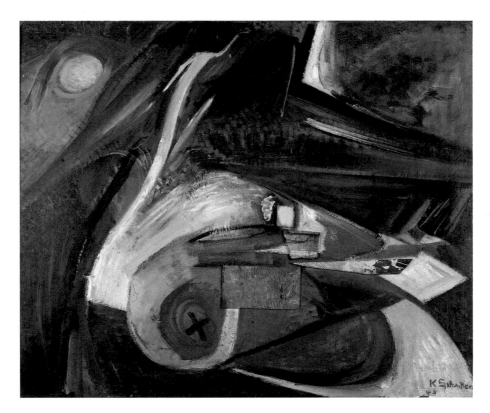

Kurt Schwitters, *Untitled (Abstract Picture)*, 1943 (cat. no. 178)

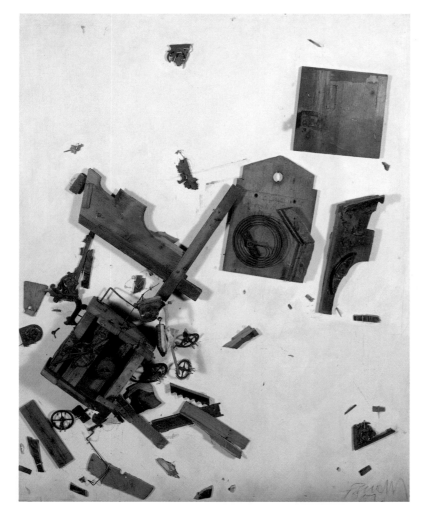

Arman, *Colère Suisse,* 1961 (cat. no. 262)

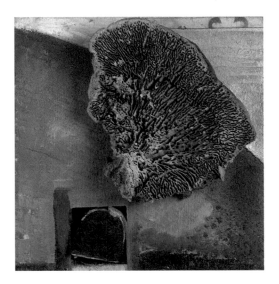

Kurt Schwitters, *Untitled (Merzpicture with Coral)*,
1944/45 (cat. no. 194)

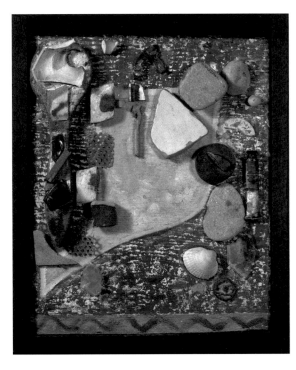

Kurt Schwitters, *Untitled (Small Merzpicture with Many Parts)*,
1945/46 (cat. no. 196)

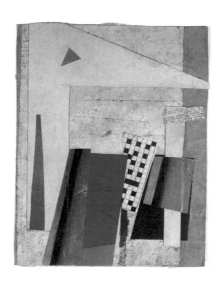

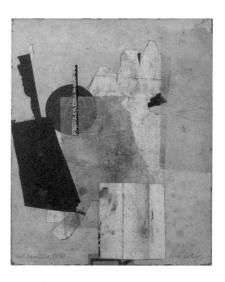

Kurt Schwitters, *pink collage,* 1940 (cat. no. 163)

Kurt Schwitters, *Untitled (Crossword Puzzle),*
1944 (cat. no. 190)

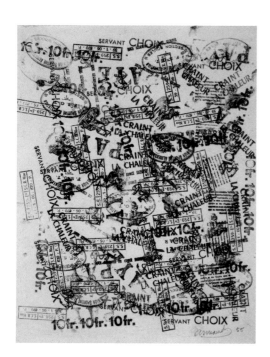

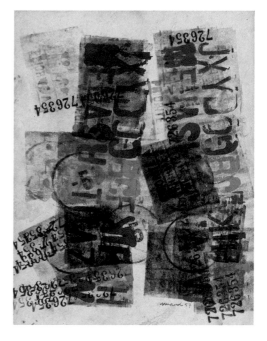

Arman, *Untitled,* 1955 (cat. no. 260)

Arman, *Priorité A,* 1957 (cat. no. 261)

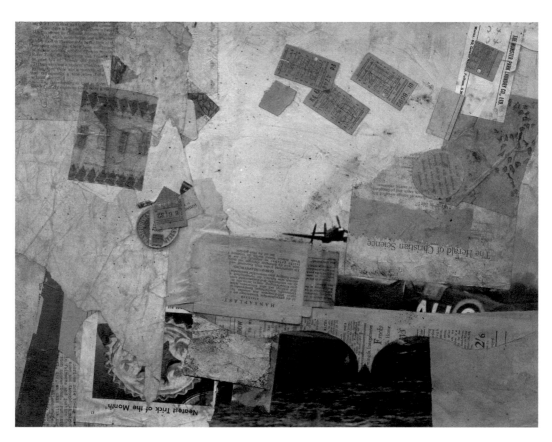

Kurt Schwitters, *Untitled (Neatest Trick of the Month!)*, 1942/45 (cat. no. 174)

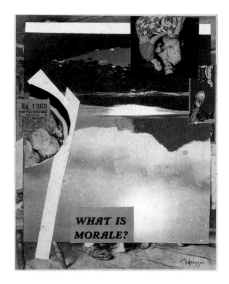

Kurt Schwitters, *Untitled (The Doll)*, 1942
(cat. no. 172)

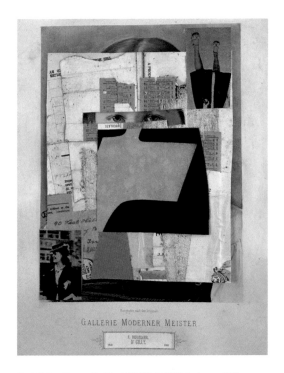

Kurt Schwitters, *Untitled (D'Cilly)*, 1942 (cat. no. 173)

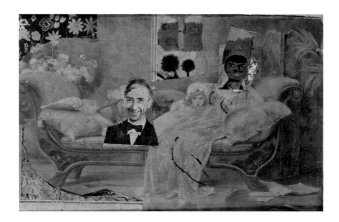

Kurt Schwitters, *Untitled (Homage to Sir Herbert Read),* 1944
(cat. no. 191)

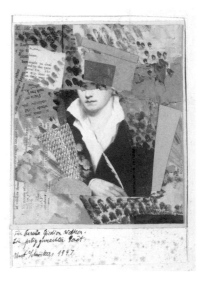

Kurt Schwitters, *For Carola Giedion Welker.*
A done over poet, 1947 (cat. nc. 226)

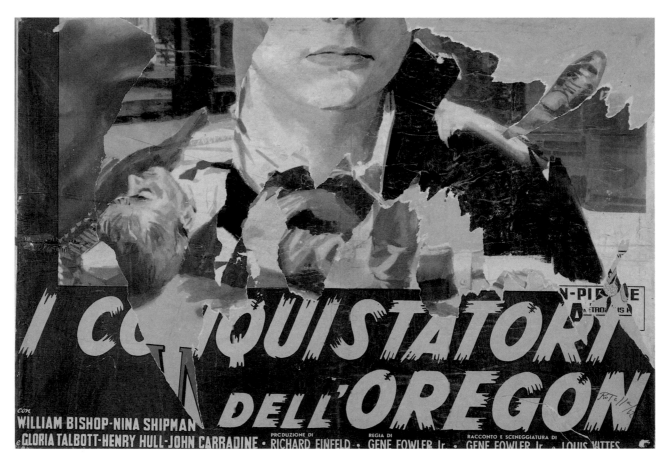

Mimmo Rotella, *Les conquérants,* 1962 (cat. no. 319)

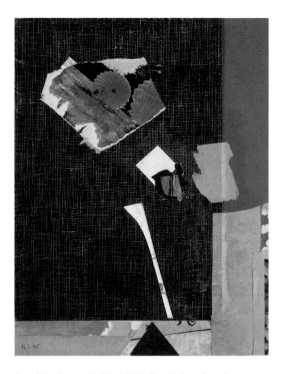

Kurt Schwitters, *Untitled (With Two Yellow Parachutes),* 1945 (cat. no. 195)

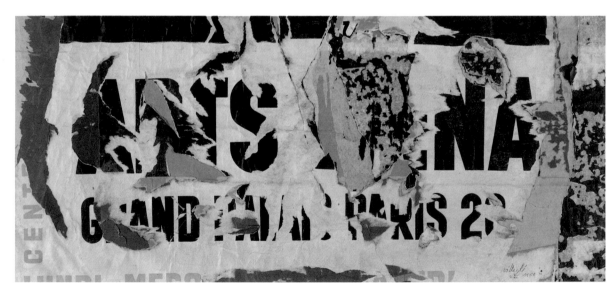

Jacques Villeglé, *Passage Bayen 17e,* 1959 (cat. no. 338)

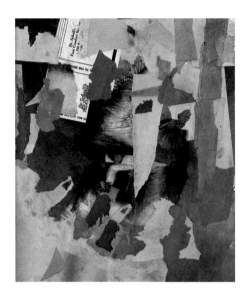

Kurt Schwitters, *c 63 old picture,* 1946 (cat. no. 203)

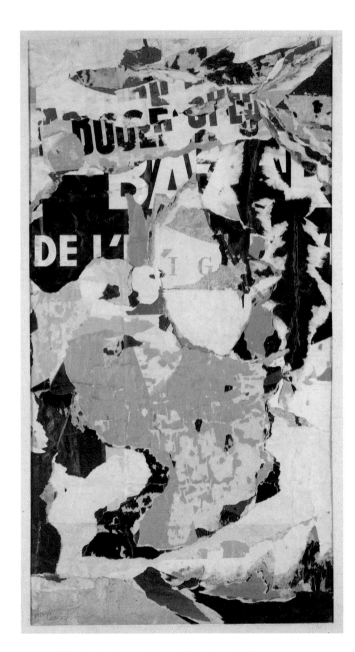

Jacques Villeglé, *Beaubourg Paris 3,* 1960 (cat. no. 339)

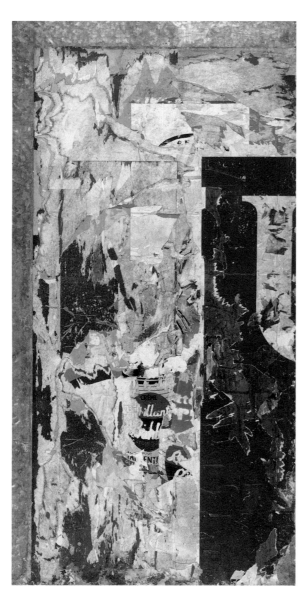

Raymond Hains, *Untitled*, 1961 (cat. no. 286)

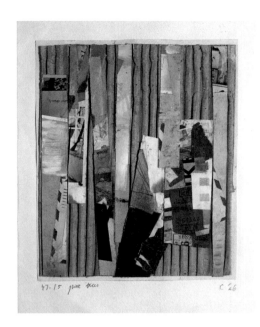

Kurt Schwitters, *47. 1E pine trees c 26,* 1946/47
(cat. no. 209)

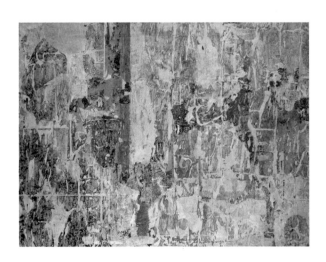

François Dufrêne, *Le Passirgranksagri passigriksa,* 1960
(cat. no. 275)

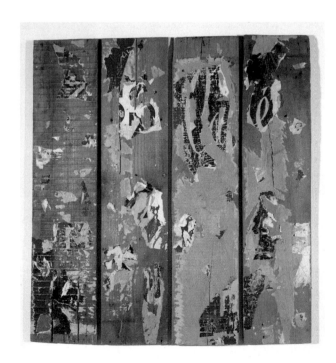

Raymond Hains, *Palisade,* 1959 (cat. no. 285)

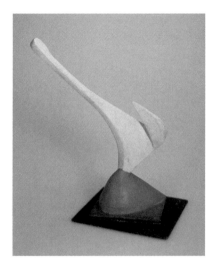

Kurt Schwitters, *Speed,* 1943 (cat. no. 181)

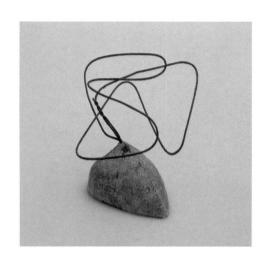

Kurt Schwitters, *Untitled (for Ernst on 16.11.43 from Dada Daddy.),* 1943 (cat. no. 180)

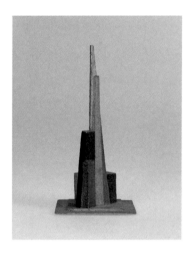

Kurt Schwitters, *Untitled (Cathedral),* 1941/42 (cat. no. 171)

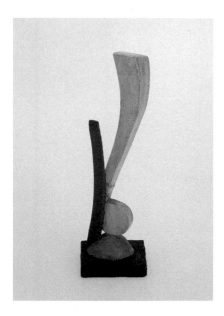

Kurt Schwitters, *Untitled (Arabesque),* 1943/45
(cat. no. 188)

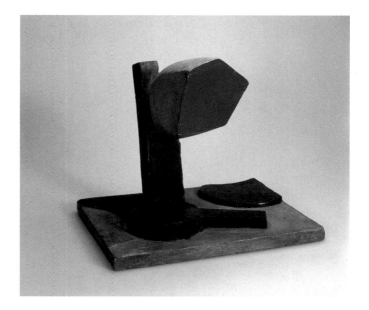

Kurt Schwitters, *Ugly Girl,* 1943/45 (cat. no. 187)

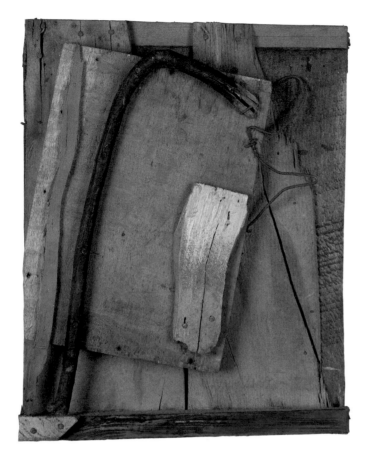

Kurt Schwitters, *Untitled (Merzpicture Pink-Yellow)*, 1943 (cat. no. 177)

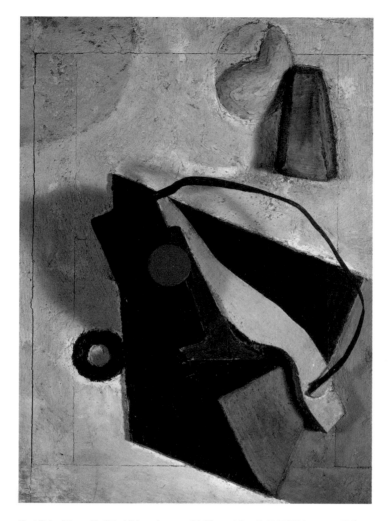

Kurt Schwitters, *Untitled (Merzpicture with Tin and Band)*, 1943/45 (cat. no. 184)

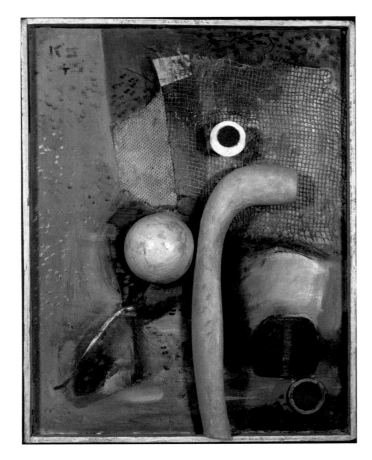

Kurt Schwitters, *Fredlyst with yellow artificial bone,* 1940–1947 (cat. no. 165)

Kurt Schwitters, *rea spot.*, 1947 (cat. no. 219)

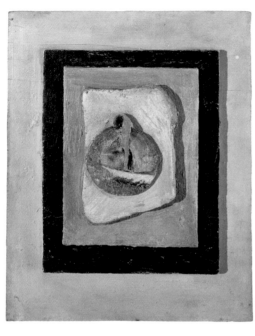

Kurt Schwitters, *Untitled (Grasmere)*, 1942/45
(cat. no. 176)

Kurt Schwitters, *Untitled (For Käte)*, 1947 (cat. no. 220)

Edward Kienholz, *The Beanery*, 1965 (cat. no. 293)

Kurt Schwitters, *Mz X 5 Magistrats,* 1947 (cat. no. 224)

Eduardo Paolozzi, *Hi Ho,* 1947 (cat. no. 305)

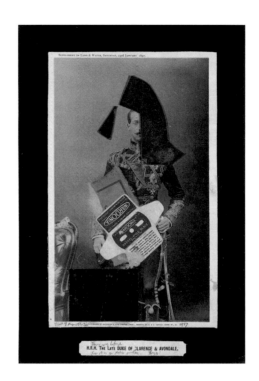

Kurt Schwitters, *This was before H. R. H. The Late DUKE OF CLARENCE & AVONDALE. Now it is a Merz picture. Sorry!*, 1947 (cat. no. 212)

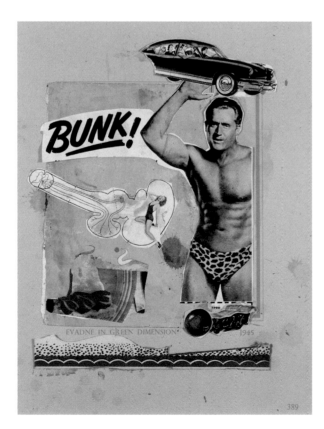

Eduardo Paolozzi, *Evadne in Green Dimension*, 1952 (cat. no. 309)

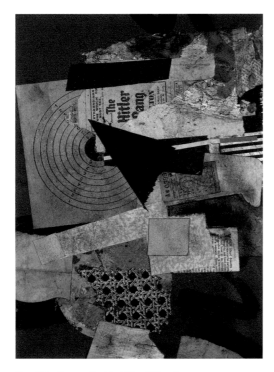

Kurt Schwitters, *Untitled (The Hitler Gang –
with Target),* 1944 (cat. no. 189)

Eduardo Paolozzi, *Man Holds the Key,* 1950 (cat. no. 307)

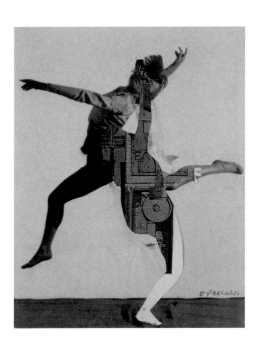

Eduardo Paolozzi, *Metaphor Time (Hermaphrodite),*
1960–1962 (cat. no. 310)

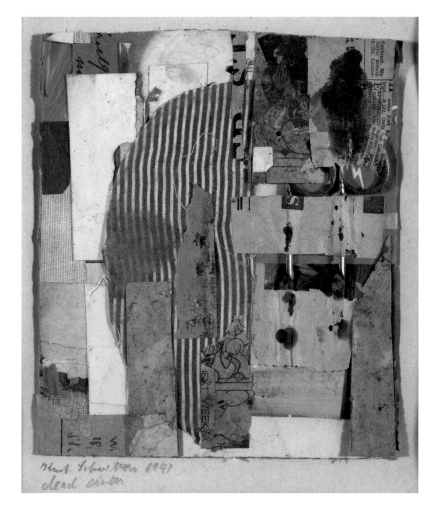

Kurt Schwitters, *dead cissors,* 1947 (cat. no. 228)

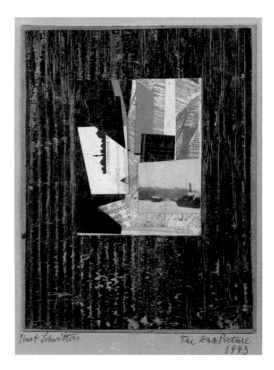

Kurt Schwitters, *The Dux Picture,* 1943 (cat. no. 179)

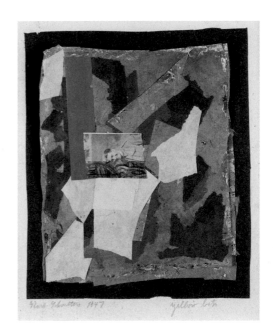

Kurt Schwitters, *yellow bits,* 1947 (cat. no. 211)

Eduardo Paolozzi, *Refreshing and Delicious,* 1949
(cat. no. 306)

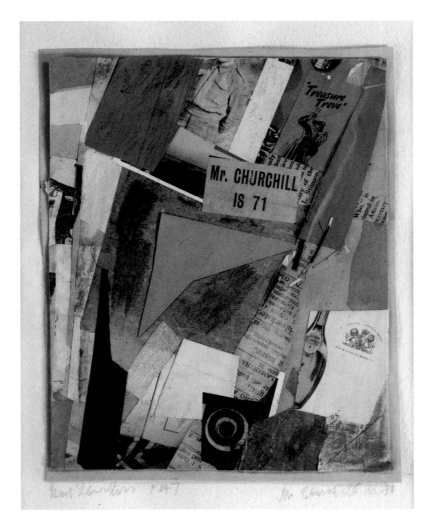

Kurt Schwitters, *Mr. Churchill is 71*, 1947 (cat. no. 216)

Eduardo Paolozzi, *You Can't Beat the Real Thing,* 1951 (cat. no. 308)

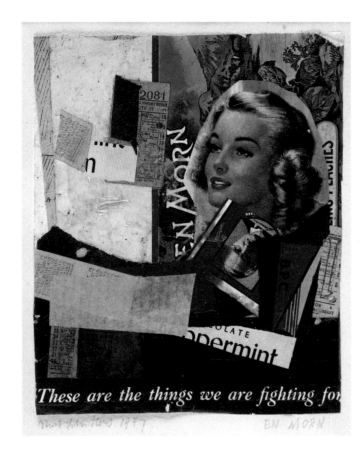

Kurt Schwitters, *EN MORN,* 1947 (cat. no. 217)

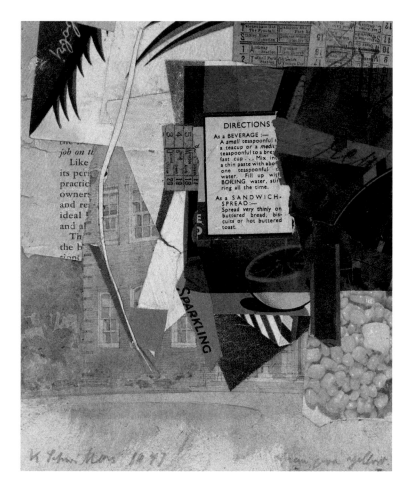

Kurt Schwitters, *Green over yellow.*, 1947 (cat. no. 227)

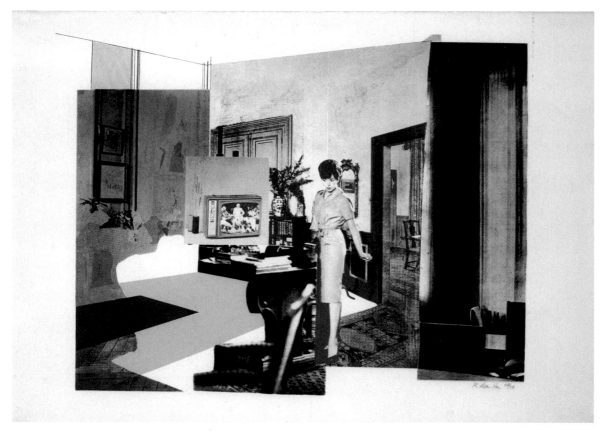

Richard Hamilton, *Interior,* 1964/65 (cat. no. 289)

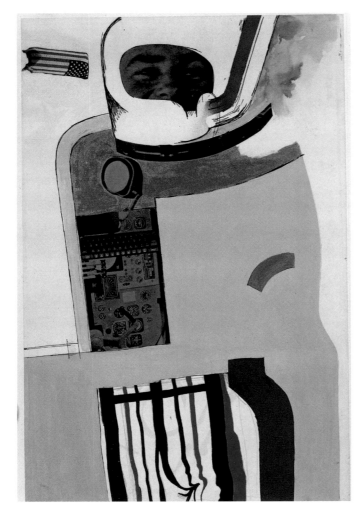

Richard Hamilton, *Let's explore the stars together*, 1962/63
(cat. no. 287)

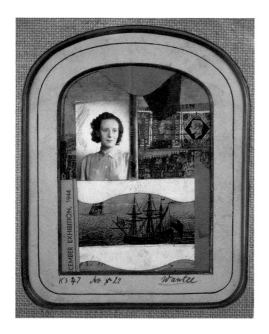

Kurt Schwitters, *Mz x 22 Wantee,* 1947 (cat. no. 213)

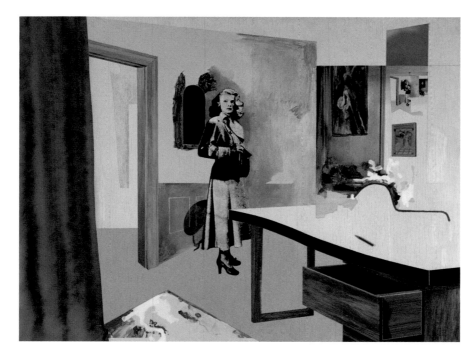

Richard Hamilton, *Interior 1,* 1964 (cat. no. 288)

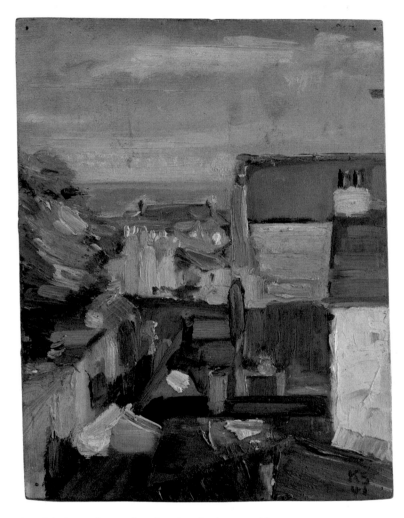

Kurt Schwitters, *Scenery from Douglas,* 1941 (cat. no. 169)

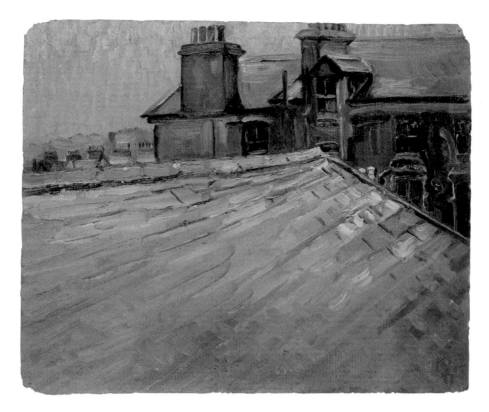

Kurt Schwitters, *Untitled (Roofs of Houses in Douglas, Isle of Man)*, 1941 (cat. no. 170)

Kurt Schwitters, *Untitled (Portrait of Dr. George Ainslie Johnston)*, 1946 (cat. no. 206)

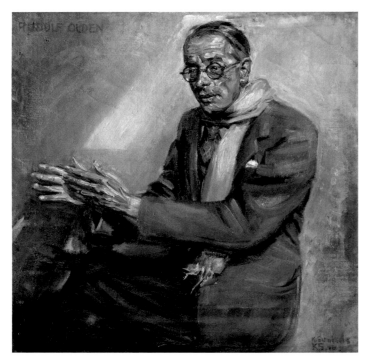

Kurt Schwitters, *Untitled (Portrait of Rudolf Olden)*, 1940 (cat. no. 164)

Kurt Schwitters, *Untitled (Rydal Water)*, 1945/47
(cat. no. 202)

Kurt Schwitters, *Untitled (Landscape from Nook Lane)*,
1946 (cat. no. 205)

Kurt Schwitters, *Untitled (Garden in the Lake District),* 1945/47 (cat. no. 200)

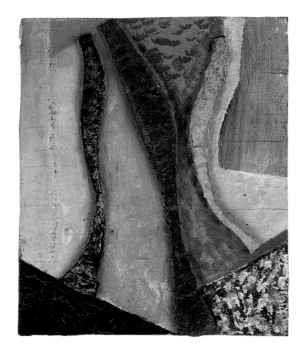

Kurt Schwitters, *Untitled (Relief Construction)*, ca. 1946
(cat. no. 207)

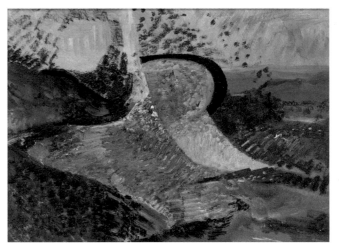

Kurt Schwitters, *Untitled (Landscape – Abstraction)*, 1945/47 (cat. no. 201)

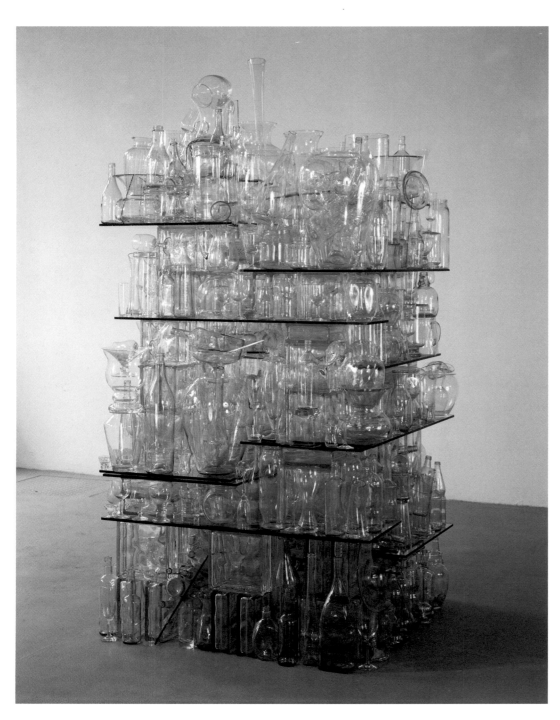

Anthony Cragg, *Clear Glass Stack*, 2000 (cat. no. 274)

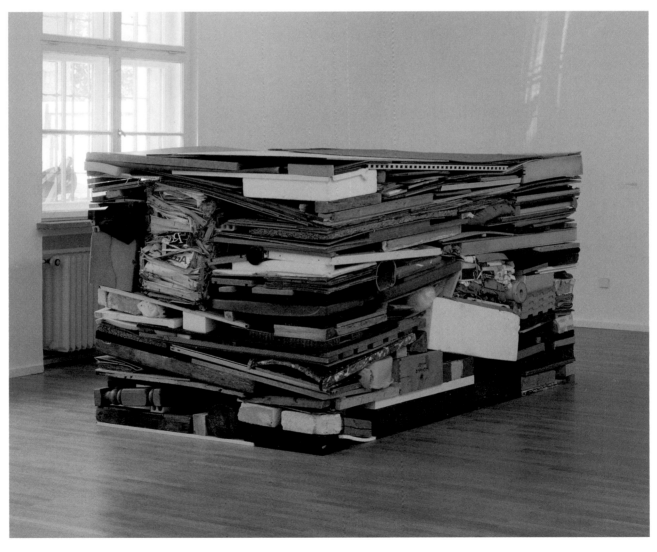

Anthony Cragg, *Stack*, 1975/2000 (cat. no. 273)

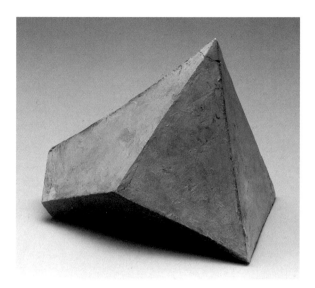

Kurt Schwitters, *Untitled (Bent Pyramid)*, 1945/47
(cat. no. 197)

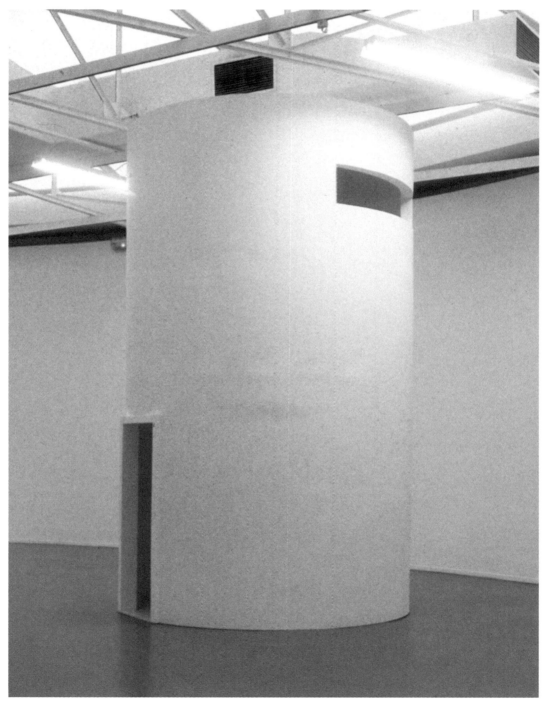

Absalon, *Cellule No. 5,* 1992 (cat. no. 259)

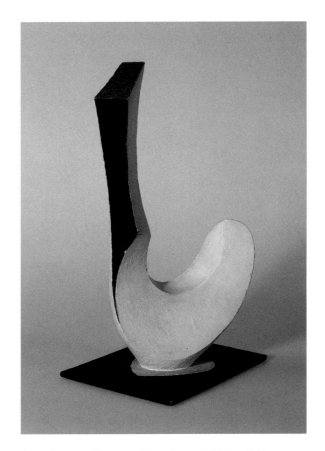

Kurt Schwitters, *Chicken and Egg, Egg and Chicken,* 1946
(cat. no. 208)

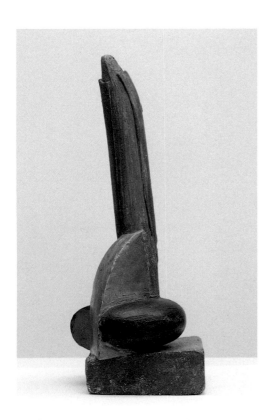

Kurt Schwitters, *Fant,* 1944 (cat. no. 193)

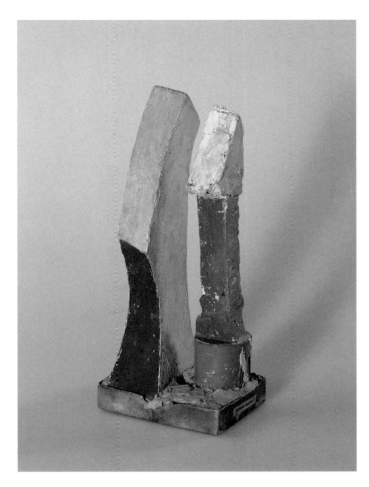

Kurt Schwitters, *Untitled (Togetherness)*, 1945/47 (cat. no. 199)

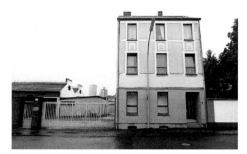

Gregor Schneider, *Haus u r,* Rheydt 1985–2000

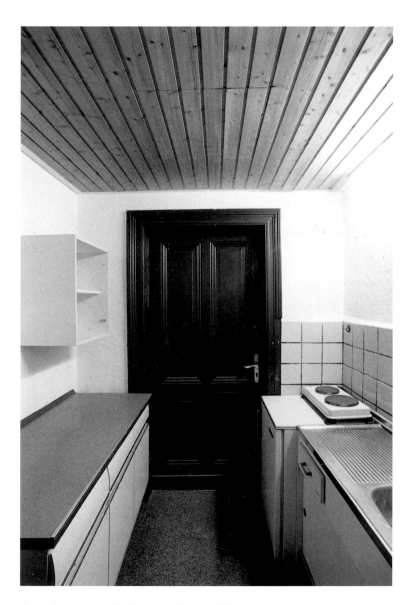

Gregor Schneider, *u r 7–10,* kitchen, Rheydt 1987

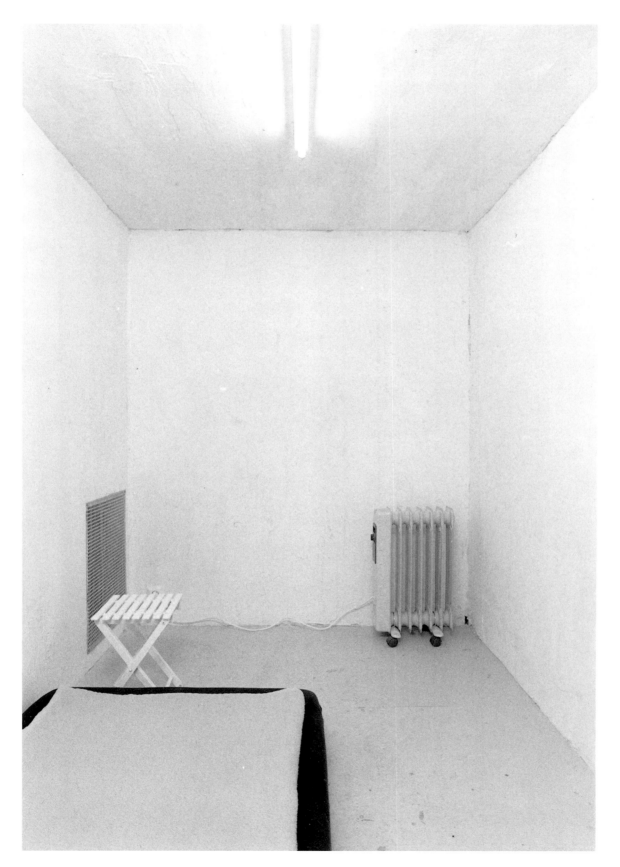

Gregor Schneider, *u r 12,* totally insulated guest room, Rheydt 1995

Jessica Stockholder, *First Cousin Once Removed or Cinema of Brushing Skin*
(detail), 1999, Power Plant, Toronto

Jessica Stockholder, *Flower Dusted Prosies*
(detail), 1992, American Fine Arts, New York

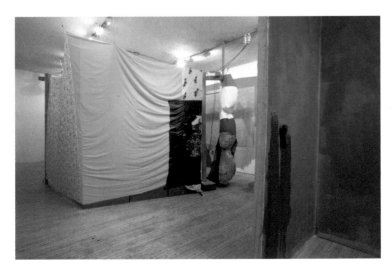

Jessica Stockholder, *Flower Dusted Prosies* (detail),
1992, American Fine Arts, New York

Jessica Stockholder, *SpICE BOXed Projec*(ion),* 1992, Galerie Metropole, Vienna

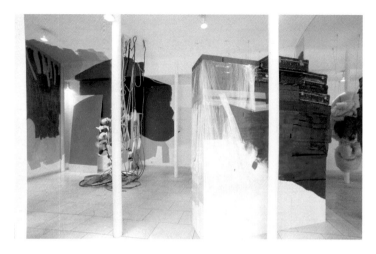

Jessica Stockholder, *'Nit Picking Trumpets of Iced Blue Vagaries*, 1997, Museum moderner Kunst, Stiftung Ludwig, Vienna

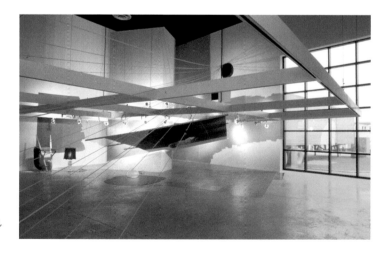

Jessica Stockholder, *Mixing Food With the Bed*, 1989, The Mattress Factory, Pittsburgh

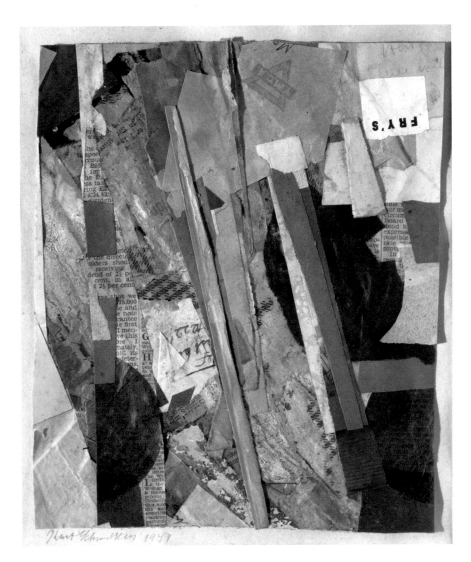

Kurt Schwitters, *FRY'S,* 1947 (cat. no. 229)

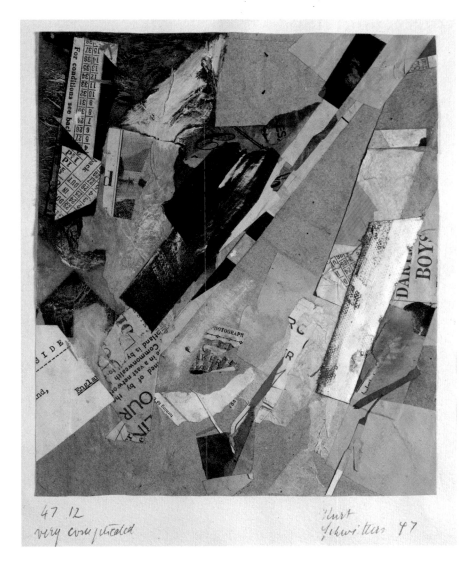

Kurt Schwitters, *47 12 very complicated,* 1947 (cat. no 223)

Lois Renner, *Youth,* 1999 (cat. no. 317)

Lois Renner, *Wimm,* 1997 (cat. no. 316)

Lois Renner, *Playstation,* 2000 (cat. no. 318)

gelatin+d.moises, *ball crazy– –*, 2000 (cat. no. 284)

"ball crazy– –
is the coming together of lucky circumstances.
a projectile, a golf ball shoots through the room at regular
intervals of some minutes. it is very quick. it whistles past the visitor's
ear and rebounds cleverly off the walls around him or her,
and back to the firing machine 'supercanon2000'. the result is
a space of speed and precisely calculated lines of fire and safety
zones. the result is a sound like a poem.
behind the ball the air closes together again and the space tingles
for several minutes in tense inner anticipation of the next shot."

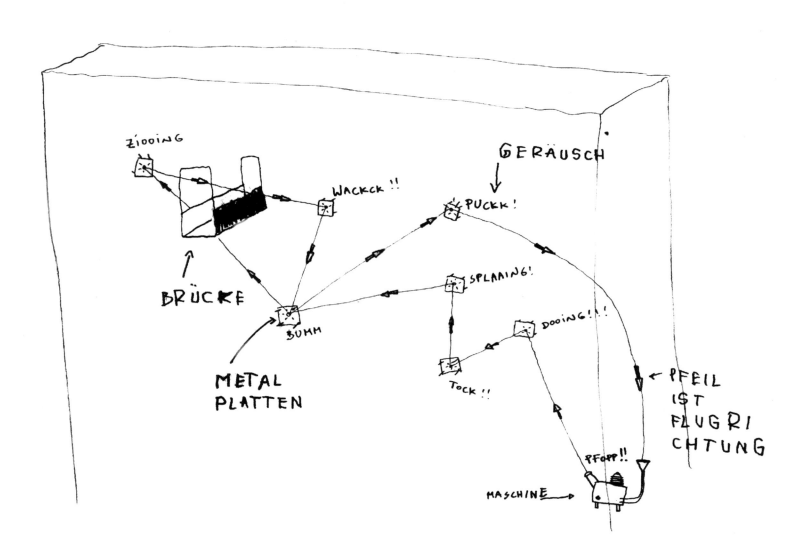

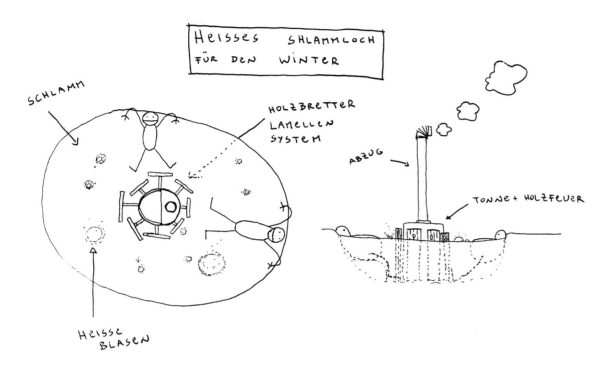

gelatin, *schlammloch* (not realized)

"this is a mudhole for cold winter days.
it is in a field in the fog and it is very ghastly round about.
there are people lying in the hole.
in the middle there is a big fat wood-burning stove which heats the hole.
air is blown in at ground level so that bubbles bubble.
the bubbling has a very solid slow fat sound.
Bluuubbb ... blubb ... bllllllluuuuuuuuuuuuuuub«

gelatin, *hugbox*, 1999, Biennial in Liverpool

"being hugged is something extremely important and wonderful.
inside the machine, when one is being hugged it is hot and one breathes only
with difficulty and the pressure on everything and specially on your ribcage is
immensely strong and one is frightened of breaking one's neck but one cannot
move a millimetre or get out of the thing and is at its mercy but fully trusting of
the machine because it would be senseless to resist, since it is much stronger
than one. much much stronger.
but afterwards one feels renewed and loved and very very happy and sexually
aroused and protected and one feels one's body all over at once but then not at
all because it is floating.

technical info
the hugbox is a pressure machine in which people are hugged. it functions by
means of weight and counterweight. the weight and the counterweight are two
large tubs with water in them. the machine is closed by the water being pumped
into the first tub. the weight of this tub closes the machine which exerts a high
level of pressure on the person standing inside.
the machine is opened by water being pumped out of the first tub backinto the
second tub."diese gewichtsverteilung fuehrt wiederum zum oeffner der
maschine.«

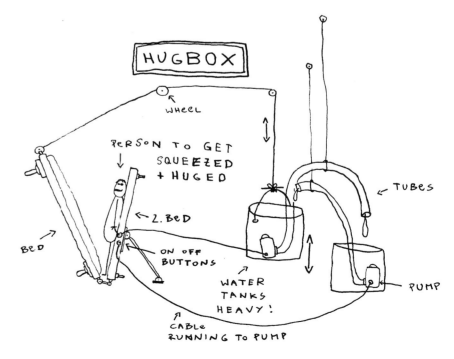

Kurt Schwitters, *Out of red,* 1947 (cat. no. 218)

Kurt Schwitters, *47. 13 new,* 1947 (cat. no. 214)

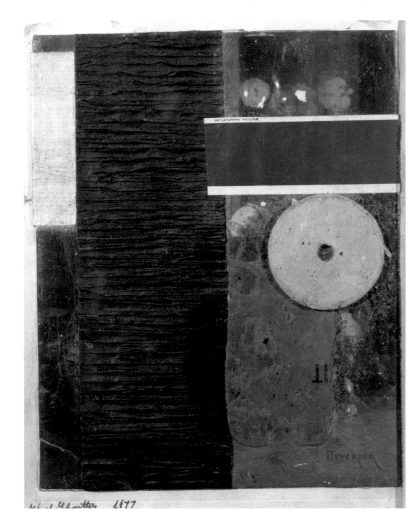

Kurt Schwitters, *Untitled (Duverger),* 1947 (cat. no. 215)

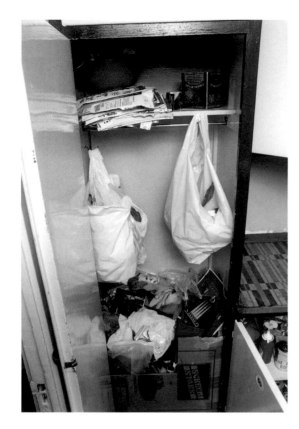

Nana Petzet, self-experiment: living according to the motto 'Sammeln Bewahren Forschen' (SBF) [Collect Preserve Research]. Collecting place for milk-cartons and plastic bags, one of the many model collecting places in the model kitchen. Final presentation of the experimental flat in Nylendugata 15, Reykjavik, 1998

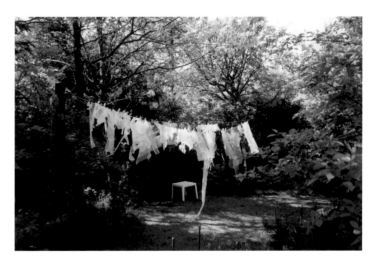

Drying sheets of plastic in the open air, Sylt, 1995

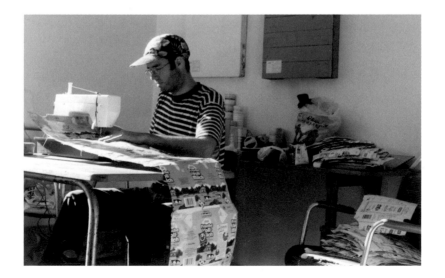

A milk-carton curtain being sewn, Munich, 1996

"If a household collects items for the SBF system, the consumer already pays attention when they are shopping as to which throw-away packagings they want to collect and re-use. Milk-cartons, folded open and cleaned, are the perfect material for making toilet bags, room-dividers and shoe scrapers."
Nana Petzet

Nana Petzet, presentation of *Sammeln Bewahren Forschen Abfallverwertungssystems*, Section 'Preserve', Exhibition *Private Werte*, Künstlerwerkstatt Lothringer Straße, Munich, 1999

"Used plastic bags plus gift ribbons can be made into baskets, these can be woven, platted or sewn. They invariably make durable, aesthetically pleasing objects." Nana Petzet

Nana Petzet during her lecture 'Technology and cultural lag – my contribution to lessening the distance.' Künstlerwerkstatt Lothringer Straße, Munich, 2000

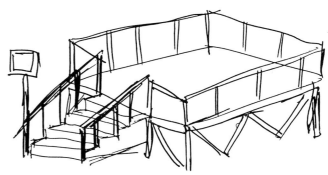

Plattform am Schwitters Wallfahrtsort
Waldhausenstrasse 5

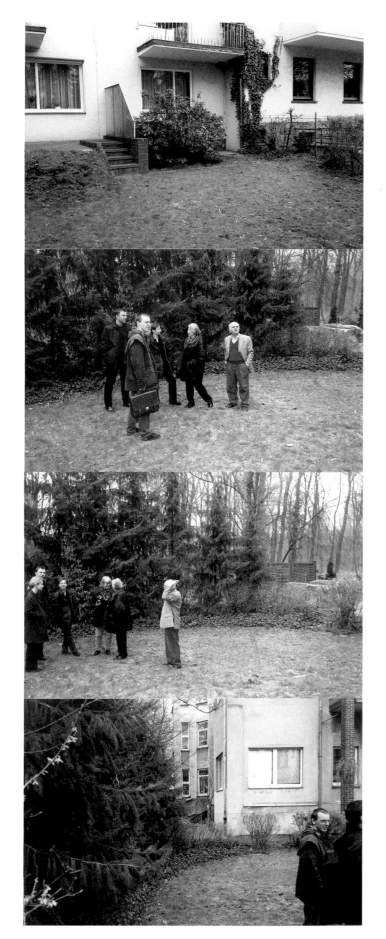

Projekt: Schwitters - Wallfahrtsort

Es geht darum den genauen Standort des eigentlichen Merzbau's auszumachen. Den Ort zu bestimmen wo in der Hochparterre-Wohnung in der Waldhausenstrasse N°5 in Hannover der erste Merzbau entstand. Es gibt dazu Skizzen, Pläne und Beschreibungen. Es wird deshalb möglich sein diesen Ort zu bestimmen. Da das Haus an der Waldhausenstrasse 5 von Bomben zerstört wurde und deshalb nicht mehr existiert ist es umso interessanter nun den im Original Standort auszumachen. Tatsächlich ist das nach dem Krieg entstandene Haus am gleichen Ort viel weniger tief und da also wo der Merzbau war, ist nun der hintere Garten. Ich will nun in den Garten diesen Standort bestimmen. Es muss dazu eine leicht erhöhte Plattform gebaut werden, sodass der Besucher auf der gleichen Höhe steht da der Merzbau im Hochparterre war und da zugleich der jetzige Garten leicht abfällt. So kann die Besucherin oder Wallfahrerin über eine kleine Treppe auf die Plattform gelangen und steht dann im Merzbau. Wenn er noch da wäre. Er oder sie steht also genau an dem Ort wo vor 75 Jahren der Merzbau war. Er oder sie steht im Merzbau. Rundherum war, ist Merz. Er ist im mega-virtuellen Raum und gleichzeitig im realen wirklichen Raum. Da war es, da ist es zugleich! (Killroy was here!) Kein Internet hilft man muss da hin! Ich will dazu einen kleinen Informationsstand über Schwitters und den Merzbau I, II und III machen. Zusätzlich gibt's souvenirs von der Plattform am schwitters-Wallfahrtsort, die man am Ort kaufen kann als Erinnerung des Besuchs hier. Thomas Hirschhorn Paris, Mai 2000

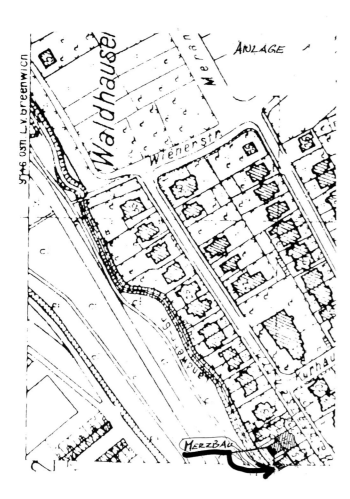

Thomas Hirschhorn, Project: Schwitters' Home – Place of Pilgrimage

Results of research into 'Waldhausenstraße 5' for Thomas Hirschhorn,
10 March 2000

Plans and maps
Almost all pre-war maps of Hanover were destroyed by the Soviet Army. The enclosed copy (encl. 1) is probably the only surviving map of the town that shows Waldhausenstraße 5, where Kurt Schwitters once lived. It is marked on the map.

The house at no. 5
The house was completely destroyed at the end of the Second World War and has been replaced by ordinary post-war housing. It is very run down. The curtains are askew, grey, and one window pane is broken. The ground floor has a Lebanese occupant. According to a neighbour he keeps himself to himself. On our visit he was not at home.
The present owner of the house, the landlord, is a master chimney sweep by trade. He lives in the house, but is probably away on a rest-cure at the moment. His sister also lives in one of the flats.

The building that now occupies this site does not go as far back as the Schwitters' house, which means that the Merzbau would be in the back garden today. We were able to gain access to the back garden through the cellar. It is no doubt also possible to get into the garden through the garage entrance. A path runs along the back of the house. Between this path and the garden itself, however, there is a ditch and a row of tall conifers which obscure the view into the garden.

The people in this area
The occupants of the house (with whom we talked) were aware of the historical significance of this site. In response to our questions they told us that virtually no-one comes calling on account of this. Insofar as some of the old houses have survived, the area seems at first sight to be a pleasant place to live. The peace is only disturbed by the noise from Hildesheimer Straße (one of the town's main traffic arteries). Waldhausenstraße itself has little traffic. Nor are there many pedestrians, and those there are just seem to be popping into the next house.

Art events in situ
Up until now, the Sprengel Museum Hannover had not carried out any events at this site. Currently, however, there is an exhibition of sculptures in the front gardens in Waldhausenstraße and in Güntherstraße. The exhibition closes on 11 March 2000.

Marco Teubner

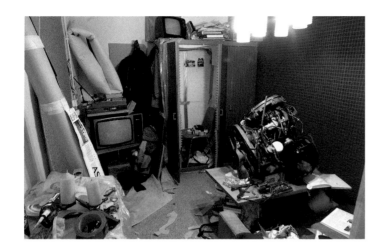

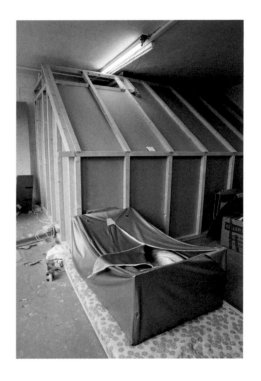

All the illustrations are of Christoph Büchel's installation *Everything will be all right,* 1999, Ausstellungsraum Goethestraße, Offenbach. Constructed attic flat of a fictive person who can never finish anything.

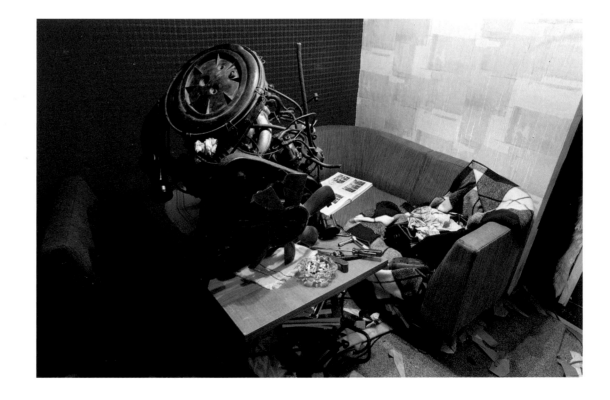

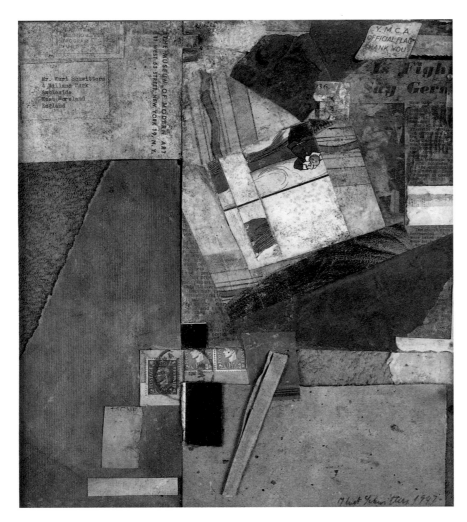

Kurt Schwitters, *Untitled (Y. M. C. A. Official Flag Thank You)*, 1947 (cat. no. 225)

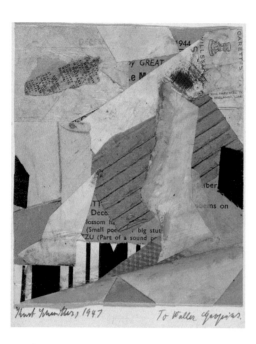

Kurt Schwitters, *To Walter Gropius.*, 1946 (cat. no. 204)

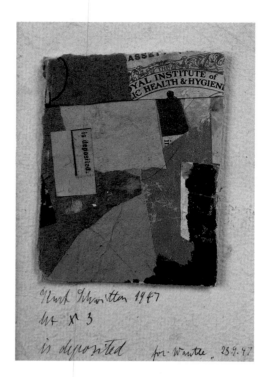

Kurt Schwitters, *Mz x 3 is deposited for Wantee 28.9.47*, 1947 (cat. no. 221)

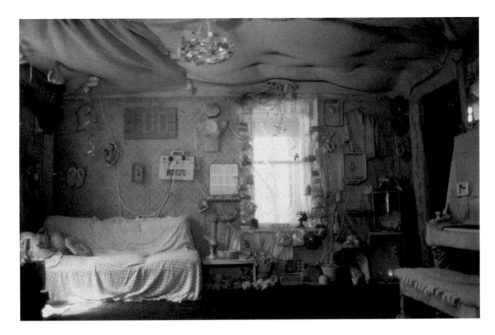

Laura Kikauka, *Funny Farm* (detail), 1997, Markdale, Canada

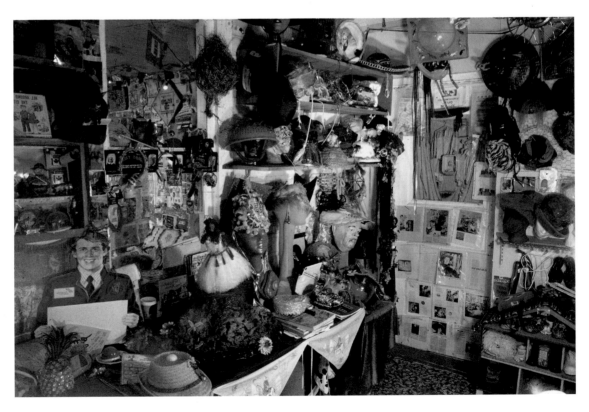

Laura Kikauka, *Funny Farm* (detail), 1997, Markdale, Canada

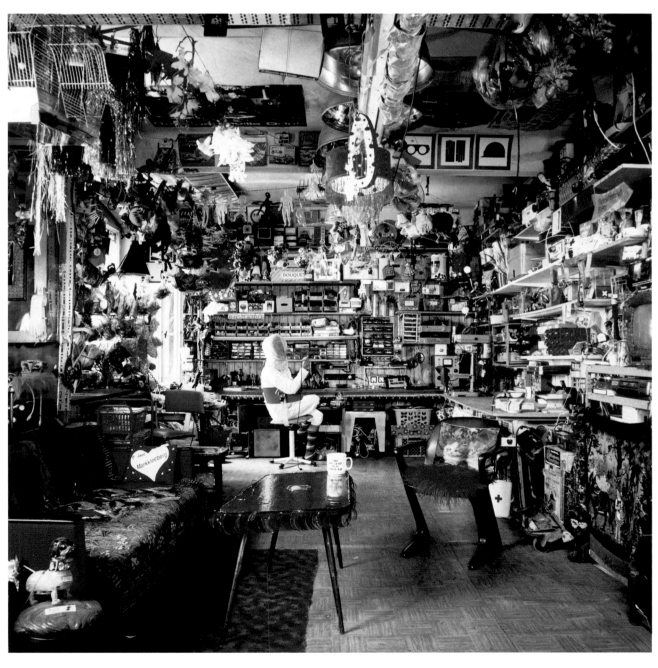

Laura Kikauka, *Funny Farm East* (detail), 1999, Ber in

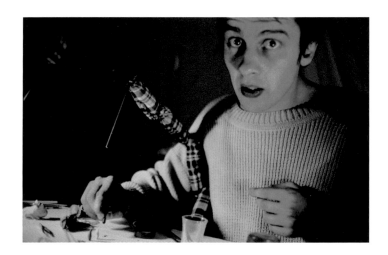

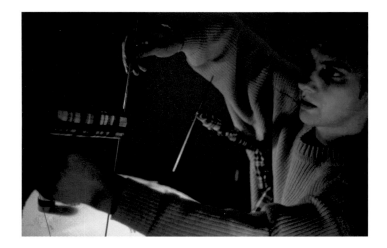

All the illustrations are of John Bock's performance
On the Diddleband of Love's Elasticity, 1997/99

All four illustrations are of John Bock's performance *Koppel op Kop*, 2000, "ars viva 99/00", Kunstverein Freiburg

I fired my gun directly into the air. The bullet travelled up into the sky and on passing over the mountain it descended to hit my enemy who was hiding on the other side.

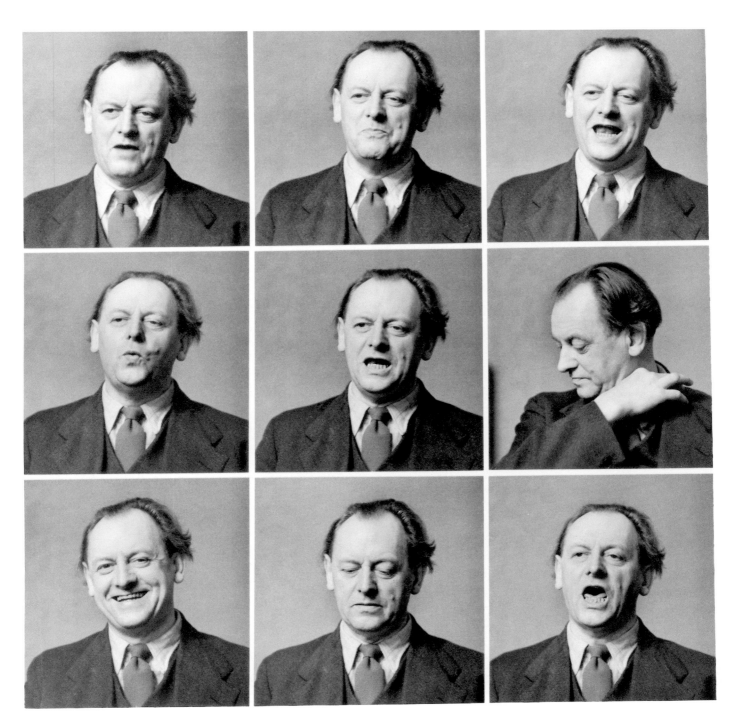

Kurt Schwitters performing the *Ursonate*, 1944

Franzobel (cat. no. 341)

Jaap Blonk (cat. no. 340)

Gerhard Rühm (cat. no. 342)

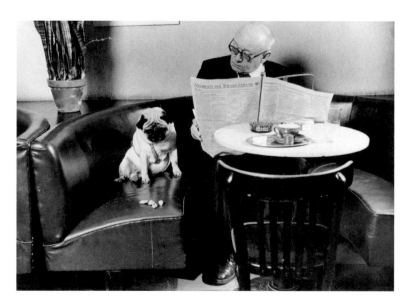

Ernst Jandl

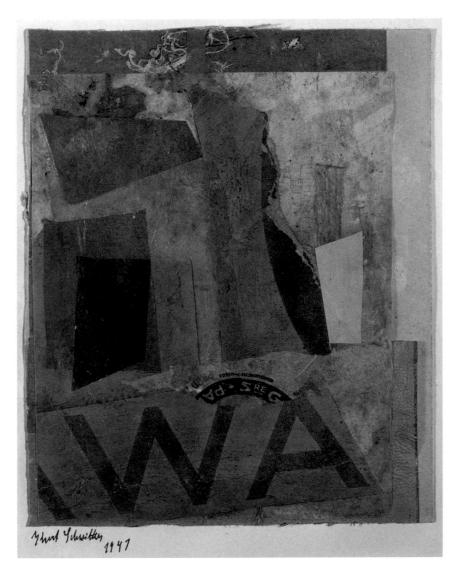

Kurt Schwitters, *Untitled (WA)*, 1947 (cat. no. 222)

ESSAYS

KURT SCHWITTERS AND HANOVER, OR OF THE TRADE AND THE TRAFFIC OF THE RESIDENTS IN THE SETTLEMENT WHERE MR SCHWITTERS IS FORCED TO LIVE

INES KATENHUSEN

In the first issue of the Hanoverian journal *Der Marstall* in 1920, there is a notice about Kurt Schwitters' novel *Franz Müllers Drahtfrühling*, informing readers that this is due to appear in the next issue as the first chapter of the *Liebesroman der Anna Blume*, and is set, according to Paul Steegemann who published *Der Marstall*, "in the settlement where Mr Schwitters is forced to live, and recounts the trade and the traffic of its residents".[1] The fact that there only ever was one issue of *Der Marstall*, that *Franz Müllers Drahtfrühling* did not appear until a good two years later and not in the "settlement" Hanover, is of no further interest here. Paul Steegemann was a highly imaginative publisher with an outstanding business sense, who was only behaving rationally when he set about building on the success that he was currently enjoying with Kurt Schwitters by announcing a new novel. He had published the volume of poetry *Anna Blume. Dichtungen* as a title in his series *Die Silbergäule*. The first edition was soon sold out, as was the second; publisher and author put their heads together about future publicity for the book. And so it was that in summer 1920 posters appeared in numerous locations throughout the town with the text of the Ten Commandments and a warning: "Be not mistaken, the Lord God shall not be mocked!" After a week these were replaced by the poem *An Anna Blume*. No other art 'campaign' in the 1920s and 30s created anything like the public sensation that now followed. Critics in all seven daily broadsheets wrote as much in disgust as in confusion about "madmen's art", "cultural Bolshevism" and "blasphemous profiteering". The social democratic *Volkswille* joined the fray. Its reporter noted with satisfaction the many threats and expressions of displeasure that were scrawled around the edges of the posters. In his view these were an indication that the "vast majority of the population were still of sound mind and wanted to help to stamp out such 'cankers'."[2]

Author and publisher readily took up the challenge to examine these commentaries in greater detail. The most incisive responses to the Anna Blume scandal – both approving and disapproving – were published in the first *Marstall*. Grouped together and with annotations from the publisher, the verbal extremes of furious invective did not dent the blithe equanimity and superiority they met with here. The only comment on the attempt to brand *Anna Blume* as a sign of cultural-bolshevist aberration was: "Yes, well, everything that discomfits the [...] citizen, that bellicose Christian, and everything that his lack of fixed mental abode prevents him from grasping, is branded as 'bolshevism' [...] Vive le bolchevisme!"[3]

This riposte came from Paul Steegemann. In its readiness to engage in sure-footed provocation it was on a par with many of Kurt Schwitters' own statements at this time. The blunter and more dogged the attack, the more telling and witty his parry. It was not without reason that in 1920 he called himself the "Hauptmann von Köpenick of painting".[4] The style and contents of his articles are typical of that time and the publications in which they appeared. In Hanover, besides the publications on Steegemann's list and Schwitters' own independent publications, his articles appeared above all in late-Expressionist journals such as *Das Hohe Ufer*, *Die Pille* and *Der Zweemann*. Like *Der Marstall*, these regarded themselves as the voice of the younger generation that had broken with the traditions of their fathers, and cultivated a pronounced anti-bourgeois stance, which was also reflected in their belief in individualism and their unconstrained love of life. It was here that Schwitters published his *Tran* articles; looking back at these and taking into account the double meaning in the German name *Tran*, meaning 'torpor' or 'fish oil', it is never entirely clear whether this name was pointing to the sluggishness of those being criticised or whether the articles were to be administered like cod-liver oil as a medical remedy for mental defects.

Against the German philistine: the journal *Die Pille*, 1921

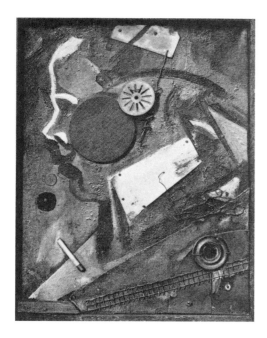

Kurt Schwitters, *Merzpicture 1 A (The Alienist)*, 1919,
private collection

Schwitters' collaboration with Rolan was certainly not a matter of course, and not only because the latter was no means unchallenged in his own field. Moreover, as the son-in-law of the painter Rudolf Hermanns, Rolan publicly spoke out on behalf of the latter, thereby supporting a keen opponent of Schwitters' in Hanover. Hermanns, born in 1860, had been a respected painter working in the traditional academic manner in the early 1920s. In view of the decreasing number of commissions that came his way, he felt he was being pushed aside by the changes on the art market in Hanover, for which he blamed the advance of the artistic avant-garde. And for this reason, in 1919 he addressed the general public with his text *Offenherzigkeiten über Kritik und Expressionismus in Hannover* [Frank Comments on Criticism and Expressionism in Hanover]. He regarded the publication of his comments as a *defence*, first and foremost against Expressionism. He set traditional landscape and genre painting against Expressionist "psychiatric art" and "fashionable folly": "In the midst of all the dirt and the misery surrounding us, under the weight of hopelessness, the art-lover, the thinker and the great masses seek to be uplifted by art, to be filled with joy and enlightenment."[7]

Whatever the case, as at other times of his life, during this period Schwitters only rarely adopted the stance of the smug know-it-all which was positively obligatory amongst many contributors to Hanover's avant-garde journals. In an effort to rise above the bourgeois, it seemed impossible for these contributors to be anything but condescending towards the supposedly typical philistine. When anyone particularly irritated Schwitters with their elitist airs, he knew only too well how to cut them back down to size. In 1920, for instance, when the neurologist and poet Karl Aloys Schenzinger relentlessly tore the Hanoverian bourgeoisie to shreds in *Das Hohe Ufer*, Schwitters countered by pointing out the lengths that Schenzinger would go to to be unbourgeois. Without a moment's hesitation he stuck a beer mat onto a portrait of Schenzinger and called it *Merzpicture* 1A *(The Alienist)*, which heralded the end of their friendship.

Instead of delighting in dissecting negative criticisms of his work, however much he enjoyed poking fun, it was more in his nature to be specially disarming when faced with a heavily armed attack. In 1924 he wrote: "Merz is *Weltanschauung*. Its nature is an absolute lack of inhibition [...] Merz is consistency. Merz means creating relationships, preferably between all the different things in the world."[5] He countered possible objections to the concept of a Merz stage in the *Dialog mit Einwürfen aus dem Publikum* [Dialogue with contributions from the floor]; in this he himself took on the role of someone patiently explaining the artistic plans which he himself was developing at the time with the actor and director Franz Rolan.[6]

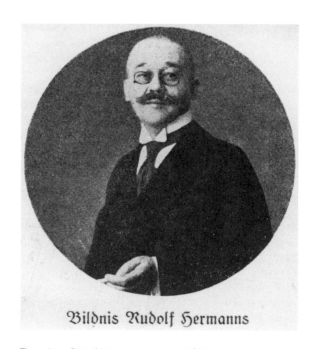

The painter Rudolf Hermanns, author of *Offenherzigkeiten*,
ca. 1918

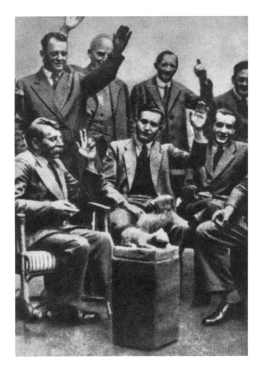

Vote in the Kunstverein. First from left, standing:
Kurt Schwitters, in the centre, seated: Alexander Dorner

Kurt Schwitters was born in Hanover in 1887, and spent most of his time there until he emigrated half a century later. In 1931, in the *Veilchenheft* of the *Merz* magazine he spelt out the significance of this town for his life and work. With amused coquetry he explains that the street where he was born, Veilchenstraße [Violet Street], had a programmatic meaning: "*for I am just that kind of violet*, that intentionally blooms in seclusion, for I am sure that I smell sweeter there." He therefore issued a plea to those who knew him: "Let me continue to bloom in my seclusion. [...] I am content if I can go on working, undisturbed and left in peace in my studio or at my writing desk, unbothered by the noise of the street or having to think about food."[14]

This search for peace, security and predictability is one reason why Schwitters, while enjoying travel, always returned to Hanover and never contemplated moving to Berlin where many of his friends and acquaintances lived. Even if Paul Steegemann's words at the beginning of this essay might lead one to think it, Schwitters never had to be "forced" to stay; he was a well-known figure in Hanover – this was not only due to

Hermanns' criticisms were directed against museum directors, reviewers and politicians involved in the arts – and also against Kurt Schwitters. Without specifically naming him, Hermanns declares that in his exhibitions one "will in future only find 'abstractions', 'metal-concrete moods' and works 'shattered by torment'"[8] by way of an exception. It should be said that the term 'abstraction' characterised much of Schwitters' work at the time, and that *Metal Concrete Mood* was the subtitle of his first abstract painting. Although Hermanns' text of 1919 provoked massive protests amongst Schwitters' friends, it obviously did not lessen his inclination to work with Hermanns' son-in-law Franz Rolan. Again a comment from 1920 sums up his position: "I am tolerant and allow each his own *Weltanschauung*."[9]

Many of his friends and acquaintances cited Schwitters' generosity of spirit and merriment but also a leaning to melancholy as his main features. People described him as a "dreamy artist", "far from any activist tendencies", "harmless, good-natured, peace-loving",[10] "a Romantic held back by his intellect"[11]; his friend Paul Steegemann called him a "complicated chump, a good soul through and through with bright child's eyes".[12] Perhaps his complex nature was also the source of his tendency to blur the boundaries between having fun and being serious, between the banal and the sublime, convention and individuality. In 1926 he described this duality: "Merz is a smile at the grave and gravity on cheerful occasions."[13]

PUBLIKUS

Publikus hat an einigen Merzbildern von Schwitters in der Ausstellung der Hannoverschen Sezession „produktive Kritik" geübt. Einzelne Bildteile wurden abgerissen, andere Dinge wurden „eingefügt": mit Zoten beschriebenes Briefmarkenpapier usw.

Die kochende Volksseele treibt liebliche Blasen. Es zeugt weder von verstandlicher Logik noch von Kultur, in bezug auf die jüngsten Erscheinungen von „Attentaten auf die Kunst" zu reden und dann selbst Kunstwerke zu schänden. Und wer schon sittlich abgerüstet hat, sollte sich nicht mehr sittlich entrüsten. „Die Kunst gehört dem Volke". Es muß zu ihr hingeleitet werden. In der Leitung scheint etwas faul zu sein.
C. S.

Attacks on Merz-art: article by Christof Spengemann in
Zweemann, 1920

the spectacle that surrounded *Anna Blume,* and was a status that he had come to accept as a matter of course. During the 1920s and early 30s he frequently published stories and programmatic texts in the various broadsheets in Hanover. In 1927, for instance, he wrote: "Unlike the critics I regard Hanover as the leading town for art in Germany. It is, of course, true that in the days when art was going in a whole number of different directions, Hanover let itself be left behind, but now it has more than caught up [...] In a town as remarkable as Hanover [...] the art that emerges must also be unusual. In contrast to the so-called art-towns, we have the advantage that we are not tied to out-dated traditions, instead in Hanover art is treated in an exemplary manner." Following this, he added that he believed "precisely a town like Hanover has given me my most valuable inspiration."[15]

His praise may have flattered some of the town's art professionals. But it was by no means appropriate, and Schwitters knew this. It was true that since the First World War there had been some progress on the local art scene and in his own artistic career. Thanks to his efforts new groups like the Hanover Secession had come together, made up of artists whose work was supported by a number of influential patrons of the arts. In 1916, above all with the founding of the Kestner-Gesellschaft and Schwitters' close contact with the initiators of the idea, Hanover now had a venue where Schwitters could exhibit work and which would provide him with his first contact with a wider public. Besides this, Schwitters was also on friendly terms not only with his colleagues in Hanover, but also with artists further afield, such as Walter Dexel, Hannah Höch and Hans Arp, and participated in a number of national and international exhibitions. The director of the art section of the Provinzialmuseum, Alexander Dorner, an art connoisseur who was respected at home and abroad, was one of a large number of Schwitters' acquaintances who, like his backers from industry, not only provided him with the opportunity to perform and present his work in private, solidly bourgeois settings but also opened up the prospect of sales. As we can see from his being a member of numerous artists' associations, from his involvement in the selection committee for the spring and autumn exhibitions, and his contributions to a whole number of newspapers and journal, Schwitters was as active as he was influential. In addition, he was the first Hanoverian member of the PEN Club, and, serving from 1929 onwards as artistic advisor, designed the typography for over 400 forms and letterheads for the Town Council, which in turn led to commissions from other authorities and companies.

Museum für Kunst und Wissenschaft (Künstlerhaus), the home of the Kunstverein, lithograph, ca. 1860

However, when his wife Helma wrote during this period that the family was in a "miserable" state, and that they were not earning enough money,[16] when her husband pointed out that he was "not in a position to go on working without the prospect of recompense",[17] then these are by no means signs that the Schwitters family, in a typically bohemian manner, was not able to handle money. The fact is that despite his many activities, the money he earned was not enough to keep the artist (from a bourgeois family that had been hit by inflation), his wife and his son Ernst. What was the good of his intense literary and press activities if his work appeared with publishers whose love of experiment was constantly dogged by existential anxiety and whose authors (including Schwitters) therefore often worked without pay? What good were the exhibitions, the readings and the discussion events if the public did come but usually bought nothing, always assuming it had not already deliberately destroyed the works on display? And what good was it being on selection committees or being a member of influential local associations if his fellow-members could make little of his own art, since their tastes had not changed significantly since the days when the country still had a Kaiser? Take the Kunstverein in Hanover for instance. A typical bourgeois institution founded in the first half of the 19th century, for generations it had offered mostly local artists an exhibition venue in the Sophienstraße, and over the years had promoted art that clung firmly to traditional bourgeois notions of nobility and beauty. Representational art, at worst Impressionism, was the only art deemed

acceptable at the Kunstverein. It had been artists like Rudolf Hermanns, the author of the *Offenherzigkeiten*, who had made the Hanover Kunstverein what it was, and who could still bring their influence to bear in the 1920s. Of course, it is true that the Kunstverein was still a fundamentally private institution, as it always had been. Nevertheless, the distance it maintained to young artistic trends (which had possibly developed since the First World War with greater intensity in Hanover than elsewhere because of the town's all too restrictive cultural politics) need not necessarily have been so detrimental to them – if, that is, the Town Council had been even half as encouraging and supportive as Schwitters had so unexpectedly claimed.

But this was not to be. As ever, the local politicians working in the arts and the conventionally-minded art institutions were united in their preference for traditional, often also mediocre art. The unbroken line that led from the monarchy to democracy meant not least that many of those formerly involved in the cultural politics of Hanover – notably the former Town Director Heinrich Tramm who was as powerful after the War as ever – were able to hold on to their positions of power in the 1920s and 30s, buoyed up and supported by large sections of the local populace. Tramm was a layman with an interest in the arts, and took pride in the contacts he had made with artists around the turn of the century who were indubitably regarded as progressive at the time. His opinions, firmly rooted in that period, about what art should and should not be, never subsequently changed. Heinrich Tramm was the most important figure when it came to decisions about public purchases of art, as well as being chairman of the Kunstverein Hannover and of other artists' associations, and up until his death in 1932 he stood surety for a cultural policy that preferred art that had been tried and trusted and, on principle, viewed any experiment with scepticism.

Particularly since Kurt Schwitters had so many insights into these mechanisms, it is all the more surprising that he should have talked of Hanover's "exemplary" attitude to art. He knew that Rudolf Hermanns, like other exponents of art that was beautiful and ennobling, regularly received support from the Hanover Town Council, while his colleagues producing abstract works were turned away. And he himself had had enough experience of the Council's practice of studiously avoiding exponents of modernism when they were making purchases for the municipal collections. Schwitters' awareness that all was not well is evident, for example, in the founding of 'the abstrakt hannover' in March 1927, for this came about on his initiative – in the hope that together with his colleagues working in the field of abstraction he would be able to make more of an impact in official art circles. Now Kurt Schwitters, Friedrich Vordemberge-Gildewart, Carl Buchheister, Hans Nitzschke and Rudolf Jahns were indeed regularly able to show their work in the Kunstverein – only the conditions were anything but satisfactory: the rooms allotted to 'the abstrakt hannover' were store-rooms rather than exhibition rooms, the labels were sloppy, and even the artists' names were often carelessly misspelt.

In view of the continuing powerful alliance between the long-established art institutions and the Town Council, for Schwitters and other exponents of modernism it was not the town of Hanover but private individuals who made their work in any sense possible, that small circle of artists, gallerists, collectors and patrons. Schwitters' tongue-in-cheek comment that Hanover was "striving ahead, into infinity in fact"[18] was made in the light of the Town Council's maxim that local cultural politicians should "pursue a sound, middle course"[19]; these two camps coloured the arts and culture in Hanover in the 1920s and 30s. It was only the ensuing tensions between the powers that favoured continuity and those who instigated ruptures, that made Hanover into that "remarkable town" that gave Schwitters his "most valuable inspiration".

Catalogue of Heinrich Tramm's private gallery, excerpt, 1913

Looking back, Käte Steinitz, who had been a close friend and colleague of Schwitters', characterised him as "international petit-bourgeois of Hanoverian extraction and construction".[20] She then went on to justify this: "After all Kurt Schwitters missed the ordered world of bourgeois careers by a hair's breadth, even if he lived thriftily with many petit-bourgeois habits, or even when he appeared to display an old-fashioned form of native wit or wanted to, he was still always completely different. He simply was not capable of being conventional." There is no end to examples of this complete differentness: here the ordered Schwitters household in the solidly middle-class Waldhausenstraße, there the proliferating *Merzbau* right next to it, here his meticulous bourgeois attire, there the grotesque delivery of the *Ursonate* – here his actions, his provocation of the general public, there his search for seclusion and calm.

There were some critics who did not regard Schwitters as credible because of these (supposed) contradictions. Above all the Berlin Dadaists dismissed him for these contradictions, finding him much too bourgeois – the "genius in the smoking jacket"[21]; one work to emerge from the Dada circles in Berlin was even called *Der Tod der Anna Blume* [The Death of Anna Blume].[22] In contrast to Schwitters, these artists regarded Dada not only as a form of artistic representation, but also as a means to incite revolutionary agitation in order to bolster Communism. It was only by distancing himself from this approach that Kurt Schwitters developed the concept of Merz art. Meanwhile he was entirely convinced that he was "of that time", even "*more than the politicians* who were of that decade".[23] Indeed in the 1920s and 30s he wrote numerous texts that discussed with great seriousness the politics of social issues, always stressing his own unconditional pacifism. In *Nationale Kunst*, for example, he wrote: "Unfortunately there are nations. The consequence of nations is wars [...]. National art helps to prepare for war. Unfortunately there is also the proletariat. It would be better if there were only people who shared the same rights and who felt the same as each other, which is after all what every member of the proletariat is striving for. The consequence of the existence of the proletariat is revolutions."[24]

Kurt Schwitters issues invitations to the founding of 'the abstrakt Hannover' (1927)

Particularly with our knowledge of the events that followed this period of artistic and political freedom in the 1920s – one may well be surprised at the naivety of these comments, at the idealising construct of a harmonious society. Indeed, certain views that Schwitters' voiced point, from our present perspective, to a remarkable innocence and detachment regarding the explosive political situation in the Weimar Republic. For instance, in November 1920 there was the proposed founding of the M.P.D. [Merz-Partei Deutschlands], the fictive Merz Party of Germany. Anna Blume was put up as the candidate and every so often the Party demanded the return of the Kaiser from his abdication. Then, in response to the increasingly uncertain political situation in the early 1930s, there was the demand that no National Socialist should ever become Chancellor of the Reich (Kennel-Man to the Reich) for he "would bite all his opponents and infect them with rabies and the whole of Germany would be like a madhouse".[25] Schwitters pursued his argument further: "A Sozi [from 'Sozialist'], I fear, will not be able to stand his ground in an exposed post ['popo' = one's posterior]." So that left the 'Cozi', the Communist. But, asks Schwitters, "who wants to have an eternal Cozi in the house? Before 5 minutes were up, everything would be completely cozed" [the made-up verb in the original German has a clear allusion

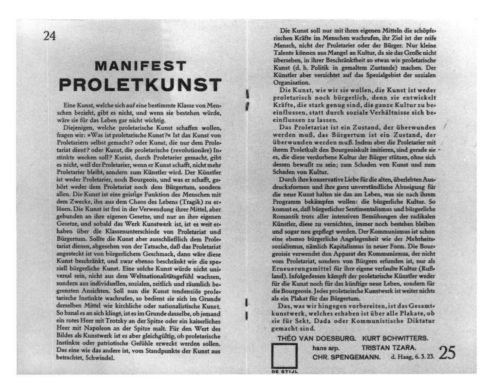

Against the link between art and politics: the 'Manifest Proletkunst', 1923

to violent sickness at this point]. And then, after the National Socialists had seized power, there were the letters to friends which closed with a Merz signature next to a swastika, in which Schwitters for instance discussed examining sprouting potatoes for the purposes of distinguishing between the Japanese, Aryans, Saurians and Jews: "Only Aryan seeds produce good stock." Hot on the heels of this came a serious confession to 'complete differentness': "Just make sure you don't turn into an Aryan".[26]

In (party) political terms, Kurt Schwitters was and remained unpredictable. Thus he always stressed the great importance that the upheavals following the November revolution had had on his life and work. But when it came to the effectiveness of revolutions in general, he declared that he "didn't think much" of them, "humans had to be ready for them".[27] In the chapter entitled *Ursache und Beginn der großen glorreichen Revolution in Revon* [The Causes and Beginning of the Great, Glorious Revolution in Revon] in the novel *Franz Müllers Drahtfrühling*, the "natives" of Revon-Hanover[28] are not driven to demand a parliamentary system because of political grievances. There already is a parliamentary system, albeit one that would be hard to beat for its inefficiency, with democratic principles that have become no more than empty talk. Instead it is the art-figure Franz Müller, a "walking Merz sculpture", "nailed with pieces of wood and wound round with wire",[29] who sparks off the revolution, by doing no more than standing still in the crowds milling about in Revon. Because of this provocative complete different-

ness, that is to say, his loitering with no obvious intent which makes him appear suspect, there is stampede of human beings, which in turn leads to the revolution. Honourable citizens, male and female, hurl wild insults at each other, like "louse carcass" and "turnip pig", public order is right out of kilter. But none of this interests Franz Müller. He leaves the scene of the action, continues to nourish himself from Revon's refuse dumps, and finds his own private happiness with the young girl Rosemarie.

Like the real November revolution in Hanover, the one in Revon was also scarcely glorious; according to Schwitters, both generated great excitement but little in the way of results, not least because the inhabitants in both place were politically immature. This in itself is based on the conviction that the necessary maturity is not to be achieved through political campaigns, but through art alone, although it was a matter of "utter indifference" to art "what form the state took".[30] It was not for politics but for art to carry out that "finest task of forming human beings, of educating them, for art is the expression of the sense of humanity felt by the noblest of human beings".[31]

The edifying and redeeming quality of art, that comes into play here as in many other statements by Kurt Schwitters, was not so very far removed from Rudolf Hermanns' typically bourgeois demands that art should uplift him and fill him with "joy and enlightenment", and it was also precisely this that turned the politically motivated Dadaists in Berlin against Schwitters. He was not out to destroy existing artistic and socio-political values, but to change values, to attempt "to make something

new from the shards",[32] and the medium that he chose to do this with was art. With an insistence that at times even implies a quasi-religious meaning for art, Schwitters – going well beyond late Expressionist *Zeitgeist* as we know it – pleaded for the ultimate goal of his work, which was to create a new, pure, mature human being. For, in his view, it was only then that one could start to build a new social order. As Schwitters saw it, true works of art "are far above the class differences separating proletariat and bourgeoisie", in terms of their value it was "immaterial whether proletarian instincts or patriotic sentiments were to be aroused. Seen from the standpoint of art, both were fraudulent to an equal degree".[33] Schwitters preferred to risk being mocked as unpolitical and "petit bourgeois"[34] rather than turn his work into a tool to serve other non-artistic interests. This was no doubt also the reason why he never answered the letters he received from the local branch of the Communist Party in Germany, trying to enlist him for Party work,[35] and why his sympathies lay instead with the artists of the Berlin November Group who demanded a diffuse, emotive "revolution of the spirit" and who had little time for concrete political campaigns.

In December 1930 Christof Spengemann, Schwitters' closest friend in Hanover, persuaded him to work at the "Kampfstelle gegen Zensur und Kulturreaktion" [Centre for the Struggle against Censorship and Cultural Reactionism] which Spengemann himself had founded. Spengemann, a journalist and writer, was a critical social democrat who had a quarrel with his own party's aims in terms of art and culture. It was under his influence that Schwitters joined the Social Democratic Party in 1932 (although this did not affect his work as an artist). The centre had been set up because Spengemann saw in Hanover, too, growing signs of a threat to modern art from reactionary groups. Supported by the Young Socialist Workers and the SPD in Hanover, the centre was to serve as a warning to a broader public. In the effort to win more supporters for the cause, also from the middle classes, plans were made for an event on 21 December 1930 entitled "Künstler in Front" (KIF – Artists in Front) as "the first step towards all artistic associations coming together as one block", and it was to provide "new blood and a fresh face" for art in Hanover.[36] Originally this was also planned to include the premiere of the stagework *Das Irrenhaus von Sondermann* [The Madhouse of Specialman] by Kurt Schwitters. This was to be a "political piece" and to be about the planning of an event called KIF and two opposing groups of

Innocuons membership. Kurt Schwitters joins the SPD (1932)

artists, those who were planning the event in order to gain "a greater influence over cultural matters" ("although non-political") and those who suspected the former of "betrayal", "filth" and "Jewish blood", describing them as "a handful of loose-living artists", and were planning to scupper the event.[37]

The closer the date came, the stronger the rumours grew that there would be trouble at the real event. Right-wing students and members of the reactionary press had announced their intention to attend, at which point members of the Social Democratic youth section offered to provide security for the venue. Thus the largely bourgeois audience arrived on the last Sunday before Christmas 1930 fully expecting a scandal. But no scandal ensued. The programme had clearly been watered down, and *Das Irrenhaus von Sondermann* was not shown. As Spengemann later recalled, Schwitters had been against the work being performed, also because he disliked the increasing politicisation of the event.

Once again Schwitters rejected his work being appropriated for political purposes, even if these were vaguely leftist. Six days after KIF had taken place, on 27 December 1930, Schwitters wrote his most programmatic text from that period. What he wrote in this on the impossibility of uniting art and politics may also be seen as a response to what he saw as his failed attempt to work, as a non-political artist, with political groups for a cultural-political end. The article came to a climax in an exhortation: "But you, you political fellow human beings from right and left, or you of the middle kind, from whatever blood-soaked intellectual camp you may come, *when you one day have finally had your fill of politics* [...], then come to art, *to pure unpolitical art that is without tendencies*, not social, not bound to one time, not fashionable. *It can revive you and it will gladly do so.*"[38] And this was also the occasion on which Schwitters wrote, with equal irony and self-confidence, that he hoped "that the time can continue to exist politically without me, whereas I know for certain, *that art still needs me for its future development.*"

But Hanover, the town that made it possible for him to bloom like a violet in seclusion and to emit a sweet scent, to work and to live, seems to have remained as "remarkable" as ever after his death. For it took decades to arrive at the same conclusion that Kurt Schwitters had already put into words as far back as 1930.

Uprising to save the liberal arts?,
Festschrift for *KIF* (1930)

NOTES

1 Paul Steegemann, "Das enthüllte Geheimnis der Anna Blume', in: *Der Marstall. Zeit- und Streit-Schrift des Verlages Paul Steegemann*, no. 1/2, 1919/1920, p. 11. The following discussion is based largely on: Ines Katenhusen, *Kunst und Politik. Hannovers Auseinandersetzungen mit der Moderne in der Weimarer Republik*, Hanover 1998. No further detailed references to this text will follow.

2 As quoted in: *Der Marstall* (as note 1), p. 30.

3 Ibid., p. 28.

4 Kurt Schwitters, 'Generalpardon an meine hannoverschen Kritiker im Merzstil (Tran Nr. 7)', in: *Der Sturm*, vol. 11, part 1, April 1920, p. 4. The Hauptmann von Köpenick was a real ex-convict in the early 20th century who, clad in an officer's uniform bought after his release from prison, sets the cat amongst the militaristic pigeons in the Berlin suburb of Köpenick.

5 Kurt Schwitters, 'Merz', in: *Der Sturm*, vol. 18, part 3, June 1927, p. 43.

6 Kurt Schwitters, 'Aus der Welt: ›Merz‹. Ein Dialog mit Einwürfen aus dem Publikum von Kurt Schwitters und Franz Rolan', in: *Der Sturm*, vol. 14, part 4, April 1923, pp. 49–56, no. 5, May 1923, pp. 67–76, no. 6, June 1923, pp. 95f.

7 Kunstgenossenschaft Hannover (publ.), *Offenherzigkeiten über Kunst und Expressionismus in Hannover. Eine Abwehr*, Hanover 1919, pp. 3, 11.

8 Ibid., p. 12.

9 Kurt Schwitters, 'Merz (Für den *Ararat* geschrieben 19. Dezember 1920)', in: *Der Ararat. Glossen, Skizzen und Notizen zur Neuen Kunst*, vol. 12, part 1, January 1921, p. 5.

10 Christof Spengemann, *Die Wahrheit über Anna Blume. Kritik der Kunst, Kritik der Kritik, Kritik der Zeit*, Hanover 1920, p. 16.

11 Kurt Voß, 'Herbstausstellung im Kunstverein. Das Lebensrecht der bildenden Kunst', in: *Hannoverscher Kurier*, 13 October 1931.

12 Letter from Paul Steegemann to Emma Klemm, as quoted in: Werner Schmalenbach, *Kurt Schwitters*, Munich 1967, p. 13.

13 Kurt Schwitters, *Merzbuch 1. Die Kunst der Gegenwart ist die Zukunft der Kunst*, Hamburger Notizbuch 1926, as quoted in: Friedhelm Lach (ed.), *Kurt Schwitters. Das literarische Werk*, vol. 5, Cologne 1981, p. 247.

14 Kurt Schwitters, 'Ich und meine Ziele', in: *Merz 21 erstes Veilchenheft*, Hanover 1931, pp. 113, 120.

15 Kurt Schwitters, 'Der Rhythmus im Kunstwerk', in: *Hannoversches Tageblatt*, 17 October 1926.

16 Letter from Helma Schwitters to Robert Michel and Ella Bergmann-Michel, 7 November 1927 (Bergmann-Michel Estate, Sprengel Museum Hannover, A48/03–1927/002).

17 Letter from Kurt Schwitters to Max Gaede, 12 May 1929, (Kurt Schwitters Archive of the Stadtbibliothek Hannover 338).

18 Kurt Schwitters, 'Hannover', in: *Der Sturm*, vol. 11, 3 June 1920, p. 40.

19 Recorded in the minutes of the meeting of the municipal theatre committee, 13 April 1921 (Stadtarchiv Hannover HR X.C.10.32).

20 Käte Steinitz, *Kurt Schwitters. Erinnerungen aus den Jahren 1918–1930*, Zurich 1963, pp. 9, 29.

21 Richard Huelsenbeck, 'Dada und Existenzialismus', as quoted in: Schmalenbach 1967 (as note 12), p. 13.

22 John Elderfield, *Kurt Schwitters*, Düsseldorf 1987, pp. 40ff.

23 Kurt Schwitters, 'Ich und meine Ziele' (as note 14), p. 114.

24 Kurt Schwitters, 'Nationale Kunst', in: *Het Overzicht*, nos. 22–24 (1925), p. 168, as quoted in: Lach 1981 (as note 13), p. 199.

25 Letter from Kurt Schwitters to Robert Michel and Ella Bergmann-Michel,

26 August 1931 (Bergmann-Michel Estate, Sprengel Museum Hannover, A28.03–1931/001-).

26 Letter from Kurt Schwitters to Robert Michel, 2 December 1934 (Bergmann-Michel Estate, Sprengel Museum Hannover, A28.01–1934/002-).

27 Kurt Schwitters, *Gefesselter Blick. 25 kurze Monographien und Beiträge über neue Werbegestaltung*, as quoted in: Lach 1981 (as note 13), p. 335.

28 'Revon' is the last two syllables of the word 'Hanover' in reverse.

29 Kurt Schwitters, *Franz Müllers Drahtfrühling*, Hamburg 1991, p. 34.

30 Kurt Schwitters, *Kunst und Zeiten, datiert im März 1926*, as quoted in: Lach 1981 (as note 13), p. 239.

31 Kurt Schwitters, 'Nationale Kunst' (as note 24), p. 199.

32 Kurt Schwitters, *Gefesselter Blick* (as note 27), p. 335.

33 As in the 'Manifest Proletkunst' which was signed jointly by Schwitters, Theo van Doesburg, Hans Arp, Christof Spengemann and Tristan Tzara, in: *Merz 2*, Number i, April 1923, pp. 24f.

34 Tristan Tzara, as quoted in: Schmalenbach 1967 (as note 12), p. 13.

35 Letter from the Communist Party of Germany, Lower Saxony, to Kurt Schwitters, 8 November 1924 (Kurt Schwitters Archive of the Stadtbibliothek Hannover 401).

36 Festschrift *Künstler in Front*, 21 December 1930 (Kurt Schwitters Archive of the Stadtbibliothek Hannover 20.3).

37 Kurt Schwitters, *Das Irrenhaus von Sondermann*, as quoted in: Friedhelm Lach (ed.), *Kurt Schwitters. Das literarische Werk*, vol. 4, Cologne 1977, pp. 121–130.

38 Kurt Schwitters, 'Ich und meine Ziele' (as note 14), p. 120.

"WHAT WOULD LIFE BE WITHOUT MERZ?" ON THE EVOLUTION AND MEANING OF KURT SCHWITTERS' CONCEPT OF ART

ISABEL SCHULZ

Merz and Kurt Schwitters have become synonyms. Ever since the artist first proposed the notion of Merz in 1919 at a presentation of his latest assemblages, his work and his person alike have been closely associated with it. Few art historians or literary critics can avoid the term in discussions of his work. Inextricably linked with the person Kurt Schwitters, as a subjective, private creation, Merz is unique in the field of art history for its exclusivity and logical consistence.[1] Although often categorised as a "facet",[2] a special form or a "late version"[3] of Dada, Merz cannot properly be compared with other avant-garde movements at the beginning of the 20th century, since it did not lead to a particular style or school. By the same token, Merz does not represent any self-sufficient art theory that could be identified independently of the creative output of the artist himself.

But what is Merz? For Schwitters himself the term 'Merz' embraces the whole of his output and his person. He uses the name as an umbrella term for his various ideas, but also uses it to stand for his activities (Merz evenings), his art (Merz pictures, Merz poems, Merzbau, etc.), his typography (Merz advertising centre) and publications (the Merz magazine). Problems arise if one reads Schwitters' writings[4] as source texts for a theory of Merz, for the texts do not describe Merz, but present it as an aesthetic phenomenon. Nor are they immediately applicable to works or to be understood as interpretations of these works, although many studies of Schwitters' work attempt to do so. Rather they reveal a stance, an awareness of which can at best lead to a deeper understanding of Kurt Schwitters' intentions. While the artist seeks in his writings to formulate retrospectively his own self-awareness and to define his own concept of art as opposed to other artistic positions, his artistic works are wholly intuitive. They are much more closely linked to the artist's inner conflicts and contradictions and show new developments well before these can make their mark on his written reflections.

Closely in step with the course of Kurt Schwitters' life and work, the meaning of Merz also changed. Originally 'MERZ' was just a printed fragment of a word, free of any fixed meaning beyond its sound and its appearance. According to Schwitters' later explanations it was originally "nothing more than the second syllable of Commerz"[5], had been taken "from an advertisement for the KOMMERZ UND PRIVATBANK"[6] and was "not translatable".[7] Like other scraps of printed matter such as the 'und' in the And Picture, the newly coined word 'MERZ' which was part of one of Schwitters' first assemblages came to be used as a title, in the Merzpicture of 1919.[8] This was exhibited for the first time in the Sturm gallery in Berlin in July that same year along with another ten Merz pictures. At the same time, Kurt Schwitters published his programmatic text 'Die Merzmalerei' in a number of art journals.[9] Thus right from the outset he seeks to go on the offensive and to define and convey his new ideas as publicly as possible – at the same time as presenting his latest works, which legitimise his ideas.

The "proclamation of Merz"[10] was no doubt closely linked to the artist's desire to create his own, unmistakable position within the already established group of Sturm artists and on the art market. With his texts he formulates his claim for public recognition and points out to the public that his at the time startling and seemingly provocative works were part of a calculated course. The early text 'Merz Painting', in which the term 'Merz' appears for the first time in his writings, sounds relatively defensive, like a pre-emptive bid to justify his work. By comparison, texts that appeared soon afterwards are already significantly more challenging, and in places read like a "manual of instructions and regulations".[11] However, the underlying tenor of his most important texts on Merz comes from an entirely personal drive – free of missionary zeal – to share his own experiences with his readers, lucidly and openly.

Kurt Schwitter, The Merzpicture, 1919, lost

What could be the reasons that moved Kurt Schwitters to choose the word Merz as a "collective name" for the "new species"[12] of his painting and as a "designation for my new style",[13] and later to retain it to describe his "relevant activities"[14] in all other areas? What are the qualities that made Schwitters regard it as suitable in the context of current terms such as Dada, the Sturm and later on De Stijl? Firstly, Merz is free of semantic and symbolic meaning and hence completely open to ongoing redefinition. Since, in German, it rhymes with Scherz, Herz and Schmerz (joke, heart and pain), there is clearly a not too distant link to the realms of sentiment and trivia that are frequently encountered in Schwitters' work. Merz can be both subject and object, masculine and neuter,[15] a noun or a verb. It stands for itself, although it is easily combined with other words as a prefix or a suffix, a quality which Kurt Schwitters made extensive use of. Merz is simple, short, pithy and new – yet spoken out loud it sounds utterly familiar, in fact it sounds exactly like 'März' (the month of March in German), which will not have escaped this word-artist.[16] The associative proximity to a month in early spring was not unwelcome as a signal for departure and new beginnings. Used as a verb, however, it "came from 'ausmerzen'"[17] (to eradicate), as Schwitters was quick to point out with some irony in a polemic against critics. But it is only rarely that this verb with such negative connotations is used in his work, as a rule we encounter "merzen" (to merz) or "vermerzen" (to merzify), in the sense of positive new creation.

But what was so revolutionary about Schwitters' work after 1918 that he wanted to find a new name for it? In 'Merz Painting', already mentioned above, we read that Merz is about "the amalgamation of all imaginable materials for artistic purposes and, on a technical level, the same value being put on individual materials as a matter of principle."[18] Here Schwitters has already found the formula for his own artistic methods which was to remain valid until the end: "The artist creates through selection, distribution and disassociation of materials".[19] Although the

creation of abstract works using non-artistic materials was by no means unheard of, there had never been such an "exclusive, relentless, expressive use […] of every imaginable form of waste from daily life"[20] as in Schwitters' nailed Merz pictures. In his search for his own mode of aesthetic expression, the discovery of the principle of collage and the equal treatment of found objects constituted a fundamental liberation for Schwitters from the conventional rules and aims of art. Henceforth Schwitters' overriding concern was the primacy of form and forming ("Merz is form. Forming means disassociation [*entformeln*].")[21] However, 'form' does not imply any fixed language of forms – for in Schwitters' case, independently of his assimilation of different stylistic influences, his formal language is subject to constant change. 'Forming' has much more to do with connecting and weighing up the most diverse of materials from the point of view of the aesthetics of their appearance and taking into account compositional criteria such as tension, rhythm, balance and harmony. According to Schwitters' theory at least, through the process of "disassociation" things lose their "individual character", their so-called "inherent vice" [*Eigengift*][22]; their original use and meaning in the world outwith Merz seem "insignificant" and "arbitrary".[23] However, the effect and expressive power of a work undoubtedly depends on the eloquence of the fragments used, their patina and the nature of their semantic character which is not entirely negated by their being incorporated into the inherent logic of the work itself. This applies equally to Schwitters' use of language and its sounds in what he himself described as "abstract" text-compositions. Schwitters extracts individual, often banal or trivial elements from a non-artistic context, able to spot them with unparalleled mastery. By combining these in a "nonsen-

Kurt Schwitters, 'Allgemeines Merz Programm', 1923,
Schwitters Archive of the Town Library, Hanover

sical" manner in an autonomous work, he succeeded in mirroring the nonsense of society at the same time as escaping that nonsense by means of his art.

In 1929 Kurt Schwitters replies to a questionnaire from the American literary magazine *Little Review*: "The happiest moment of my life was when I discovered that everything is really indifferent."[24] The dismissal of "meaningful" content in the work is linked with the recognition – of crucial importance in the emergence of Merz – that claims to truth are futile and that all things are 'indifferent'. [Translator's note: the German notion of 'gleich-gültig' used by the author at this point, means both 'indifferent' and 'equally valid'.] For Schwitters, art is no longer an epistemological tool but "an end in itself",[25] "the most useless thing in the world".[26] His creativity is not guided by goals and aims that originate outside of art, but is oriented purely towards the rules which he postulated as Merz, where everything rests on the creative powers of the artist: "The artist has his laws within himself."[27] With Merz the lesson that had been learnt from the political and moral upheavals after the First World War – namely that there is no single valid truth – was turned in a positive direction. In Schwitters' work, as though overcoming the negativity of Dada, loss becomes a form of "gain".[28] In contrast to the Dadaists, who rejected being tied down and avoided any kind of pro-

gramme, Schwitters declares "My standpoint is Merz",[29] and through Merz he arrives at his own private "Weltanschauung".[30] Even if the scepticism of Dada remains characteristic of Merz, nevertheless Schwitters' postulation of a *Weltanschauung* is in itself enough to separate his concept of art from Dada.

In his monograph on Kurt Schwitters, John Elderfield describes Merz as "a unifying principle for everything he did, one that could absorb and collate the styles and techniques and media that accumulated as his career developed", as a "way of reconciling the disjointed, the disassociated and the anomalous – like a gigantic collage."[31] The invention of Merz, that is to say the evolution of a unique artistic standpoint and method, was the indispensible foundation for all his subsequent activities. After 1919 Kurt Schwitters systematically applies the term Merz not only to his pictures but to everything else he does too: poetry, sculpture, architectural models and dramaturgical texts, which leads to it quickly becoming a kind of trademark. During the time of the Weimar Republic, when experiment was rife, Schwitters works in all different media and art genres as he tries out the newly-won freedom to form with found materials. Distinctions that are still made today, for instance between painting and reliefs, poetry and drawing or music and language are clearly obsolete when it comes to the assemblages and collaged picture poems or the *Ursonate* by the Merz artist. The essence of Merz is "an absolute lack of inhibition, a complete lack of prejudice",[32] as Schwitters declared, thereby emphasising that Merz should not be understood as an ordering of particular materials or contents, but as an opening-up and expansion of art and of the expressive potential of the medium being used. "Forms of art do not exist, they have been artificially separated from one another. There is only art. And Merz is the work of art in general terms, not a speciality."[33] Consequently Schwitters extends his concept of art to all those things that will readily relate to each other. This includes the immaterial and the incalculable. "Unknown values"[34] can most certainly be taken into account and existing relationships can be 'formed' "even when I don't recognise them".[35] The aim is, by taking into account all the contributory factors, to create a rhythmically balanced relationship, a sense of equilibrium between the aesthetically dis-

parate, no matter whether the work itself is a picture, a stage perform-
ance, a domestic room or the architecture of a whole town. In 1920 Kurt
Schwitters talks of the *"Merzgesamtkunstwerk"* which brings together
all art forms in one artistic entity[36], using the term with specific refer-
ence to the design of an abstract Merz dramatic piece on the Merz
stage, as it were a moving, living Merz picture, whose different compo-
nents – stage design, text, score, actors and audience – all merge into
one during the course of the performance. We can witness the coming
to life of this *Merzgesamtkunstwerk*, but we "cannot create it, because
we too would only be parts of it, in fact material."[37] This comment
touches on the possibly most radical aspect of Merz as *Weltanschau-
ung*. The artist and all those "who are working in the spirit of the con-
cept"[38] will ultimately themselves become part of the all-embracing
"total Merz vision of the world",[39] in which the aesthetic decisions that
the artist takes apply equally to life. In Merz, art and life become one
inextricable entity. One's own life becomes an art product ("Everything
that an artist spits is art"),[40] one's *Weltanschauung* becomes the work.

The *Merzbau* in Hanover – an architectonic sculpture that grew unabated
from 1923 until 1937, which united different forms, including painting,
assemblage, sculpture and architecture, which was both workplace and
living space for the artist – was perhaps the closest Kurt Schwitters
came to realising his notion of a "total Merz vision of the world". Unlike
the *Merz Stage* project of 1920, however, Schwitters never describes

the *Merzbau* as a *Gesamtkunstwerk*, although the literature on the sub-
ject frequently uses this term in connection with it.[41] Schwitters, for his
part, sees the *Merzbau* as a component in the joining of art and non-art
in the "total Merz vision of the world", which goes far beyond the
Gesamtkunstwerk. In retrospect he also ranks the Merz pictures as no
more than "preparatory studies for the collective forming of the world,
for the general style".[42] The artist only talks of the *Gesamtkunstwerk* on
one other occasion, namely in 1923 in the context of the 'Manifest
Proletkunst'. In this manifesto demands for proletarian art are rejected
and countered with the notion of a "universal" art. Work was already
under way by the signatories (Schwitters, Arp, van Doesburg, Tzara and
Spengemann) on "the *Gesamtkunstwerk*, which is superior to all
posters, whether these have been made for champagne, Dada or
Communist dictatorships".[43] Throughout his life Schwitters resists any
attempt to turn art into a political instrument. He shares his artist-
friends' awareness of the crisis facing art in society after the First World
War. He admires the fact that "although their work was problematic in
the society of the time, they did not give art up, but – even if only tem-
porarily – granted it its own autonomous value."[44] Yet he never follows
the line taken by Theo van Doesburg and El Lissitzky who believe in the
revolutionary role of an art that was fit for the time, which would help
humanity to liberate itself. He does not seek to join their visionary
escape into the future. The goal of bridging the gulf between art and
social reality becomes irrelevant in the light of Merz as *Weltanschauung*.
For, after all, Merz means there is no need to wait for political revolution
nor for human beings to lose their sense of alienation before we can
achieve oneness in art and life, on the contrary Merz means that life and
art are already flowing into each other.

In 1922, in the journal *Der Sturm*, Kurt Schwitters catchily claims "Today
every child knows what Merz is."[45] This is obviously an exaggeration,
but it does point to the artist's self-confidence in himself and in his strat-
egy. For Schwitters Merz has become an indispensible part of life (fig.
2).[46] As a term, it stands for his identity as an artist, which he henceforth
underlines by combining or equating Merz with his own name. In 1922,
when his new volume of poetry *Die Blume Anna. Die neue Anna Blume*
appears, on the title page the author is named for the first time as "Kurt
Merz Schwitters". In visitors' books and in his private correspondence
he increasingly often signs with Merz, sends "best wishes from Merz at
home"[47] or closes with "herzmerzlichsttt".[48] During the 1920s Schwit-
ters publicises his various Merz activities in a variety of ways with print-
ed materials that he himself designed. All of these bear the word in the

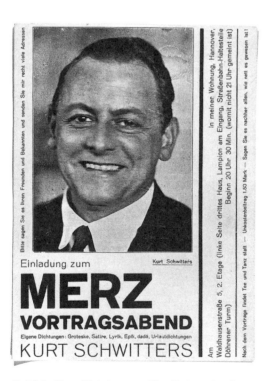

Kurt Schwitters, 'Einladung zum Merz Vortragsabend'
[Invitation to a Merz evening], 1926 or later, Sprengel
Museum Hannover

Kurt Schwitter, 'Drucksache!', cut-out postcard, printed as the last page of the magazine *Merz 2*, 1923

same capital letters, almost always in a sans serif typeface, which makes it readily recognisable over the years whenever it appears in the ever growing number of avant-garde journals and flyers. In addition, as for example on the 'Einladung zum Merz Vortragsabend' [Invitation to a Merz evening], the name Merz is also combined with a portrait photograph of the artist. Besides this, in 1923 Schwitters also designs a number of versions of a striking Merz logo, which – particularly on a multi-lingual postcard from the Merz publishing company – seeks to attract the attention of possible subscribers to the *Merz* magazine. Under the influence of the works of the Russian Constructivists, after their exhibition in 1922 in the Galerie van Diemen in Berlin, the black square also turns up on Kurt Schwitters' work like a collective trademark for new design and as a synonym for avant-garde art.[49] In the years that follow, the typeface and the Merz block contribute significantly to the term Merz, establishing something like a corporate identity for his work. As far as contents go, the essentials of the theory of Merz are largely in place by this time. Now the task is to work with like-minded artists, collaborating and exchanging ideas, in order to spread the "meaning of the Merz idea throughout the world".[50] In numerous international journals Schwitters again publishes his underlying thoughts on Merz and on the autonomous work of art, which take on a more concrete form through his engagement with the utopias of the Dutch De Stijl group and the Russian Constructivists. He stresses the mediating character of the Merz idea, which is not trying to create a new world, but striving for an active response from artists to the conditions prevailing in the real world. On the occasion of his exhibition in the Sturm gallery in November 1926 Schwitters publishes a drawing, in which he positions Merz as his partic-

ular contribution to non-representational painting alongside Mondrian, Kandinsky and Moholy-Nagy within the coordinates of Constructivism.[51] Typical items in the individual formal vocabularies of all artists have, in Schwitters' case, been rhythmically linked together under the dominant signature of MERZ. Schwitters underlines that he is not merely concerned with precise forms, but also with the "song" that sounds in those forms.[52]

At the height of his career in 1927 the *Große Merzausstellung* takes place, and Schwitters looks back in the catalogue over his development so far. Now for the first time he makes a distinction between "typical Merz pictures" from his so-called "revolutionary period" from 1919 until 1923, the "transitional pictures" that followed these, and the most recent Merz pictures of 1926. With respect to the latter, he comments that "they should be regarded firstly as composition and only secondly as Merz" since they "contained so few *impulses*" [author's italics] that he had not formed himself, while the "contrapuntal working [was] the main thing".[53] Amongst the works referred to here, of which only a few have survived, besides assemblages and reliefs there are also abstract oil paintings without collaged items. Yet Schwitters himself marked them on the reverse as *Merz*.[54] Thus the definition of works as 'Merz' cannot simply be reduced to whether they involve collage or not, as has often been tried. Instead it must be more broadly understood along the lines of the term "impulse" as used by Schwitters.

Kurt Schwitters, *Untitled (Mondrian, Schwitters, Kandinski, Moholy)*, 1926, lost

Kurt Schwitters, *Untitled (Merz Werbezentrale)*, 1934, Estate of Kurt Schwitters, on loan to Sprengel Museum Hannover

After the founding of the Merz advertising centre in Hanover in 1924, Kurt Schwitters worked increasingly as a typographer during the mid to late 1920s. His activities in the 'ring neuer werbegestalter' (ring of new advertising designers), which had been set up in 1927, as well as his own numerous, successfully completed projects bear witness to the extent of his work as a typographer. Although advertising design, unlike art, must fulfil practical tasks, for Schwitters it shares the same aim as his art, namely to "create relationships" and, through these, to achieve a certain sense of order.[55] Schwitters' typographical work is one aspect of his artistic production and, in the sense that it involves design, for him it is also part of his "total Merz vision of the world". Merz appears on almost all of the firm's own publicity, from 1926 onwards inside another logo: an equilateral triangle with a white disc in the middle, under which are the words "MERZ Werbezentrale", heavily underlined. This logo printed in dark red on writing paper together with a version with a black disc, becomes the dominant element in a collage of 1934: this is one of the very few works anywhere in the artist's output after the *Merzbild* in which the word 'Merz' is present in writing. Having significantly cut away the word "Werbezentrale", Schwitters places the two Merz logos in virtual isolation on the picture surface. They form a counter-balance to an image in the lower part of the picture which shows a mass gathering, at the centre of which there is an abstract sculpture straining upwards. This also serves as a pivotal point for the Merz flags floating freely in space. Against the background of political events at the time of its making, this collage seems like a declaration of allegiance and an attempt on the part of the artist to make a stand. After being slandered by the National Socialists in 1933 as "degenerate", he was increasingly forced into inner exile and was stripped of the means to earn a living, not only by being dismissed as the typographer for the Hanover Town Council.[56] Yet, while the avant-garde was in its final stages, Schwitters nevertheless stayed true to his own *Weltanschauung*, which had "pure unpolitical art"[57] writ large on its banners.

Despite the very different living conditions that Schwitters had to face in exile after 1937, the fundamental compositional principles of Merz remained the basis and the centre of his creative work – despite the change in the materials, the contents and the formal language of his late works. During this period the "level of feeling" achieved through the composition of a work once again takes greater precedence as an aim of Merz art.[58] The term Merz itself disappears increasingly from his field of vision. After 1931 it is almost entirely absent from the titles of works.

The few works where it does still occur, are dedicated to old friends like Jan and Edith Tschichold or Käte Steinitz, who had been involved in Schwitters' Merz activities when they were at their most intense in the 1920s. Unlike those around him in his new situation in exile, they know him above all as the inventor and embodiment of Merz. The naming of the familiar synonym sounds like a reminder of times gone by. To judge by Schwitters' art-historical texts written in exile, most of which were not published during his lifetime, it seems that for him the idea of Merz had not lost its relevance after over twenty years. Looking back from the temporal distance and isolation of exile, Schwitters views the invention of Merz and the making of his Merz pictures as a past achievement in art history, although Merz itself is not just a temporary phase in his output. Here and there his renowned (self)ironical sense of humour lights up for a moment, as in the text 'My Art and my Life', in which he weaves a web of art-historical classifications, moral philosophy and his own life as an artist, that by its sheer nonsense amply demonstrates the questionability of any attempt to define and explain art. And Schwitters signs off in English from this late example of Merz art with the words: "That is my confession I have to make

MERZ."[59]

NOTES

1 On the last page of the volume of poetry *Die Blume Anna. Die neue Anna Blume*, Berlin 1922, Schwitters draws attention to the copyright for Merz: "Kurt Schwitters is the inventor of MERZ and i and recognises no-one besides himself as a Merz artist or i-artist."

2 Werner Schmalenbach, *Kurt Schwitters*, Munich 1984 (Cologne 1967; London 1970), p. 106.

3 John Elderfield, *Kurt Schwitters*, London 1985, p. 231.

4 Important sources are the *Merz* magazine which appeared from 1923 onwards and the theoretical texts not published during the artist's life, which have since been published in vol. 5 of Kurt Schwitters' literary texts, *Manifeste und kritische Prosa*, ed. by Friedhelm Lach, Cologne 1981.

5 Kurt Schwitters in: *Merz 6, Imitatoren watch step!*, October 1923, p. 57.

6 Kurt Schwitters in: *Merz 20, Kurt Schwitters Katalog*, 1927, p. 99.

7 Schwitters 1923a (as note 5), p. 57.

8 Acquired in 1920 by Paul F. Schmidt for the Städtische Kunstsammlungen Dresden, confiscated by the Nationalist Socialists in 1935, recorded in the exhibitions of 'degenerate art' until 1941, lost after that date.

9 *Der Sturm*, vol. 10, part 4, July 1919, p. 61; *Der Cicerone*, vol. 11, part 18, September 1919, pp. 580 and 582; *Der ZWEEMANN, Monatsblätter für Dichtung und Kunst*, first edition, November 1919, p. 18.

10 Stephen C. Foster, '›Merz‹. Ein Modell für die Transaktion von Kultur', in: *Kurt Schwitters Almanach*, vol. 3, 1984, p. 166; see also: Eberhard Roters, 'Die Blaue Blume Anna — Kurt Schwitters und die zwanziger Jahre in Hannover (1978)', in: idem, *fabricatio nihili oder Die Herstellung von Nichts. Dada Meditationen*, Berlin 1990, p. 217.

11 Friedhelm Lach, 'Foreword', in: Lach 1981 (as note 4), p. 15.

12 Schwitters 1927a (as note 6), p. 100.

13 Kurt Schwitters, 'Tran 1 Ein solider Artikel. Eine Anwienerung im Sturm', in: *Der Sturm*, vol. 10, part 5, 1919, p. 76.

14 Schwitters 1927a (as note 6), p. 100.

15 To my knowledge Schwitters never uses the word Merz in the feminine.

16 Schwitters himself plays with this double meaning that derives from the identical sound in German of 'e' and 'ä': "So ist Merz mit E, sagen Sie aber ruhig mit ›Ä‹, Frau Meier, der Merzfrühling wird doch in Ihr Herz einziehen mit Vogelsang in der Merzsonate in Urlauten" [Thus Merz is spelt with E, but you just go ahead and say 'Ä', Frau Meier, the Merz (March) spring will enter your heart with birdsong in the Merz sonata in primal sounds], in: *Braunschweiger Volksfreund*, 26 January 1924, as cited in Lach 1981 (as note 4), p. 188. In *Merz 21 erstes Veilchenheft*, 1931, p. 106, it appears as: 'Im Merz blühen die meisten Veilchen' [Most violets bloom in Merz (March)].

17 Kurt Schwitters, 'Tran 35', in: *Der Sturm*, vol. 15, part 1, March 1924, p. 30.

18 Kurt Schwitters, *Die Merzmalerei*, as cited in Lach 1981 (as note 4), p. 37.

19 Ibid.

20 Schmalenbach 1984 (as note 2), p. 115.

21 Kurt Schwitters in: *Merz 7*, January 1924, title page. [Translator's note: The original reads "Merz ist Form. Formen heißt entformeln." See Schmalenbach 1970, p. 247, note 30a on the difficulty of translating 'entformeln' and 'Entformung'. Schwitters was as creative in his use of language as in any other area of his work, and there is no direct equivalent in English to this neologism, because the German conveys at the very least a mixture of de-forming, trans-forming and disassociating objects or materials both temporally and physically.]

22 Kurt Schwitters in: *Merz 1, Holland Dada*, January 1923, p. 10. [Translator's note: see Elderfield 1985, p. 237 where the author discusses possible translations of 'Eigengift' – again, this is a term devised and used by Schwitters in a very particular way. Elderfield translates it as "inherent vice or personality poison": although the word would not be immediately comprehensible to the German speaker, from the implications of its literal meaning it would be clear that the loss referred to here is a positive one.]

23 Kurt Schwitters, 'Merz', in: *Der Ararat*, vol. 2, no. 1, January 1921, p. 5.

24 Kurt Schwitters, 'About me by myself', in: *Little Review*, May 1929, as cited in Lach 1981 (as note 4), p. 322.

25 Kurt Schwitters, 'Kunst und Zeiten', first published in: *Fronta. Internationaler Almanach der Aktivität der Gegenwart*, Brno 1927, pp. 13–15, as cited in Lach 1981 (as note 4), p. 239.

26 Kurt Schwitters, 'Mein Merz und Meine Monstre Merz Muster Messe im Sturm', in: *Der Sturm*, vol. 17, part 7, October 1926, p. 107.

27 Schwitters 1923a (as note 5), p. 60.

28 Lambert Wiesing, *Stil statt Wahrheit. Kurt Schwitters und Ludwig Wittgenstein über ästhetische Lebensformen*, Munich 1991, p. 87.

29 Kurt Schwitters, *Merzbuch 1 Die Kunst der Gegenwart ist die Zukunft der Kunst*, manuscript, 16.10.1926, for a Merz book to be published in the Bauhaus series, which was announced but never published, as cited in Lach 1981 (as note 4), p. 247.

30 Kurt Schwitters, 'Merz', first appeared in the journals *Pasmo* and *Contimporanul*, later in: *Der Sturm*, vol. 18, part 3, June 1927, p. 43.

31 Elderfield 1985 (as note 3), p. 238.

32 Schwitters 1927b (as note 30), p. 43.

33 Schwitters 1923b (as note 22), p. 11.

34 Ibid., p. 9.

35 'I form interrelations which exist, even when I don't recognize them.' Letter from Schwitters to Margaret Miller, Museum of Modern Art, New York, 11.12.1946. Copy in the Kurt Schwitters Archive in the Sprengel Museum Hannover.

36 Schwitters 1921 (as note 23), pp. 6f.

37 Ibid., p. 9.

38 Ibid., p. 5.

39 Kurt Schwitters, 'Herkunft, Werden und Entfaltung', in: *Sturm Bilderbücher IV Kurt Schwitters*, Berlin, undated (1920), unpaginated.

40 Kurt Schwitters, 'Merz', in: El Lissitzky, *Die Kunstismen*, ed. by Hans Arp, Erlenbach-Zurich, Munich and Leipzig 1925, p. XI.

41 See Dietmar Elger, *Der Merzbau. Eine Werkmonographie*, Cologne 1984, pp. 114f.

42 Schwitters 1923b (as note 22), p. 9.

43 Kurt Schwitters, 'Manifest Proletkunst', in: *Merz 2 Nummer i*, April 1923, p. 25.

44 Michael F. Zimmermann, 'Über unseren Umgang mit Schwitters. Bemerkungen aus Anlaß der Kurt Schwitters-Retrospektive in Hannover, Sprengel Museum, 4. February – 20. April 1986', in: *Kunstchronik*, part 2, 1987, p. 56.

45 Kurt Schwitters, 'i (Ein Manifest)', in: *Der Sturm*, vol. 13, part 5, May 1922, p. 80.

46 Schwitters pastes an advertisement for a *MERZ Mappe 1*, into his notebook and complements it with the question 'What would life be without MERZ?'. For more on the print folios by the Expressionist-inclined Kairos Verlag of the later gallerist Karl Nierendorf see Ursula Dustmann, 'Die Kölner Zeitschriften und Verlage für aktuelle Kunst und Literatur', in: *Max Ernst in Köln. Die rheinische Kunstszene bis 1922*, Kölnischer Kunstverein, Cologne 1980, pp. 114–125.

47 Letter from Schwitters to Walter Dexel, 2.6.1921, in: Ernst Nündel (ed.), *Kurt Schwitters. Wir spielen, bis uns der Tod abholt, Briefe aus fünf Jahrzehnten*, Frankfurt a. M. and Berlin 1986, p. 51.

48 Letter from Schwitters to Walter and Grete Dexel, 19.9.1922, ibid., p. 72.

49 See Wulf Herzogenrath, 'When Did Merz Meet The Black Square?', in: *Kurt Schwitters*, IVAM Centre Julio González, Valencia 1995, pp. 501–504.

50 Schwitters 1923b (as note 22), p. 8.

51 Reproduced in: *Der Sturm*, vol. 17, part 7, October 1926, p. 105. Original lost.

52 Ibid., p. 107.

53 Schwitters 1927a (as note 6), p. 100.

54 This applies for example to: *Merz 1926,5 Wie senkrecht-waagerecht*, 1926, Estate of Kurt Schwitters, on loan to the Sprengel Museum Hannover, and *Merz 1926,8 Verschobene Flächen*, 1926, Staatliche Museen Preußischer Kulturbesitz, Neue Nationalgalerie, Berlin.

55 Kurt Schwitters in: *Werbegestaltung. Die neue Gestaltung in der Typographie*, Hanover, undated, as cited in Lach 1981 (as note 4), p. 218.

56 See Werner Heine, 'Der kurze Frühling der Moderne, oder – Futura ohne Zukunft. Kurt Schwitters' typographische Arbeiten für die Stadtverwaltung Hannover 1929–1934', in: *'Typographie kann unter Umständen Kunst sein'. Kurt Schwitters, Typographie und Werbegestaltung*, Landesmuseum Wiesbaden 1990/91, p. 96.

57 See Kurt Schwitters, 'Ich und meine Ziele', in: Schwitters 1931 (as note 16), p. 117.

58 Kurt Schwitters, 'Das Ziel meiner Merzkunst', manuscript, 10.4.1938, as citec in Lach 1981 (as note 4), p. 364.

59 Kurt Schwitters, 'My Art and my Life', manuscript, undated (1940–1946), as cited in ibid., p. 387.

Kurt Schwitters, 'My Art and my Life', manuscript sheet, undated (1940–1946), Schwitters Archive in the Stadtbibliothek Hannover, extended loan

"MY GOAL IS THE *MERZGESAMTKUNSTWERK...*" ON THE UNITY OF KURT SCHWITTERS' ŒUVRE

ANETTE KRUSZYNSKI

The term 'Merz', as coined by Schwitters in 1919, referred to his entire artistic output. This included collages, assemblages, sculptures, Merz structures, drawings, prints, typography, his literary output and his paintings, of which a not inconsiderable number were landscapes and portraits. Yet Schwitters' reputation today is founded almost exclusively on his abstract works, and it is these that have made a particular impact on European and American artists since the days of movements such as Nouveau Réalisme and Pop Art. Art historians have also concentrated their researches on this part of Schwitters' work. His late works, particularly his representational works were long neglected, with the result that Schwitters' desire that his work should be regarded as a single entity has not been fulfilled.

Schwitters' collages and assemblages were 'rediscovered' in the 1950s. Credit is due above all to Werner Schmalenbach that this unique body of work became known to a wider public.[1] In this first wave of interest the main focus was on works that Schwitters made up until the 1930s. The late work from his exile in Norway and England was only taken into account insofar as it conformed to the notion of Merz that was already firmly established, in other words the creative combination of disparate materials to generate new compositions, or the reworking of items in which words and texts were often incorporated into the composition. *For Käte* (cat. no. 200, p. 178) of 1947, for instance, appears to be a continuation of the compositional principles of early Merz collages. In it Schwitters combined cuttings from contemporary comic strips and heightened the drama of the original plot by cutting away and obscuring different sections. By veiling certain areas and adding the heads of old men, he increased the appeal of the centrally placed beautiful young woman. Thus he laid bare the unconscious selectivity of the viewer's perception.

In the second phase of Schwitters' reception in the 1980s, attention was also paid to the late works, which were not made according to the principles of collage familiar from his earlier works.[2] Above all the exhibitions in London in 1981 and in Cologne in 1985 showed works in which the practice of gluing items together is combined with Expressionist-influenced painting and which also demonstrate Schwitters' own reception of Surrealism.[3] In these exhibitions there were also a small number of representational works to be seen. It was not only during his training that the artist produced work of this kind, but throughout all the various phases of his career, largely disregarding contemporary styles; he himself viewed these as an indispensible part of his creative work. Up until the 1980s researchers took little heed of these representational works. People simply did not know what to make of the views of Norwegian fjords, lonely farmsteads and portraits, painted in a pastose, late-Impressionist manner, apparently bereft of any independent stylistic development and at best no more than a half-hearted response to contemporary stylistic currents.

Page from Kurt Schwitters' photograph album, 1930s, Djupvasshytta (Norway)

Due consideration of Schwitters' entire œuvre has not only brought to light the different facets of his artistic cosmos, but has also revealed the stylistic rifts in his work. The questions in need of answers concerned the significance of the return to Expressionism in Schwitters' late works and the function of the representational works in his œuvre as a whole.

Born in 1887, Schwitters made contact with the avant-garde at the end of the First World War. Before that, in the period after his training at the School of Applied Arts in Hanover and at the Academy of Art in Dresden (until 1914), his activities had largely followed academic tradition. The painting *A S Landschaft I. Hochsommer* (A S Landscape I. Midsummer) of 1914/16 (cat. no. 5, p. 17) falls into this period; it leads the viewer along a country path into a flat landscape, broken up by isolated trees. In contrast to the Impressionist style in this landscape, in the same year the artist was also addressing Expressionist-Futurist ideas in *Vision*, a portrait of his wife Helma in a moment of spiritual introspection.

With his conventional portraits, which were well received, Schwitters repeatedly declared his allegiance to a conservative public, although in the early 1920s he spent a considerable time working on abstractions. However, he could certainly not be sure of a similarly positive response to his Merz art. This was the background to the *Porträt der Maria Oehlmann* (Portrait of Maria Oehlmann) of 1922 (cat. no. 79, p. 23), a small pastose oval painting, possibly a commission, showing a three-quarters profile of a young girl.

As his career progressed Schwitters continued to paint portraits and landscapes. From time to time he received commissions. Yet in these works Schwitters was not bowing to prevailing trends in art. Nor did he submit to the demands of the National Socialists in the period after they had seized power. While he was not politically active, he nevertheless refused to cooperate in any way with the dictatorship. In an attempt to explain his representational works, it has been suggested that they provided the artist with an element of balance and relaxation when he was otherwise devoting himself to his avant-garde work.[4] The works made in exile, which include a large number of landscapes and above all portraits, have been described as "bread and butter" pictures, which Schwitters produced for tourists passing through or as commissions, in order to earn his living.[5]

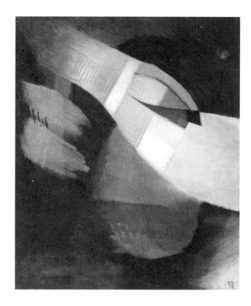

Kurt Schwitters, *Untitled (Picture with Pale Stripe)*, 1938, Galerie Gmurzynska, Cologne

But this evaluation is a direct contradiction of Schwitters' own approach. The artist not only insisted on the unity of his entire œuvre but also had no hesitation in putting his name to his landscape works. In 1921 he wrote in the journal *Der Ararat*: "My aim is the *Merzgesamtkunstwerk*, which embraces all types of art in one artistic entity."[6] The fact that he included the representational works without reservation is evident from a letter to Katherine S. Dreier in 1925, in response to her reference to a possible exhibition in the New York Société Anonyme: "Should I perhaps send some of my new nature studies, for besides my purely artistic works, ever since 1909 I have also been constantly occupied with straightforward landscape studies and portraits."[7]

The multi-disciplinary approach which Schwitters advocated in *Der Ararat*, and which was a central concept in his life's work, linked the visual arts with theatre and literature and implied that the representational works should not be seen in isolation but as one with the rest of his output as a whole, be it representational, abstract, Expressionist or Constructivist. This same all-embracing view emerges from the response of other artist-colleagues to his work. In his well-known outburst of invective directed at the Hanover artist, the Dadaist Richard Huelsenbeck (1892–1974) paved the way for a new view. Irritated by Schwitters' lack of interest in Dada, Huelsenbeck expressed his displeasure in sarcastic

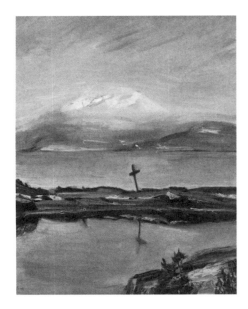

Kurt Schwitters, *Lonesome Cross*, 1939,
Estate of Kurt Schwitters, on loan to the Sprengel
Museum Hannover

remarks about the latter's collages, in which he professed to find a
strong petit-bourgeois tendency: "His preference for glued pictures with
'alien' materials [...] showed that he recognised his own deep inclination
towards the primitive, to simple forms. He wanted to get away from the
complicated, over-burdened perspectival present." And even more
sharply he poured scorn on Schwitters as a "[...] genius in a smoking
jacket. We called him the abstract Spitzweg, the Kaspar David Friedrich
of the Dada revolution."[8] While Huelsenbeck was referring primarily to
the abstract works, his words may be applied equally well to the repre-
sentational paintings. His condemnation was after all directed at
Schwitters' underlying thinking which, of course, coloured the latter's
entire output.

In retrospect conclusions may also be drawn about the artist's underly-
ing attitude from comments made by the Danish artist Per Kirkeby (born
1938). While he himself was staying in Norway, Kirkeby came across
landscapes by Schwitters and became interested in these so-called
bread-and-butter pictures because he felt they had something in com-
mon with his own aspirations. Kirkeby's visual output is a balancing act
between figurative and abstract painting, and he felt that Schwitters'
landscapes also owed much to the realm of abstraction. He viewed

Schwitters' landscapes as "forbidden pictures, the kind that do not cor-
respond to 'history' – repressed, shameful memories of the constraints
imposed on the German painter." And with particular reference to one
landscape he wrote: "I thought this was a fantastic picture. It matched
my crazy state of mind. A liberation from locked ideas, oppressive, as
are ultimately all attempts to break out, a pure construction."[9] Like
Huelsenbeck's earlier remarks, Kirkeby's comments only apply to one
part of Schwitters' artistic activities, the landscapes. At the same time
they are also an assessment of the underlying characteristics of Schwit-
ters' visual output. While Kirkeby saw from the representational land-
scapes that Schwitters had the ability to cast himself free from the
familiar and to overstep existing boundaries, Huelsenbeck, by contrast,
read petit bourgeois limitations into the collages.

In his search for innovation, Schwitters was working largely in isolation
and without direct contact with other artists. He restricted his field of
vision to his immediate surroundings. Huelsenbeck regarded this as an
attempt to avoid the "perspectival present". But for Schwitters this con-
centration on what was around him was one of the fundamental condi-
tions for producing something new. In the art-province of Hanover after
the First World War, Schwitters had succeeded – with Merz – in estab-
lishing a new mode of artistic expression. Schwitters kept a distance
between himself and the major cultural centres such as Berlin and Paris
and continued to live in Hanover, where he was tireless in his efforts to
disseminate his Merz art but at the same time side-stepped direct con-
tact with the avant-garde and was only sporadically involved in the con-
temporary Dada scene. And after 1937, when he was in exile, he again
worked on his own. His links to the Norwegian art scene were as tenu-
ous as his links with other artists in England after 1940. Even after he
had moved to the Lake District, Schwitters still kept aloof from the artis-
tic avant-garde. Yet Schwitters himself did not feel he was running the
risk of missing the avant-garde boat. In his case, isolation had a liberat-
ing effect and allowed him the freedom to invent a new pictorial dimen-
sion of his own.[10]

This concentration on his own surroundings naturally led Schwitters to use the materials he found close at hand, and he applied this practice to all the different forms in his repertoire, be they collages, landscapes, sculptures or anything else. Schwitters elevated the accoutrements of everyday life into art. He used the things he found, which, in a city, of course included old tickets, packaging and scraps of paper. When he moved into the country he increasingly used materials from nature and incorporated leaves, stones, wood and plants into his assemblages. Thus he solved the conflict that had arisen from his love-hate relationship with the city.[11] Echoing Jean-Jacques Rousseau's "back to nature" he reversed the route that the Brücke artists had taken in the early years of the century, and in his self-reflections found the "liberation from locked ideas" that Kirkeby had referred to. When the detritus of civilisation was deployed in his work, which now happened less and less, it was done with particular emphasis, as in the case of the snippets of paper in *Merzbild Alf*, 1939 (cat. no. 157, p. 143). In a romanticising, floatingly airy composition of flowers, plants and leaves, the little piece of printed paper stubbornly holds its own like a remnant of an order that has long been invalidated, overtaken by the power of nature and colour.

The natural surroundings in which Schwitters found himself, not only provided his materials but also had a direct influence on his compositions. In a text for *Der Ararat* Schwitters had already gone into this mutual influence: "My personal response to nature now seemed the most important thing to me. The picture became a mediator between myself and the viewer. I absorbed impressions, I painted a picture according to these: the picture acquired expression."[12] In 1933 he once again confirmed the importance of nature in his work. In reply to the

question "Que pensez-vous de l'influence des arbres sur votre travail?", Schwitters answered, "Dans mes compositions abstraites, il y a influence de tout ce que j'ai vu dans la nature, par exmple les arbres."[13] He put it very clearly in a letter to Katherine S. Dreier in 1937: "I paint landscapes and portraits, and am making progress there. I am not of the opinion that painting now has nothing to do any more with nature as an incividual phenomenon, simply because abstraction has proved itself to be the best compositional solution. For I personally regard abstract art as one path but not as the only one. Mind you, it is not possible to take up some earlier direction, and every violation of individual natural phenomena, as in *neue Sachlichkeit*, is completely wrong, because logically abstraction should be above that. But a new, sober, passion-free study of nature, plus the results of this portrayed in the picture, is not only allowed. but is an important complement to abstraction."[14]

Schwitters' evaluation of nature may be seen in a photograph album with pictures that he himself had taken.[15] The prints show rock formations and ice structures, and are arranged in rows according to their motifs. Schwitters used the view-finder of the camera to compose the picture just as if he were painting a picture. Part of the aim was simply to capture a landscape motif on film. *Landschaft mit Schneefeld, Oppblusegga* (Landscape with Snow Field, Oppblusegga), 1936 (cat. no. 139, p. 153) is an example of a painting based on a photograph. Between the dark cliffs of a fjord the glittering white of the snow flashes like a raging waterfall. Lowering dark clouds extend across the top of the image. Besides being open to a representational reading this landscape may

Kurt Schwitters, *Picture of Spatial Growths / Picture with Two Small Dogs*, 1920/39, Tate Modern, London

also be understood as an abstract composition of light and dark forms. *Landschaft mit Schneefeld, Oppblusegga* is thus a composition with different compositional values. The striving to create a balance between contrasting components is achieved on the canvas by corrective over-painting or by wiping away areas of paint. The same process is evident in the numerous shots of virtually the same motif. Schwitters would appear to have treated his work outdoors and after photographs as equally valid procedures. Works such as *Rote Linie* (Red Line), 1937 (cat. no. 142, p. 136) or *Komposition Nr. 114 U*, 1938, may have been painted after photographs and/or nature. Whatever the processes involved, all of these works are about the harmony of the composition.

In this connection it is worth coming back to Kirkeby's comments that Schwitters' landscapes are "pure construction". Aside from the sensuality and emotionality of the works, every composition – in Kirkeby's opinion – is a built structure, which evolves under the influence of the outside world and is only complete when the interplay of the individual components, the forms and the colours, makes sense. Thus there is a tension between the original postcard-picture motif and the actual motif. The original motif was only a starting point; the actual, real motif, the adaptation of what the artist had seen, only comes to light during the painting process.[16] In this respect, Schwitters' landscapes are constructed exactly like those by Caspar David Friedrich; Schwitters often compared himself with Friedrich as did others, such as Huelsenbeck in the remarks quoted earlier. In analogy to a statement by the Romantic Caspar David Friedrich, for instance – "Art may be a game, but it is a serious game" – in 1946 Schwitters wrote to his colleague Raoul Hausmann: "A game with serious problems. That is art."[17] And in his works, too, Schwitters often alluded to Friedrich. Thus his *Hochgebirgs-friedhof (Abstraktion)* (Mountain Graveyard [Abstraction]) of 1919 (cat. no. 27, p. 29), in analogy to Friedrich's *Morgen im Riesengebirg*, depicts a cross standing in isolation in the landscape. And again in 1939, the towering cross in a wide landscape in *Lonesome Cross* points to the same famous forerunner.[18] Schwitters strips Friedrich's motif of its allegorical heights by bringing the viewer realistically close to the scene and by painting in a modern expressive, impasto style. The allusion to the repertoire of Romanticism might at first seem to introduce an element of kitsch into the painting, yet, as Kirkeby points out, Schwitters succeeds in keeping the main focus on the composition itself: "For the actual structure in Schwitters' landscapes is not dependent on the props he uses. It lies in the colours and in the handling of the material masses in space, as painters say. The space is what the picture is about, although it is impossible to put this into words."[19]

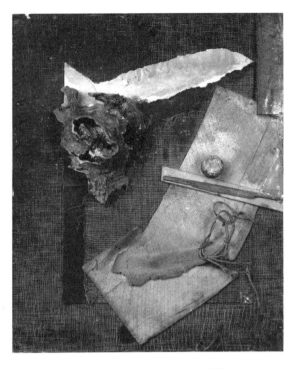

Kurt Schwitters, *Untitled (Wood on Black)*, 1943/45, Kunstsammlung Nordrhein-Westfalen, Düsseldorf

Before Merz, in his search for a visual language of his own, Schwitters had already engaged with the stylistic currents of the day. A striking example from this time is the previously mentioned *Hochgebirgsfriedhof*. Drawing on Cubist-Futurist principles, Schwitters composed an abstract-seeming mountain landscape with rough crosses, executed in intense colours and with lively brushwork. His abstract collages and assemblages from the early 1920s also have similar traces of Cubism and Expressionism. Gradually these are replaced by elements of Constructivism, which are also evident in the typography Schwitters himself designed. In all respects, there is a clear distinction between his late works and the filigree glued works he made in the early days of Merz. His late collages and assemblages are imbued with vigorous colour. The accentuation of Cubist elements by means of Expressionist detail leads to a raw, emotional visual language with allusions to Cubism. In contrast to the contemplation, perfection and clarity that contemporaries such as Mondrian were pursuing in the 1930s, Schwitters was seeking the wayward, the side-tracks leading away from purity and order. He abandoned the path to abstraction which had been laid by Cubism in its function as a model of modernism.[20]

The renewed deployment of elements of Expressionist style in effect drew together the contents of compositions that otherwise consisted of many small parts. This may be seen, for instance, in the works which Schwitters asked to have sent from Hanover to Norway, and which he reworked there. A virtuoso example of the use of Expressionist stylistic elements is the *Merzbild 29A. Bild mit Drehrad* (Picture with Turning Wheel) of 1920 and 1940; cat. no. 55, p. 55). Clumsy materials like wooden spars lend the landscape format an almost cumbersome quality. Large areas of over-painting not only draw disparate details together but they also create tension between right-angled and rounded forms Another work to be changed later was *Bild mit Raumgewächsen / Bild mit zwei kleinen Hunden* (Picture with Spatial Growths/Picture with 2 Small Dogs) of 1920, which was then reworked in 1939. Expansive arcs, running from below to the upper left, add a layer of circles and sections of circles to the original mosaic-like composition. The dark areas in the lower reaches create an impression of atmospheric expansiveness.

New to Schwitters' visual language in the 1930s were the organic forms that emerged from the influence of nature combined with elements of abstract Surrealism. A notable example of this is the *Merzbild mit Algen* (Merzpicture with Algae) of 1938 (cat. no. 152, p. 143). Various objets trouvés, pieces of wood, algae and twigs seem to be growing out of the background and snaking upwards, ending in the long arrow-like point of a piece of wood. The composition, whose painted, abstract 'naturalist' background calls to mind thoughts of water plants, has an open character. With coarse, rapid brushstrokes Schwitters creates an illusion of space that one can imagine extending into infinity. Plant-like, amorphous elements also play an important part in other works such as *Ohne Titel (Holz auf Schwarz)* (Untitled [Wood on Black]), 1943–1946 which

Schwitters made during his time in England. Two large sections of a circle form brackets against a fine mesh. The whole is dominated by a gnarled piece of tree bark, an object trouvé from nature which is answered by semi-circular fragments of a wooden panel. Schwitters exploits the natural qualities of the material, its dynamics and vitality and intensifies the impression of the pictorial gesture. Similarly in *Young Earnest* (1946, fig. 6), he again creates a Surrealist illusion from found objects. He adds pieces of white and red paper to an abstract composition on a blue ground; the structure of the pieces of paper is reminiscent of painted sections in other works. The movement towards the upper left is countered on the right by a pale, roughly-structured beam, vertical and geometrical. In a number of purely painted works, Schwitters moved right away from collage, as in the previously mentioned *Komposition Nr. 114 U*, focusing instead on the openness of an abstract arrangement of colours that drive outwards beyond the picture frame. Tension is created by means of the sharp contours of certain areas as opposed to others that spread unchecked.

Kurt Schwitters, *Untitled (Young Earnest)*, 1946,
Kunstsammlung Nordrhein-Westfalen, Düsseldorf

Schwitters regarded his artistic work as the logical realisation of an underlying concept. He resisted being regarded as someone who ignored tradition.[21] Certain of the fact that he was rigorously pursuing his own course, he spoke disparagingly of artists such as Picasso who, in his view, changed their style as the whim took them.[22] The contradictions in Schwitters' output – his recourse to Expressionism alongside his loyalty to Naturalism – should be seen as intrinsic to his overall output.[23] His exploitation of hand-made, coarse materials in the manner of the Expressionists helped him – like his interest in nature – to avoid slavish accuracy and to create his own compositional foundation for his new visual language. Schwitters was not interested in depicting the external world but in preserving the autonomy of the work by means of an equilibrium of colours and forms, independent of figuration and abstraction.[24] In his late works, this led ultimately to the harmonious coexistence of collage themes and the realistic depiction of nature.

Another artist-colleague, Georg Baselitz (born 1938), had also noticed Schwitters' desertion of the well-trodden stylistic paths and the appeal that the impure and the disordered had for him. Like Kirkeby and Schwitters he, too, was exploring the possibilities and the limitations of the medium of painting. In a text about the Merz artist, Baselitz describes an imaginary visit to Schwitters' studio. In stark contrast to the meticulous set up of the studio and the objets trouvés ready to be used in assemblages, he finds white plaster shapes strewn across the carpet. He describes the subversive energy that emanates from this unsettling sight: "The glowing coal has fallen from the stove and immediately the carpet catches light. Something of that sort has happened to the entire world of pictures out there. Schwitters has pushed open a window, and as though he had at last discovered the secret, is shouting hurray into the street."[25]

NOTES

1 The crucial exhibition that brought Schwitters' œuvre to public notice in post-war Germany took place in the Kestner-Gesellschaft in Hanover in 1956. See also Werner Schmalenbach, Kurt Schwitters, London 1985.

2 See John Elderfield, *Kurt Schwitters*, Düsseldorf 1987, pp. 216ff.

3 See *Kurt Schwitters im Exil: Das Spätwerk 1937–1948*, Marlborough Fine Art, London 1981; *Kurt Schwitters, Die späten Werke*, Museum Ludwig, Cologne 1985. The following observations are above all indebted to the studies by Werner Schmalenbach, John Elderfield and Siegfried Gohr (in: Cologne 1985, see above), and Klaus Stadtmüller (ed.), *Schwitters in Norwegen, Arbeiten, Dokumente, Ansichten*, Hanover 1997.

4 "I myself work on portrait painting in order to keep myself fit for abstract painting and sculpture": Schwitters in a letter to Nelly van Doesburg on 10.9.1946, in: Ernst Nündel (ed.), *Kurt Schwitters. Wir spielen, bis uns der Tod abholt, Briefe aus fünf Jahrzehnten*, Frankfurt a. M. and Berlin 1985, p. 228. See also Magdalena M. Moeller, 'Schwitters vor MERZ', in: *Kurt Schwitters 1887–1948*, Sprengel Museum Hannover 1986, p. 98.

5 Werner Schmalenbach takes this view, backing it up with reference to comments by Schwitters in his letters, see Schmalenbach 1967 (as note 1), pp. 158f. See letter to Katherine S. Dreier written in January 1947, in: Schwitters 1985 (see note 4), p. 26: "In practice I live from my portraits because I cannot live from abstractions. But I don't regard them as art. I only do them so that I can work on my Merz without making concessions. I wouldn't do any portraits if I could make real art." Schwitters often proposed painting portraits for payment, as for instance in a letter to Hallgarten on 16.7.1943, ibid., pp. 176f., see also the letter to Mr. Rogger of 16.7.1943, in: Schmalenbach 1967 (as note 1), p. 174. Schwitters carried out commissioned portraits above all while he was in internment camp in England.

6 *Der Ararat*, 1921, pp. 6f.

7 Letter of 15.8.1925, in: Schwitters 1985 (as note 4), pp. 96f. Schwitters also mentions the concurrence of abstract and representational works in a letter to Edith Tschichold of 30.12.1942, ibid., p. 173f.

8 Richard Huelsenbeck, 'Dada und Existenzialismus', in: Willy Verkauf, *Dada, Monographie einer Bewegung*, Teufen 1957, pp. 57ff.

9 Per Kirkeby, 'Norwegische Landschaften', in: Hanover 1997 (as note 3), p. 31.

10 See Per Hovdenakk, 'Kurt Schwitters in Norwegen', in: Hanover 1997 (as note 3), pp. 16 and 19. During the National Socialist dictatorship Schwitters was not regarded as a welcome visitor in Norway.

11 See Elderfield 1987 (as note 2), pp. 220f.

12 *Der Ararat*, 1921, p. 4.

13 Reply to a questionnaire from the journal *abstraction, création, art non figuratif*, 1933, as quoted in: Hanover 1986 (as note 4), p. 188.

14 Letter of 24.7.1937, in: Schwitters 1985 (as note 4), pp. 137f.

15 The most comprehensive illustrations from the photograph album are in *Kurt Schwitters*, publ. by the Galerie Gmurzynska, Cologne 1978, pp. 12–23.

16 See Per Kirkeby, in: Hanover 1997 (as note 3), pp. 31f.

17 Letter of 8.8.46, in: Schwitters 1985 (as note 4), p. 216. The quotation by Caspar David Friedrich comes from a letter to Philipp Otto Runge, as quoted in: William Vaughan, "Landschaftsmalerei und die 'Ironie der Natur'", in: *Ernste Spiele, Der Geist der Romantik in der deutschen Kunst 1790–1990*, Haus der Kunst München, Stuttgart 1995, p. 565.

18 Caspar David Friedrich, *Morgen im Riesengebirge*, 1810/11, Schloss Charlottenburg, Berlin; see also the photograph by Ernst Schwitters with his father, Kurt Schwitters, as Friedrich's *Wanderer über dem Nebelmeer* (ca. 1818). Illus. in: Hanover 1997 (as note 3), p. 12.

19 Per Kirkeby, in: Hanover 1997 (as note 3), p. 32.

20 See Rudi Fuchs, *Conflicts with Modernism or the Absence of Kurt Schwitters / Konflikte mit dem Modernismus oder die Abwesenheit von Kurt Schwitters*, Bern and Berlin 1991, p. 37ff.

21 "For here people regard me as a radical innovator without a sense of tradition, and nothing could be more wrong": Schwitters in a letter to Katherine S. Dreier on 15.8.1925, in: Schwitters 1985 (as note 4), p. 97.

22 Schwitters viewed Picasso as an imitator, see letter to Otto Gleichmann on 18.12.1946, in: Schwitters 1985 (as note 4), p. 251. Or: "I am still an Impressionist although I am MERZ. In the case of the gangster Picasso you ask: which artist is he copying today. In my case you ask: what has he worked through. I am not ashamed to be capable of making good portraits, and – still do so. But that is not avant-garde any more." Letter to Raoul Hausmann on 19.12.1946, in: Schwitters 1985 (as note 4), p. 254.

23 "Contradictions complement each other and go to make up the whole – the whole artist Kurt Schwitters", see Hanover 1986 (as note 4), p. 98.

24 See Siegfried Gohr, 'Kurt Schwitters – Eine Einführung in das Werk der Jahre 1930 bis 1948', in: Cologne 1985 (as note 3), p. 11. See Kurt Schwitters, 'Vermischung von Kunstgattungen', 1940, in: Friedhelm Lach (ed.), *Kurt Schwitters. Das literarische Werk*, vol. 5, Cologne 1981, p. 372: "[…] except here I want to talk solely about pure (abstract) painting. Here surface and colour are nothing other than surface and colour, a (rhythmic) composition of colours on a consciously confined surface."

25 Georg Baselitz, *Kurt Schwitters*, New York and Bielefeld 1990, unpaginated.

"ATELIER MERZBAU" – THE *MERZBAU* IN THE TRADITION OF ARTISTS' STUDIOS AND THE PROBLEMS OF ITS RECONSTRUCTION

ULRICH KREMPEL

Dedicated to Robert Lee

In art-historical literature on rooms designed and constructed by artists in the 20th century, the *Merzbau* has by now in effect entered the realm of myth and legend. After all it is not only regarded as "central to the work of Kurt Schwitters"[1] but it also seen as the definitive artist-designed room in the early 20th century; in 1987 Harald Szeemann described it as a "myth", earlier in 1960 Klaus Jürgen-Fischer had called it a "pantheon of Dadaism";[2] it has even been called an "individualised, secularised 20th century cathedral".[3]

This is partly due to the unattainability of the real *Merzbau* which Schwitters himself worked on over the years. Having evolved in the artist's studio, this creation extending over a number of rooms was only accessible to friends and invited visitors after Schwitters left Hanover in 1937. Its destruction during the Second World War in the air-raids of 1943 meant that for subsequent generations the Hanover version of the *Merzbau*, hitherto an integral part of the artist's life, was shifted into an ungraspable, imaginary dimension. After 1945 the only information to be had on the installation was from a small number of photographs and the memories of the artist, his family and other contemporaries. Art-historical literature on Schwitters attempted to evaluate and research the structure, but only ever according to the author's own position. Amongst practising artists, who were starting to become aware of their spiritual fathers in the early years of the century, the fame of this mysterious creation grew, a creation no-one could enter and which was buried far away in the destroyed past. At the same time the desire developed to rise above the damage done by the Nazis and the war, and to breathe new life into the thinking and the riches of the artistic avant-garde. Today a relatively faithful reconstruction of one of the rooms of the *Merzbau* is on view in the Sprengel Museum Hannover as a permanent installation; the same room – again housed here – also exists as a second, mobile, touring version. This reconstruction was made in the early 1980s on the initiative of Harald Szeemann for the exhibition *Der Hang zum Gesamtkunstwerk*; with advice from Ernst Schwitters, the artist's son, who knew the *Merzbau* from his day to day contact with it until he left Germany (at age of seventeen), the reconstruction was realised by the Swiss architect Peter Bissegger.

Harald Szeemann was well aware of the problems involved in his attempt at a reconstruction, and wrote in 1987: "Should one reconstruct a myth? Can one capture a moment in a continuous creative process? These questions, tossed hither and thither for so long, fell by the wayside on the day when the egocentric exhibitions-organisers-type wish – to have been in the MERZbau, and to have spent a night in it – took the upper hand. In short: the Ludwig II in me broke through – the one who also wants to make the things that one would like to have around one – and he sent pleasure on a forced march."[4] Here Szeemann is casting himself in the role of the art patron, who is in a position to turn his private obsessions into reality; he is drawn by the lost, private aura of the work of art, he wants to enter it like the few real visitors in the past. Like the artist himself he, too, wants to be present in the work, he wants to make a journey through time into the locked past of a work of art. It is to such artist-like monomania that we owe the existing versions of the reconstruction. At the same time Szeemann's ironic admission of his own self-indulgence sets the initiator of the reconstruction apart from its visitors, for he was certainly the first and last guest to stay overnight in the reconstruction.

Both in international exhibitions and by their daily presence in the museum, the reconstructions of the *Merzbau* today convey a real sense of that lost work. The touring version crops up in large exhibitions, generally as a white cube, which transports us into the world of Schwitters' creation when we step inside it. Not so in the museum, here the visitor breaks off from a tour of the museum and enters into an initially darkened, seemingly endlessly high room, in which a mirror-ceiling reflects an odd construction: the outside view of the structure of the reconstruction itself, with the word *Merzbau* properly readable in the mirror. The visitor then passes down a neutral, white corridor, where felt slippers are lying in readiness (according to an account by Ernst Schwitters, his fathered offered just such slippers to visitors to the *Merzbau*), and on into the heart of the *Merzbau*. The room – its design and its contents – embrace the visitor, drawing him or her to the free space in front of the

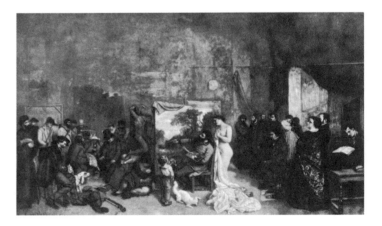

Gustave Courbet, *The Painter's Studio*, 1856, Musée d'Orsay, Paris

window looking out into the garden, which is visible through the window courtesy of a black-and-white photograph; looking from here in the other direction the visitor sees the arches and grottos, the entrances and passages of the interior. By means of two different lighting schemes, the reconstruction (laid out as Schwitters' son Ernst remembered it) may be seen in a day-version, with daylight from the said garden, and in a night-version, lit by numerous light bulbs hidden in the reconstruction. The cuboid upper level of one room in the *Merzbau*, in which we find ourselves, takes on a physical presence. Our view into the depths of the grottos, however, originally built into showcases, which we know from historic photographs and from descriptions by the artist, is halted on one and the same surface level: this view ends at photographs of details of the interiors that suggest we might be looking into real spatial depths but whose grainy black-and-white images only convey a pale idea of the spatial reality of the objects they portray.

Besides the only partially re-created spatiality of the reconstruction, the problematic lighting arrangements and the lack of any colour whatsoever – which must at least have been visible in the grottos – it is above all the uniformity of the colours of the surface in the room that are disturbing. The paint used in the construction draws a skin of colour over the shapes in the interior that equalises and blends; no trace now of the different shades of white, the chipped edges and repairs on the original. Furthermore: the reconstruction is intended to be looked at by many potential visitors; it is in a museum, and thus it sacrifices the usability of the original – the right to feel and to touch, occupy and own – in favour of observation alone. What a difference there is in looking at steps rising up in a passage (ending at the ceiling in the reconstruction) and the chance of clambering up the steps and spending the night in a secluded raised bed! The public nature of the reconstruction follows the principles of the museum; the original on the other hand was shrouded in the privacy of the studio, which was in turn part of the Schwitters' apartment, and initially escaped the National Socialists' philistinism, even after the artist emigrated, simply by being contained in the artist's private sphere in his apartment. In the truest sense the *Merzbau* was a hidden place, only to be entered in the presence of the artist and curator, a hortus conclusus.

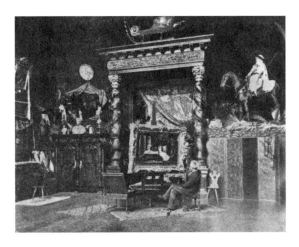

Mihály von Munkáscy's studio in Paris,
Avenue de Villiers 53, no date

Despite any inadequacies and freely admitted inaccuracies in the reconstruction, in many ways the experience it offers overshadows attempts to construct the historically correct yet intrinsically fleeting, perpetually changing form of this work that accompanied Kurt Schwitters on his journey through life and which was ultimately lost. Even when the reconstruction is juxtaposed with the relevant black-and-white photographs of the historical situation this does not lessen the dominance of the constructed space. Indeed, in a certain sense the photographs of the historical situation at the entrance to the reconstruction serve to verify and confirm the reconstruction which now awaits us in place of the original. It is almost impossible for the unprepared visitor to the museum to leave behind the impressive density and atmosphere of this theatrical space and to go on to arrive at a historically accurate reading of the *Merzbau* in old pictures and original texts; this all the more so in that any initiation into the nature of the column/cathedral which is the *Merzbau*, and which changed constantly until 1937, needs dry reading and reflection and has nothing to do with the sensuality of what happens on a visit to this interior.

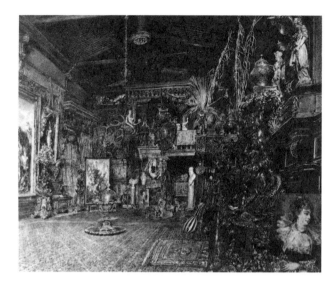

Rudolf von Alt, Makart's studio in Vienna, 1885,
Historisches Museum, Vienna

"CREATIVE ARTISTS SHOULD LIVE LIKE KINGS AND GODS"[5] THE STUDIO AS A WORKPLACE AND CULT-SPACE IN THE 19TH CENTURY.

"This is the whole apartment. The marked part was the *Merzbau*", wrote Kurt Schwitters on a ground plan of his apartment in a letter to Christof and Lucie Spengemann on 25.4.1946.[6] A look at what the artist had to leave behind during his exile shows what life was like and how Kurt Schwitters lived in his house in Waldhausenstraße. Having started off in rather cramped, modest conditions on the second floor, in the end the family occupied the spacious ground floor. Here Schwitters had set up a studio. When he left Hanover, three ("marked") rooms in the apartment were given over to his artistic work. In the early 20th century Schwitters lived much as many bourgeois artists in the late 19th century had done: in bourgeois surroundings, with their living space and workplace all on the same level. Schwitters' studio was public to a certain extent, it could be visited by invitation or for events put on by the artist. Like many other studios of the day it was as much for work as for the artist to present himself as he wanted to be seen.

The 19th century had liberated artists from the aristocracy and the Church as their sole clients. This liberation of art from any number of obligations meant that artists now joined the army of anonymous individual existences in the cities, clustered around the academies and art schools. The bourgeois artist, without a permanent patron, now had no spacious workplace at his disposal. As a rule, in the early 19th century the artist's studio was a room in an apartment or a house. The artist's studio was both workshop and workplace, and was not very different from other bourgeois places of work. During the Romantic era a modest workplace was a matter of principle: in Georg Friedrich Kersting's depiction of Caspar David Friedrich of 1811, the studio is shown as a modest, almost empty room in a bourgeois house, with half-drapes at the windows and furniture reduced to the minimum required for the purpose. In the 19th century the studio view became a picture type that reflected

This essay aims to examine the gap that is visible between the character of the lost original and that of the reconstruction. It situates the *Merzbau* in a tradition that has so far been ignored in this context – that of the studio as a workplace and cult-space. The essay will show that in the privacy of a non-public studio situation, a piece evolved which only lost the character of the traditional studio later on in its evolution. Furthermore this essay will outline the conditions that must be met by any museum-based, historically founded work on the existing reconstruction of a room from the *Merzbau*, which in themselves amount to an underlying awareness that the stage the *Merzbau* had reached in 1937 was one that was in principle open to further change, but which could not in fact be changed. The reconstruction of the *Merzbau* today must be seen as pars pro toto: an action shot of the last stage it reached.

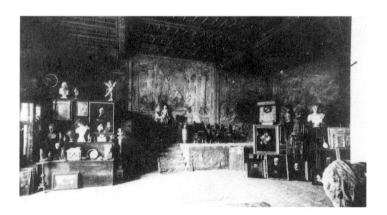

Franz von Lenbach's studio when the artist was still alive,
before 1904, Städtische Galerie im Lenbachhaus, Munich

the self-image and self-confidence of the artist. The post-Romantic artists of the later 19th century abandoned the programmatic moderation of the Romantics. Drawing heavily on the increasingly powerful cult of the genius in the arts, they staged their studios as the place where the mysterium art was created – whether, like Gustave Courbet in his studio view of 1856, they depicted the studio allegorically as a confessional scene aspiring to encompass the entire world, or whether, like the artists of the later 19th century, they organised their entire life and demeanour like a public performance and furnished their apartments and their studios alike as staged settings for the purpose of self-representation.

In 1855, Gustave Courbet painted an early major work, *The Artist's Studio. A True Allegory Concerning Seven Years of My Life.*[7] As Werner Hofmann showed early on, for Courbet this picture was not just a report of his life and an account "of the world in which his art dwelled".[8] It was also a self-portrait and a friendship picture, a picture of that age and a cross-section through human society. Courbet's accusatory attitude to contemporary life leads to diverse symbolic areas, which are nevertheless "held together by the central apotheosis of artist genius".[9] The seven-year creative process that produced the final work combines the non-simultaneity of the figures and scenes to create a simultaneity within the work of art itself; this in itself is in keeping with the openness of the studio space that is constantly changing in the picture, from the interior of a high room hung with pictures, through various groups of figures to a view of the landscape seen in the painting on the easel. Besides portraying a grand interior, Courbet also presents different pictorial types such as self-portrait, nude, portrait, group portrait and others; realistic depictions and allegories combine in complex, inextricable layers. As a process, a combinatory method such as this would seem to have an affinity with the principles governing the genesis and construction of Kurt Schwitters' *Merzbau*, which similarly arrived at its final stage of composition and construction after a lengthy period of gestation and as a compilation of very different moments in the artist's life and work.

Besides these structural correspondences in attitudes to the artist's studio, there is another hitherto neglected aspect in the pre-history of the *Merzbau*, that is to say the studio as a 'cult-space' in the art history of the late 19th century. With the increasing incorporation of socially successful, easily consumable art into the rapid economic evolution of middle European society, the studio became an essential showroom and presentation room for the socially acceptable artist, both for his art and for his own social role; this was reflected in certain styles of decoration, in the splendour of the decor, the refinement of the furnishings and the inclusion of all sorts of other objects. In the late 19th century – the Grün-

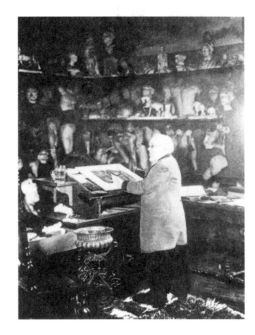

Adolph von Menzel in his studio, ca. 1895, Hamburger Kunsthalle

derzeit in Germany – the studio was a carefully furnished and staged room. "Indeed, some of the *Gründerzeit* artists maintained just as 'grand houses' as the wealthy captains of industry, financial magnates and stock exchange condottiere. One need only call to mind Wagner's lifestyle in Villa Wahnfried, the Renaissance palace that Lenbach occupied in Munich, or Makart's gigantic studio that was built for him in Vienna at the government's expense. "[...] Significantly it was less his painterly œuvre than his studio which became the epitome of the grand-bourgeois 'drive towards higher things'. For here one found the extravagant, eclectic 'studio style', that style which had no style [...]. In this studio, that could even be viewed at certain times of day, the visitor could see knights' armour, stuffed birds, palm fronds, skins of beasts of prey, tapestries, old German furniture, aristocratic coats of arms, oriental carpets and a precious picture on the easel, that is to say all the things that industrialists would use to feather their caps. The whole is neither a liv-

ing space nor a workplace, but a magnificent room intended first and foremost for show."[10] The painter Mihály von Munkáscy built a residence and studio in Paris with room for 800 guests,[11] and the studio of the painter Eduard Grützner was described as follows: "Large baroque chests stand around, the couch is covered with a precious rug, on the floor there are valuable Persian carpets and flamboyant bear-skins, the chairs are like high thrones covered in velvet. Nowhere is there a smell of paint or work. For the Lord's sake, no spots of paint! It seems as though the artist is waiting like Titian for a mighty patron to lift up his brush for him. On the easel stands a picture, not one that is being worked on, but a finished composition, a 'Falstaff' […]".[12] The self-stylisation of the artist serves as a "mood setter"[13] for the visitor and suggests associations; and the visitor's expectations of the artist are played on to no less an extent when the studio is presented in a state of "finely calculated painterly disorder".[14]

Such notions of comfortable bourgeois life held their own with other *Gründerzeit* ideas. To the successful, socially recognised artist the salon and the studio were mutually enriching realms of his life. The decorative schemes in the studios of Makart, Grützner or von Munkáscy might be described as *mixtum compositum*, where the overall effect is achieved by bringing together items from different exotic and national sources for inspection and admiration. In these ensembles the essence of the artist's work only emerges sporadically in isolated places (on an easel perhaps, on plinths, on the wall). Schwitters, who lived in a similarly bourgeois manner in his own apartment, used his studio in a distinctly comparable sense, the only difference being that he excluded all the bourgeois accoutrements of domestic life, or only used them ironically. Schwitters knew the cult-space studio, as favoured by the *Gründerzeit* artists; the staging of the *Merzbau* studio is as ironical a recasting of the bourgeois cult-space studio as is its radical reformulation; ultimately, however, it is also a continuation of a new attitude towards the role of the studio in the artist's life that had emerged around the turn of the century.

For the artists of the late 19th century, the abandonment of the *"Gründerzeit* culture of objects"[15] also marked their farewell to romanticised notions of the artist as genius. In 1905 Paul Schultze-Naumburg described the discrepancy between the artist's studio as portrayed in literature and the reality of the situation: "What fantastic dreams hovered before him, of luxuriously furnished studios with plump cushions on soft ottoman sofas, with magnificent paintings behind them and charming young girls who had been the models for them, just as sweet as their painted selves; the carefree life of a genius, the artists' parties! No, these are but fantasies, the studio is a place of work, simply that. Not all artists have Makart's money or inclination to turn their workplaces into fairytale rooms. Studios are in the buildings at the back of the house. Big, bare rooms, painted white, lit only by the cold north light. […] The furniture is modest. An upholstered chair or a flat divan, an antique cupboard, a few plain wooden stools, a big table with the painter's equipment. The main thing is the work."[16]

This same emphasis on the work factor is also clear in views of Kurt Schwitters' studio from 1921. On the wall and in the space itself there are numbers of objets trouvés as well as his own works; on the easel is a picture that has just been started, on the work-bench and on the floor there are object boxes. A table, stool, tidied-away boxes and objects are to be seen. Work gets done here, that is obvious, and at the same time, things are also stored, hung on the walls or kept in boxes until they are

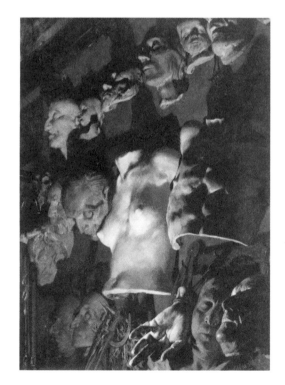

Adolph von Menzel, studio wall, 1872,
Hamburger Kunsthalle

Kurt Schwitters, *Grotto witn Cow Shape,
Merzbau,* Hanover, ca. 1932/33, Kurt
Schwitters Archive in the Sprengel
Museum Hannover

"ATELIER MERZBAU"

In Oslc in 1938, after he had left Hanover for ever, Schwitters wrote in 'Bogen 1 für mein neues Atelier' (Sheet 1 for my new studio): "First it is important to mention its name. It is called 'Haus am Bakken'. My studio in Hanover is called 'Merzbau'."[18]

In 'Bogen 2' the artist reviews the situation: "Before Ernst left Hanover he devoted two days to photographing everything in my studio that seemed to him of importance. I helped him and hence experienced the studio once again as a whole.

I was not particularly happy when we were doing this, because much in the Atelier Merzbau seemed out of date to me, but I didn't really think I could build a new studio again.

Ernst said he very much liked the forms, in a way it was his adieu. I didn't need to say adieu because I wasn't intending to leave."[19]

needed again. While the Merz-picture on the easel in the centre is the reason for the photograph, in another reading the photograph also tells of the artist's working practices. Similar elements – the wall with pictures, the ensemble of found and collected objects, the simplicity of the furnishings – were also found in artists' studios around the turn of the century, for instance in Menzel's studio. Menzel captured the picturesque charm of his studio in paintings such as *Atelierwand* (Studio Wall) of 1872. In these compositions, as though in a credo, the artist makes public witness on a restricted, professional level; by adding together the different components one can arrive at the artist's statement of his view of the world. Under the banner of artistic reform, it is but a short step from here to the *atelier-musées* of the great French artists of the time. This is well exemplified in a view of August Rodin's *atelier musée* in Meudon (around 1896); in this contemporary style of presentation, consciously chosen by the artist, the neutral studio becomes an intentionally laconic setting for the artist to present his œuvre. Both older examples, like the view of Schwitters' studio, make it clear that the apparently private studio in the early years of the century should be read as a "representation of modes of thinking",[17] and that the evolution of Schwitters' studio from the site of the column to the major complex, the *Kathedrale des erotischen Elends* (Cathedral of Erotic Misery), follows in this tradition.

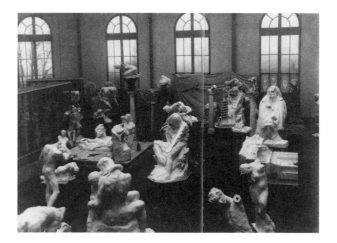

Auguste Rodin's *atelier-musée* in Meudon, after 1896

Kurt and Helma Schwitters as a young married couple
in *Biedermeier* surroundings, Waldhausenstr. no. 5,
ca. 1917/18

There is a strangely broken air about this note written in exile in Norway;
Schwitters' efforts to cope in the very new situation as an émigré were
fraught with immense difficulties. Beyond their relevance to Schwitters'
private situation, there are two important aspects to these remarks that
have hitherto received little attention. Firstly, the combinatory term
'Atelier Merzbau' which has so far not been commented on – a term
indicating that this was a place for art, as specifically private (although at
times strategically opened to the public) as the atelier in the art world of
the 19th and early 20th centuries. The *Merzbau* had evolved in the
security and privacy of the studio; it seems that now the studio and the
Merzbau had grown into one indivisible entity – although this entity did
exclude certain functions of the normal studio, such as the presentation
of finished works. Thus Schwitters wrote in a letter to Katherine S. Dreier
in 1937: "But in the studio there are no pictures to be seen any more,
just the studio itself, which is much more important."[20]

And the other point: Schwitters himself refers to his dissatisfaction with
the contents of the "Atelier Merzbau". Much seems to him passé, but
he neither plans a reworking of the dissatisfactory state of the studio,
nor is he able to set about making a new version ("a new studio"). This
distancing view recedes over the years; the longer he is in exile the
more the last state of the *Merzbau* gains in significance and acquires an
aura even for the artist, for whom it was now unattainable – as it is for
us today. Schwitters visits it in his memory and imagination; perhaps it
is precisely this, the memory of the unattainable creation, which should
be regarded as the last state of his work.

Schwitters' dissatisfaction with the version he left behind in 1937 is of
fundamental significance; even if it is not possible to understand it in
detail, it nevertheless highlights the continuous creative process by
which the *Merzbau* was constantly changing and would have gone on
changing. It is true that the exiled artist was constantly anxious about
the continued existence of his work in Hanover and suffered that it
should lead such a hidden existence (for instance writing to Katherine
Drier in 1936: "Of course I don't show my studio to anyone [...] Not
being able to show it to anyone makes me so despondent.")[21] as he
also suffered that his main work was largely misunderstood; but very
soon he was thinking of new Merz buildings in new places. Thus he
wrote to Alexander Dorner in 1937: "Yes, ask Mr. Barr. I have asked him
to give me the opportunity to make a room sculpture, of the kind he
liked so much in Hanover. He politely declines. But he has bought pho-
tos of my Merzbau from Ernst without paying for them."[22] The dream of
realising a new *Merzbau* in New York never came to fruition; however, at
the same time, Schwitters had started to make a new studio (and hence
a new *Merzbau*) in the 'Haus am Bakken'. In October 1937 he referred
to this in a letter to Katherine Dreier: "I am building a new studio here
as a visible sign that a new life is starting for me. I am only 50 years old,
one can still start again at that age. All in all life is so dreadful that one
would rather not have been born. On this basis life is quite tolerably
good."[23] And after he emigrated again, now to England, the project got
its third wind in the 'Merzbarn' in Little Langdale, with the help of a
fellowship from the Museum of Modern Art, New York

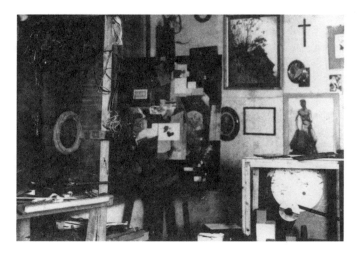

Kurt Schwitters' studio in Hanover, ca. 1921

But let us look once again at the evolution of the "Atelier Merzbau" in Hanover, as far as we can still follow it today. In 1931 Schwitters first published images and text on the work which became known in all its complexity as the *Merzbau*, but which he himself – due to the genesis of the work and the idea – initially called 'Säule' (column) or 'Kathedrale des erotischen Elends' (Cathedral of Erotic Misery): a sculptural work made by adding all kinds of found objects to the column that had been in the studio – in a state of constant change – since 1923. "It grows more or less according to the same principle as a city, somewhere or other another house is to be built, and the Board of Works must check to see that the new house does not spoil the whole appearance of the city. In the same way, I find some object or other, know that it belongs on the K d e E, take it with me, glue it on, paste it, paint it in the rhythm of the overall effect, and then one day it turns out that a new direction must be created, wholly or partially over the bodies of previous objects. In this way, I leave things as they are, only covering them up either wholly or partially, as a sign of their downgrading as individual units."[24]

Having been started in 1923, the *KdeE* had long taken on much greater dimensions. "It is 3 by 2 by 1 metres [...]",[25] as Schwitters reported in 1931. The additive collage principles of his early period plus the constant associative fixing of found objects to the column or the walls behind it had meanwhile led to a formal structure in its own right, which conformed to constructivist principles, if anything. "As the structure grows bigger and bigger, valleys, hollows, caves appear, which then lead a life of their own within the overall structure. The juxtaposed surfaces give rise to forms twisting in every direction, spiraling upward. An arrangement of the most strictly geometric cubes covers the whole, underneath which shapes are curiously bent or otherwise twisted until their complete dissolution is achieved."[26] This geometric, stereometric structure was a completely new, ordering, form-giving step in the gradual evolution of the column and the cathedral, which had started with Dadaist combinations and montages in the grottos. "The literary content is dadaist: that goes without saying, for it dates from the year 1923, and I was a Dadaist then. but since the column has taken seven years to build, the form – in keeping with my developments in my own thinking – has become ever more rigorous, specially in its curves."[27]

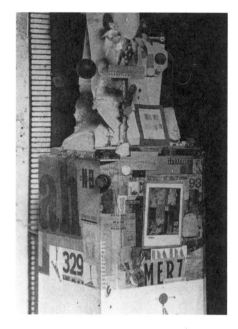

Kurt Schwitters, *Merz column*, state of ca. 1923

In 1931 Schwitters described the Dadaist content of the grottos, some partly already overgrown by others: "Each grotto takes its character from some principal components. There is the **Nibelungen Hoard** with the glittering treasure; the **Kyffhäuser** with the stone table; the **Goethe grotto** with one of Goethe's legs as a relic and a lot of pencils worn down to stubs; [...] the **Sex-Crime Cavern** with an abominably mutilated corpse of an unfortunate young girl [...]; the **Ruhr district** with authentic brown coal [...]; an **art exhibition** with paintings and sculptures by Michelangelo and myself [...]; the **dog kennel** [...]; the **organ** which you turn anticlockwise [...]; the **10% disabled war veteran** with his daughter [...]; the **Monna Hausmann** [...]; the brothel [...] and the great **Grotto of Love**. [...] I have only mentioned here a small part of the literary content of the column. Some grottos have long since disappeared under the present surface, like for example the **Luther Corner**."[28]

In 1933 Schwitters listed the – passé – Dadaist elements in his total composition rather differently, and very cursorily, in the journal *abstraction, création, art non figuratif*: "Le 'Merzbau' est la construction d'un intérieur par des formes plastiques et des couleurs. Dans des grottes vitrées sont des compositions de Merz qui forment un volume cubique et qui se réunissent à des formes cubiques blanches en formant l'intérieur. Chaque partie de l'intérieur sert à la partie voisine d'élément

"I IMPLORE YOU ALL, LET ME CONTINUE TO FLOWER IN MY OBSCURITY."[31]

In 'Ich und meine Ziele' of 1931, Schwitters made his first public reference to the *Merzbau*, although not without teasing his readers a little: "The K d e E is one of those typical violets that flowers in hiding. Perhaps my K d e E will always remain hidden, **but not I**."[32] The artist's prophecies have certainly been fulfilled, albeit in a tragic reversal of the expected reasons. With the help of scholarly research and reconstructions, we draw closer to the artist's work despite the passage of time, although we shall never know its true character for certain nor the artist's last version of the "Atelier Merzbau".

With regard to future work on and with the – theoretical and factual – reconstruction of the *Merzbau*, certain conditions must apply that have so far received little attention:

The existing space should be understood as pars pro toto of a significantly larger work process, which already filled a number of rooms of the house in Hanover when Schwitters left;

the *Merzbau is precisely that and evolved* from the artist's studio;

the *Merzbau* was a place for private and only limited public use;

the *Merzbau* in Hanover was not working towards some ultimate, intentional artistic version, and is only a final version by dint of circumstances; the Hanover *Merzbau* is only a stage in the artist's lifelong work on the *Merzbau*, which existed in different versions in different places;

and last of all: the *Merzbau* in Hanover is a museum of its own history, veiling past versions of itself within itself.

This structure has to be understood as a private work by an artist, not as a theatrical event; this means that there should be a limit on the number of visitors at any one time, with due attention being paid to additional information of whatever kind on its formation and evolution. It is only then that it will be possible to properly understand and experience the work as special and important in the output of Kurt Schwitters.

médiateur. Il n'y a pas de détails qui forment comme unité une composition limitée. Il y a un grand nombre de différentes formes qui servent de médiateur du cube jusqu'à la forme indéfinie."[29] In the same text Schwitters refers to his use of forms taken from nature as well as those of a linear construction.

It is clear, that after a long period of Dadaist collecting, the column and the Cathedral of Erotic Misery were increasingly incorporated into a constructivist spatial structure in the early 1930s. Already in 1933, in the artist's own description of the work for the international art world, there are fewer references to the original impulsive adding of objets trouvés to an original, ironic work of art, which for a time had functioned like a "bocca de la verità" – a sculptural basic form which, with every addition, took on a new, different meaning in terms of its contents. This was now replaced with the unified appearance of the total structure; a unified entity of white, cuboid forms and cuboid glass showcases with Merz-themes (the grottos) – the latter still in colour – which all went together to form the same interior. Schwitters' descriptions highlight the ambivalence of the work at the time when he wrote the text. The work rescued past stages of the artist's development in his artistic career, repositioned them in a new formal and artistic context, and preserved them – withdrawn, but present – in the new form. Thus each new *Merzbau* became a museum of past versions of itself; legible or archaeologically reconstructable, the individual stages of the installation were preserved in their last state.

The simultaneity of the non-simultaneous, the combination of Dadaist, Expressionist and Constructivist elements in one space bespeaks the almost natural, gradual growth of the *Merzbau*. Its evolution until Schwitters left Hanover has been relatively comprehensibly documented in research so far.[30] However, nowhere is any attention paid to Schwitters' expression of his own dissatisfaction with the stage the *Merzbau* had reached shortly before he left Hanover. Yet the state of the work as captured in the 1937 photographs is the one that served as the basis of the reconstruction in the 1980s. At the very least, the artist's reservations regarding the state of what had been achieved ought to be mentioned in connection with the reconstruction, even if it has so far not been possible to determine the specific details of Schwitters' own self-criticism.

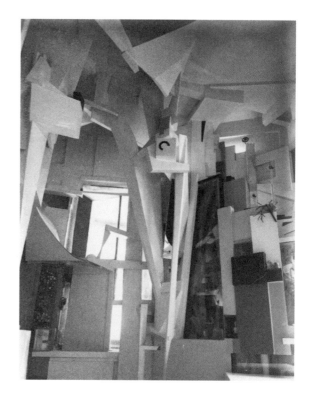

Kurt Schwitters, "Atelier Merzbau", Hanover, ca. 1933

NOTES

1 Dietmar Elger, *Der Merzbau von Kurt Schwitters. Eine Werkmonographie*, Cologne 1999, p. 139.

2 Ibid., p. 12.

3 Karin Orchard, 'Kurt Schwitters. Leben und Werk', in: Ulrich Krempel and Karin Orchard, *Kurt Schwitters*, Hanover 1996, p. 46.

4 Harald Szeemann, 'Die Geschichte der Rekonstruktion des MERZbaus (1980–1983)', in: *Kurt Schwitters 1887–1948*, Sprengel Museum Hannover, Hanover 1987, p. 256.

5 Johann Wolfgang von Goethe, as quoted in: *Lexikon der Kunst*, vol. 1, Leipzig 1987, p. 315. On the concept of the studio as a cult-space, see Franzsepp Würtenberger, 'Das Maleratelier als Kultraum im 19. Jahrhundert', in: *Miscellanea Bibliotheca Hertziana*, Munich 1961, pp. 502f.

6 Illustrated in: Hanover 1987 (note 4), p. 86.

7 As quoted in: *Courbet und Deutschland*, Hamburger Kunsthalle und Städtische Galerie im Städelschen Kunstinstitut Frankfurt a. M., Cologne 1978, p. 21.

8 Werner Hofmann, *Das Irdische Paradies*, Munich 1974, p. 9.

9 Ibid., p. 12.

10 Jost Hermand, 'Der gründerzeitliche Parvenu', in: *Aspekte der Gründerzeit*, Akademie der Künste, Berlin 1974, pp. 10f.

11 Ibid.

12 Richard Hamann and Jost Hermand, *Epochen deutscher Kultur von 1870 bis zur Gegenwart*, vol. 1, *Gründerzeit*, Munich 1971, p. 25.

13 Wolfgang Ruppert, *Der moderne Künstler. Zur Sozial- und Kulturgeschichte der kreativen Individualität in der kulturellen Moderne im 19. und frühen 20. Jahrhundert*, Frankfurt a. M. 1998, p. 320.

14 Friedrich Pecht, *Aus meiner Zeit*, Munich 1894, p. 234, as quoted in: ibid.

15 Ibid., p. 325.

16 Ibid., p. 324.

17 Ibid., p. 316.

18 Friedrich Lach (ed.), *Kurt Schwitters. Das literarische Werk*, vol. 5, Cologne 1981, p. 365

19 Ibid., p. 367.

20 Elger 1999 (see note 1), p. 34.

21 Gwendolen Webster, 'Kurt Schwitters and Katherine Dreier', in: *German Life and Letters*, New Series, vol. 52, no. 4, October 1999, p. 452.

22 Letter from Kurt Schwitters to Alexander Dorner on 12.12.1937, in: Ernst Nündel (ed.), *Kurt Schwitters. Wir spielen, bis uns der Tod abholt. Briefe aus fünf Jahrzehnten*, Frankfurt a. M. and Berlin 1975, p. 42. Barr was director of the Museum of Modern Art, New York.

23 Letter from Kurt Schwitters to Katherine Dreier on 13.10.1937, in: ibid., p. 139.

24 Kurt Schwitters, 'Ich und meine Ziele', in: Lach 1981 (see note 18), p. 343, as transl. in Schmalenbach 1967, p. 130.

25 Ibid, p. 344.

26 Ibid., as transl. in Elderfield 1985, p. 154.

27 Ibid., p. 345. partially transl. in Elderfield 1985, p. 161.

28 Ibid., pp. 344f., as transl. in Elderfield 1985, p. 161.

29 Ibid., p. 354.

30 There is detailec information on sources in Dietmar Elger's *Merzbau* monograph (see note 1); more recent literature is listed in the second edition.

31 Ibid., p. 347.

32 Ibid., p. 345.

ON DISAPPEARING IN SPACE
WALK-IN COLLAGES FROM SCHWITTERS TO THE
PRESENT DAY

SUSANNE MEYER-BÜSER

"To get into the installation, first you have to crawl through the clothes' cupboard. Push the clothes aside, and you'll find the entrance behind them!" – says the visitor who has just returned from an expedition into the world of Christoph Büchel and who is now encouraging me to make a foray into the labyrinth of this work of art. Meanwhile, I am standing in a room that is full to overflowing, and which creates not the slightest impression of being an art gallery. It is more like some kind of a living room, whose myriad contents have survived several years of being stored in a cellar, items whose natural destiny would have been the bulky refuse collection. Everything seems temporary, untidied-away, or simply forgotten. A vague smell of decay has settled over the scene. Wherever you look, newspapers, magazines and other remains of the day. A ladder is propped up against a cupboard, there is a tennis match on television, there is something or other on the radio.

Having clambered through the cupboard, visitors proceed towards larger spaces by going down narrow passages and across barriers. Confrontations with the unexpected on all sides. Additional walls necessitate detours or facilitate diversions, mezzanine floors open up alternative routes. Some corners can only be reached by means of ladders and positively daredevil climbs, while others can only be seen from a window or from a height of three metres. The setting is dominated not only by fragmentation and improvisation but also by ingenious combination. Leftovers from a private household mingle with found objects from the

streets and building materials. Guests in this art installation are in extremely uncertain territory: "Can I get any further, where does it end, what's the right way?" As one picks one's way through the space, the perspectives are constantly changing, and the individual furnishings can themselves become mobile and set out on a tour of their own through the installation. Like the slightly swaying, creaking floors that one moves around on, nothing is stable or final. But just as abruptly as visitors found themselves in the installation, suddenly they are outside it again: in the curator's office. A rub of one's eyes, the bad dream is over, daily life reclaims the visitor.

These were the impressions at least one visitor had at an exhibition by the Swiss artist Christoph Büchel, who – with a fine sense of detail – has staged the inner world of a person who will start anything but finishes nothing, who is threatening to drown in chaos in his/her search for happiness and beauty. *Alles wird gut* (Everything will be all right) is the title of the first room in a multi-part installation shown in 1999 in the Kunsthalle St. Gallen.

Christoph Büchel is trying to realise a 20th-century artist's dream. His temporary interiors are designed to cancel out the division between recipient and work of art by physically drawing the viewer into the work; they set out to thoroughly confuse the perception of the art-object with the self-perception of the viewer-subject. The visitor feels like an intruder, but also like a constituent part of the work itself, and experiences the art in an oddly fluctuating double perspective.

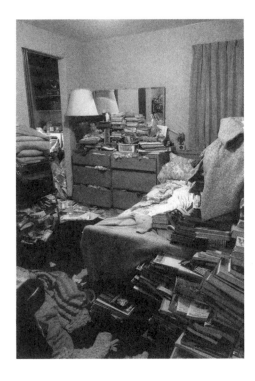

Christoph Büchel, *Home Affairs*, 1998,
TBA Exhibition Space, Chicago

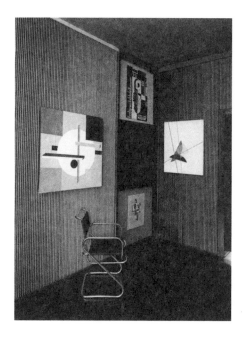

El Lissitzky, *Cabinet of Abstracts*, 1928,
reconstruction 1979, Sprengel Museum Hannover

Büchel's strategy aims to mix fiction and reality. As a medium he gener-
ally chooses rooms that are out of the reach of strangers: private resi-
dences, personal space. He uses apartments as exhibition venues for
his environments or even reconstructs whole chunks of domestic life in
public galleries. He simulates private situations and works with the
ambivalent fascination that glimpses into someone else's personal space
can have on new guests. At the same time, Büchel also succeeds in
somewhat loosening the visitor's one-sided notion of art-reception. After
the initial shock and hesitation at the supposedly private nature of the
scene, in the end curiosity and a sense of adventure win the upper hand.
Visitors find themselves succumbing to the pull of spaces filled with
puzzles and surprises, only to discover they are in a world with its own
rules. Quite unintentionally, visitors have become an element in a work
of art, a building block in a fantasy machine. Visitors may even see and
feel themselves *transferred* into another subject.

Spatial installations and environments[1] became an accepted item in the
repertoire of artistic expression in the 1960s and 70s. Painters and
sculptors like Allan Kaprow, Jim Dine, Claes Oldenburg and Robert
Whitman created spatial collages in galleries, private homes and public
places. However, the roots of spatial installations go back to the early
1920s. Artists and theorists operating in the avant-garde context of
Futurism, Dadaism and Constructivism reacted provocatively to the pas-

sive role of the art recipient and his/her contemplative attitude to the
work of art. Viewed from the perspective of art-historical debate, the
arrival of montage plunged the hitherto widespread idealistic aesthetic of
autonomy into deep crisis – along with the notion that the meaning of
individual works could be found in their depiction of reality, in their medi-
ation and edification. This ultimately led to the redefining of the notion of
artistic work. In the following, we will focus on this redefinition.

One of the impulses for the dissolution of the traditional unity of a work
of art came from the attempts by Cubist painters to open up the division
between art and life by including fragments of reality in their pictures.
While it is true that the picture painted with a particular object or idea in
mind continued to be the main purpose in art production, nevertheless
the closed character of the work and the restriction of the recipient's
response to contemplative empathy were increasingly being replaced by
open forms, by experiments with uncertain outcomes and by ever-new
ways of breaking down barriers. And even if related historical attempts
to bring art and life closer together were soon embroiled in intractable
contradictions, nevertheless the 'provocation of the viewer' remained a
central topos in the art world.

The Futurists can be identified as the first to recognise the inadequacy
of traditional modes of reception and to look for ways to change the sit-
uation. Their thinking hinged on the manner in which works of art were
presented or displayed, which then led them to consider the places and
the organisation of the exhibitions themselves. As early as 1918, in his
drawing *Progetto di arredamento futurista* (*Design for a Futurist Interior*),
Giacomo Balla was already proposing an exhibition design in which the
pictures and the walls would be viewed as a single entity. The walls
were no longer mere surfaces to present the paintings, intended to make
the most of individual paintings, now they themselves were coloured,
'total' compositions.[2] Balla's concept was crucially influenced by the idea
of simultaneity; it not only presumed the juxtaposition of different ele-
ments, it also demanded that these should be absolutely equal in impor-

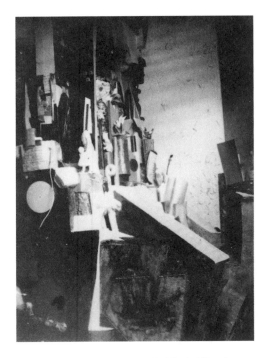

Kurt Schwitters, *K d e E* [Cathedral of Erotic Misery], 1928, destroyed

tance. Features of the space and its decoration which had hitherto at best been noticed as decorative surroundings could now be perceived as aspects of an artistic strategy and as part of an overall order in which the viewer was allocated a new position. "The divisions between 'higher' and 'lower', between the 'more or less artistic' [were] negated"[3]; this in turn required a more active reading of pictures or sequences of pictures. At the same time the meaning of paintings as individual works and the value put on their contents were affected by the new attention being paid to the design of the space, to principles of presentation and forms of perception. Thus the focus of interest began to break free from its fixation with the notion of the autonomous work, it extended beyond traditional boundaries and little by little discovered the interplay between open art-forms and art-contexts that were cheek-by-jowl with life.

The Russian Suprematist, Iwan Puni, went a step further than Balla by turning the exhibition space itself into a collage. In 1921 at his solo show in the Sturm gallery in Berlin, he distributed his paintings around the whole space, and included the ceiling and the floor in his calculations. In addition he covered any bare surfaces with drawings, letters, figures and numbers.[4] By negating the clear spatial framework and through the disparate proportions of the individual elements, he brought out the three-dimensional, "directionless" mode of the presentation, thereby also creating a multi-perspectival situation for the recipient. The viewer had to move to and fro in the space, reflecting on his/her perception and actively adjusting it. Viewers were able to experiment independently with viewpoints, changing perspectives, proximity and distance. Thus Puni succeeded in introducing a new dynamism into the relationship between viewer, picture, wall and space.

Similarly, at the First International Dada Fair in Berlin in 1920, the participating artists had already abandoned the traditional method of arranging pictures along visual axes. The paintings and panels of text were arranged asymmetrically on the walls, the sculptures stood freely in the space, and a pig-head puppet in a police uniform dangled from the ceiling. The overall design, however, was still oriented towards the individual object. Intervention in the architecture itself was not yet an option in those days. Nevertheless, the Dada Fair did come up with an innovation which may be seen as the spark that kindled the development described here. Johannes Baader showed *Das große Plasto-Dio-Dada-Drama: Deutschlands Grösse und Untergang durch Lehrer Hagendorf* (ca. 1920). This was the first modern sculptural assemblage ever to be presented in an exhibition.[5] Seen from the present perspective, it has often been compared to Kurt Schwitters' Merz column which was at the heart of his legendary *Merzbau*.

A striking position in the history of spatial collage is occupied by the *Proun* rooms by the Russian Constructivist El Lissitzky. Although he also did not touch the architecture as he found it, his spatial set-ups detach themselves from the parameters of the building and individual objects in such a way that they can be regarded as the earliest examples of free installation art.[6] Lissitzky used the term *Proun* to mean "creative forming (mastery over the space), by means of the economic construction of redeployed materials."[7] He bade farewell to the practice of painting walls or hanging pictures on them. He viewed his treatment of a wall no longer merely as a matter of imbuing the surface with rhythm, but as part of his endeavour to dynamise the space with elemental forms and materials. The most radical *Prouns* room in terms of autonomous composition was made in 1923 for the *Erste Russische Kunstausstellung* (*First Exhibition of Russian Art*) in the Galerie van Diemen in Berlin, and may be seen today as a reconstruction in the Van Abbemuseum in

Eindhoven. Unlike Lissitzky's *Demonstration Spaces*, which were made at the same time, the *Prouns* room was free of decorative or didactic aspirations. In 1926 Lissitzky made the so-called *Dresden Room*, a "demonstration space" for non-representational art, and in 1928 he produced his *Cabinet of Abstracts* for the Sammlung neuer Kunst in the Provinzialmuseum Hannover. The *Cabinet of Abstracts* may be seen today as a reconstruction in the Sprengel Museum Hannover. The term "demonstration space" already points to the main function of this installation: Lissitzky was increasingly conceiving his environments as didactic "experience spaces" for Constructivist works and designs. The *Dresden Room*, on the other hand, is specifically set up as an interactive space, and, by means of various mechanisms, can actually be made to react. "With every movement the visitor makes in the space, the effect of the walls changes, what once was white becomes black and vice versa. Thus the pacing of the human beings leads to 'an optical dynamism'. This renders the viewer active. The game with the walls is complemented by the cassettes gleaming through. The visitor raises and lowers the perforated lids, discovers new pictures or covers up what does not interest him or her. The visitor is physically forced to engage with the objects on show."[8] Precisely calculated optical and spatial effects thus led to a *work in motion*. However, the real key to a new concept of the work of art lies in the changed processes of its reception: the viewer becomes an alert participant. He/she enters a work of art and tests out its rules, without losing sight of his/her own experiences. He/she independently practices new modes of perception. And when visitors leave the work of art, they should take with them into their daily lives something of what happened inside.

In the context of the history of the avant-garde in art, much of which aimed at putting an end to the boundaries between art and life, many other artists were also seeking to find a practical use for their concepts of space. While Lissitzky was more interested in questions of aesthetic perception, numerous other artists were pursuing direct political and social aims. This was also the background to the environments in public places, such as the *Café Pittoresque*, designed by the Russian Constructivists Alexander Rodchenko, Vladimir Tatlin and Georgi Jakulow in Moscow in 1917, or the *Aubette* (1926–1928), a restaurant with a dancefloor in Strasbourg, with an interior designed by Hans Arp, Sophie Taeuber-Arp and Theo van Doesburg. However, the more the distinctions between the aspirations of art and the praxis of life were dissolved, the less likely it was that in these settings the viewer would come to an aesthetic experience of the difference between art and everyday life.

At the same time, the furnishing of private studios had acquired a new importance. Thus in his Paris studio in the rue du Départ, Piet Mondrian applied the same strict principles of composition that he adhered to in his paintings. In the end, however, his studio made no claims to being an independent work of art, but grew into a three-dimensional showroom, which above all provided an effective framework for his individual paintings.

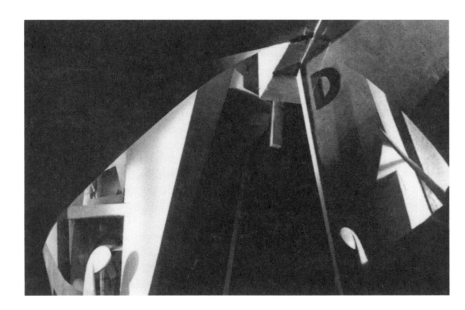

Kurt Schwitters, detail of the Hanover *Merzbau* with Madonna, ca. 1933

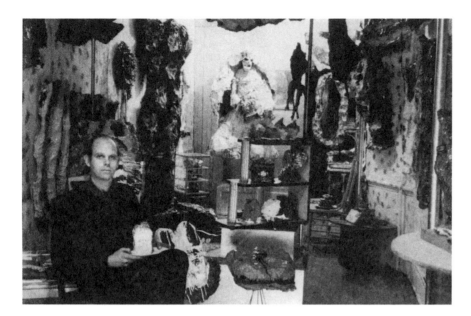

Claes Oldenburg, *The Store*, 1961–1962, Ray Gun Mfg. Co.,
107 East Second Street, New York

Similarly, up until 1923, Kurt Schwitters' studio only served as an artisti-cally inspired storage space for Dadaist works of art, snippets from newspapers, found objects from the street and other collage materials. It was only after 1923 that Schwitters started to gradually transform his studio into an architectonic, sculptural structure, his *Merzbau*. Although, like other artist-colleagues, he drew on his existing sculptures and paint-ings as the basis for further constructions, nevertheless Schwitters' new artistic strategy was aiming for a fundamentally different quality: as the *Merzbau* grew, so the original architecture disappeared. Now it was no longer a matter of painting or using walls, but of completely dismantling the old function of the space and turning his studio into a wholly uncon-strained space for experiencing art. The *Merzbau* was the logical applica-tion of the plea Schwitters had already made in 1919 for "pure art".[9]

Schwitters' idea of "merzing" his own studio grew gradually and need-ed some encouragement. His artistic orientation may well have been partly guided by his early rejection of the aims of the Berlin Dadaists. Unlike his Dada colleagues who proclaimed their allegiance to a form of aggressively polemical anti-art, in his relative seclusion in Hanover, Schwitters developed a rather more positive, forward-looking concept of art. "Merz" became something of a trademark for him. A particular fea-ture of Schwitters' collages and assemblages lies in their "evaluation", that is to say, in the harmonious balancing of all the individual parts. The colours, textures and materials of the found objects were juxtaposed

according to criteria that did not negate traditional concepts of art, but which enriched and complemented them. In contrast to the Berlin Da-daists, who almost exclusively used components in their collages that had some social or political significance, like scraps of newspaper, Schwitters did not subject his found objects to any specific selection process. His collages contain scraps found in the streets or in a printer's workshop just as much as fragments from art books and magazines or apparently chance individual found items. With this, if anything, apolitical collage technique, he was making a conscious choice not to follow the route of the Berlin Dadaists, who for their part reproached him with being "bourgeois" and excluded him from their circles.[10]

Through his friendship with Theo and Nelly van Doesburg, by the early 1920s Schwitters was starting to identify with the thinking of the Constructivists and the Dutch de Stijl group. An important project which cemented this link was the so-called "Feldzug Holland-Dada" [Holland Dada Campaign] which Kurt Schwitters, the van Doesburgs and the Hungarian artist Vilmos Huszár embarked on in the winter of 1922/23. During the course of this trip he came into close contact with the theo-ries of the de Stijl group, and it will have been of particular importance for Schwitters' later development that the Dutch artists were debating various concepts of space at the time and produced a manifesto in 1923, in which they described a Constructivist environment.[11] This was put into practice that same year in Theo van Doesburg's design for a uni-versity hall and in El Lissitzky's first *Prouns* room in Berlin. As it happens El Lissitsky himself moved to Hanover that same year.

Thus Kurt Schwitters was surrounded by unusually stimulating people and notions; Constructivist concepts of space inspired his own thinking and formed a mental platform on which the idea of "merzing" could set-tle. Meanwhile, the immediate impulse for the *Merzbau* may have come from a room that Schwitters visited during his Holland Dada Campaign: "In Amsterdam I saw a lunch room, where old bits of stalactites had been used to create an artificial stalactite cave. I asked myself in won-

der: 'why'. Do the people in Amsterdam find stalactite caves stylish? Yes? Then I'm right that the style in Amsterdam is stylelessness. And that is dada. Like in Berlin. And if it has to be a stalactite cave, why have it extended into infinity with massive mirrors? That little room in Amsterdam that says: 'The whole world is an endless lunch room in the form of a stalactite cave', that little room is utter dada."[12] This room became a kind of beacon for Schwitters, for in it he found one criterion that was also important in his own art production: the absence of any specific intention. Schwitters favoured a playful, experimental attitude to his materials and a meaning-free atmosphere open to new perceptions and experiences.

From the first beginnings of the *Merzbau* in 1923 up until roughly 1929, Schwitters was initially creating a walk-in Dada environment that was made – like his collages and assemblages – from everyday found objects. It was only in 1929 that he started to smooth and model the walls, painted them a uniform shade of white and added Constructivist forms. Some corners and showcases, however, retained their earlier style, dominated by fragments of materials. Thus, until its destruction during an air raid in 1943, the *Merzbau* displayed both Dadaist and Constructivist traits in its form. In its final stages it extended through three rooms in the living quarters of the Schwitters' house in Hanover.[13] The artist himself had various names for his *Merzbau*, including "Cathedral", "Cathedral of Erotic Misery" [Kathedrale des erotischen Elends] or simply "KdeE".

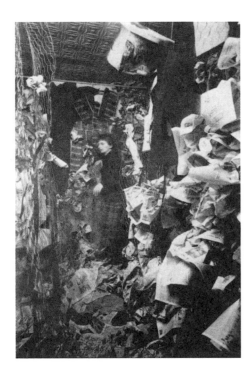

Allan Kaprow, *An Apple Shrine*, 1960,
Judson Gallery, New York

Few visitors had the opportunity to see the *Merzbau* with their own eyes. The artist preferred "to bloom in seclusion" and no doubt also wanted to maintain his own privacy. He could withdraw from daily life into this unique environment and when the National Socialists first put restrictions on his artistic activities and ultimately blocked them altogether, the *Merzbau* increasingly became a place of refuge for the artist. In its entirety the installation included numerous grottos and niches, with souvenirs from friends – locks of hair or neck-ties, for instance – walled into them by Schwitters. Ingenious electrical circuits provided dramatic lighting, at times guinea pigs enlivened the scene. Amongst the select few who were allowed to enter this intimate anti-world were Schwitters' artist-friend Rudolf Jahns and Alexander Dorner, the then director of the Provinzialmuseum Hannover. Both knew the *Merzbau* before it started to change after 1929. Rudolf Jahns remembers: "It was a strange feeling of detachment that overcame me at the time. This room had a quite particular life of its own. The steps that one took scarcely made a sound and there was absolute silence. Only the form of the grotto circled around me and brought to mind words that refer to the absolute in art."[14] By contrast, Alexander Dorner's brief account of the same space could hardly have been more different or dismissive. He described the Merzbau as a "collection of dirt and smears, a sick, sick-making regression into the social irresponsibility of a child playing with rubbish and dirt."[15]

The common core of these two reactions lies in the violent emotions that the *Merzbau* evidently sparked off. It was utterly at variance with prevailing concepts of a work of art and could not be accommodated within the framework of conventional hermeneutics. The wealth of materials and their intense effect on all the senses precluded an unambiguous, objective response from the viewer. The installation forced the visitor, both physically and mentally, to enter into the work and to succumb with all their senses to the rules of the game that were in operation there. Thus the *Merzbau* demonstrates a radical change in the modern understanding of art. Schwitters' wildly proliferating spatial collage marked an intermediate, directional highpoint on the path to a new way of dealing with art. The recipient had to relinquish his/her safe distance and become a *participating* viewer if he/she wanted to meet the challenge of modern works – unless they simply refused, as did the Hanoverian museum director, Alexander Dorner.

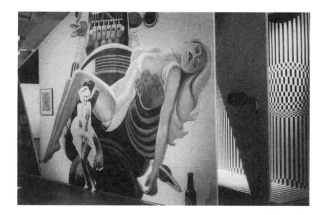

Detail of the exhibition *This is Tomorrow*, London,
Whitechapel Art Gallery, 1956, contribution by Richard Hamilton,
John McHale and John Voelcker

Amongst the fundamental aesthetic innovations which affected the previously distanced stance of the viewer, was the principle of openness which in turn led to the dissolution of traditional boundaries between different genres. The *Merzbau* was a *work in process* and, if Schwitters had had his way, would never have been finished; up until it was destroyed it was unfinished, "as a matter of principle".[16] The perpetual reorganisation and realignment of the materials meant that there was no final, fixed meaning. It was impossible to foretell the direction that would be taken by the processes of production and perception relating to the *Merzbau*, and this had to be constantly re-set. In keeping with this, the delineation of the work was permeable, on principle, although this meant it was also insecure and disturbing.

The *Merzbau* as an extended work of art could thus only be grasped and perceived by a participating viewer, who was literally prepared to let him or herself in for the work. This also meant both physically and mentally stepping across a threshold and, for the duration of one's stay *in* the artwork, allowing oneself to be enveloped in an alien, baffling subjectivity, albeit at the same time viewing oneself as a part of the art object. Thus the clear dividing line between subject and object shifted, opening up room for aesthetic experiences beyond fixed habits and patterns of perception.

This rich expansion of traditional notions of a work of art led to the *Merzbau* retaining its great interest for subsequent generations of artists right up to the present day, and to its being regarded by many as a key work in the art of the 20th century. And it is precisely its detachment from other avant-garde projects that today appears as an advantage and has given it its status as *the* original environment. Artists and art critics have long regarded the *Merzbau* as the "prototype of environmental sculpture"[17], which in turn has led to the unexpected, enduring influence of Schwitters.

Seen in this light, the *Merzbau* paved the way for the environments and Happenings of the post-war era. In Susan Sontag's view, "radical juxtaposition"[18] was the most notable feature of the New York Happenings by Allan Kaprow, Red Grooms, Jim Dine, Claes Oldenburg, George Brecht and other artists in the late 1950s. This also applied to the environments which could be regarded as the intellectual foundation for the Happenings and which at times were also chosen as venues. According to Allan Kaprow, the leading light amongst these artists, the path to Happenings and performance started with collage, it then led via Action Painting to assemblage and lastly to environments.[19] The artists involved in Happenings had largely been painters and, like the artists of the 1920s, were starting to search for new forms of expression that would encourage the viewer to develop a more active, intense response to art. And again, as it had been all those decades ago, the resulting aesthetic focused on urban waste and valueless materials, which the young artists then explored in their assemblages. In Kaprow's view, it was the collage that first inspired a particular thinking that is impure, that is to say anti-classical, anti-aesthetic and anti-traditional and which is about accepting not only the incidental, but everything that is there.[20] The *Merzbau* and Kurt Schwitters' collages thus became models for junk art. At the same time, however, they also inspired many artists working in Abstract Expressionism such as Robert Motherwell or Robert Rauschenberg with his *Combine Paintings*; two artists amongst many, who may serve to represent those many in this context.[21]

The first environments to be seen in the post-war period emerged in semi-public spaces, in galleries such as the Hansa Gallery or the City Gallery in New York that were run by artists. Rather more geared towards the wider public were the Reuben Gallery and the Judson Gallery which showed artists like Kaprow, Oldenburg and Dine, and which exchanged exhibitions with each other. This was where legendary environments such *An Apple Shrine* (1960) by Allan Kaprow were made, with the walls of the exhibition space entirely covered in crumpled newspaper. In the exhibition *Environments, Situations, Spaces* in the Martha Jackson Gallery in 1961, Claes Oldenburg presented *The Store* for the first time. He put brightly-coloured plaster objects in the shape of food and items of clothing in the front window of the gallery, like a chaotic shop window. Shortly afterwards he rented a shop for two months in East Second Street and sold his art objects there like ordinary consumer goods. He was playing with the mechanisms of supply and demand, producing stock in the workshop at the back that was then sold in the

The individual scenarios, in keeping with the dynamic overall concept, were neither 'finished' nor statically fixed. As was often the case in the art of the 1950s, a sense of collective flowing and growing was a recurrent motif in the individual works. The plenitude of materials and wealth of invention, common to all the works, cast a spell over visitors to the exhibition. The installations had quite obviously and very unusually been built *for* the general public, and were positively asking to be noticed. As Bazon Brock wrote: "these artistic entities that envelope the visitor are prey to their own potential negation, for they only exist as long as we move around within them. They cannot be prescribed for us. The form of their negation is decided by us, in that we determine our own participation in them."[25] This means that in the appropriation of this form of art, the criterion of attentiveness acquires a wholly new status as a constitutive element in the work itself. Without the *participating* viewer the art loses itself in meaninglessness. The walk-in collages in the tradition of Schwitters' *Merzbau* introduced attention *per se* as a new resource in the business of making art.

front shop.[22] Thus these spatial collages and marginal works from the 1950s and 60s had little to do any more with the seclusion of Schwitters' *Merzbau*. The New York environments were no longer private enclaves, but demonstrations that made an impact on the general public.

The chosen venues soon moved from the semi-public gallery world to art institutions steeped in tradition. As early as 1956, The Whitechapel Art Gallery in London put on the exhibition *This is Tomorrow* in which forty artists and architects showed work in a series of pavilions. A sequence of twelve booths transformed the exhibition space into a "total landscape"[23] of art, film and elements of photography. And in 1962 the Stedelijk Museum in Amsterdam presented *Dylaby*, which demonstrated the range of environments at the time in six different artistic positions.

The exhibition *Dylaby* is particularly notable because here, for the first time, six very different yet equally highly developed approaches to spatial collage were shown in immediate proximity to each other: this proved to be the first time the new genre of walk-in spatial installations found itself more profoundly situated as a topic in theoretical discourse Working together, Robert Rauschenberg, Martial Raysse, Niki de Saint-Phalle, Daniel Spoerri, Per Olof Ultvedt and Jean Tinguely had built a *dynamic labry*-rinth.

Daniel Spoerri took a fictive exhibition space complete with sculptures, paintings and visitors and turned it on its side by 90°. The result was an attack on the viewer's sense of equilibrium. Niki de Saint-Phalle showed a fairytale grotto with monsters and fabulous plants. Ultvedt's contribution was a high, quasi Constructivist structure using wooden lathes and transparent surfaces, while Raysse constructed a play-room with bright, plastic blow-up objects. However different the designs were, they all challenged the visitor and demanded a high level of awareness and attention. For Lucy R. Lippard the result was a "total or synaesthetic art recalling Kurt Schwitters' Merzbau construction, as well as the extravagant interior decorations of the International Surrealist Exhibitions from 1938 on".[24]

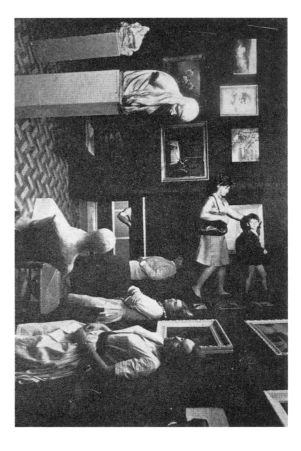

Daniel Spoerri, Installation in the exhibition *Dylaby*, Stedelijk Museum Amsterdam, 1962

Martial Raysse, Installation in
the exhibition *Dylaby*, Stedelijk
Museum Amsterdam, 1962

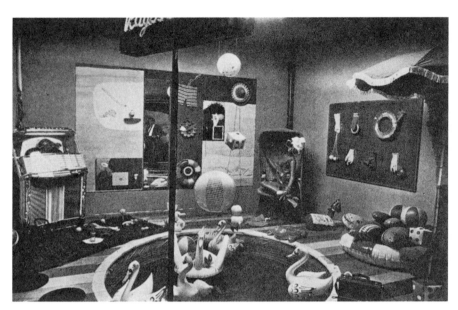

By way of a conclusion, we will look at the work of Gregor Schneider to represent those younger artists who almost literally capture their visitors in their environments. For many years now, in his rooms and performances he has been working on the notion of disappearance – of objects, of his own identity, of the physical being of the viewer. Over a period of ten years of constant rebuilding (1988–1998), he transformed his parental home into the *Haus u r*. As in the case of Christoph Büchel, with whom this essay began, Gregor Schneider's work as an artist starts with the bricks and mortar of human living. But the result, as it is experienced by the guest in his house, seems very different. The artist takes the safe haven of family life, the protective roof under which people eat, play and sleep, and fills it with a living nightmare. *Haus u r* is a labyrinth of confused layers of walls, shafts and spaces that have evolved over years of adding and repositioning many tons of building materials, during which time the artist himself has lost sight of the sequence of layers. Even x-rays would not reveal the truth because numerous rooms have lead cores. Normal life has been completely eliminated. If a visitor comes – in itself a rare event – they can only see round on a personally guided tour and quickly realise that they must completely yield up their trust in order to get out into the open air again. Certain twists in the route are easy to spot while others can only be discovered with help from the artist. Occasionally one encounters the remains of some former existence, there are rags here and there, preserving jars with conserves standing around. Some things, for which the artist once had a fondness, have now been walled in, Schneider remarks en passant. Everything is over-laid with a sense of extinction and disappearance. In some rooms, there is a semblance of normality: a guest room, completely white and nicely tidied, but outside the window there is another window and another window and then a wall. Or a little kitchen with a window: it seems to be light outside, and there is a curtain in front of the window, moving slightly in the gentle draught. But the fruit on the table is made from plastic, the window is fake, the draught comes from a ventilator, the light is from a spotlight, and in any case the whole kitchen is rotating slowly and imperceptibly on its own axis. The longer visitors stay in this house, the sooner they lose the cornerstones of their everyday orientation. Not a sound is heard from outside, all one hears is one's own footsteps and breathing. The smell of plaster and mortar invades one's nose, and without daylight one loses any idea of time. *Haus u r* simulates a situation with no way out, and fills the visitor with an inescapable sense of his or her own meagre, personal existence.

NOTES

1 Both the term 'installation' and 'environment' evolved in the context of American 'Junk Art' in the late 1950s, as descriptions of a three-dimensional walk-in collage or assemblage. The term 'Happening' is said to have first been used by Allan Kaprow in 1959, when he conceived *18 Happenings in 6 Parts* for the Reuben Gallery in New York. See Jürgen Claus, *Kunst heute,* Reinbek bei Hamburg 1965, p. 208. The terms 'spatial installation', 'environment' and 'walk-in collage' are used largely synonymously to refer to artist-designed interiors and exteriors.

2 Germano Celant, *Ambiente Arte. Dal Futurismo alla Body Art*, Venice 1977, p. 22.

3 Ibid.

4 A. B. Nakov (ed.), *Kasimir Malevich*, Paris 1975; *Iwan Puni (Jean Pougny), 1892–1956. Gemälde, Zeichnungen, Reliefs*, Haus am Waldsee, Berlin 1975.

5 Helen Adkins, 'Erste Internationale Dada-Messe Berlin', in: *Stationen der Moderne. Die bedeutenden Kunstausstellungen des 20. Jahrhunderts*, Berlinische Galerie, Berlin 1988, p. 167.

6 Celant 1977 (as note 2), p. 22.

7 Rolf Wedewer (ed.), *Räume und Environments*, Cologne and Opladen 1969, pp. 45f.

8 El Lissitzky, 'Demonstrationsräume', as quoted in: Uwe M. Schneede, *Künstlerschriften der 20er Jahre. Dokumente und Manifeste der Weimarer Republik,* Cologne 1986, p. 255.

9 Dietmar Elger, *Der Merzbau, Eine Werkmonographie,* Cologne 1999 (Diss., 1984), p. 47.

10 Adkins 1988 (as note 5), p. 157. This was also the reason why Kurt Schwitters was not represented at the *First International Dada Fair* in 1920 in Berlin.

11 John Elderfield, 'On a Merz-Gesamtwerk', in: *Art International*, vol. 21, part 6, Lugano 1977, p. 21.

12 Kurt Schwitters, 'Dadaismus in Holland', in: idem. (ed.), *Merz 1 Holland Dada,* Hanover, January 1923, p. 6.

13 Discrepancies regarding the number of rooms most probably go back to the artist himself sowing the seeds of myth.

14 Rudolf Jahns (1927), as quoted in: Elger 1999 (as note 9), p. 112.

15 Elger 1999 (as note 9), p. 16.

16 Letter from Kurt Schwitters to Christof and Lucie Spengemann, 25.4.1946, in: Ernst Nündel (ed.), *Kurt Schwitters. Wir spielen, bis uns der Tod abholt. Briefe aus fünf Jahrzehnten,* Frankfurt a. M. and elsewhere 1973, p. 194.

17 William S. Rubin, *Dada, Surrealism, and Their Heritage*, New York 1968, p. 56; see also Karin Thomas, *Bis heute. Stilgeschichte der bildenden Kunst im 20. Jahrhundert*, Cologne 1981, p. 139; and see also Hans Burkhard Schlichting, 'Dada Hannover', in: *Tendenzen der zwanziger Jahre. 15. Europäische Kunstausstellung,* Neue Nationalgalerie and elsewhere, Berlin 1977, pp. 3/82–3/89, here: p. 3/87.

18 As in the title of an essay by Susan Sontag, 'Happenings: an art of radical juxta-position', in: idem, *Against Interpretation and Other Essays*, New York 1986, pp. 263–274.

19 Allan Kaprow, *Assemblage, Environment and Happening*, New York 1967, pp. 155–165; see also Justin Hoffmann, '"You crumple and turbulate" – Kurt Schwitters and the Action Art of the Sixties', in this catalogue.

20 See statement by Allan Kaprow in: Wedewer 1969 (as note 7), p. 21.

21 William S. Rubin, *Dada und Surrealismus*, Stuttgart 1978, p. 150.

22 Barbara Haskell, *Blam! The Explosion of Pop, Minimalism, and Performance 1958–1964*, New York and London 1984, pp. 69f.

23 László Glozer (ed.), *Westkunst: Zeitgenössische Kunst seit 1939*, Rheinhallen Cologne 1981, p. 239.

24 Lucy R. Lippard, *Pop Art*, London 1966, p. 185.

25 Bazon Brock, in: *Environments*, Kunsthalle Bern 1968, as quoted in: Wedewer 1969 (as note 7), p. 21.

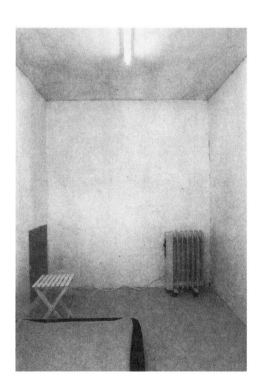

Gregor Schneider, *u r 12*, guest room, 1995, Rheydt

THE ELOQUENCE OF WASTE
KURT SCHWITTERS' WORK AND ITS RECEPTION IN AMERICA

KARIN ORCHARD

"I think I could do well in the USA." (Letter from Kurt Schwitters to Helma Schwitters, 11 June 1941)

Last year in the May issue of the American art journal *Artnews*, when the journal's editors together with critics and curators listed "the century's 25 most influential artists" Kurt Schwitters was not amongst those chosen. Instead the list named artists such as Max Ernst, Henri Cartier-Bresson, Walker Evans, Robert Rauschenberg, Mark Rothko and Marcel Duchamp. Despite this "relative absence of Kurt Schwitters"[1] in the late 20th century, in the 1950s and 60s he had been hailed along with Marcel Duchamp as a hero of Modernism and as a role model for avant-garde artists in the post-war period.

In order to analyse the response amongst artists in the USA to Kurt Schwitters' work, and its influence on the next generation, it is necessary to establish what artists, critics and curators living there could have known of his work. We have to ask which works from which periods of his career could be seen in the original, which of his theoretical and literary texts were available in English translations, how he was presented in publications and exhibition catalogues, in which contexts, in what kind of galleries, museums and exhibitions he was present? Since Schwitters, to his regret, never visited the United States, he did not have the opportunity to promote his work there personally nor to captivate audiences there with his skills as a speaker and performer. If he had been able to fulfil his plans to go the United States or even to emigrate there, his impact would no doubt have been that much greater, for he generally made a memorable impression with his pleasing, humorous yet eccentric personality.

Schwitters' contacts with the USA went back to 1920, the year after he had started to work on his so-called 'Merz' collage technique. The initiative came from the American collector Katherine S. Dreier, who was looking for new artists and ideas for the Société Anonyme, which she had founded with Marcel Duchamp and Man Ray in New York. In her search she travelled through Europe, assiduously making new contacts.[2] It was in Herwarth Walden's Sturm gallery in Berlin, that she first encountered the nailed and glued pictures by Schwitters that were causing a scandal at the time. Convinced of their quality, from then on she showed Schwitters' work almost every year in the exhibitions of the Société Anonyme which also used to tour throughout the United States. The most important of these exhibitions was certainly the *International Exhibition of Modern Art* in the Brooklyn Museum in New York in 1926.[3] Since the legendary Armory Show in New York in 1913, there had been no comparable major exhibition of international contemporary art in the United States. Katherine S. Dreier had asked Schwitters and his wife Helma to assist in the selection process, particularly for the Constructivist section. They both enthusiastically threw themselves into this task and acted as European agents for the Société Anonyme. In 1931 Schwitters was even appointed an Honorary President of the society. In the Brooklyn exhibition there was a total of eleven works by Kurt Schwitters on show.

Over the years Katherine S. Dreier purchased a large number of works by Kurt Schwitters from all the different stages in his career, both for her private collection and for the collection of the Société Anonyme. This became partly accessible to the general public when Dreier gave it to

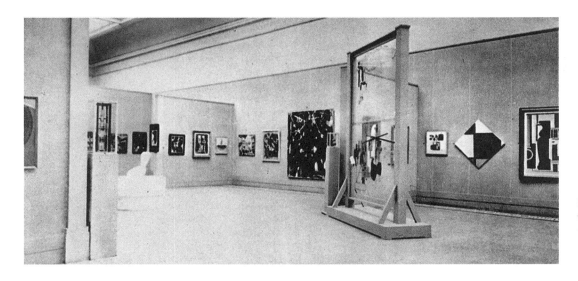

International Exhibition of Modern Art in the Brooklyn Museum of Art, New York, 1926, in the centre Duchamp's *Grand Verre*, left – cut – Kurt Schwitters' *Merz 1003. Peacock's Fan*, 1924

the Yale University Art Museum in 1941. After her death in 1952, Marcel Duchamp was named as the administrator of the private collection left in her estate. He donated nineteen works by Schwitters to the Museum of Modern Art (MoMA) in New York, another eleven went to the collection in Yale University Art Museum, three to the Solomon R. Guggenheim Museum in New York, one Merz picture and one collage to the Phillips Collection and two works to the American University in Washington. But Katherine S. Dreier's support for Schwitters did not stop at the purchase of works of art for her collection; she also smoothed the path for purchases by other leading private American collections and assisted the artist and his family financially during the difficult years of his exile. She did not meet him face to face until 1926 when she visited him in Hanover. There was a second meeting in 1929; once again they met in Hanover, this time together with Duchamp. There is no detailed record of this meeting, and we can only speculate as to how this single encounter between these two protagonists of Modernism may have gone. Schwitters felt greatly flattered by the interest Katherine S. Dreier took in him, particularly since this committed collector offered him a good chance of becoming better known in the USA. Yet Dreier found it difficult to interest a wider public in Schwitters' art. In her speech at the first one-man show of Schwitters' work in New York in the Pinacotheca Gallery in 1948, she was very open: "It has taken a long time for the American public to respond to the Schwitters though we had shown them already in 1920. I had thought that the response would come as quickly as did that of Klee, not realising that Schwitters was far more difficult for the average person to understand because he was purely the painter and there was no approach through the intellect which Klee reached through his whimsical delineation of ideas. This all happened 27 years ago and except for a few lovers of the rare quality of Schwitters' 'Merz' collages, he remained almost unknown in this country".[4] But by his first one-man show on American soil at the latest, Schwitters was recognised as a leading protagonist of abstract modernism.

Again through Dreier, in 1935 contact was made with the newly founded Museum of Modern Art in New York, which was – alongside the Société Anonyme – the most important institution for modern art. On Dreier's suggestion, the director of the Museum, Alfred Barr, visited Schwitters in Hanover, and bought one picture that year and two the following year for the Museum of Modern Art collection.[5] In the extremely influential exhibitions put on by MoMA in 1936, Cubism and Abstract Art[6] and Fantastic Art, Dada, Surrealism[7] there were collages by Schwitters and Merz pictures, as well as photographs of the Merzbau on display and illustrated in the catalogue. The catalogue essay in the shape of an introduction to Dada by Georges Hugnet devoted a whole section to Schwitters.

The regard that those responsible at the Museum of Modern Art had for Kurt Schwitters and his work is evident from the fact that they awarded him a Fellowship as a means of supporting him in his work on a third Merzbau. Since 1946 Schwitters, together with Alfred Barr and the curator Margaret Miller, had been working on plans to complete earlier Merzbuildings; initially the idea was to rebuild and restore the Merzbau in Hanover that had been destroyed in 1943 during the war; later on discussions turned to the question of completing the Haus am Bakken, the Norwegian Merzbau in Lysaker near Oslo which Schwitters had had to abandon when he fled the country. However, the wholesale destruction of the Hanover Merzbau and Schwitters' precarious state of health meant that neither of these was a viable possibility. By this time the artist was already living in the Lake District, which led him to consider undertaking a new Merz project in a barn in Elterwater near Ambleside. The first instalment of the Fellowship of a thousand dollars arrived punctually in June 1947 on his 60th birthday, and he started immediately on his Merzbarn. Yet this project, too, was never to be finished since Schwitters died early the following year.

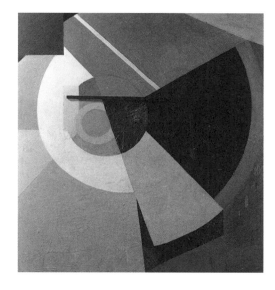

Kurt Schwitters, Merz 1003. Peacock's Fan, 1924, Yale University Art Gallery, Gift of Collection Sociéte Anonyme

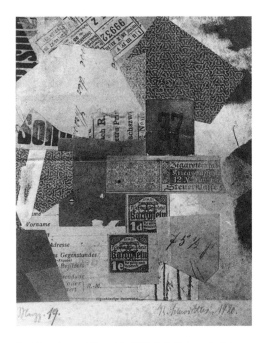

Kurt Schwitters, *Merz. 19*, 1920, Yale University Art Gallery, Gift of Collection Sociéte Anonyme

The exhibition was very positively received and reviewed. The most influential critic and promoter of the emergent Abstract Expressionism, Clement Greenberg, wrote that Schwitters and Hans Arp – even if at a "certain distance" – could be seen to be following in the footsteps of Picasso and Braque, the "great masters of collage".[10] Greenberg's estimation of the significance of collage resulted in a far-reaching reassessment of this technique: "The medium of collage has played a crucial role in the painting and sculpture of the 20th century, and it is the most trenchant and direct key to the aesthetics of genuine modern art."[11]

Since the planned one-man show of Kurt Schwitters' work in MoMA did not come to fruition, credit for putting on the first solo presentation of his work in the USA goes to a commercial gallery. At the same time, the exhibition in the Pinacotheca Gallery in New York also became, by force of circumstances, a memorial exhibition, since it opened shortly after the death of the artist on 19 January 1948. This exhibition had also been

In 1946, Schwitters also discussed other projects besides the Merzbau with the Museum of Modern Art: a one-man show, and another planned project that his participation in an international group show focusing on collage which involved was initially intended for summer 1947. However, both shows were repeatedly postponed – and in the end Schwitters' first one-man show in MoMA did not take place until 1985. During the earlier discussion period, Schwitters had already selected 39 recent collages and sent them to New York in four groups.[8] Some of these were shown in the major exhibition *Collage* which finally took place from 21 September until 5 December 1948, after Schwitters' death. Nineteen collages by Schwitters were shown, eight from 1946/47. Besides Picasso with twenty works and Max Ernst with twelve collages, Schwitters was one of the few artists in this influential exhibition whose work was shown in any great numbers.[9] This in itself bears witness to the recognition he enjoyed at MoMA as a pioneer of the art of collage. In the short introduction to the list of exhibits, his Merz art is described as being "distinct from the anti-aesthetic and political directness of the Dada movement in Germany" – a distinction that was to be very important for the subsequent reception of his work. Although Schwitters' œuvre has frequently been labelled as Dada, the qualities of his more aesthetic approach had in fact been recognised early on.

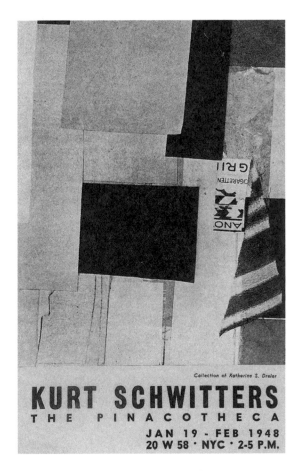

Catalogue pamphlet for the exhibition *Kurt Schwitters* in the Pinacotheca Gallery, New York, 1948

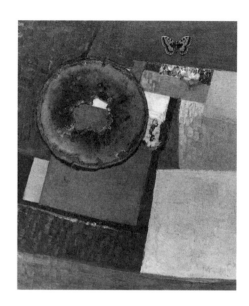

Kurt Schwitters,
Maraak Var 1. 1930,
Peggy Guggenheim
Collection, Venice

planned during Schwitters' lifetime and he had partly selected the works himself. Once again, it was Katherine S. Dreier who had introduced the gallerist Rose Fried to the work of the German Dadaist and who also supported the exhibition by lending works. Schwitters and Rose Fried had enjoyed a lively correspondence since late 1946 and were both enthused by their shared plans for an exhibition. In order to set this exhibition apart from the *Collage* exhibition which was scheduled to take place at the same time in MoMA, Schwitters suggested showing Merz pictures and sculptures as well as collages.[12] In the end the exhibition contained collages and constructions, mainly from 1946/47, with 26 entries in the catalogue.

Even before the exhibition had opened Rose Fried was already able to sell works, with the result that she asked Schwitters and Katherine S. Dreier to send more works.[13] From a commercial point of view the exhibition turned out to be a disaster, because while it was running only another two works were sold. But over time the situation changed and in October 1948 Rose Fried wrote to the artist's son, Ernst Schwitters, asking for more works, since "there is growing interest in them and I would like to put on an exhibition again this year, if possible".[14] The opening of a second one-man show with the title *Small Group of Collages by Kurt Schwitters* was, however, delayed until 1953. In 1954 and 1956 Rose Fried showed his work in group shows, amongst others in her important *International Collage Exhibition*, which took place in spring 1956, and with eighty-five selected works traced the development of collage from the beginnings of Modernism right up to contemporary works by artists such as Robert Motherwell, Lee Krasner and Anne Ryan, to name just a few of the American participants.

During the war and in the immediate post-war period, the reception of Kurt Schwitters' art reached one of its early highpoints. New York became a focal point for the avant-garde in art, and the Merz artist played an important part in this as an inspiration and role model. His increasing renown coincided with the emergence of an independent art scene and new artistic tendencies in the USA, the so-called New York School, Abstract Expressionism and Neo-Dada. There was even a suggestion that the new movement should be called Neo-Merz instead of Neo-Dada.[15]

Robert Motherwell is regarded as one of the leading exponents of Abstract Expressionism. His early works had been included alongside Schwitters' works in the aforementioned exhibition *Collage* in MoMA in 1948, as well as in the collage exhibition that Rose Fried put on in her gallery in 1956 However, the exhibition which had originally sparked off his interest in this medium had taken place much earlier. In 1942, Motherwell had met the American collector and gallerist Peggy Guggenheim, who had owned one of Schwitters' larger works since 1940 – his assemblage *Maraak Var I* of 1930 – and who had already exhibited five collages by Schwitters as long ago as 1938 in London, in the *Collage* exhibition in her first gallery, the Guggenheim Jeune.[16] Motherwell must certainly have been able to study her collection in detail, particularly since he later advised Peggy Guggenheim on art matters. In October 1942 she had opened her legendary Art of the Century Gallery in New York, and was planning the major international *Exhibition of Collage* for the following year, which was to include artists such as Picasso, Matisse and – of course – Schwitters. In addition this was to be the first overview exhibition of collage in the United States. The young American artists Robert Motherwell, Jackson Pollock and William Baziotes were also invited to contribute collages to this exhibition. All three were a little hesitant at first, since they had never made any collages before, and Motherwell and Pollock decided to carry out their first experiments in Pollock's studio This proved to be a crucial experience in Motherwell's development and from that point onwards, collage played a major part in his œuvre.[17]

Robert Motherwell was not only recognised as an artist but also made a name for himself as a leading critic and art historian, and as such he was responsible for *The Dada Painters and Poets: An Anthology*, which is still the standard work in English on the Dada movement. It first appeared in 1951 and quickly became a kind of bible for all those who were interested in Dada at the time. One might even go so far as to say that it was this publication that first aroused any real enthusiasm amongst artists and critics for Dada.[18] Motherwell was the first to introduce a wider English-speaking public and above all a large number of artists and critics to Schwitters' work and theory. In his introduction to the anthology, and similarly in the annotated bibliography by the librarian at MoMA, Bernard Karpel, Schwitters occupies more space than any other artist. A whole chapter is given over to an English translation of Schwitters' programmatic text *Merz* of 1920, in which he formulated his Merz theory for the first time. Another chapter contains Schwitters' text on 'Theo van Doesburg and Dada', and in Georges Hugnet's essay on the history of the Dada movement Schwitters again occupies a prominent position: "It was Schwitters who gave Dada its final impetus".[19] The basic artistic approach that Hugnet identified in Schwitters struck a nerve amongst the younger generation of American artists: "Walking along the street, he would pick up a piece of string, a fragment of glass, the scattered princes of the waste land, the elements of these infinitely inspiring landscapes. At home, heaps of wooden junk, tufts of horsehair, old rags, broken and unrecognisable objects, provided him with clippings from life and poetry, and constituted his reserves. With these witnesses taken from the earth, he constructed sculptures and objects which are among the most disturbing products of his time. To the principle of the object, he added a respect for life in the form of dirt and putrefaction. [...] Schwitters suggested the irrational tastes that we know from our dreams: spontaneity and the acceptance of chance without choice."[20]

Apart from Motherwell's anthology, at that time there were scarcely any English-language publications on Kurt Schwitters or translations of his texts. Carola Giedion-Welcker's essay on Schwitters, which first appeared in *Weltwoche* in 1947, and which was published in the *Magazine of Art* as an obituary in October 1948 with the title, 'Schwitters: or the Allusions of the Imagination', was the first extended, copiously illustrated text on Schwitters to become available in the English-speaking world. In addition there was also the small pamphlet-catalogue produced for the exhibition in the Pinacotheca Gallery in 1948, with texts by Katherine S. Dreier, Naum Gabo and Charmion Wiegand.

Even if the gallerist Rose Fried was more of an enthusiastic, idealistic art-lover than a successful business woman and art-dealer, nevertheless her exhibition made a major impression on the New York public and, as we know, on at least one artist: Anne Ryan.[21] Born in New Jersey in 1889, Anne Ryan was already 58 years old when she first came into contact with Kurt Schwitters' art. As a self-taught artist it had been some time before she started to explore print techniques, especially wood-cuts. She moved in artistic circles and knew Jackson Pollock, Barnet Newman and Hans Hofmann, who supported her in her work. However, she only arrived at her own language of forms – which brought her overnight recognition amongst the New York avant-garde – after she had visited the Schwitters exhibition in Rose Fried's gallery. Her daughter remembers that first visit to the gallery: "Mother went from one collage to another in a passion of delight. She knew instantly and completely that she had found her métier. And she was practically exalted. She had a great capacity for joy but I never saw her so consumed by it [...] We went home and before she put water on for supper, she was at her work table making collages. During the following weeks she visited the Fried Gallery a couple of times [...]."[22] In the six years until her death in 1954, Anne Ryan worked exclusively on collages. Her works were valued highly, yet her success is largely forgotten today. These small-format works, mainly in fabric and paper, display a fine feeling for materials combined with a sense of structure and pictorial composition; they show the influence of Cubism, of Paul Klee and – above all – of Kurt Schwitters.

Robert Motherwell, *View from a High Tower*, 1944, private collection, New York

In the early to mid-1950s, there were at least four exhibitions of Ryan's collages in the influential Betty Parsons Gallery in New York: three one-woman shows (1950, 1954 and 1955) and a joint show with Lee Krasner (1953).[23] The Betty Parsons Gallery was one of the few galleries in New York to specialise exclusively in contemporary art. Parsons had good contacts amongst important collectors and leading institutions for modern art such as the Museum of Modern Art. She was much respected by artists, particularly since she was a working artist herself. Yet, just like Rose Fried's gallery, the Betty Parsons Gallery never had the same commercial success as the comparable galleries owned by Sam Kootz, Leo Castelli and Sidney Janis. Betty Parsons, looking back, commented that when she opened her gallery in 1946, of the fifteen or so galleries in New York at the time, only three or four specialised exclusively in contemporary art.[24] At the time in New York there were only around fifty professional artists, everyone knew everyone and they were on familiar terms with one another.[25] People talked about art with the European émigrés amongst their numbers, and visited the few exhibitions that showed the new, radical works of the avant-garde. Kurt Schwitters was by no means unknown in these circles.

In September 1948, Sidney Janis opened his gallery space at 15 East 57th Street – directly opposite the Betty Parsons Gallery.[26] Thanks to the triumphant progress of Abstract Expressionism Sidney Janis established himself as an extremely successful gallerist and art-dealer, since early on he had managed to entice the most promising young artists away from Betty Parsons, including Jackson Pollock in 1952, Franz Kline and Mark Rothko in 1953, and Robert Motherwell the year after that. Sidney Janis' practice was to show these younger artists either together with or alternately with established exponents of Classical Modernism such as Fernand Léger or Piet Mondrian, in order to break down the wider public's resistance to new art forms. One of the modernists, whom he exhibited very frequently in the years to come, was Kurt Schwitters. Shortly after the latter's death, Janis had made contact with Edith Thomas,

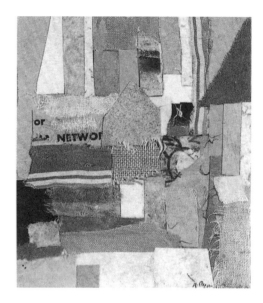

Anne Ryan,
Untitled, no. 140,
ca. 1948–1954,
Washburn Gallery,
New York

Schwitters' companion during the last years of his life in England, and had acquired a large number of works from her, either buying them directly or taking them on commission. These were predominantly collages from Schwitters' late period in England, since the artist had had to leave his early works and his large Merz pictures behind in Lysaker and Hanover when he fled to England. Thus the American public was much more familiar than its European counterpart with the late collages from the ensembles on loan to MoMA, to Rose Fried and from Edith Thomas.[27] In contrast to the rediscovery of the Merz artist in post-war Europe, which – largely due to the preferences of Werner Schmalenbach and the artist's son, Ernst Schwitters – concentrated on the early 'classical' Merz drawings and pictures, there had been a continuous interest in Schwitters' works in the USA since the early 1920s, and in the 1950s this was directed above all to the late works, for the reasons touched on earlier.

Furthermore, in the USA there was now an independent, self-confident art-market demanding to buy Classical Modernist objects. The extensive one-man shows of Kurt Schwitters' work in the Sidney Janis Gallery in 1952 (with a catalogue that listed 70 works), 1956 (57 works), 1959 (75 works) and 1962 (54 works) were therefore the first exhibitions of his work to be commercially successful. Whereas Rose Fried had still been asking $75 for a collage in 1947, and had passed $50 of that on to the artist,[28] by 1954 Sidney Janis' price for a late collage had already risen to $300.[29] Schwitters' work, just like the abstract American art of the time, had meanwhile become so popular that it even found its way into lifestyle magazines such as *Vogue*.[30] In the 1950s Sidney Janis became the most important dealer for Schwitters' work in the USA; his works were now being bought by major private collections such as those owned by the Rothschilds and the Rockefellers. In the early 1960s, how-

View of the exhibition *Kurt Schwitters* in the Sidney Janis Gallery, New York, 1952

dismiss him as an imitator. He himself later denied that Schwitters had been a direct influence and claimed that he had only become aware of the art of the Dadaist after he had already evolved his own style. In view of the immediate proximity of the two galleries, and the small number of artists, gallerists and critics in New York amongst whom Rauschenberg moved, and whose conversation would often turn to Schwitters and Dadaism in those days, this claim of ignorance is somewhat unconvincing. Moreover, Schwitters was not only the subject of four one-man shows in the Sidney Janis Gallery, he was also present in a whole variety of group shows. And in addition to that, the gallery had extensive storage space – even today it still owns over forty collages – which any interested party could have access to, so that by 1953 at the latest, Rauschenberg will have had ample opportunity to see works by Schwitters, with the exception of the 1952 exhibition, because at the time he was travelling in Italy with Cy Twombly. At the same time, it is perfectly possible that he could have visited the 1948 exhibition in the Pinacotheca when he spent a few days in New York in February.[31] In an

ever, Janis' had to yield his dominant position to Marlborough Fine Arts who had signed an exclusive contract with the administrator of the artist's estate and henceforth, working with the artist's son, Ernst Schwitters, coordinated all future activities worldwide, such as exhibitions and sales, thereby contributing to the growing fame of the artist beyond the United States.

It is not only to Sidney Janis' credit that he established Kurt Schwitters in the American art-market. This New York gallerist also nurtured the popularity of Dada in the United States. One of the most influential exhibitions of this movement was *Dada 1916–1923* in April and May 1953 in the Sidney Janis Gallery. None other than Marcel Duchamp was in charge of the hanging, and he also designed the catalogue: a poster-sized sheet of silk-paper, printed, and crumpled into a ball, which then had to be retrieved from a trash can. Schwitters' work was on prominent display in this exhibition: the catalogue lists six of his works which were shown along with publications and his *Merz* magazines.

One of the visitors at this exhibition was Robert Rauschenberg. This visit is Rauschenberg's earliest recorded encounter with Schwitters' œuvre. He, too, was one of Betty Parsons' artists and had his first one-man show in her gallery, opposite Sidney Janis' rooms, in 1951. Rauschenberg is often hailed as Schwitters' greatest successor, although some

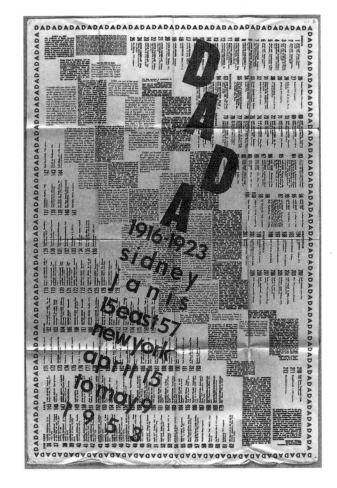

Poster catalogue for the exhibition *Dada 1916–1923* in the Sidney Janis Gallery, New York, 1953, designed by Marcel Duchamp

interview in 1965, he recalled that on a visit to a Schwitters exhibition it had felt "as if the whole exhibition had been made just for me",[32] and, later on, that he had "found out about collages because everyone was talking about Schwitters and I wanted to know more about him".[33] He even bought some late collages by Schwitters, as did Jasper Johns and Cy Twombly.

On closer examination, the influence of the Merz artist appears to be self-evident, particularly when one compares Rauschenberg's early work from the 1950s, his *Red Paintings* and his *Combine Paintings* with Schwitters' late works. Of course their aims and solutions are different, for despite their comparable use of waste and debris, Rauschenberg has quite different artistic intentions. His aim is to show that found objects retain their everyday identity, even if they become part of a work of art. Rauschenberg operates in the realm between art and life, while Schwitters wants to bridge the gap between art and life.[34] All materials, even waste, seem to the Dadaist to be suitable components in a work of art. This transformation is the main preoccupation of Merz.

"The waste of the world becomes my art" – this quote from Schwitters served as the motto for the first comprehensive book on collage that was published by Harriet Janis (the wife of Sidney Janis) and Rudi Blesh in 1962. This publication marked the highpoint of Schwitters reception in the 1950s and 60s in the United States, for it is enhanced with numerous illustrations of his work, his writings are quoted to explain his theories and his name is on practically every page. The authors draw their critical investigation of collage to a close with the following statement: "Schwitters moved from dada to a prophecy of this generation's leap from anti-art's social and esthetic protest to the calm acceptance of our harvest of junk as material for a truly contemporary art – and let the chips of meaning fall where they may. They use junk as an act of moral and esthetic integrity, as the only realistic course. Their intellectual god is Marcel Duchamp who preceded dada, then transcended its negative limitations; their guide is Schwitters who heard the mute eloquence of our waste."[35] Due respect is paid to the inventors of modern collage – Picasso, Braque and Arp, but Schwitters takes precedence as the true master of collage using found objects.

In the critical assessment in the 1950s and 1960s of the precursors and the progress of post-war art, Schwitters was seen as the equal of Marcel Duchamp. Often the two were named in the same breath when it came to identifying the most important influences on art until well into the 1960s and 70s – not to mention literature, sound poetry and music. American artists and critics recognised Schwitters' achievements even if his unwieldy, scarcely narrative abstraction meant that he never attained the wide public acclaim of a Picasso or Paul Klee. He is often described as an 'artist's artist', whose real impact came when artists pursuing new directions – in Abstract Expressionism, Neo-Dada and Pop Art – were searching for role models and inspiration, and found a rich seam in Schwitters' late work.

Kurt Schwitters, *Modish*, 1947,
formerly collection of Robert Rauschenberg

NOTES

1 Rudi Fuchs, *Conflicts with Modernism or the Absence of Kurt Schwitters/Konflikte mit dem Modernismus oder die Abwesenheit von Kurt Schwitters*, Bern and Berlin 1991.

2 See Gwendolen Webster, 'Kurt Schwitters and Katherine Dreier', in: *German Life and Letters*, vol. 52, no. 4, 1999, pp. 443–456.

3 See Ruth L. Bohan, *The Société Anonyme's Brooklyn Exhibition. Katherine Dreier and Modernism in America*, Ann Arbor 1982, pp. 47f., 55.

4 Katherine S. Dreier, unpublished manuscript (carbon copy), Kurt Schwitters Archive in the Sprengel Museum Hannover.

5 *Reichardt-Schwertschlag Der Weihnachtsmann*, 1922, Collage, 18.7 x 15.2 cm; *Mz. 379. Potsdamer*, 1922, Collage, 17.9 x 14.4 cm; *Zeichnung A 2 Haus. (Hansi)*, 1918, Collage, 17.9 x 14.5 cm.

6 The works exhibited were *Strahlen Welt Merzbild 31B*, 1920, and *Merzkonstruktion (oben)*, 1921, as well as four collages from 1921 to 1926, both assemblages were illustrated in the catalogue.

7 The exhibits included *Strahlen Welt Merzbild 31B*, 1920, three collages from 1920 to 1922 and nine photographs of the *Merzbau*; the Merz picture and two photographs of the *Merzbau* were illustrated in the catalogue.

8 Lists from the estate in the Kurt Schwitters Archive in the Sprengel Museum Hannover.

9 According to the hectographed exhibition list 102 works were shown. There was no catalogue, although there was evidently a plan to publish one, see the letter from Margaret Miller to Kurt Schwitters, 29 November 1946, copy in the Kurt Schwitters Archive in the Sprengel Museum Hannover.

10 Clement Greenberg, untitled, in the column 'Art', in: *The Nation 167*, no. 21, 27 November 1948, pp. 612ff., reprinted in: idem, *The Collected Essays and Criticism*, ed. by John O'Brian, Chicago and London, 1986, pp. 259–263, here p. 262.

11 Ibid., p. 259.

12 Letter from Kurt Schwitters to Rose Fried, 25 January 1947, Archives of American Art, Rose Fried Gallery Papers, microfilm no. 2206.

13 Letter from Rose Fried to Kurt Schwitters, 27 May 1947, Kurt Schwitters Archive in the Sprengel Museum Hannover. Amongst other things she sold a collage to a "young artist", see letter from Rose Fried to Katherine S. Dreier, 25 March 1947, Yale University, The Beinicke Rare Book and Manuscript Library, New Haven, Box 29, Folder 838. Unfortunately it is not possible to say who this artist might have been.

14 Letter from Rose Fried to Ernst Schwitters, 31 October 1948, Kurt Schwitters Archive in the Sprengel Museum Hannover.

15 Irving Sandler, 'Ash can revisited', in: *Art International IV*, no. 8, 1060, p. 29, as quoted in: Maria Müller, *Aspekte der Dada-Rezeption, 1950–1966*, Essen 1987, p. 86.

16 The Surrealist painter Roland Penrose acted as advisor for the exhibition. He and the art-critic Herbert Read, who also knew Peggy Guggenheim very well and helped her when she was planning her museum, had been the main organisers of the Exhibition of *Twentieth Century German Art* in the New Burlington Galleries in London, in which Schwitters was represented and which Peggy Guggenheim certainly saw. Herbert Read was one of the few who stood up for Schwitters in England and had written an essay for Schwitters' first one-man show in Jack Bilbo's Modern Art Gallery in London in 1944. The close friendship between Peggy Guggenheim and Nelly van Doesburg provided another chance to become acquainted with Schwitters' work, in that Nelly van Doesburg had long been a friend of Kurt Schwitters and owned numerous collages by him; a further chance was through the Belgian Surrealist E. L. T. Mesens, who had been a friend of Schwitters since 1927. With his London Gallery Mesens was Peggy Guggenheim's neighbour in Cork Street and presented Schwitters' second one-man show in England in his gallery in 1950.

17 See H. H. Arnason, 'On Robert Motherwell and his Early Work', in: *Art International X*, no. 1, 1966, pp. 17–35, here p. 23.

18 For instance Barbara Rose, 'Dada Then and Now', in: *Art International VII*, no. 1, 1963, pp. 22–28, here p. 28.

19 Georges Hugnet, 'The Dada Spirit in Painting', in: Robert Motherwell, *The Dada Painters and Poets: An Anthology*, New York 1951, p. 162.

20 Ibid., pp. 163f. The text had been previously published in a slightly different version in the Museum of Modern Art exhibition catalogue, *Fantastic Art, Dada, Surrealism*, 1936.

21 On Anne Ryan see: *Anne Ryan Collages*, Brooklyn Museum, New York, 1974; Donald Windham, 'Anne Ryan and her collages', in: *Artnews*, 73, no. 5, 1974, pp. 76–78; *Anne Ryan. Collages from Three Museums*, Washburn Gallery, New York, 1991.

22 As quoted in: *Painting and Sculpture from the Collection*, Walker Art Center, Minneapolis, 1990, p. 447.

23 Lee Hall, *Betty Parsons. Artist, Dealer, Collector*, New York 1991, pp. 182f.

24 Laura de Coppet and Alan Jones, *The Art Dealers*, New York 1984, p. 23.

25 Peter Watson, *Sotheby's, Christie's, Castelli & Co. Der Aufstieg des internationalen Kunstmarkts*, Düsseldorf and elsewhere 1993, p. 346.

26 On the history of the gallery see: *Three Generations of Twentieth-Century Art. The Sidney and Harriet Janis Collection of the Museum of Modern Art*, Museum of Modem Art, New York 1972, pp. 210–230.

27 For more detail see Karin Orchard, "'Meine Zeit wird kommen'". Voraussetzungen der Rezeption von Kurt Schwitters in Europa und den USA', in: *Entdeckungen in der Hamburger Kunsthalle. Essays zu Ehren von Helmut R. Leppien*, Hamburger Kunsthalle, Hamburg 1999, pp. 65–69.

28 Letter from Rose Fried to Kurt Schwitters, 27 May 1947, Kurt Schwitters Archive in the Sprengel Museum Hannover.

29 Illustration of the collage *PA CO*, 1947 and picture caption including the price in: *Vogue*, December 1954.

30 See Serge Guilbaut, *Wie New York die Idee der modernen Kunst gestohlen hat. Abstrakter Expressionismus, Freiheit und Kalter Krieg*, Dresden and Basel 1997, pp. 215 und 238f.

31 For a detailed biography of Robert Rauschenberg see Joan Young and Susan Davidson, 'Chronologie', in: *Robert Rauschenberg. Retrospektive,* Museum Ludwig Köln, Ostfildern/Ruit 1998, pp. 551–553.

32 As quoted in Roni Feinstein, *Random Order: The First Fifteen Years of Robert Rauschenberg's Art, 1949–1964*, Diss., New York University, Ann Arbor 1990, p. 158.

33 Robert Rauschenberg in conversation with Barbara Rose, in: Robert Rauschenberg et al., *Kunst heute*, no. 3, Cologne 1989, p. 59.

34 See Joachim Jäger, *Das zivilisierte Bild. Robert Rauschenberg und seine Combine Paintings der Jahre 1960 bis 1962*, Klagenfurt and Vienna 1999, pp. 52–63.

35 Harriet Janis and Rudi Blesh, *Collage. Personalities, Concepts, Techniques*, Philadelphia and New York 1962, p. 255.

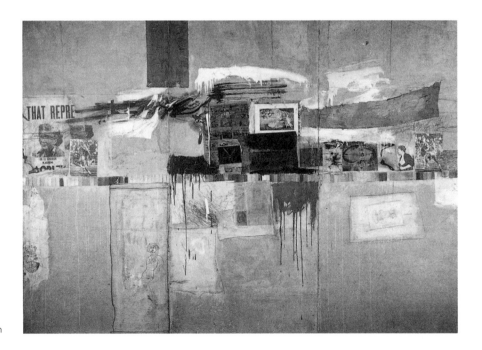

Robert Rauschenberg,
Rebus, 1955, private collection

FATHER OF THE FATHERS OF POP: KURT SCHWITTERS

ISABELLE EWIG

In 1979 Reyner Banham made the film *Fathers of Pop – The Independent Group*, documenting the work of this group founded in London in 1952. Amongst others its members included the artists Eduardo Paolozzi, Richard Hamilton and John McHale, with the critic Lawrence Alloway and Reyner Banham himself providing the theory to go with the practice. The group used to meet informally to talk about topics from science and technology, architecture and art. Since the making of that film there has no longer been any doubt as to the pioneering role British artists played in the genesis of Pop Art: well before their American colleagues they had already come up with the new visual language. As a result, the socio-political context of the evolution of Pop Art was re-examined anew.[1] This essay will focus on Kurt Schwitters' part in the genesis of Pop Art from the point of view of both iconography and context, even although Schwitters, along with Marcel Duchamp and Max Ernst, was only one of the role models that this new generation of artists turned to.

Kurt Schwitters' writings on the genesis of his Merz pictures reveal a will to construct that brings to mind his argument with the Berlin Dadaists and his sympathy for the Constructivists. It almost seems as though the underlying principle of Merz could be understood as a metaphor for the reconstruction of Europe after the First World War. But after 1945, too, Merz was again convincingly relevant, although this time the Constructivist aesthetic (that once again had to be adapted to fit the circumstances) did not emerge victorious. Perhaps Schwitters had meanwhile become aware of the collapse of the Utopia that had been the driving force behind this aesthetic. Whatever the case, the reconstruction of the world that he now saw before him was obviously guided by different values. In a mixture of irony and fascination Schwitters reflected these values in several collages in the 1940s. The collage *EN MORN* of 1947 is typical of this. The English sentence "These are the

things we are fighting for" at the lower edge of the picture would appear to underline its meaning. In a certain sense it is even the key to the picture, for in 1947 this slogan used by the Allies was still very much alive in people's minds. Its mere mention was no doubt enough to awaken memories of the war and to evoke images that did not have to be specifically depicted in the collage itself. Even today, a glance at the July 1940 issue of the magazine *Picture Post* is enough to give an impression of the effect of this slogan. An article with the title 'What we are fighting for' compares Hitler and Churchill, totalitarianism and democracy. This slogan for freedom also recalls the London exhibition *For Liberty* which was put on in March 1943 by the Artists' International Association. This exhibition took the statutes of the Atlantic Charter of August 1941 as its central theme, with other sections of the exhibition allocated to 'This is what we are fighting for', 'This is how we are fighting' and 'This will happen unless'. Oskar Kokoschka's picture with the telling title *What we are fighting for* is the only work from that show that has entered the annals of art history. It is part of a series of political allegories made between 1939 and 1943 and is a "crushing denunciation of warfare in general and the social circumstances in which it is fermented."[2]

The struggle that Kokoschka was focusing on is the same one that the slogan on the lower edge of *EN MORN* was referring to four years later. Where Kokoschka was caught up in the present and in the event itself – his picture was made during the Second World War and was designed as an accusation against the present he knew – Schwitters' collage intervenes *a posteriori*, as it were, in that he makes *EN MORN* into a

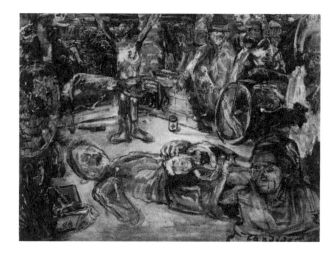

Oskar Kokoschka, *What we are fighting for*, 1943,
Kunsthaus Zürich

work about the past, a work about memory. But the challenging, solemn sentence that functions like a picture caption by virtue of its placement in the collage, also points to a different, comparatively undramatic struggle that is alluded to in the pictorial elements used by Schwitters: peppermint chocolate wrapping paper and the torn label from a jar of peach conserve (with a fragment of the trade name [GOLD]EN MORN at the top edge), a picture of a platinum blonde pin-up girl and a tranquil landscape. The fact is that the struggle against Fascism and for peace was followed by the struggle for modern comfort, for prosperity, distraction and consumption, a trend that came directly from the United States. Schwitters confronts both realities in a single picture. The bitter irony in this engagement with contradictory worlds is immediately reminiscent of the late collages by Richard Hamilton and Eduardo Paolozzi. If it is the latter that springs most vividly to mind, then this is not only due to iconographic parallels but also to the fact that Schwitters and Paolozzi were working at the same time as each other: the British artist was making collages such as *I Was a Rich Man's Plaything* in the same year as Schwitters made *EN MORN*. Like Schwitters, Paolozzi mixes the visual language of the relative prosperity of the post-war period with memories of the war itself, in his case by including a picture of a bomber and the provocative slogan "Keep 'em flying!" in *I Was a Rich Man's Plaything*. The iconographic affinity between Schwitters' and Paolozzi's work is no coincidence, but goes back to their similar experiences during the war, despite the considerable difference in their ages – a gap of almost forty years separates the two. Paolozzi had grown up in Edinburgh as the son of poor Italian immigrants, and during the 1930s had spent his summer holidays in Italy in Mussolini's youth camps. When war broke out (Paolozzi was only sixteen years old at the time), he and his family were interned as 'hostile aliens'. (His father was later killed in a torpedo attack on the *Arandora Star*, at sea in the Atlantic.) Three months later Paolozzi was released and – paradoxically but typically for the time – was draughted into the Royal Pioneers Corps to fight against the Italians and the Germans from June 1943 until September 1944. The images of war that emerge in the work of both Schwitters and Paolozzi go back to similar experiences. The other reality, that both artists con-

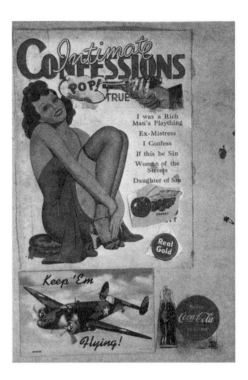

Eduardo Paolozzi, *I Was a Rich Man's Plaything*, 1947, Tate Britain, London

trast with the events of the war, is, however, more dream than reality. Their images of luxury and prosperity have little to do with the socio-economic and cultural conditions in post-war Britain, where widespread shortages continued into the 1950s, and where London was having to rebuild after war damage. Thus for both Schwitters and Paolozzi the present – both in relation to the past and to a virtual, idealised present – turned into a possible image of a near future. In Paolozzi's case this dichotomy is not only evident in his collages. It is also apparent in some of his sculptures, which "carry traces of the imprints of manufactured objects, from bombsights to polyethalene toys".[3] In a talk given in 1958, the artist invoked the past war, remembering a Nazi fighter plane that had been shot down: "[…] bent and torn but still recognisable as a Junkers. The rump, part of its bared anatomy like a wounded animal! A piece of zinc alloy, filled with Scottish shale. *Fragments of an autobiography.*"[4]

In 1943 Paolozzi started to take an interest in pictures in illustrated magazines. While he was attending evening classes at the Edinburgh College of Art because he wanted to become a commercial graphic artist, he started to collect pages from magazines, which he then archived in his *Scrapbooks*. It was not until 1945 that he started to use this material for collages. In this respect the few months that he spent in London,

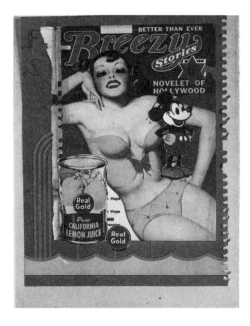

Eduardo Paolozzi, *Real Gold*, Tate Britain, London

Kurt Schwitters' own indirect contact with 'the American way of life' was through Käte Steinitz who had emigrated to the United States in 1936. In her letters she took particular delight in describing the Americans' eating habits, claiming that they "ate applepie with american cheese, pears with creamcheese and ham with pineapple (ananas) and everything with everything",[7] like corn flakes, peanut butter and, above all, hamburgers. But Käte Steinitz knew only too well that none of these things were to be had in Europe: "I wish I could feed ALL my european friends which are left instead of telling food stories."[8]

This remark shows clearly the gulf between post-war Europe and the consumer society in the United States. It also explains the irony in the collages by Schwitters and Paolozzi, even if neither could resist a certain fascination with the current wave of consumerism, although this really only crossed the Atlantic in the form of images. In Schwitters' case, Käte Steinitz also fulfilled an important mediating role. In 1946 she came up with the idea of wrapping everything she sent the artist in 'funnies': "These are popular figures," she explained to him, "and go on for years this TRACY, or RED RIDER, or POPPEYE. They are the step of devel-oppement toward DISNEY, who would not be possible without the tradi-tion of the FUNNIES. [...] It is very commonplace and stupid, but popular. The ENIGMATIC AMERICAN SOUL...."[9] At first sight Schwitters did not find the American comics amusing, and Käte Steinitz explained to him, "I also cannot laugh about Funnies and I am bored, but I think it is the origin of Disney. Donald Duck for instance is a Funny Feature... more than Chaplin. It is also on the line of Busch (the continuation story of accidents), only they are flat and materialistic and trivial and have no Busch philosophy."[10] She therefore encouraged Schwitters to "merz" some American comics and greetings cards, for "without Merz all this is Kitsch and trivial and stupid, with Merz it becomes "cosmic" sozusagen [so to speak]."[11] The result of all of this was, amongst other things, the renowned collage *For Käte*, which was subsequently cited in every general history of Pop Art as a forerunner to the movement.

enrolled at St. Martin's School of Art, were crucial. While he was there he frequently visited E. L. T. Mesens' London Gallery, where he discovered the great exponents of Surrealist collage, but also Kurt Schwitters (whose exhibition mounted by the London Gallery he also visited). "So the idea of collage did not come to me at art school, but at the sight of Schwitters' collages, which I even saw in the original as far as possible."[5]

As far as contemporary avant-garde trends were concerned, Paolozzi was much affected by his encounter with Tristan Tzara in Paris where he had settled in June 1947. In Paris Paolozzi was also fascinated by the images of the American culture of consumption which were increasingly spreading through Europe, and he stocked up with basic collage materials from his American friends. "Many Americans were living there with their wives. As ex-GIs they found Paris a better place to live. That was how I acquired the bulk of my materials, for example magazines from the wives of these American friends. They in turn had everything sent to them from the States."[6]

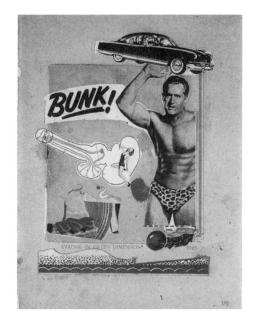

Eduardo Paolozzi, *Evadne in Green Dimensions*, 1952, Victoria and Albert Museum, London

Kurt Schwitters, *Scenery*, 1947,
private collection

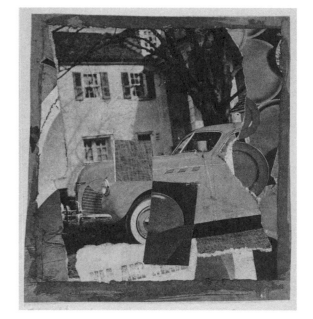

The glamour of cinema advertising also appealed to Schwitters during
this period. Stars and anonymous advertising beauties people his col-
lages, Bing Crosby, for instance (on a still from a war film) and Rita Hay-
worth (from a cosmetics advertisement). Combined with reproductions
of works like Franz von Defregger's *Der verwundete Jäger* and *Muse-
stunde* they give traditional images a contemporary feel.

Although Schwitters chose similar iconographic materials to Paolozzi,
that is to say comic strips and images of luxury and glamour, the same
visual vocabulary leads to very different results. Schwitters' collages use
snippets of images; this diminishes their capacity to transmit information
directly. Moreover Schwitters used them cumulatively, with the result
that each scrap loses something of its own meaning for the sake of the
work as a whole. Paolozzi on the other hand respects the integrity of
individual items and only ever places them next to each other. Thus each
single component remains recognisable and preserves its own informa-
tion value. By juxtaposing the different elements, Paolozzi wants to
heighten the impact of each, in order to demonstrate the representative,
even archetypal character of each: "My aim was to connect those found
images with my own experience and by this means to make an icon, a
totem, different symbolic forms."[12]

This practice led to the famous epidiascope projection of 1952, when
the Independent Group put on its first event: for several hours, in a rapid
sequence, Paolozzi showed his collages and pages from the Scrapbooks
which he henceforth referred to as *Bunk*, a slang expression that he
used to mean something like 'nonsense' or 'rubbish'.[13] These images
which he had started to collect in 1943 and later also presented in public
became an important source of inspiration for the Independent Group.
Furthermore they provided the necessary incentive to launch the debate
on "mass-produced urban culture".[14] One collage made by Richard
Hamilton in 1965 encompasses all the themes that occupied the group
from the time of its foundation up until it was finally dissolved. He had
chosen its components from a list of topics: "Man – Woman – Humanity

– History – Food – Newspaper – Cinema – TV – Telephone – Comics (pic-
ture information) – Tape recording (aural information) – Cars – Domestic
appliances – Space",[15] all of which he considered suitable for addressing
the question, *Just what is it that makes today's homes so different, so
appealing?* This step amounts to a systematisation of Paolozzi's ideas
and a will to create a programmatic work, which was obviously influ-
enced by the circumstances surrounding the making of this collage: it
was conceived as a poster for the exhibition *This is Tomorrow*, which
took place in the Whitechapel Art Gallery in summer 1956 and was co-
organised by the Independent Group. Particularly influential in the make-
up of the exhibition were Richard Hamilton and John McHale, both of
whom were keen to show that 'tomorrow' (the future) could only be
contemplated in close conjunction with yesterday (the past) and today
(the present) – a topic that Schwitters and Paolozzi had already been
addressing in their collages ten years earlier.

The exhibition was devised as a collaborative project involving painters
and architects – it was characteristic of the Independent Group to do
without specialisms. Indeed there was a desire to cross the boundaries
between different art forms and to focus on the 'Parallels between Art
and Life' as one exhibition in 1953 was called. It was as though the
group were following Schwitters' maxim "to create relationships, prefer-
ably between all the different things in the world".[16] In *This is Tomor-
row*[17] the space planned by Richard Hamilton, John McHale and the
architect John Voelcker had two main characteristics: firstly there was
its 'structure', its actual construction. This was asymmetrical and con-
sisted of floor-to-ceiling triangles and trapezoids. The shifting perspec-

tives were calculated to unsettle the viewer's sensual perception of the space. Secondly there was the visual material that obscured the architectural structure. Drawn from such differing realms as film, science fiction, comics and the consumer world, it was designed to replicate the "fine art – Pop Art continuum" that Lawrence Alloway was searching for. This space, with the nickname 'Crazy House', is highly reminiscent of the bizarre construction of the *Merzbau* in Hanover, and the idea that Schwitters had, according to Käte Steinitz, set aside her last packet of comics from June 1947 for his new "life's work", the *Merz Barn*, is not without appeal. This affinity between Merz constructions and the space designed by Hamilton, makes it clear that the campaign to rescue the Merz Barn, which was relocated at the University of Newcastle in 1965, owed a great deal to Hamilton.

It was primarily Paolozzi who introduced the artists of the Independent Group to Kurt Schwitters' work. However, there were other factors involved which should also be mentioned: work by the Merz artist had been presented in London galleries since the late 1930s, there had been two solo exhibitions – one put on by Jack Bilbo in 1944 and the other put on by E. L. T. Mesens in 1950 – and his work had also been included in a number of group exhibitions. In 1938 the photographer Nigel Henderson had shown his own work alongside that of Schwitters in the *Exhibition of Collages, Papiers-collés and Photomontages* in the Galerie Guggenheim Jeune.[18] Moreover it is likely that at least one member of the Independent Group knew the Merz artist personally: this was Toni del Renzio, the Surrealist ex-dissident, who had married Ithell Colquhoun in the early 1940s, who in turn was a friend of Schwitters.[19] And it should not be forgotten that the Independent Group developed their activities under the wing of the Institute of Contemporary Art (ICA)

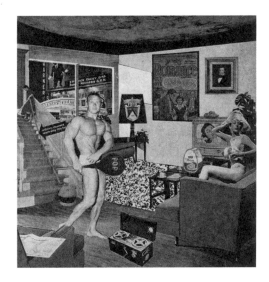

Richard Hamilton, *Just what is it that makes today's homes so different, so appealing?*, 1956, Kunsthalle Tübingen

founded in 1948. Of the founder members some had been in contact with Schwitters, namely Roland Penrose and E. L. T. Mesens as well as the critic Robert Melville and the film-maker Jacques Brunius. However, the ICA embodied first and foremost a dream of Herbert Read's, who had been cherishing a plan to open a museum for modern art in London since the 1930s.[20] Once the ICA had been founded, however, he abandoned the idea of a museum, which he now felt could only restrict free spirits. He now preferred a venue that was open to all kinds of activities that did not necessarily have to have a direct link with the visual arts. He encouraged inter-disciplinary cooperation and exchange, and he himself had a special interest in the sciences, in anthropology and psychoanalysis. No doubt he also hoped that the ICA could become a forum for his own anarchist ideals. Thus it seems paradoxical that the members of the ICA should have questioned Read's authority in the early 1950s, claiming that, as a critic, he embodied a purely academic perspective.[21] In fact Read straddled the gap between two generations of artists. In the exhibition catalogue for the Modern Art Gallery he pointed out Schwitters' originality within the avant-garde movement, commenting that there was "in his whole attitude to art a deep protest against the chromium-plated conception of modernism. The bourgeois loves slickness and polish: Schwitters hates them. He leaves his edges rough, his surfaces uneven. He realizes that the created object is always an approximation to the imaginative conception, and that it is only the fussy and irrelevant intellect that would like to give precision to the organic reality of art."[22] This aesthetic, which runs counter to what had already become Classical Modernity, in a certain sense pre-empts the stance of the critic Lawrence Alloway in the catalogue for *This is Tomorrow* where he took up arms against "purity of media, golden proportions, unambiguous iconologies."[23]

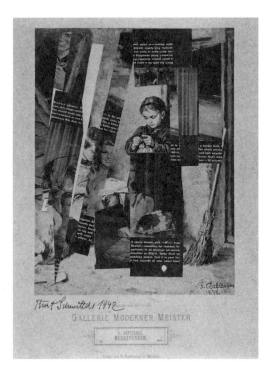

Kurt Schwitters, *Untitled (The Hours of the Muses)*, 1942, The National Museum of Modern Art, Kyoto

NOTES

1 See David Robbins (ed.), *The Independent Group. Postwar and the Aesthetics of Plenty*, Cambridge, Mass., and London 1990.

2 Robert Radford, 'Kokoschka's Political Painting in Britain' (1983), as quoted in: *Oskar Kokoschka*, Tate Gallery, London 1986, p. 323.

3 Lawrence Alloway, 'The Development of British Pop', in: Lucy R. Lippard, *Pop Art*, London 1997, p. 35.

4 Eduardo Paolozzi, *Note d'une conférence à l'ICA 1958*, London 1958 (Author's italics).

5 Daniel Abadie, 'Entretien avec Eduardo Paolozzi', in: *Un siècle de sculpture anglaise*, Galérie nationale du Jeu de Peaume, Paris 1996, p. 191.

6 Eduardo Paolozzi, as quoted in: Winfried Konnertz, *Eduardo Paolozzi*, Cologne 1984, p. 50.

7 Käte Steinitz, letter to Kurt Schwitters, 31.8.1947, Schwitters Archive of the Stadtbibliothek Hannover.

8 Ibid.

9 Käte Steinitz, letter to Kurt Schwitters, 15.10.1946, Schwitters Archive of the Stadtbibliothek Hannover.

10 Käte Steinitz, letter to Kurt Schwitters, 25.2.1947, Schwitters Archive of the Stadtbibliothek Hannover.

11 Ibid.

12 Eduardo Paolozzi, as quoted in: Konnertz 1984 (as note 6), p. 51.

13 The expression 'Bunk' appears in the collage *Evadne in Green Dimensions*, 1952. It comes from a newspaper cutting; the original is in the scrapbook *Mechanics and handicraft*. The double meaning of 'Bunk' as 'nonsense' or 'running off' is again reminiscent of Merz.

14 This expression comes from Lawrence Alloway.

15 Richard Hamilton, *Collected Words. 1953–1982*, London 1982, p. 24.

16 Kurt Schwitters, 'Merz' (1924), as quoted in: Friedhelm Lach (ed.), *Kurt Schwitters. Das literarische Werk*, vol. 5: *Manifeste und kritische Prosa*, Cologne 1981, p. 187.

17 The exhibition was not restricted to the members of the Independent Group. Altogether twelve groups showed environments.

18 Since the early 1930s Peggy Guggenheim had taken an interest in the young Nigel Henderson, whose mother ran her gallery for a number of years.

19 See Ithell Colquhoun, 'Kurt Schwitters in England', in: *Fantasmagie*, part 29, Brussels 1971, unpaginated. In the 1960s she used the word *Merz* in the titles of her works.

20 Herbert Read participated in several projects, including a project with Peggy Guggenheim, in which Schwitters was also involved.

21 In 1953 Read's opinions on aesthetics were much debated in the Independent Group. See Nigel Henderson, in: Jürgen Jacob, *Die Entwicklung der Pop Art in England von ihren Anfängen bis 1957. Das Fine/Popular Art Continuum*, Frankfurt a. M. and elsewhere 1986, p. 59.

22 Herbert Read, 'Kurt Schwitters', in: *Painting and Sculpture by Kurt Schwitters (the Founder of Dadaism)*, The Modern Art Gallery London, 1944, unpaginated.

23 Lawrence Alloway, 'Design as a Human Activity' in: *This is Tomorrow*, Whitechapel Art Gallery, London 1956, unpaginated.

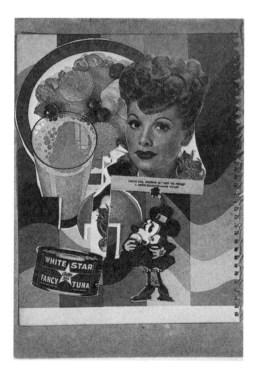

Eduardo Paolozzi, *Meet the People*, 1948,
Tate Britain, London

KURT SCHWITTERS AND NOUVEAU RÉALISME

DIETMAR ELGER

As one of the centres of Dada, Paris occupied a special position. It was here around 1920 that the movement enjoyed a highpoint, albeit as brief as it was late. Many of its leading exponents had only returned to the French capital after the war – from Zurich (Tristan Tzara), Cologne (Hans Arp) or New York (Marcel Duchamp, Francis Picabia). In Paris they joined the circle of young writers around the poet André Breton. At this time the central political thrust of Dadaism, its protest against the conventional norms of bourgeois society with its nationalist militarism, was already a thing of the past. With the end of the First World War the old social order had collapsed. By 1921 artists and writers in Paris were therefore already looking for new aesthetic experiences, opening their works to the anti-rationalist thought processes of Surrealism.

A loose sequence of five essays by the critic Georges Hugnet, published in the *Cahiers d'Art* between 1932 and 1936, proved to be the only attempt for many years in France at an art-historical assessment of Dada. Their collective title, *L'Esprit Dada dans la Peinture*, also mapped out the perspective from which subsequent recipients viewed Dada. In December 1956, a more substantial article on *L'Internationale Dada* by Michel Seuphor appeared in the journal *L'Œil*. Hugnet himself added to his essays from the 1930s and published them in 1957 as a book with the more general title *L'Aventure Dada*. At the same time the Galerie de l'Institut in Paris mounted a retrospective exhibition on the movement. In addition to a number of literary items, this predominantly featured pictures and objects by Hans Arp, Marcel Duchamp, Max Ernst and Francis Picabia. Fifty years after Dada was founded it received recognition by a French art museum. This was effected in 1966 by the Musée d'Art Moderne de la Ville de Paris together with the Kunsthaus Zurich.

Georges Hugnet's writings and the exhibition of 1957 show clearly that here the reception of Dada was not primarily focusing on the radical anti-art position or on the socially-critical potential of Dada. Instead the emphasis was on the innovative pictorial language that the artists had evolved for their works, which admittedly founded a new artistic tradition but which never questioned the aesthetic object itself. Thus it is not in the slightest surprising that above all critics pointed out the importance of Marcel Duchamp and Kurt Schwitters. Precisely because of this line of argument, which also constituted an attempt to institutionalise Dada in the museum world, the artist Max Ernst was against the exhibition in the Galerie de l'Institut: "I'm not interested in those people, who

so are forcefully trying to make Dada into a museum piece…!"[1] Marcel Duchamp's provocative presentation of a bicycle wheel (1913) or a bottle-drier (1914) as ready-mades had launched a debate on the character of a work of art and its relationship to reality, which in art-historical terms reached well beyond the interests of the other Dadaists, who above all had been reacting to an acute political situation.

Kurt Schwitters had already underlined his independence from Dada by describing his own art as Merz, and he reiterated the point in numerous critical comments: "Pure Merz is art, pure Dada is non-art; and both consciously so."[2] However radical Schwitters' treatment of waste from the streets and found scraps of paper, his aim was always to create a harmoniously composed work of art. The Hanoverian Merz artist was never an iconoclast, yet within pictorial conventions his material collages exploit to the full the potential of the picture as such. Precisely this quality meant that his work was to become the most important point of reference for the Nouveaux Réalistes – alongside Duchamp, but well ahead of all the other Dadaists. Like Schwitters, the French artists were seeking to work directly with objects from their daily surroundings. They were clearly fascinated by Schwitters and Duchamp's practice of admitting materials of whatever kind into the artistic process.

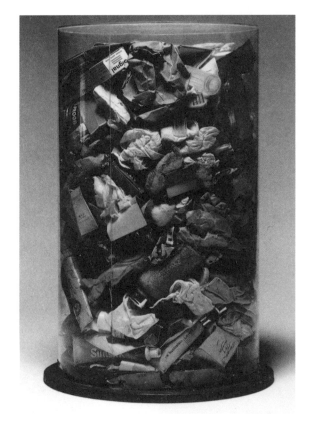

Arman, *La Poubelle de Jim Dine*, 1961,
Collection Ileana Sonnabend, New York

On the occasion of a group exhibition held in April 1960 in the Galerie Apollinaire in Rome, the French critic Pierre Restany published an essay in the slim accompanying catalogue, which he entitled 'Nouveaux Réalistes'. This was the first time the term was used, but proved to be so fitting for all the artists in the exhibition that it was immediately accepted as a group name by Arman, Raymond Hains, François Dufrêne, Yves Klein, Jacques de la Villeglé and Jean Tinguely, and was later adopted by critics to describe a particular style. The catalogue essay, which has since come to be regarded as the first manifesto of Nouveau Réalisme, describes with a tinge of pathos the artists' efforts to deal with reality in aesthetic terms: "With full, affective expressive powers – that are the more significant for their force – and with the liberation of the creative individual through the, of course, at times apparently baroque appearance of some experiments, we are setting out towards a new realism of pure sensibility. Herein lies at least one of the paths to the future."[3] In this essay Pierre Restany groups six individual artists together, although some had been independently developing their work for over ten years by then. Some had long been friends and had often shown work together. Thus credit goes to Restany above all for recognising a shared stylistic phenomenon in a multiplicity of individual artistic achievement. Six months after this manifesto appeared the artists caught up with Restany. At a meeting in Yves Klein's studio they solemnly signed a declaration to that effect: "On Thursday 27th October the Nouveaux Réalistes became aware of their collective uniqueness. Nouveau Réalisme = new approach to the defence of reality."[4] Besides the artists who had participated in the exhibition in Rome, the signatories also included Daniel Spoerri and Martial Raysse, as well as Pierre Restany himself.

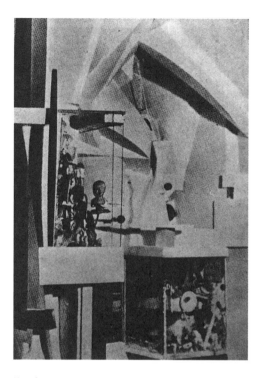

Kurt Schwitters, *Merzbau (Grotto with Doll's Head* and *Gold Grotto)*, 1933, destroyed.

The artists were united to a man in their criticism of painting by *Informel* artists and from the Ecole de Paris which had dominated the 1950s and whose subjective gesture the Swiss artist Jean Tinguely satirised in his méta-matic machines. The Nouveaux Réalistes sought instead to use the materials of the city to engage in a direct confrontation with the aesthetic of everyday life. Their attention was attracted above all by the objects of mass-consumption and by the aggressive images of the media age. They made away with consumer articles from department stores and tore posters down from advertising hoardings. The materials were then treated in their studios, before being presented to the public in galleries and museums as transformed reality. Taking up Duchamp's concept of the ready-made, for the Nouveaux Réalistes the crucial artistic act was already accomplished in the decision to use a particular motif or material, which for them was more important than the actual creative process. All the same, it was important to the Nouveaux Réalistes to uphold certain conventions. For their exhibitions they very deliberately chose established art venues. And in order that their works, outwith this context, should be the subject of aesthetic debate, they framed their material like traditional pictures or presented them as sculptures on classical plinths. The same function that the signature "R. Mutt" served on

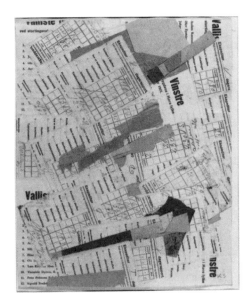

Kurt Schwitters, *Untitled (Vinstre)*, 1936–1938,
formerly Collection Arman

Marcel Duchamp's urinal was fulfilled here by the signature of the artist:
it legitimates the exhibited material as a work of art. In 1960, the year
that Nouveau Réalisme came into being, Jacques da la Villeglé justified
the artist stamping his authority in this way: "It is always regrettable
when one signs a torn-down poster [...] yet with my trademark I simplify
recognition and prevent destruction. Beauty must after all pay tribute to
bourgeois circumstances."[5]

At night Villeglé tore shreds of posters off advertising hoardings, these
he then mounted on canvas before finally presenting them as objets
trouvés, as found pictures. Meanwhile, for his *tableaux pièges*, Daniel
Spoerri would take objects found by chance on a table and fix them to
the surface and then hang the table-top on the gallery wall as a picture.
Arman, on the other hand, was interested first and foremost in the
object as a mass-product. In his so-called accumulations he would heap
a number of identical objects in a showcase without their being any evi-
dence of a will to compositional order. "The object was raised up onto a
plinth, isolated or, for the sake of an analogy, presented in a particular
manner, alienated from its usual context and thereby acquiring a differ-
ent reality"[6]: Arman's own account of the process by which an everyday
object was transformed into an artefact. By shifting the perceptual con-
text the artists were not only compelling the visitors to their exhibitions
to experience anew the objects and poster motifs on show and to see
them as aesthetic values, but were also sending their public away with a
fresh view of the world of medial images in any city centre. "Just look,
the pictures in the galleries are found outside in the streets, too, where
posters have been torn down from the advertising hoardings",[7] as
Daniel Spoerri once said when he was describing the aims of the
Nouveaux Réalistes.

Although Spoerri was the only one of the Nouveaux Réalistes to make
an object expressly as a *Homage to Schwitters* (1964), it was Arman
who most emphatically declared his appreciation of and engagement
with the work of Kurt Schwitters. Thus in 1980, when he was in Hano-
ver for an exhibition, he self-confidently had his photograph taken below
the street sign for Kurt-Schwitters-Platz outside the Sprengel Museum
Hannover. As early as 1954 he had already seen the Schwitters' exhibi-
tion in Heinz Berggruen's Paris gallery. As it happens, for over forty years,
up until the major retrospective in the Musée National d'Art Moderne at
the Centre Georges Pompidou in Paris, this was the only exhibition in
France devoted to work by the Merz artist.[8] Later Arman even bought a
work by Kurt Schwitters, his small collage *Untitled (Vinstre)* from
1936–1938. In 1982, in conversation with Bernhard Holeczek, he still
vividly remembered his visit to the Galerie Berggruen: "In fact it all
began with Kurt Schwitters: in 1954 in the exhibition at Berggruen's in
Paris I saw Schwitters' rubber-stamp drawings. I was enthused by them
and went home where I immediately started 'stamping'. [...] Today I
know how much Schwitters influenced me in the mid-50s, firstly – but
not only – with his rubber-stamp drawings."[9] This encounter with the
role model Kurt Schwitters thus lit a touchpaper for Arman, which led
directly to his own experiments. Schwitters' attitude as an artist to han-
dling found materials, is echoed above all in Arman's stamped works, his
accumulations and his *Poubelles* (rubbish bins). During the course of an
interview in 1978, Jean Tinguely, too, declared the debt he owed to
Schwitters as one of his artistic father figures: "In my case, art is in a
way not art. There is a Dada past in there, our Dada Max, by which I
mean Ernst, or that Dada Duchamp or that Dada Merz (Schwitters),
those Dada people taught me a pretty good lesson."[10]

In 1961 the Nouveaux Réalistes put on a joint exhibition in the Galerie J, in Paris, for which Pierre Restany devised the title *A 40° au-dessus de Dada*. On the occasion of this exhibition Restany's second manifesto appeared under this same title, which is significant both for the implied proximity to Dada and for the evident effort to maintain a certain distance and to define an independent position. In his text, Restany particularly stresses the positive creative energies of the Nouveaux Réalistes as opposed to the anti-aesthetic attitudes of the Dadaists, at the same time redefining the function of the ready-made: "Marcel Duchamp's anti-art gesture assumes positivity. The dada mind identifies with a mode of appropriation of the modern world's exterior reality. The ready-made is no longer the climax of negativity or of polemics, but the basic element of a new expressive repertory."[11] Tacitly Restany was also shifting the Nouveaux Réalistes closer to Schwitters' position.

In 1961 in the journal *Zero*, Arman explained his choice of material as a conscious decision in favour of "the realm of trash, waste and worn out products, in short everything that is beyond use".[12] In saying so, he joined an artistic tradition that Kurt Schwitters had already formulated for himself in 1935 as "The world's waste becomes my art."[13] Arman drew close to the Hanoverian Merz artist above all with his *Poubelle-Portraits* in the 1960s. In a text on the 'Origins of Merz', Kurt Schwitters reported on his own experience of describing the character of the subject of a

Raymond Hains, *Paix en Algérie*, 1965,
Collection Ginette Dufrêne, Paris

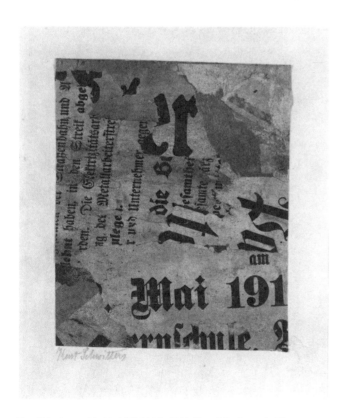

Kurt Schwitters, *Untitled (Mai 191)*, 1919, Kurt Schwitters Archive
in the Sprengel Museum Hannover

portrait by choosing and composing selected items: "At the time I was painting a portrait of Luise Spengemann, it was early 1919. I tried to make a composition with small objects that were lying around in the room, and tried to characterise her essence with these."[14] The success of this method surprised Schwitters himself. When it later came to the numerous friendship grottos in the *Merzbau*, he proceeded in a similar manner by placing a momento in each grotto that characterised the person concerned: for the Doesburg grotto he chose a piece of cravat, the Mies van der Rohe grotto had a thick pencil in it, and in László Moholy-Nagy's grotto he hid a pair of socks belonging to the artist. Even if the meaning is barely decipherable to the outsider, all these things brought back to Kurt Schwitters very personal memories of those whose names the friendship grottos bore. While Schwitters thus very consciously chose certain objects to work with, Arman's appropriation of material was more cursory and owed more to chance. He used to empty his friends' waste-paper baskets into glass containers and present these as

portraits. For Arman, the chance accumulation of material amounted to a kind of sociological portrait, with the life of the subject of the portrait reflected in what they had thrown away. And indeed, when the visitor to an exhibition of his work takes a closer look at the materials, a more private and more intense picture of the personality emerges than a conventional depiction could ever achieve.

Within Nouveau Réalisme there is a distinct group made up of the so-called décollagistes, namely Raymond Hains, François Dufrêne and Jacques de la Villeglé. If classical collage can be described as an additive working process, in which countless scraps of paper are combined to form the final composition, then décollage is a matter of subtraction, whereby posters stuck on top of each other are torn down and the under-layers are partially laid bare again. Most notably, the décollagistes had discovered the large-format posters on advertising columns or hoardings as material and as a visual world for their art. The chance meeting of different fragments of images from the consumer world, from culture and politics can evoke an endless array of associations for the viewer. Meanwhile, in other works, the structure of the layers of paper forms a complex, abstract, coloured surface. As early as 1949, a year after Schwitters' death, Raymond Hains had already first started tearing down posters, after previously only ever having photographed them. The décollagistes met in the mid-1950s and despite maintaining close contact, each nevertheless still continued to develop his own work independently. While Hains was interested in the associative potential of the poster motifs that ensues when disparate images and texts come up against each other, Jacques de la Villeglé was fascinated by the formal qualities of the torn-down posters, which in his view took on the quality of found abstract images. The surfaces in Dufrêne's works manifest similar structures although he preferred to work with the backs of posters, which gives many of his works a more unified appearance as far as the colour goes. Moreover, having collected his materials, he often worked on them once he was back in the studio.

While the Parisian décollagistes flamboyantly appropriated the posters on whole advertising hoardings and then stuck these to canvases, Schwitters favoured a positively surgical technique. When he was out and about in the town, using a sharp knife he would carefully cut little pieces out of posters on advertising columns and collect any bits of rubbish from the street that particularly caught his attention. At home he would clean and dry the items he had collected, before including them – often years later – in his Merz pictures and drawings, thereby giving them a new artistic meaning. The Merz artist and the décollagistes were thus drawing on the same materials. But whereas the latter accepted posters on hoardings as objets trouvés, which by virtue of being untreated and hence not falsified could directly express the artists' everyday world, Schwitters' scraps of paper largely provided a starting point, and as such first had to be detached from their everyday function, before they could take on a new aesthetic quality during the making of the final work.

Another feature shared by Kurt Schwitters and the Nouveaux Réalistes is that they were not political revolutionaries and they were most definitely not iconoclasts; their aim was purely artistic renewal. For this reason the Nouveaux Réalistes found themselves confronted with just the same criticisms from the surviving political Dadaists that Kurt Schwitters had had to ward off some forty years previously. In 1961, the Berlin artist Richard Huelsenbeck, who had given himself the pseudonym 'World Dada', but whose work Schwitters had mocked as "Hülsendadaismus",[15] vented his outrage in the Frankfurter Allgemeine Zeitung: "How can these people – artists – whatever you want to call them – how dare they describe themselves as Dadaists?"[16] And Raoul Hausmann, a lifelong friend of Kurt Schwitters, bemoaned the lacking political aspirations of the Nouveaux Réalistes: "They have no desire to attack anything, to shatter anything, to pillory anything, they are not a protest, all they show is that they know a recipe and that they 'know' how it is done."[17] Nevertheless political events were not entirely absent from their art. Thus in 1961 Raymond Hains presented an entire exhibition of décollages which all had decipherable fragments referring to the war in Algeria. Similarly Kurt Schwitters always incorporated the latest social situation into his Merz drawings, as in the collage Untitled (Mai 191) of 1919, which contains legible references to political unrest and strikes by metal workers.

Ultimately, however, there is a visible distinction between Schwitters' working methods and those of the Nouveaux Réalistes. While Schwitters only ever wanted to design and to form, the French artists set greater store by the aesthetic quality of a chance event or of an object trouvé, choosing the most striking examples from the multiplicity of materials and motifs at their disposal as ready-mades. In his so-called i-drawings, which are generally made from papers with superimposed text or images, Kurt Schwitters had similarly restricted the compositional act to deciding how the paper should be cropped. In his second *Merz* magazine he explained the genesis of these works and the principle behind them: "The artist recognises that in the world of forms that surrounds him, some detail need only be isolated and extracted from its context for a work of art to emerge, that is to say, a rhythm that can also be registered as a work of art by others with an artistic turn of mind."[18] This explanation from 1923 could readily serve as instructions for the Nouveaux Réalistes, for it is an astonishingly accurate description of their artistic approach and their notion of what a work of art can be.

NOTES

1 Max Ernst, as cited in: Maria Müller, *Aspekte der Dada-Rezeption 1950–1966*, Essen 1987, p. 30.

2 Kurt Schwitters, *Banalitäten (3)* (1923), in: Friedhelm Lach (ed.), *Kurt Schwitters. Das literarische Werk*, vol. 5, Cologne 1981, p. 148.

3 Pierre Restany, *Die Nouveaux Réalistes* (16 April 1960), as cited in: *Westkunst*, Messehallen, Cologne 1981, p. 243.

4 See *1960 Les Nouveaux Réalistes*, Musée d'Art Moderne de la Ville de Paris and elsewhere, 1986/1987, illus. p. 216.

5 Jacques de la Villeglé, *Die kollektive Realität* (1960), as cited in: Müller 1987 (as note 1), p. 147.

6 Arman (1969), as cited in: *Arman. Parade der Objekte. Retrospektive 1955 bis 1982*, Kunstmuseum Hannover mit Sammlung Sprengel, Hanover 1982, p. 40.

7 Daniel Spoerri *Überstorf, 15.8.1986 (Exzerpte aus einem Interview von Dieter Schwarz)*, in: Paris 1986/1987 (as note 4), p. 28.

8 From the 1950s onwards Schwitters was, however, represented in numerous thematic exhibitions. In 1980 the Galerie Gmurzynska in Cologne presented his work in a solo exhibition at the FIAC art fair in Paris.

9 Arman (1982) as cited in: Hanover 1982 (as note 6), p. 36.

10 Jean Tinguely and Siegfried Salzmann, Interview in: *Jean Tinguely. Meta-Maschinen*, Wilhelm Lehmbruck Museum, Duisburg 1978, p. 9.

11 Pierre Restany, *Forty Degrees Above Dada*, as cited in: Kristine Stiles and Peter Selz (eds.), *Theories and Documents of Contemporary Art*, Berkeley/Los Angeles/London 1996, p. 308.

12 Arman (1961), as cited in: *Pop Art*, Museum Ludwig, Cologne 1992, p. 230.

13 Kurt Schwitters (1935), as cited in: Ernst Nündel, *Schwitters*, Reinbek bei Hamburg 1981, p. 8.

14 Kurt Schwitters, 'Der Ursprung von Merz' (1942–1947), in: Friedhelm Lach (ed.), *Kurt Schwitters Das literarische Werk*, vol. 3, Cologne 1975, p. 275.

15 See Kurt Schwitters, 'Merz' (1920), in: Lach 1981 (as note 2), pp. 74–82. [Here Schwitters is making a play on the German 'Hülse' meaning 'husk' or 'pod'.]

16 Richard Huelsenbeck, 'Dada mit und ohne Gaga' (1961), as cited in: Müller 1987 (as note 1), p. 89.

17 Raoul Hausmann. *Neorealismus, Dadaismus* (1963), as cited in: Müller 1987 (as note 1), p. 139.

18 Kurt Schwitters, 'i' (1923), in: Lach 1981 (as note 2), p. 139.

"CRUMPLE AND TURBULATE" KURT SCHWITTERS AND THE ACTION ART OF THE 1960s

Title page of *Fluxus cc V Tree*
(Fluxus Newspaper No. 1),
January 1964

JUSTIN HOFFMANN

The springboard for this essay is the inspiration that other artists have found in Kurt Schwitters' work. In investigating the relationship between Schwitters and the art production of the 1960s, however, this essay does not set out to show later generations explicitly citing Schwitters as their point of reference. Instead, individual cases may serve to demonstrate interconnections in the art of the 20th century which in turn point to lines of development that did not run continuously, but progressed in leaps and bounds, unexpectedly crossing each other – processes that often took place away from the trends dominating the art market. In a sense Kurt Schwitters himself justifies this approach when he writes in 1924: "Merz means creating relationships, preferably between all the things in the world."[1]

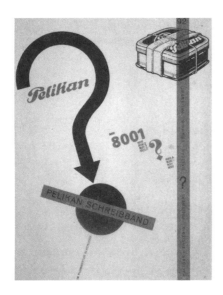

Kurt Schwitters, *Thesen über Typographie*, from:
Merz 11, Typoreklame, 1924

LABELS AND LAYOUTS

In the past, names of art movements were often coined by non-artists, and it was not unusual for these names to have had a pejorative sense at first ('Impressionism' for instance). In the 20th century, however, they were often invented by the artists themselves. 'Merz' and 'Fluxus' are typical examples. They are short and easy to remember. 'Merz' only referred to art produced by Kurt Schwitters; by contrast, during the course of the 1960s George Maciunas succeeded in widening the scope of the term 'Fluxus' – his own invention – to cover a whole movement, with it finding favour over other rival names. Wolf Vostell's 'Décollage' made as little headway against it as Dick Higgins' 'Intermedia' or George Brecht and Robert Watts' 'Yam'. Ultimately all these artists allied themselves to the Fluxus group and worked successfully under this label. For Kurt Schwitters, Dada presumably constituted a comparable umbrella term, one towards which he felt a sense of allegiance and under the auspices of which he carried out his work – just as Fluxus had served individualists like Vostell, Brecht, Ono, Filliou, Køpcke, Paik and Beuys. It is interesting to note that neither designation takes the form of an 'ism',[2] so prevalent in art history, but that instead both have the same catchy quality as names of brands and companies. In order to disseminate their ideas, both Dada and Fluxus artists organised tours and events in a variety of different European towns and cities.

Another comparatively under-researched similarity between Schwitters and the Fluxus artists is their interest in typography and print layouts. The Merz artist, George Maciunas, Wolf Vostell and numerous exponents of American Pop Art all earned a living as graphic designers for public and private clients. Schwitters also went into the theory of graphic design and of typography in particular. In his 'Theses on Typography' he speaks out for a reassessment of its importance: "In certain circumstances typography can be art."[3] He delivered slide lectures putting forward his ideas on designing layouts according to principles of abstract composition.[4]

One striking feature of many Fluxus editions and publications is the use of extremely diverse typefaces. Clarity and legibility were sacrificed for the sake of the overall composition. Individual letters are tightly packed, linking interestingly with each other, at times even merging. In their unusual layouts Fluxus artists often used unusual graphic features such as the pointing hand familiar from newspapers and advertisements.[5] They consciously alluded to commonplace layouts and simple designs, only to alienate these in the process. The layout of their publications and the design of their objects were intended to awaken interest and to encourage purchases. Their products were available in Willem de Ridder's Fluxshop, amongst other places. In his own graphic works, Schwitters also readily availed himself of arrows and pointing hands. Although he proposed a unified layout in theory, his preference for abstract rhythms did not necessarily mean that his designs were easy on the recipient; the very sheet on which the 'Theses on Typography' is printed serves as a good example of this. Dietrich Helms stresses Schwitters' nonchalance and love of innovation in his graphic design and illustrates his point with this particular layout, perhaps precisely "because this text is presented in a form that is difficult to read – a grey block of closely set, over-long lines."[6]

One surprising point is the way that Kurt Schwitters was able to reconcile his artistic output with Capitalist conditions of production. In this connection 'Merz' served him as a label for wide-ranging, multi-genre activities. Originally a fragment from the word 'Commerzbank', during the 1920s Schwitters guided 'Merz' back in the direction of 'Commerz'. For many years he was chairman of the 'ring neuer werbegestalter'. He produced designs for Hanover firms like Pelikan and Bahlsen,[7] and his motto was: "Better no advert than a bad one."[8] In his view "it was important in any advertising that it gives the impression that this is a firm that does more with its products, how they look and how they are offered for sale."[9] Schwitters had no problem turning abstract art to Capitalist uses – despite its originally having been bound up with the

desire for a new, utopian society. In 1929 he landed a particularly large contract: to design all the printed materials and advertisements put out by the town council in Hanover, from the simplest of forms right through to programmes for the Opera House.[10] Unlike Andy Warhol's Factory, however, Schwitters' firm remained a one-man business, perhaps specifically because he made a clear distinction between the commissions he carried out and the work that he did for himself. As it happens, both George Maciunas and Emmet Williams also worked for official bodies: in the early 1960s Maciunas was employed by the U.S. Air Force in Wiesbaden as a graphic designer while Williams wrote copy.[11]

MATERIALISATIONS

In a number of texts, the earliest from 1919, Kurt Schwitters put forward his concept of a 'Merz stage'. His vision of an experimental theatre was never realised, and yet it had a major influence on later generations. Above all in the 1960s, people came to recognise the significance of the theory behind the 'Merz stage'. In 1965, Jürgen Becker and the Action artist Wolf Vostell published the book *Happenings. Fluxus. Pop Art. Nouveau Réalisme*, in which Jürgen Becker named Schwitters as the precursor of Happenings: "[…] meanwhile, as one of the patriarchs of

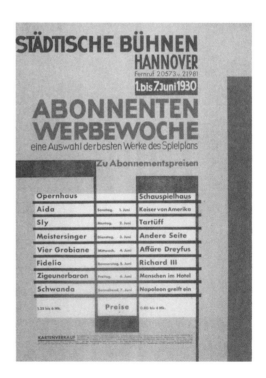

Kurt Schwitters, Poster for the 'Abonnenten-Werbewoche' [Subscriptions Publicity Week], Städtische Bühnen Hannover, 1930

contemporary art practice, he [Schwitters] had already described various aims which were then realised in Happenings".[12] Becker also cites a lengthy passage from Schwitters' 'An alle Bühnen der Welt' [To all the World's Stages] from 1919. The style and contents of this text are influenced, on one hand, by Dada and Expressionism and, on the other, by the climate of revolution after the end of the First World War. By choosing a title that starts with the words "An alle" ["To all"], Schwitters was adopting a form of address common in revolutionary circles at the time. Many declarations issued in those days, like the proclamation of the commissars' republic in Bavaria in 1919, began with the word "An [das bayrische Volk]". With his address "An Alle", in November 1918 Lenin informed the people of the triumph of the German revolution. In the essay 'Merzbühne und Normalbühne Merz. Zum Happeningcharakter der Bühnentheorie von Kurt Schwitters', Gabriele Diana-Grawe interprets the forceful tones of Schwitters' text as an ironic parody of the statements issued by the Futurists, albeit without saying why she takes this line.[13] But Schwitters' exhortation is less an attack on Marinetti than a humorous, euphoric outpouring filled with metaphors and allusions. Its emphatic tone may well have been meant entirely seriously and is readily understood from a historical perspective. The text is a mixture of revolutionary/avant-garde attitudes, expressive pathos and Dadaist strategies of abstraction and ambiguity. According to Schwitters there was no longer any sharp dividing line between sense and nonsense: "The more intensely the work of art destroys rational representational logic, the greater the possibility of artistic rebuilding."[14] If Schwitters' text is taken to be predominantly ironic, it loses all its bite.

One important feature linking the programmatic text by the Merz artist and the artists' Actions of the 1960s, is their artistic standpoint: the view that literally anything can be integrated into a work of art, from banal everyday objects to human beings: "The materials for the set [of the Merz stage] are any solid, liquid or gaseous bodies […]."[15] "People can also be used."[16] In Joachim Büchner's view, Schwitters may be regarded as the "most material" thinker amongst his own generation of artists.[17] The Viennese Action artist, Otto Mühl, demonstrated – with extreme radicalism – the use of organic and non-organic, living and dead materials in his so-called 'Material Actions'. "Material Action is painting that has grown beyond the picture surface, the human body, a set table or a space becomes the picture surface, time is added to the dimensions of the body or the space. The human being does not participate as a human being, as a person, as a sexual being, but as a body with particular qualities. In the Material Action the human being is cracked open like an egg and shows its yoke."[18] The very titles of Mühl's works, such as *Still life with the heads of a female, a male and a cow* (Material Action no. 9, 11.6.1964), make plain the desired levelling of objects and bodies to no more than a means of expression.

Two pages from *The Stars & Stripes*,
30 August 1962 and 21 October 1962

Otto Mühl, *Material Action No. 9, Still Life – Action with the heads of a female, a male and a cow*, 11.6.1964 in Düsseldorf

Kurt Schwitters formulated his ideas on the Merz stage at a time when he had affiliated himself with the Dadaists, although they did not all welcome him equally. Schwitters used to perform sound poetry and short dramatic scenes at Dada events. Forty years later George Maciunas devised the term 'Neo-Dada' for the work that was soon to be seen in the context of Fluxus. In the Galerie Parnass in Wuppertal, on 9 June 1962, Maciunas had a text read, which he called 'Neo-Daca in New York' – a designation for artistic utterances which in his opinion could no longer adequately be described using conventional genre distinctions. As Maciunas saw it, the Neo-Dadaists were working in the realms of "concretism" and "art nihilism" and were equally opposed to the abstract and the realistic art forms of the day.[19] The Concretists were not interested in the symbolic potential of objects but in their physical qualities, for instance in the sounds they made. Like the Dadaists, this new generation also incorporated chance into their work. One week after Maciunas' lecture, the festival 'Neo-Dada in Music' took place in the Kammerspiele in Düsseldorf. This included, amongst other things, the premiere of Nam June Paik's *One for Violin*, which was to become the most-performed piece from the Fluxus movement. The first real Fluxus event in Düsseldorf was the *Festum Fluxorum Fluxus* (2nd/3rd February 1963) organised by Joseph Beuys. Beuys' performances of two of his works in this festival were his first Actions as a Fluxus artist. In his *Siberian Symphony, 1st Movement*, Beuys produced a dead hare, amongst other things, and deeply shocked the audience by extracting its heart. Beuys' materials – not just in his Actions but also in his collages – were intended first and foremost to engender intense emotions and to illuminate his ideas, such as his concept of energy and the way it could be directed and stored.

The Fluxus Festival in Copenhagen in November 1962 was organised by Arthur Køpcke, who had been living there since 1953. He had much in common with Kurt Schwitters: his multi-media works whose absurd logic recalls the thinking behind the Merz stage, his use of stamps as a means of expression, particularly his assemblages – syntheses of cheap, everyday objects – and his paintings, which, as in Schwitters' case, often take easel painting as their starting point. Thus it is hardly surprising if his Fluxus colleague Henning Christiansen, who was also a friend of Beuys', should have reported: "Funnily enough, Køpke himself describes how Daniel Spoerri told him that Addi's works are too artificial, that they are too composed. This was just the same complaint Kurt Schwitters had had to endure from Hugo Ball, i.e. Schwitters was not a proper DADAist, because he could paint too well."[20] Perhaps this is the most fundamental link between Schwitters and Køpke: both remained faithful to painting despite the otherwise conceptual focus in their art.

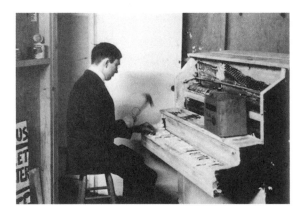

George Maciunas in *Piano Piece*, New York, 1964

The Fluxus artist Robert Filliou shares his delight in games and poetry with both Schwitters and Køpcke. In his 'Principles of Poetic Economy' which are close to the notion of Merz, he speaks out for the "permanent creation of lasting freedom". He regarded the shop that he and George Brecht set up in Villefranche-sur-mer as a "centre of permanent creation".[21] "We made games, invented and disinvented objects, corresponded with the lowly and the mighty, drank and engaged in conversation with our neighbours, produced floating poems and rebuses and sold them by mail order [...]".[22] The fact that these principles could also have a political alignment is shown by the event he put on to demonstrate solidarity with the Afro-American activist Angela Davis in 1971. In this Action at art intermedia in Brussels, Filliou did not offer the public anything material, nothing that could be sold on, all he offered was a meeting with the artist, which was supposed to be worth the equivalent of about £5.00 to the guest. On his invitations to the event he called the Action *Work as Play* or *Work as Reward*.[23] The proceeds were to go to help with the legal costs for the court case Angela Davis was facing.

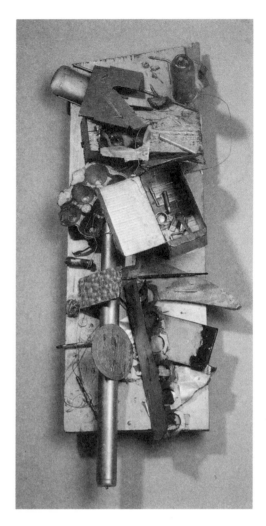

Arthur Køpcke, *Assemblage*, 1963, Hamburger Kunsthalle

MERZING AND DESTROYING

A large section of the text 'An alle Bühnen der Welt' is written in the form of a set of instructions. These frequently relate to acts of destruction, such as: "First lay out some enormous surfaces, extend them into imaginable infinity, cloak them in colour, push them around threateningly and make their smooth innocence buckle. Crumple and turbulate different bits and bend hole-ridden parts of this nothingness endlessly together. Paste over smoothing surfaces. Take a dentist's drill, a meat-mincing machine, a scraper-outer for tram-tracks, omnibuses and automobiles, bicycles, tandems and the tires thereof, *ersatz* tires from the war too, and deform them."[24]

The form chosen for these instructions is strikingly reminiscent of the 'event cards' widely used in Fluxus circles. These cards incite the holder to undertake particular activities, which may involve the holders themselves turning into actors. Some of the instructions on these cards are barely possible and are first and foremost poetic in character. As a comparison to Schwitters' text, here is an example from Yoko Ono, *Collection III*, from 1963:
"Break your mirror and scatter the pieces over different countries. Travel and collect the pieces and glue them together again.
You may use a letter or a diary instead of a mirror.
You may break a doll or an airplane a thousand feet high in the sky over a desert."[25]

Kurt Schwitters suggests acts of deforming of exactly the kind that artists then carried out in the 1960s. The very word 'Merz' has associations of destruction in that it forms one syllable of the German verb 'ausmerzen' meaning 'to eradicate or destroy'. The deforming of vehicles as Schwitters demands in his Merz stage text was later put into practice by

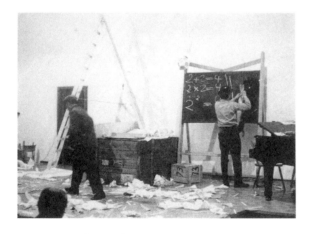

Joseph Beuys, *Siberian Symphony, 1st Movement*, Festum Fluxorum Fluxus, 3 February 1963 in Düsseldorf

such diverse artists as César, Allan Kaprow and Wolf Vostell. The latter described how he had arrived at the term 'décollage' through a report on a plane crash: "I am interested in dé-coll/age as a process, as a new art theory, and I was fascinated by the use of the word dé-coll/age in connection with a plane crash, a double dé-coll/age, I was gripped by the theory of this and was goaded into looking more closely at the term I had found, and I discovered that it is an ambivalent term, which can be hugely extended in every direction."[26] One passage in Schwitters' text 'An alle Bühnen der Welt' seems to have struck a particular chord with Vostell: "Have locomotives drive into each other […]".[27] On 14 September 1963 he carried out his Action *Neun Nein Décollagen* near Wuppertal. The most sensational part of this Action was Point 2, entitled "130 kilometres per hour". This involved two engines near a shunting yard ramming an old Mercedes standing on the track.[28] Vostell had elevated the traffic accident, making it into an aesthetic act.

The tools Schwitters suggests for deforming organic materials, "a dentist's drill, a meat mincing-machine", recall the ideas of the Viennese Actionists, who in fact went much further in their fantasies of destruction that in the Actions they actually realised. Thus Günter Brus writes in his text 'Selbstbemalung' [Self-Painting], published in 1965: "Paint yourself, strangulate, pester and plague, sit in a white water closet and torture yourself until you draw blood, I never have enough chopping knives, kitchen knives, […] spiral drills, cuticle scissors, pastry wheels, wire snares, barbed wire, glass splinters, battle firing gear, bone raspers […]. Self-painting = infinitely savoured suicide."[29]

THE INTERDISCIPLINARY EVENT

The use of non-artistic materials and the concept of extended collage also link Kurt Schwitters with the Korean artist Nam June Paik who has lived in Germany since 1956. Besides John Cage, it was the work of the Dadaists and Schwitters that inspired Paik. Schwitters' Merz stage performances were always also intended as audio-experiences. "The materials for the score are all the notes and sounds that can be made by violin, drum, trombone, sewing machine, ticking clock, stream of water etc."[30] One passage in particular from 'An alle Bühnen der Welt' almost sounds like instructions for an Action by Paik: "A stream of cold water runs into a pot across the back of the man on one of the sets. As it does, he sings C sharp, D, D sharp, E flat, the whole workers' song: A gas flame has been lit under the pot to boil the water, and violins play a melody that shimmers pure and like a young girl."[31] Paik's instructions for *Simple* (first performed in 1961) read:

"The performer carries out the following actions:
1. throws beans into the auditorium
2. smears shaving creme on his body
3. put rice in the shaving creme
4. slowly unwind a roll of paper
5. step into water tub
6. come back and play the piano for a bit with a baby's pacifier in your mouth."[32]

The use of the term Happenings to bring together all the various artforms was particularly promoted by the American artist Allan Kaprow. "The Merz stage only knows of the melding of all factors into a *Gesamtkunstwerk*,"[33] as Kurt Schwitters wrote in 1919. "I demand the Merz stage. I demand the exhaustive bringing together of all artistic forces to form the *Gesamtkunstwerk*"[34] – thus the opening of his text 'An alle Bühnen der Welt'. For Kaprow the evolution of the visual arts naturally

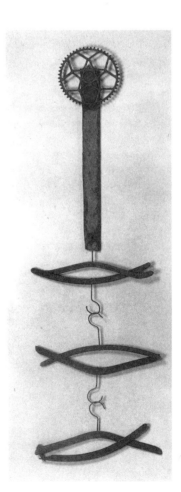

Robert Filliou,
I comme dans poisson, 1961,
Hamburger Kunsthalle

Günter Brus, *Self-Mutilation 3*, Spring 1965, Vienna

led to what he had described as Happenings. In order to demonstrate this, he proposed a line of evolution that progressed in five stages from the easel painting to the Happening. Easel painting was followed by collage (around 1912), Action Painting (around 1950), assemblage (mid-1950s), environments (late 1950s) and finally Happenings.[35] This process, however, does not pursue an entirely straight course. The decisive feature of the Happening is not that it is a multi-media event – for that already exists in opera – but in its relationship with the public. The distance between artist and viewer is largely abandoned. In his book *Strukturen des Happening*, Winfried Nöth names the Merz stage as the precursor of Happenings. He registers various common features between Schwitters' Merz stage and Kaprow's Happenings: both use sound, the everyday, the absurd and the disparate.[36] In an essay written jointly with Franz Rolan, entitled 'Aus der Welt: MERZ', Schwitters also stresses the collaboration between actors and audience. Both the performers and the public are viewed as material.[37] "A piece for the Merz stage needs more rehearsals than any other stage-work, because it is not made at a writing desk but on the stage itself."[38]

Like the Action artists from the 1960s, Kurt Schwitters underlines the beauty of the moment, the significance of the ephemeral: "In contrast to drama or the opera, all the parts of the Merz stage-work are inextricably bound up in each other; it cannot be written, read or heard, it can only be experienced in the theatre itself."[39] The concept of the original is specifically preserved in Action art and its ephemeral nature. The ritual of art is presented as an unrepeatable event, and the uniqueness of the Action generates a sense of the special quality of the moment. Art becomes an event.

NOTES

1 Kurt Schwitters, 'Merz' (1924), as quoted in: Friedhelm Lach (ed.) *Kurt Schwitters. Das literarische Werk*, vol. 5, Cologne 1981, p. 187.

2 Hans Arp and El Lissitzky, *Die Kunstismen 1914–1924*, Zurich 1925.

3 Kurt Schwitters, 'Thesen über Typographie', in: *Merz 11, Typoreklame*, 1924, p. 91.

4 Carola Schelle, 'Anmerkungen zu den verschiedenen Lichtbildvorträgen von Kurt Schwitters', in: *»Typographie kann unter Umständen Kunst sein« Kurt Schwitters. Typographie und Werbegestaltung*, Landesmuseum Wiesbaden, 1990, pp. 108f.

5 For instance *Fluxus cc V Tree (Fluxus Newspaper No. 1)*, January 1964.

6 Dietrich Helms, 'Merz und Merzwerbe – an einigen Beispielen entlanggehangelt', in: Wiesbaden 1990 (as note 4), p. 14.

7 Karin Orchard, 'Kurt Schwitters. Leben und Werk', in: idem, *Kurt Schwitters. Werke und Dokumente*, Hanover 1998, p. 47.

8 Kurt Schwitters, 'Thesen über Typographie' (as note 3), p. 91.

9 Ibid.

10 Werner Heine, 'Der kurze Frühling der Moderne, oder Futura ohne Zukunft. Kurt Schwitters' typographische Arbeiten für die Stadtverwaltung Hannover 1929–1934', in: Wiesbaden 1990 (as note 4), p. 94.

11 Emmet Williams, "Vorbemerkungen zum Interview in 'The Stars & Stripes'", in: *1962 Wiesbaden FLUXUS 1982*, Museum Wiesbaden, Berlin 1983, p. 81.

12 Jürgen Becker, untitled, in: idem and Wolf Vostell (eds.), *Happenings. Fluxus. Pop Art. Nouveau Réalisme*, Reinbek bei Hamburg 1965, p. 7. In their text 'Merzbühne und Normalbühne Merz. Zum Happeningcharakter der Bühentheorie von Kurt Schwitters', in: Gerhard Schaub, *Kurt Schwitters. »Bürger und Idiot«*, Berlin 1993, pp. 72–80, Gabriele Diana Grawe erroneously names Wolf Vostell as the author of the foreword to the book.

13 See note 12.

14 Kurt Schwitters, 'Die Merzbühne' (1919), as quoted in: Lach 1985 (as note 1), p. 42.

15 Ibid.

16 Kurt Schwitters, 'An alle Bühnen der Welt', as quoted in: Lach 1985 (as note 1), p. 41.

17 See Joachim Büchner, 'Kurt Schwitters und MERZ', in: *Kurt Schwitters 1887–1948*, Sprengel Museum Hannover, 1986, p. 16.

18 Otto Mühl, untitled, in: *Otto Mühl – Ausgewählte Arbeiten 1963–1986*, publ. by the Archiv des Wiener Aktionismus, Friedrichshof 1986, unpaginated.

19 See Justin Hoffmann, *Der Zerstörungsmythos in der Kunst der frühen sechziger Jahre*, Diss., Munich 1992, pp. 109f.

20 Henning Christiansen, 'was ist das?', in: *Arthur Køpcke. Bilder und Stücke*, daadgalerie Berlin, 1987, p. 48.

21 Robert Filliou, 'La Cedille qui sourit', in: *Robert Filliou*, Sprengel Museum
Hannover 1984, p. 40.

22 Ibid.

23 Robert Filliou, 'Einladung zur Teilnahme. Solidaritätsveranstaltung für Angela
Davis, art intermedia, Brussels, 21.10.1971', in: *Robert Filliou*, Sprengel Museum
Hannover 1984, p. 131.

24 Kurt Schwitters, 'An alle Bühnen der Welt', as quoted in: Lach 1985
(as note 1), p. 40.

25 Yoko Ono, *Collection III*, as quoted in: Hoffmann 1992, (as note 19), p. 267

26 Wolf Vostell, as quoted in: Justin Hoffmann, *Destruktionskunst. Der Mythos
der Zerstörung in der Kunst der frühen sechziger Jahre*, Munich 1995, p. 107.

27 Kurt Schwitters, 'An alle Bühnen der Welt' (1919), as quoted in: Lach 1985,
p. 40 (as note 1).

28 Hoffmann 1995 (as note 26), p. 117.

29 Günter Brus, 'Selbstbemalung', in: idem (ed.), *Le Marais*, Vienna 1965,
unpaginated.

30 Kurt Schwitters, 'Die Merzbühne', as quoted in: Lach 1985 (as note 1), p. 42.

31 Kurt Schwitters, 'An alle Bühnen der Welt', as quoted in: Lach 1985
(as note 1), p. 41.

32 Nam June Paik, *Simple (1961)*, in: Wulf Herzogenrath, *Nam June Paik.
Fluxus – Video*, Munich 1983, p. 22.

33 Kurt Schwitters, 'Die Merzbühne', as quoted in: Lach 1985 (as note 1), p. 42.

34 Kurt Schwitters, 'An alle Bühnen der Welt', as quoted in: Lach 1985
(as note 1), p. 39.

35 Allan Kaprow, *Assemblage, Environment and Happening*, New York 1967,
pp. 155–165.

36 Winfried Nöth, *Strukturen des Happening*, Hildesheim and New York 1972,
p. 217.

37 Franz Rolan and Kurt Schwitters, 'Aus der Welt: MERZ', as quoted in: Lach
1985 (as note 1), p. 156.

38 Ibid., p 163.

39 Kurt Schwitters, 'Die Merzbühne' *(1919)*, as quoted in: Lach 1985, p. 42
(as note 1).

Allan Kaprow, *Household*, 1964, Ithaca, N.Y.

"YOU CAN'T AVOID SCHWITTERS" ON THE CRITICAL RECEPTION OF THE MERZ POET SINCE 1945

GERHARD SCHAUB

The late Kurt Schwitters' enduring influence on artists in the most diverse of spheres has been as varied and many-faceted as his own artistic work. Visual artists like Robert Rauschenberg, Joseph Beuys, Timm Ulrichs, Per Kirkeby, Happening and Fluxus artists like Allan Kaprow and Wolf Vostell, rock musicians like Konstantin Wecker and David Bowie, composers like György Ligeti and Bernd Alois Zimmermann, writers like Ernst Jandl, Gerhard Rühm, Franz Mon and Helmut Heißenbüttel: all these and many more have named the Merz artist as a forerunner, an inspiration or even a teacher. Yet before Schwitters reception became a success story – before the mid-1950s – his influence was a *quantité négligeable*. This was due to the unfavourable circumstances which hampered the reception of Schwitters' work after 1945. In his last years as an exile, before his death in England in 1948, Schwitters himself could do very little to influence the opinion posterity would have of him – particularly since he was isolated and in bad health at the time. Furthermore – and this was to be the most serious hindrance to any early, concentrated reception of Schwitters' works – the political, social and cultural climate in post-war Germany was inauspicious in the extreme to German artists and writers who had gone into exile. It was virtually impossible for them to settle again in their native country because they were not welcome there; only the exceptions were invited to return, and even after the end of National Socialism the majority were not able to shake off the stigma of having been classed as "degenerate", of having been reviled, and deprived of their citizenship.

In Schwitters' case the sorry state of the early phase of his reception may be seen in the small number of obituaries, exhibitions and publications in which his contemporaries even noticed the work of the Merz artist between 1945 and 1955. His death on 8 January 1948 in the English Lake District only prompted two obituaries in German newspapers. One, a mere ten lines, appeared in the Berlin *Tagesspiegel* on 15.2.1948 in the shape of a press report by Edwin Redslob, who had heard from Hannah Höch of the death of her friend; the other appeared in the *Hannoversche Presse* on 5.2.1948, due to the efforts of Christof Spengemann, Schwitters' closest friend when he was still in Hanover. Without Spengemann, the Merz artist's native town might well have remained in ignorance of the death of their most important son in the 20th century. In 1949, a year after the event, when the art critic Franz

Roh wanted to publish an obituary by Friedrich Vordemberge-Gildewart in the Munich monthly *Die Kunst und das schöne Heim*, the journal's editorial board refused him permission.[1] Thus it was not until 1950 that the wider German public with an interest in art was informed of Schwitters' death three years previously – in an article with the heading "in memoriam" in the journal *Das Kunstwerk*, written by the editor Leopold Zahn, who described Schwitters as having been "reviled at home" and dying as an "émigré in England", and referred to his one-man art movement Merz as an independent form of Dada. More informative and appropriate to the artist's standing than the German obituaries were those published abroad in 1948/49. Apart from the two that appeared anonymously in the English local press, where Schwitters was remembered as an "artist of international repute" and his Merz art was described as "world known",[2] all the articles in his memory published abroad were written by friends of the artist.[3]

It was not only obituaries but also exhibitions of his work that were far and few between in the first years after his death. The first Schwitters exhibition in Germany did not take place until 1956, by which time there had been six solo exhibitions abroad between 1948 and 1956. These exhibitions in Basel, New York, London and Paris would most likely not have taken place if they had not been inspired and supported by Schwitters' friends and enhanced with works lent by them.

Kurt Schwitters performing the *Ursonate*, in the 1920s, Kurt Schwitters Archive in the Sprengel Museum Hannover

In the Federal Republic of Germany, which came formally into existence in 1949, pictures by Schwitters were not shown until 1955 at the documenta in Kassel.[4] Three works were shown,[5] on loan from Hans Arp and his later wife Marguerite Hagenbach.

However, Schwitters' rediscovery did not take place at the documenta, but at the "first comprehensive memorial exhibition" put on by Werner Schmalenbach from 4 February until 11 March 1956 in the rooms of the Kestner-Gesellschaft in Hanover. Following that exhibition with its 208 exhibits there was no longer any doubt as to the importance of Schwitters' Merz art, having been a matter of dispute for so long, reviled by the National Socialists and scarcely appreciated since 1945; now – as Schmalenbach shrewdly put it in the exhibition catalogue – it had "withstood the trial by fire of history". Without in any way belittling the significant part played by those abroad in popularising Merz art after 1945, one has to agree with Dietmar Elger when he concludes that his "actual rediscovery"[6] started in Hanover in 1956. At a stroke Schwitters' work had made its mark with this exhibition: on the art market, with critics and amongst the interested public. After 1956 there was no longer any way of avoiding the Merz artist Schwitters.

As far as exhibitions abroad were concerned, a whole number of artists were involved in the early exhibitions between 1948 and 1956 as initiators, lenders or organisers: Hans Arp, Tristan Tzara, E. L. T. Mesens, Hannah Höch and a younger artist-colleague, the *informel* painter K. O. Götz.[7] While artists played an important part in the first Schwitters exhibitions after the Second World War, the Schwitters retrospectives in the 1950s were in turn a source of inspiration for a whole number of artists, Neo-Dadaists in the USA and Nouveaux Réalistes in France, amongst them Robert Rauschenberg, Arman and Daniel Spoerri. Schwitters was and still is first and foremost an artists' artist. A comment by the dramatist Heiner Müller seems particularly appropriate for Schwitters and his Merz art: "The effect of a work of art consists mainly in its effect on other works of art."[8]

Schwitters reception in the 1950s received an additional boost from the gradual increase in the number of Dada exhibitions at the time. For Schwitters was always represented in these with considerable numbers of works, as for instance in the *International Dada Exhibition*[9] put on in 1953 by Sidney Janis in New York, and in 1958 in the Düsseldorf Dada show *Dokumente einer Bewegung*.

Kurt Schwitters, *contra punkt*, 1938, Musée National d'Art Moderne, Centre Georges Pompidou, Paris

By the late 1950s/early 1960s Schwitters was recognised and established worldwide as an important visual artist, as demonstrated by the increasing frequency with which his works were shown in museums: the first Schwitters exhibitions in German art museums took place in Ulm in 1961 and in the Wallraf-Richartz-Museum in Cologne in 1963. Besides gallerists and art dealers, the pillars of early Schwitters reception were initially friends of the artist and collectors of Merz art; these were joined in the 1950s by directors of public galleries and Neo-Dadaists and Nouveaux Réalistes, and in the 1960s by museum directors, who now gradually started buying larger works by the Merz artist: the assemblage *Das Sternenbild* (The Star Picture) of 1920 was the "first large Schwitters to arrive in a European museum after the war".[10]

What exhibitions did for the reception of the Merz *artist*, publications did for the Merz *poet*: indeed they were vital to his literary reception at all. Every exhibition, every publication of Schwitters' work after 1945 was both a precondition *and* a record of his reception. Since his writings had been banned in 1933 and thus excluded from the market, after 1945 they had to be made available again, in other words they had to be published. This was obviously fraught with difficulties, for independent publications of Schwitters' writings only started to emerge in the book market between 1964 and 1966 as reprints or facsimile prints.[11] When Friedrich Lach, with the access that he had to the literary estate, was

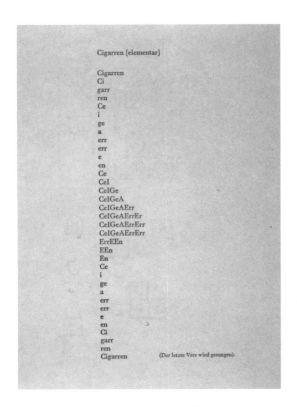

Cigarren [elementar]

Cigarren
Ci
garr
ren
Ce
i
ge
a
err
err
e
en
Ce
CeI
CeIGe
CeIGeA
CeIGeAErr
CeIGeAErrEr
CeIGeAErrErr
CeIGeAErrErr
ErrEEn
EEn
En
Ce
i
ge
a
err
err
e
en
Ci
garr
ren
Cigarren (Der letzte Vers wird gesungen).

Kurt Schwitters, 'Cigarren (elementar)' (1921), from:
Elementar. Die Blume Anna. Die neue Anna Blume,
Berlin 1922

able to provide the "first overview of the literary work" of Schwitters in 1971, the latter's extensive literary opus was still largely unknown.[12] This did not change until Lach published *Das literarische Werk* in five handsome volumes between 1973 and 1981, with texts that had in the main never been published before.

The earliest reception of Schwitters' writings in the post-war period had, however, already started in the 1950s when a number of individual poems and prose texts by him were published in anthologies and journals. The first major sign of his literary reception, and for a long time the most influential, was the volume *Anthologie der Abseitigen. Poètes à l'Ecart*, published in Bern in 1946. Initiated by Hans Arp[13] and edited by the Zurich art and literary critic Carola Giedion-Welcker, this poetry anthology contains thirteen poems by Schwitters, including the *Scherzo* from the *Ursonate*, the Merz Poem 1 *An Anna Blume* and the *Basel* poem of 1935. With its many texts that were otherwise very hard to come by, and which – as the editor put it in her foreword – were exceptional for their "bold advance into new verbal territory and experiment", this anthology was a positive treasure trove for many of the experimental

writers in the post-war, German-speaking world. In this volume they were able to rediscover for themselves a literary tradition, buried by the Nazis, that had been interested in the materiality of language. Two prominent exponents of experimental, concrete poetry after 1945 – Franz Mon and Gerhard Rühm – later made specific reference to the deep significance of the *Anthologie der Abseitigen* for their own work on and with language.[14]

The first sign of a wider interest in Schwitters in Germany was the publication of a text by Schwitters criticising critics, the *Tran* article no. 26, *An alle Kritiker*, which appeared in January 1951 in the *Monatszeitschrift für zeitgenössische experimentelle Kunst und Poesie META* (no. 3), edited by the painter and poet K. O. Götz. And it was less through the publication of this text than through his role as a mediator of Schwitters' work, that Götz became very important to a younger generation of artists. It was his promotion of the Merz artist, whose collages and poetic works he had already much admired when he was in Dresden during the Second World War,[15] that led to a circle of people forming in the early 1950s in Frankfurt – like the young Franz Mon – whom Götz "alerted to Schwitters' poetic works".[16]

But it did not get slowly but surely under way until the mid-1950s. Evidence of Schwitters' early literary reception may be found in the anthologies *Lyrik des expressionistischen Jahrzehnts* (1955), *Dichtung moderner Maler* (1956), *Transit* (1956), *Movens* (1960), *Museum der modernen Poesie* (1960), and in the two collections on the *Literatur-Revolution 1910–1925* (1960/61) and the journal *Akzente* (1963), in which a whole number of individual Schwitters texts were reprinted – mostly poems, but also prose texts (*Der Schürm*, *Auguste Bolte*) and manifestos (*Merz, Aus der Welt: »Merz«*). Insofar as they were without access to first editions of Schwitters' writings from the 1920s, up until 1963 post-war authors got to know his work through these anthologies and journals. The early phases of Schwitters' literary reception had three main features: they went hand in hand with contemporary experimental literature and art to which the three above anthologies were dedicated (*META*, *Transit* and *Movens*); in their initial stages the prime movers were visual artists and writers like Arp, Götz, Mon and Höllerer; they

progressed in "decade leaps" and were largely dependent on first publications and reprints of Schwitters' texts.[17]

Although it is true to say that the first phase of Schwitters' literary reception began in the mid-1950s, it was not until the 1960s – when he was no longer regarded as "wayward" and lost – that the poet Schwitters was properly rediscovered.[18] Moreover: since that time Schwitters has had a productive, enduring effect on many writers and artists. Their number is so great that it is only possible to glance cursorily at some of those inspired by his work.

Franz Mon (*1926), one of the first and most steadfast Schwitters recipients in German-speaking literature since 1945, was already introduced by K. O. Götz to some of the Merz poet's writings in the early 1950s. In his collected essays[19] from 1957 to 1992 no other artist is mentioned so frequently as the Merz artist. Why was Mon interested in Schwitters? Which texts particularly attracted his attention? Above all it was the innovative, "elemental" – in short the experimental – texts by the Merz poet that Mon returned to again and again, claiming Schwitters as one of the most important, ground-breaking precursors and initiators of experimental literature after 1945. Schwitters had originally collected several of his experimental texts in a slim volume of poetry with the significant title *Elementar. Die Blume Anna. Die neue Anna Blume* (Berlin 1922), and Mon clearly worked from this edition for he refers to it in a

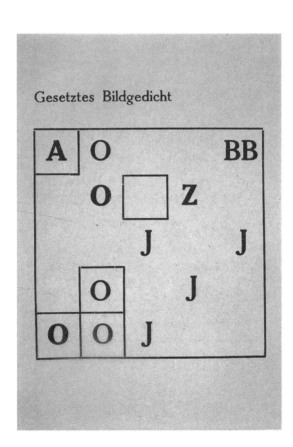

Kurt Schwitters, 'typographical picture poem', from:
Elementar. Die Blume Anna. Die neue Anna Blume, Berlin 1922

number of places in his writings. In Mon's view "Schwitters [is] one of – perhaps *the* discoverer of the intermedium in art", that is to say, for him literature and visual art, literature and music have become "permeable", for him there are no longer any "sharp boundaries between the arts".[20] Mon explains the intermediality of Schwitters' work by drawing on two examples from his phonetic and visual poetry: the *Ursonate*, the prototype of a sound-poem consciously based on a musical form, "in which the sound qualities of the language are used autonomously and without concern for meaning as such"[21]; and the 'typographical picture poem', which appeared in the *Neue Anna Blume* collection of 1922. This "early example of visual poetry" consists of upper case letters taken from thirteen typesetters' boxes and five small squares which "are set in a square frame according to typographical and compositional principles and without reference to semantics or syntax".[22]

Besides the "elemental" texts in *Neue Anna Blume*, which also served other concrete poets almost like a founders' charter for early experimental literature, Mon most appreciated the grotesque story *Auguste Bolte*. He interprets it as an "anti-novella", which marks an important "moment of departure from a classical form towards an open form", in which Schwitters "clears the ground for a new, unclassical concept of text": "text as form which is both momentary and open-ended".[23] In Mon's view, the "doubts regarding the genre of the novella" are connected to the "dissolution of conventional narrative attitudes" in *Auguste Bolte* which was suited to an individual whose fate was not yet decided, an individual to whom the unexpected could happen".[24] Much of what Mon writes about *Auguste Bolte* also applies to his own *herzzero*, published in 1968 and his longest text to date, which "shakes up the classical use of subject matter", replacing it with language as the "centre of the action", refuting customary genres and demonstrating "language as fulfilment" and "text as process".[25] Thus one might well regard the anti-novella *Auguste Bolte*, if not as a subtext, then at least as an important stimulus for the "anti-novel" *herzzero*. Like Schwitters, Mon is a poet of the "intermedium in art", like the latter he has produced visual and phonetic texts, verbal collages and text pictures, thereby significantly extending the reach of intermedial art. Far from being an epigone, he

took up impulses and ideas that he found in Schwitters' work, and advanced them independently and creatively.

Since 1945 no writer has engaged more intensively with Schwitters' literary work than did Helmut Heißenbüttel (1921–1996).[26] In his numerous, informative analyses of Schwitters' work, Heißenbüttel's goal was to rehabilitate the Merz poet, so long undervalued, and to instate him as one of the founding fathers of experimental literature. Already in 1972 he was lauding Schwitters as "a writer who tried out much that was to become important to the literature of the 20th century" and "which now can only be imitated".[27] And as late as 1987, he described the literary output of the Merz poet "as a unique anthology of 'other' literature […] in which numerous discoveries are still to be made [and] which still shows how much there once was in it".[28] For Heißenbüttel, the poetic radicalism of the Merz poet – which is in itself a matter of politics[29] – is to be found above all in his *elemental* texts, that is to say in his numbers and letter poems, which do not use number-words or phonetically spoken letters but purely the printed symbols,[30] and therefore are not constructed from the basic elements of language at all. The fact that Schwitters "declares these [minimal] elements of language to be a poem"[31] is rightly regarded by Heißenbüttel as a literary parallel to abstract painting: "Only when one becomes fully aware of how Schwitters in 1923, in the realm of language and literature, was already trying out step by step those features that were to change the whole of the visual arts, can one fully recognise how fundamentally important this activity

was and still is."[32] The fact that literature has nothing to do "with anything other than language"[33] is a central poetological theorem proposed by Heißenbüttel, which he sees realised in more than a few texts by the Merz poet, above all and in exemplary fashion in the story *Auguste Bolte*, in which Schwitters demonstrates the "system of literature out of language itself".[34]

Even in an occasional text on 'Kurt Schwitters als Schriftsteller'[35] in 1976, Heißenbüttel manages to touch illuminatingly on a whole number of pointers to the importance of this painter and poet: saying that he was "one of the greatest ever comics in German literature" and "the greatest Constructivist amongst German writers", that he should be regarded equally highly as a painter and a poet, that the "appreciation which he enjoyed as an author and writer" was, "however, in precisely reverse proportion to the price his pictures fetched". One has to ask oneself if this unequal estimation does not still prevail today, in the year 2000 – less with respect to writers and artists over the last four decades, but very much so with regard to the broader literary public, including many Germanists, critics and other mediators of literature.

The rediscovery of the writer Schwitters coincided with the rise and establishment of concrete poetry in the 1950s and 60s. Many of the authors who moved in concrete poetry circles – besides Mon and Heißenbüttel, their friend the literary scholar and writer Reinhard Döhl[36] should also be mentioned here – were declared admirers of Schwitters' work. These also included the Viennese poets Gerhard Rühm and Ernst Jandl. Since I have elsewhere already explored some of the traces left by the Merz poet in their work,[37] here I will concentrate on 'theoretical' statements by Rühm and Jandl regarding the Merz poet.

Gerhard Rühm (*1930) discovered Schwitters around the mid-1950s in the *Anthologie der Abseitigen*. He and his friends in the Vienna Group saw Schwitters and a number of other writers represented in the anthology – such as August Stramm and Hans Arp – as the "re-found, actual tradition" that their own efforts "were organically connected to".[38] Rühm's 1976 essay *der wortkünstler kurt schwitters* constitutes a detailed examination of the work of the Merz artist. In it Rühm points to

Gerhard Rühm, 'Crossing – Hommage à Kurt Schwitters', first printed in: Michael Erlhoff und Klaus Stadtmüller (eds.): *Kurt Schwitters Almanach*, Hanover 1987

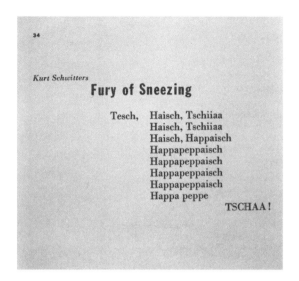

34

Kurt Schwitters

Fury of Sneezing

Tesch, Haisch, Tschiiaa
 Haisch, Tschiiaa
 Haisch, Happaisch
 Happapeppaisch
 Happapeppaisch
 Happapeppaisch
 Happapeppaisch
 Happa peppe
 TSCHAA!

Kurt Schwitters, 'Fury of Sneezing', first printed in Raoul Hausmann and Kurt Schwitters, *PIN*, London 1962

boundaries between genres, who has successfully taken poetry forwards above all at its margins – moving both towards the visual arts and towards music.

Like Rühm and Mon, Ernst Jandl (1925–2000) also became aware of Schwitters' work as far back as the mid-1950s, in his case through the 1955 anthology *Lyrik des expressionistischen Jahrzehnts*.[42] It is hardly surprising that the speech and recitation artist Jandl – who owed his great popularity above all to his own performances of his phonetic poems – should have been interested first and foremost in the sound-poet Schwitters. As in 1965, in the *International Poetry Reading at the Royal Albert Hall* in London where he performed the *Niessgedicht*,[43] Jandl continued to include sound-poems by the Merz poet in his recitations.[44] In Jandl's eyes, the great achievement of the sound-poet Schwitters was to have opened up the realms of poetry, by freeing "the voice from the restrictions of even an imaginary language of syllables and words".[45] As Jandl saw it, this emancipation of the voice reached its highpoint in the *Ursonate* by Schwitters, whom he hailed as the "master of great sound-poems composed according to musical principles".[46]

Himself a great humorist and nonsense poet, Jandl did not overlook the humour and nonsense in the work of his kindred spirit Schwitters.[47] For him, Schwitters was one of those authors who have "deposed reason as the absolute ruler and have thus extended the realms of poetry into infinity".[48] When, in his third Frankfurt lecture on poetry, Jandl named Kurt Schwitters as the only poet writing in German who had approached the same level as his most important literary exemplar, Gertrude Stein, he could not have paid a greater compliment to the Merz poet. "These two", Jandl concluded, "contain almost everything that we can have today. That we can learn from for our own poetry."[49]

The influence that Schwitters had on these writers in the main goes back to the Merz poet's experimental, intermedial, "elemental" texts. But that by no means covers the full extent of this 'total' artist's influence, for Schwitters also wrote theoretical texts on the theatre, and composed stage works, he was a performer and pre-happening artist, a typographer and book artist. And after 1945, sooner or later his influence

the fact that as a poet Schwitters had "still not acquired the status that befitted his significance" and that it had taken a younger generation to rediscover Schwitters as a "one of the key figures in modern art ... often finding their own ideas surprisingly confirmed but also driven forwards".[39] In his essay Rühm, by implication, made clear what particularly interested him in Schwitters' work and inspired him in his own work: it was Schwitters' quality as a word-artist – influenced by August Stramm and the word-art theories of the *Sturm* – with his "concentration on the word as a phonetic, rhythmic entity"[40]; the literary Constructivist with his "abstract ... elemental" letter and number poems largely free of any semantic associations; and not least the sound-poet with his *Ursonate*, with which Schwitters had become "a pioneer of a genre that now existed in its own right: 'auditive poetry'".[41] Rühm, himself an experienced performer, recited the *Sonate in Urlauten* on 21 March 1974 in a broadcast by the Süddeutscher Rundfunk in Stuttgart. He assimilated everything from "his" Schwitters in which he saw his own work "confirmed but also driven forwards" and challenged, and strove to continue that work differently, better or more consistently. Like Schwitters, to this day he works intermedially, an all-round artist blurring and crossing the

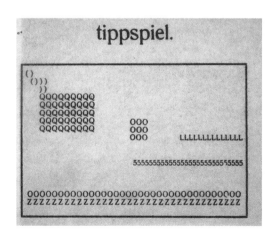

tippspiel.

Kurt Schwitters, 'Typing Game', from the Yugoslavian journal *Tank*, Ljubljana 1927

Kurt Schwitters, 'Studio', from:
G. Zeitschrift für elementare Gestaltung,
no. 3, June 1924

was felt in all these fields. Of all the various repercussions of his work, it is only possible to touch on two areas here: Schwitters' impact as a stage-theoretician and as a sound-poet, the creator of the *Ursonate*.

The writer, translator, author of stage and radio plays, Paul Pörtner (1925–1984), was one of the first authors to point out the achievements of the stage-theoretician Schwitters in the context of his own efforts around 1960 to reactivate the concept of "total theatre", by reprinting three important theatre manifestos by the Merz artist.[50] In his book *Spontanes Theater* of 1972, Pörtner writes of Schwitters' Merz-stage (*Merzbühne*) project that it "most probably had the strongest influence of all the many theatre manifestos in the 1920s".[51] Pörtner was particularly interested in Schwitters' expectations of actors and the public as explained in his dialogue *Aus der Welt: »Merz«*, where is it said that the actor is to extemporise and improvise, and that the public should participate in the performance as a constitutive and creative factor of the Merz stage work; with all its various reactions, it should be planned for and integrated.[52]

It was not by chance that in 1960 – at the time of the publication of the Merz-stage manifestos – Pörtner started to write stage pieces, or rather to make plans for stage pieces, in which he put into practice Schwitters' demands. And in doing so he took the active participation of the public a stage further than Schwitters: after the premiere of his thriller *Scheren-schnitt* he made ever greater provision in his plans for the public to participate in the piece.[53] In 1972, when Pörtner described the Merz-stage projects as having "the strongest influence" of all 1920s manifestos on

theatre in the 1960s, he knew precisely what he was referring to, having felt this influence so strongly himself.

An important chapter in the history of the influence of the Merz poet is the reception of the *Ursonate*, whereby two different echoes should be distinguished from each other: on the one hand its resonance amongst sound-poets such as Jandl, Rühm and Mon, on the other hand its significance as a text 'score' for acoustic realisations and interpretations by performance artists, actors, singers, musicians and composers. Of the four available recordings of the *Ursonate* on vinyl and as CDs,[54] particular mention should be made of the rhythmically daring, musically accomplished interpretation by the Dutch vocal virtuoso Jaap Blonk. Other performances of the *Ursonate* – by the flautist Eberhard Blum, the pianist and musicologist Siegfried Mauser, the composer Wilhelm Killmayer and musicians from the jazz scene – demonstrate that the *Ursonate* has consistently attracted performers from the world of music. It also confirms Franz Mon's comment that "to this day it possesses an enduring musical fascination".[55]

It has not only been highbrow interpreters that have become devotees of Schwitters' work. The Merz poet has also enjoyed unexpected respect from leading exponents of so-called popular music, admittedly not in performances of the *Ursonate*, but in 'pop versions' of *Anna Blume*. The songwriter and rock musician Konstantin Wecker has composed a set of *Variationen über ein Thema von Kurt Schwitters* entitled *Anna Blume*,[56] and the hip-hop band Freundeskreis, in its chart-topping song *A-N-N-A* ("Immer wenn es regnet muß ich an dich denken" – Always when it rains I have to think of you) has turned Schwitters' parody of a love poem into a modern love song to the "hip-hop fan" Anna.[57]

The literary and musical reception of Schwitters' work is a wide field that has so far not been intensively cultivated.[58] Thus, for instance, as yet there have been no investigations into the reception of the Merz poet in Great Britain, Canada, France or the USA. It may be surprising for some to learn that his work also had an influence in the German Democratic Republic – in the wake of the reception of Dada – albeit much later and under difficult, different circumstances to that in the

Federal Republic. However, this delay is readily explained by the prolonged ostracisation of avant-garde artists in the cultural life of the GDR. After a hesitant start by the younger generation of artists and writers living in Berlin's Prenzlauer Berg in the late 1970s and early 1980s, by 1985 – not only in East Berlin but also in the provinces – there was an astonishing renaissance of Dada and Merz. It lasted, and even intensified, right up until the end of the GDR, which could almost tempt one to draw a chronological parallel between the fall of the GDR and the emergence of the Dada-revival and other avant-garde art movements. In terms of Schwitters' reception during this time, the first major anthology of texts by Schwitters to appear in book form in the GDR was published in 1985 by the East Berlin publishers Volk und Welt.[59] And on the occasion of the centenary of the birth of Schwitters, the Lindenau-Museum in Altenburg put on a major Schwitters exhibition with the title *Von MERZ bis heute* (From MERZ to today) from 15 November 1987 until 17 January 1988. This was accompanied by a 68-page catalogue which was already in its fourth edition by 1988. After 1988, in West and East Germany alike, the group *electronics & voice* led by Hannes Zerbe had great success with its MERZ Jazz programme, consisting of texts by Schwitters. In their GDR performances, the group was not least so successful because they "gave plenty of room to the widespread need to express opposition."[60] As shown by Detlef Böhnki,[61] the influence of Schwitters' style can be seen in the work of numerous modern GDR writers, such as Frank-Wolf Matthies, Bert Papenfuß-Gorek and Adolf Endler.[62]

During his own lifetime Schwitters was under no illusions as to the value put on his work or its resonance. Yet in view of his renown after his death, he was rightly aware early on of his own significance as an avant-garde artist. In the autobiographical text 'Ich und meine Ziele' of 1931, he wrote, filled with self-confidence: "I know that I am an important factor in the development of art and will remain important for all time. I say this with such emphasis, so that later on people will not say: '*The poor man had no idea how important he was.*' […] I know very well that for me and all the other important personalities of the abstract movement the great time is yet to come when we will influence a whole generation, only I fear I will not experience it personally. […] *My time will come*, that I do know […] And if you people of the future want to do something to make me particularly happy, then try to recognise the important artists of your own time. That is more important for you and would be a greater joy for me, than if you discover me at a time when I have already long been discovered."[63]

Emmett Williams, 'kurt schwitters, i shit …', first printed in: Michael Erlhoff and Klaus Stadtmüller (eds.), *Kurt Schwitters Almanach*, Hanover 1987

NOTES

1 See letter from Franz Roh to Vordemberge-Gildewart written in 1949, in: Friedrich Vordemberge-Gildewart, *Briefwechsel*, Wiesbaden 1997, vol. 2, pp. 152f.

2 *Lake District Herald* of 12.1.1948. The other obituary appeared on 17.1.1948 in the *Westmoreland Gazette*.

3 Those concerned were: Hans Arp, Annie Müller-Widmann, Friedrich Vordemberge-Gildewart and Carola Giedion-Welcker, who all wrote obituaries drawing on their own personal memories that were published in Switzerland, Holland, the USA and France. The obituaries by Hans Arp and Annie Müller-Widmann are reprinted in: Gerhard Schaub (ed.), *Kurt Schwitters: »Bürger und Idiot«. Beiträge zu Werk und Wirkung eines Gesamtkünstlers*, Berlin 1993, pp. 135–138. For more on the obituaries by Friedrich Vordemberge-Gildewart and Carola Giedion-Welcker see Schwitters-Archiv der Stadtbibliothek Hannover (publ.), *Bestandsverzeichnis 1986*, p. 192, nos. 1733, 1734, 1740.

4 The annotated bibliography by Martin Papenbrock, *»Entartete Kunst« – Exilkunst – Widerstandskunst in westdeutschen Ausstellungen nach 1945*, Weimar 1996, does not list any exhibition before 1955 with works by Schwitters.

5 Exh. cat., *documenta. Kunst des XX. Jahrhunderts*, Munich 1955, p. 60.

6 Dietmar Elger, ›Ich bin ein Veilchen, das verborgen blüht‹. Zum Stand der Schwitters-Forschung', in: *Kurt Schwitters 1887–1948*, Sprengel Museum Hannover 1986 (2nd revised and enlarged edition, Frankfurt a. M. and Berlin 1987), p. 51.

7 See K. O. Götz, *Erinnerungen*, Aachen 1994, vol. 2: 1945–1959, p. 212, who reports that he was "not entirely uninvolved" in the lead up to the exhibition in the Kestner-Gesellschaft, because on a visit to Norway in 1955 he had suggested to Schwitters' son Ernst that the Kestner-Gesellschaft could put on a exhibition.

8 As quoted in: Jan-Christoph Hauschild, 'Der Autor als Leser. Überlegungen zu Georg Büchners Literaturrezeption', in: Fausto Cercignani (ed.), *Studia Büchneriana. Georg Büchner 1988*, Milan 1990, p. 109.

9 For more on this exhibition see Maria Müller, *Aspekte der Dada-Rezeption 1950–1966*, Essen 1987, pp. 26ff. Schwitters was represented here with 13 exhibits, in Düsseldorf with 51 exhibits.

10 Werner Schmalenbach, *Die Lust auf das Bild. Ein Leben mit der Kunst*, Berlin 1996, p. 116. This picture came in 1963 to the Kunstsammlung Nordrhein-Westfalen in Düsseldorf, where Schmalenbach was the director from 1962–1990.

11 See Kurt Schwitters, *Memoiren Anna Blumes in Bleie*, Berlin 1964; Ernst Schwitters (ed.), *Kurt Schwitters. Anna Blume und ich. Die gesammelten Anna Blume-Texte*, Zurich 1965; Kurt Schwitters, *Anna Blume. Dichtungen*, Zurich 1965; Ernst Schwitters (ed.), *Kurt Schwitters. Auguste Bolte*, Zurich 1966.

12 Friedhelm Lach, *Der MerzKünstler Kurt Schwitters*, Cologne 1971, p. 8.

13 Letter from Carola Giedion-Welcker to Vordemberge-Gildewart on 21.3.1946, in: Friedrich Vordemberge-Gildewart, *Briefwechsel*, Wiesbaden 1997, vol. 1, p. 303.

14 See Franz Mon, 'Meine 50er Jahre', in: Jörg Drews (ed.), *Vom »Kahlschlag« zu »movens«. Über das langsame Auftauchen experimenteller Schreibweisen in der westdeutschen Literatur der fünfziger Jahre*, Munich 1980, p. 49; see also Gerhard Rühm, Foreword, in: idem (ed.), *Die Wiener Gruppe. Achleitner, Artmann, Bayer, Rühm, Wiener. Texte, Gemeinschaftsarbeiten, Aktionen*, Reinbek bei Hamburg 1967, p. 9.

15 See K. O. Götz, *Erinnerungen*, Aachen 1993, vol. 1: 1914–1945, pp. 181, 189, 221.

16 K. O. Götz, *Erinnerungen*, Aachen 1994, vol. 2: 1945–1959, p. 181. In the early 1950s a copy of the first printing of *Auguste Bolte* (1923) did the rounds amongst Götz's friends in Frankfurt and generated "a positive Schwitters cult" (Götz 1993, see above, p. 189).

17 Hans-Jürgen Hereth, *Die Rezeptions- und Wirkungsgeschichte von Kurt Schwitters, dargestellt anhand seines Gedichts »An Anna Blume«*, Frankfurt a. M. 1996, p. 157.

18 In 1965, in the foreword to the new edition of her *Anthologie der Abseitigen* Carola Giedion-Welcker pointed out that the term "abseitig" (distant, wayward), in the sense of "awkward in terms of access" no longer applied to many of the poets in the anthology.

19 See Franz Mon, *Essays. Gesammelte Texte 1*, Berlin 1994, p. 337. For more on the quotation in the title of this essay, see ibid., p. 7.

20 Ibid., pp. 7f., 15.

21 Ibid., p. 247.

22 Ibid., p. 133.

23 Ibid., pp. 185f.

24 Ibid., p. 185.

25 Ibid., pp. 238, 240, 191–203.

26 Helmut Heißenbüttel wrote seven pertinent essays and articles on the Merz poets. Aside from the three mentioned in subsequent notes, the other four are: Helmut Heißenbüttel, 'Gertrude Stein, Kurt Schwitters und der Fortschritt in der Literatur. Ein Pamphlet', in: Jörg Drews (ed.), *Das Tempo dieser Zeit ist keine Kleinigkeit. Zur Literatur um 1918*, Munich 1981, pp. 183–190; idem, *Versuch über die Lautsonate von Kurt Schwitters*, Wiesbaden 1983; idem, 'Über einige Gedichte von Kurt Schwitters', in: *Kurt Schwitters Almanach 1987*, Hanover 1987, pp. 104–110; idem, 'Das i-Gedicht von Kurt Schwitters', in: *»Typographie kann unter Umständen Kunst sein.« Kurt Schwitters. Typographie und Werbegestaltung*, Landesmuseum Wiesbaden 1990, pp. 41f.

27 Helmut Heißenbüttel, 'Die Demonstration des i und das Trivialgedicht. Der Dichter Kurt Schwitters', in: *Text + Kritik*, part 35/36: Kurt Schwitters, 1972, p. 2.

28 Helmut Heißenbüttel, 'Auguste Bolte und Anna Blume oder die Welt der Sprache. Versuch über die Literatur von Kurt Schwitters', in: Hanover 1986 (as note 6), p. 45.

29 Heißenbüttel 1972 (as note 27), p. 2.

30 Ibid., p. 3.

31 Ibid.

32 Ibid.

33 Helmut Heißenbüttel, *Über Literatur. Aufsätze und Frankfurter Vorlesungen*, Munich 1970, p. 207.

34 Heißenbüttel 'Auguste Bolte und Anna Blume oder die Welt der Sprache', in: Hanover 1986 (as note 6) pp. 42f.

35 Helmut Heißenbüttel, in: programme notes on the performance of the grotesque opera *Der Zusammenstoß* in the Tübinger Zimmertheater (Premiered 8 October 1976), unpaginated.

36 See Reinhard Döhl, *Es Anna*, Berlin 1966; see also his extensive study on 'Kurt Merz Schwitters', in: Wolfgang Rothe (ed.), *Expressionismus als Literatur*, Bern and Munich 1969, pp. 761–774.

37 See Martina Kurz, 'Kuwitters Kinder. Kurt Schwitters' nachhaltige Spuren in der Gegenwartsliteratur am Beispiel von Ernst Jandl und Gerhard Rühm', in: Schaub 1993 (as note 3), pp. 116–130.

38 Gerhard Rühm, Foreword, in: Rühm 1967 (as note 14), p. 9.

39 Gerhard Rühm, *der wortkünstler kurt schwitters*. The quotation is from an essay that was first published in 1976 in the catalogue of a small Schwitters exhibition in the Galerie Klewan in Vienna, in the version revised by Rühm in: Schaub 1993 (as note 3), p. 31.

40 Ibid., p. 32.

41 Ibid., p. 40.

42 See Ernst Jandl, *für alle*, Darmstadt and Neuwied 1974. pp. 219, 226.

43 See the photograph of the reading in the Royal Albert Hall, in: Ernst Jandl, *my right hand / my writing hand / my handwriting*, Neue Texte 16/17, Neue Ausgabe, Vienna 1985, unpaginated.

44 Thus in his *Frankfurter Poetik-Vorlesungen* of 1984, in which he performed the short sound-poem *boo* and the *Kleine Gedicht für große Stotterer*. See Ernst Jandl, *Das Öffnen und Schließen des Mundes. Frankfurter Poetik-Vorlesungen*, Frankfurt a. M. 1990, pp. 27f., 75f.

45 Ibid., p. 26.

46 Ibid., pp. 26, 75.

47 On the "humorist" Schwitters see ibid., p. 75.

48 Klaus Siblewski (ed.), *Ernst Jandl. Gesammelte Werke 3. Stücke und Prosa*, Frankfurt a. M. 1990, p. 620.

49 Jandl 1990 (as note 44), pp. 71f.

50 See Paul Pörtner, *Experiment Theater*, Zurich 1960, pp. 116ff. (*Die Merzbühne, Erklärungen meiner Forderungen zur Merzbühne*), and Paul Pörtner, *Literatur-Revolution 1910–1925. Dokumente, Manifeste, Programme*, Neuwied and Berlin 1961, vol. 2: *Zur Begriffsbestimmung der Ismen*, pp. 541–545 (*Aus der Welt: »Merz«*).

51 Paul Pörtner, *Spontanes Theater. Erfahrungen Konzepte*, Cologne 1972, p. 96.

52 Ibid., p. 97.

53 Paul Pörtner, Afterword in: *Scherenschnitt. Kriminalstück zum Mitspielen*, Cologne and Berlin 1964, p. 90; see also Pörtner's stage work *Entscheiden Sie sich! Mitspiel*, Cologne 1965.

54 See Kurt Schwitters, *Ursonate*. Performer: Jaap Blonk, LP, BVH AAST, Amsterdam 1986; idem, *Ursonate*. Voice: Eberhard Blum, CD, Hat Hut, Therwil 1992; idem, *Ursonate*. Performer: Arnulf Appel, CD, Logo, Obernburg am Main 1993; idem, *Fümms bö wö tää zää Uu & Ribble Bobble Pimlico. Ein Konzert für Schauspieler*, CD, PT 2000, Vienna 1997.

55 Mon 1994 (as note 19), p. 132.

56 The title arranged by Konstantin Wecker and Wolfgang Dauner is on the record: *ganz schön wecker*, Global-Musicon, Munich 1988.

57 See the CD by Freundeskreis, *Quadratur des Kreises*, Four Music, Columbia 1997.

58 One exception is the Siegen dissertation by Hans-Jürgen Hereth (as note 17), which documents the different echoes of *Anna Blume* "in the realms of art (Pop-Art, Happening), literature and theatre" (p. 186).

59 See Joachim Schreck (ed.), *Kurt Schwitters. Anna Blume und andere Literatur und Grafik*, Berlin 1985.

60 Hans-Jürgen Linke in his review of a performance of the group with their *MERZ-Jazz* programme in the Frankfurt Mousonturm, in: *Frankfurter Rundschau* of 21 January 1995, p. 19.

61 Detlef Böhnki *DADA-Rezeption in der DDR-Literatur*, Essen 1989, p. 185. On Schwitters reception see ibid., pp. 50f., 96 (fig. 13), 102, 153f.

62 See Adolf Endler, 'Minidrama: Zwei beim Packen', in: idem, *Der Pudding der Apokalypse. Gedichte 1963–1998*, Frankfurt a. M. 1999, p. 151. This minidrama, written in 1985, consists of two sentences from the 104-line poem *Flucht* by Kurt Schwitters ("Er: Hörst du das Maschinengewehr? / Sie: Vergiß die Zahnbürste nicht." – 'He: Don't you hear the machine guns? / She: Don't forget the toothbrush.').

63 Friedhelm Lach (ed.), *Kurt Schwitters. Das literarische Werk*, Cologne 1981, vol. 5, pp. 345f., 348.

LIST OF WORKS

Note on dates of origin:
When the making of a work is known to have lasted for a specific time, the relevant years are given joined by a dash. If a piece was re-worked a considerable time after the original date of its making, the relevant years are joined with the word "and". A forward slash indicates the time-span within which a work was most probably made.

KURT SCHWITTERS

1 (p. 13)
Ohne Titel (Blütenstudien), 1908
[Untitled (Blossom Studies)]
Pencil, tempera on paper
18 x 14.5 cm
Estate of Kurt Schwitters

2 (p. 14)
Ohne Titel (Interieur), ca. 1910
[Untitled (Interior)]
Oil on cardboard
62.5 x 86.5 cm
Private collection, Lübeck

3 (p. 16)
Ohne Titel (Bauer auf einem Weizenfeld, 1912
[Untitled (Farmer on a Wheat Field)]
Oil on card
23.5 x 33 cm
Private collection

4 (p. 17)
Gehöft mit Gänsen, ca. 1913
[Farmstead with Geese]
Oil on cardboard
65 x 49 cm
Private collection

5 (p. 17)
A S Landschaft 1. Hochsommer, 1914/16
[A S Landscape 1. Midsummer]
Oil on canvas
45 x 60.4 cm
Private collection, Augsburg

6 (p. 15)
Strickende Alte, 1915
[Old Woman Knitting]
Oil on canvas
110 x 100 cm
Ute Thio, Mannheim

7 (p. 19)
Ohne Titel (Porträt Helma Schwitters), 1916
[Untitled (Portrait of Helma Schwitters)]
Oil on canvas
45 x 38.5 cm
Estate of Kurt Schwitters

8 (p. 16)
Ohne Titel (Landschaft und Hof in Opherdicke, West-falen), 1916
[Untitled (Landscape and Farmstead in Opherdicke, Westphalia)]
Oil on canvas
14 x 24 cm
Franz-Josef Wrede

9 (p. 18)
Ohne Titel (Lesende), 1916
[Untitled (Woman Reading)]
Chalk on paper
29.8 x 22.3 cm
Estate of Kurt Schwitters

10 (p. 18)
Ohne Titel (Gerd Schwitters, Kopfstudie 1), 1916
[Untitled (Gerd Schwitter, Study of Head 1)]
Pencil on paper
33.1 x 26 cm
Estate of Kurt Schwitters

11 (p. 20)
Die Plätterin, 1917
[The Ironer]
Oil on cardboard
68.7 x 49.5 cm
Estate of Kurt Schwitters

12 (p. 30)
Abstraktion No 16 (Schlafender Kristall), 1918
[Abstraction No 16 (Sleeping Crystal)]
Oil on canvas
73.5 x 51.5 cm
Estate of Kurt Schwitters

13 (p. 28)
Verschneite Häuser, 1918
[Snowcovered Houses]
Oil on canvas
42 x 51.7 cm
Sprengel Museum Hannover, on loan from the
Sammlung Nord/LB in der Niedersächsischen
Sparkassenstiftung

14 (p. 38)
Zeichnung A 6, 1918
[Drawing A 6]
Collage
17.8 x 14 cm
Private collection

15 (p. 24)
Z 14 Fabrikhof., 1918
[Z 14 Factory Yard.]
Charcoal on paper
20.5 x 13 cm
Estate of Kurt Schwitters

16 (p. 24)
Z 15 Kirche und Häuser, 1918
[Z 15 Church and Houses]
Charcoal on paper
20.7 x 13 cm
Estate of Kurt Schwitters

17 (p. 24)
Z 130 Abstrakte Zeichnung, 1918
[Z 130 Abstract Drawing]
Charcoal on paper
14.7 x 12 cm
Estate of Kurt Schwitters

18 (p. 26)
Z 40, Kanal (2), 1918
[Z 40, Canal (2)]
Charcoal on paper
12.9 x 20.3 cm
Estate of Kurt Schwitters

19 (p. 26)
Z 71, Der Einsame. (2), 1918
[Z 71, The Lonely One. (2)]
Charcoal on paper
16.4 x 11 cm
Galerie Gmurzynska, Cologne

20 (p. 25)
Z 81 [?] Fabrik, 1918
[Z 81 (?) Factory]
Chalk on paper
19.6 x 14.1 cm
Staatliche Kunstsammlungen Dresden,
Kupferstich-Kabinett

21 (p. 27)
Abstraktion 150, 1918
[Abstraction 150]
Chalk on paper
16.6 x 12.1 cm
Estate of Kurt Schwitters

22 (p. 27)
Z 122 Die Versuchung d. h. Antonius., 1918
[Z 122 The Temptation of St. Anthony.]
Chalk on paper
17.7 x 11.2 cm
Estate of Kurt Schwitters

23 (p. 41)
Merzbild 1 B Bild mit rotem Kreuz, 1919
[Merzpicture 1 B Picture with Red Cross]
Collage, oil
64.5 x 54.2 cm
Deutsche Bank AG, Frankfurt/Main

24 (p. 42)
Merzbild 9 b das grosse Ichbild / Merzbild K 7 [?],
1919
[Merzpicture 9 b The Great Ich Picture /
Merzpicture K 7 (?)]
Collage
96.8 x 70 cm
Museum Ludwig, Cologne

25 (p. 40)
Merzbild 13 A Der kleine Mergel, 1919
[Merzpicture 13 A The Small Mergel]
Assemblage, oil
41.4 x 32.4 cm
Indiana University Art Museum,
Jane and Roger Wolcott Memorial, Bloomington

26 (p. 43)
Das Undbild, 1919
[The And Picture]
Assemblage
35.5 x 28 cm
Staatsgalerie Stuttgart

27 (p. 29)
Hochgebirgsfriedhof (Abstraktion), 1919
[Mountain Graveyard (Abstraction)]
Oil on cardboard
91.5 x 72.6 cm
Solomon R. Guggenheim Museum, New York

28 (p. 21)
Ohne Titel (Porträt des Buchhändlers Julius Beeck),
1919
[Untitled (Portrait of the Bookseller Julius Beeck)]
Oil on cardboard
90 x 60 cm
Sprengel Museum Hannover, on loan from the
Bomann-Museum, Celle

29 (p. 22)
Ohne Titel (Bauernhof und Weg bei Vrestorf), 1919
[Untitled (Farmstead and Path near Vrestorf)]
Oil on card
14 x 23.5 cm
Klaus Lieckfeld, Hamburg

30 (p. 36)
Ohne Titel (Mit roter 4), 1919
[Untitled (With Red 4)]
Collage, coloured pencil, pencil, stamping ink on paper
17.6 x 15.2 cm
Estate of Kurt Schwitters

31 (p. 37)
*Anna Blume, Dichtungen (Zeichnung für den
Buchtitel),* 1919
[Anna Blume, Dichtungen (Draft of Title Page)]
Pen, watercolour on paper
22.3 x 14.4 cm
Spencer Collection, New York Public Library

32 (p. 33)
Aq. 7. (Mann schaaft Lilablau), 1919
Watercolour, pencil on paper
31.1 x 24.4 cm
Margo Pollins Schab, Inc., New York

33 (p. 32)
Aq. 14. (Lokomotive rückwärts.), 1919
[Aq. 14. (Locomotive Backwards.)]
Watercolour, pencil, chalk on paper
17.3 x 14.1 cm
Estate of Kurt Schwitters

34 (p. 34)
Ohne Titel (Berlin–Friedenau), 1919
[Untitled (Berlin–Friedenau)]
Coloured pencil, stamping ink on paper
20.2 x 16.4 cm
Estate of Kurt Schwitters

35 (p. 35)
Ohne Titel (Ferienkolonie für Taubstumme), 1919
[Untitled (Holiday Camp for Deaf Mutes)]
Coloured pencil, stamping ink on paper
15.1 x 11.4 cm
Galleria Blu, Milan

36 (p. 31)
Ohne Titel 'Zwei Kreise, aus: Das Kestnerbuch), 1919
[Untitled (2 Circles, from: Das Kestnerbuch)]
Woodcut
28.1 x 21.5 cm
Sprengel Museum Hannover

37 (p. 31)
Ohne Titel (Lithografie, mit Nietenlöchern), 1919
[Untitled (Lithograph, with Rivet Holes)]
Lithograph
18 x 14 cm
Cabinet des estampes, Geneva

38 (p. 34)
Aq. 24. Der Kopf unter der Mühle., 1919–1920
[Aq. 24. The Head Below the Mill.]
Watercolour, coloured pencil on paper
24.2 x 19.7 cm
Estate of Kurt Schwitters

39 (p. 53)
Ohne Titel (Merz), 1919–1923
[Untitled (Merz)]
Assemblage
28.1 x 20.1 cm
Fondazione Marguerite Arp, Locarno

40 (p. 39)
Merzbild Einunddreissig, 1920
[Merzpicture Thirty-One]
Assemblage, oil
98 x 66 cm
Sprengel Museum Hannover, on loan from the
Sammlung Nord/LB in der Niedersächsischen
Sparkassenstiftung

41 (p. 44)
Das Bäumerbild, 1920
[The Bäumer Picture]
Assemblage
17.8 x 21.3 cm
Private collection, Southern Germany

42 (p. 52)
Ohne Titel (Merzbild Rossfett), ca. 1920
[Untitled (Merzpicture Horse Grease)]
Assemblage
20.3 x 17.1 cm
Private collection, New York

43 (p. 45)
Merzz. 53. rotes bonbon., 1920
[Merzz. 53. Red Bonbon.]
Collage
13 x 9.7 cm
Solomon R. Guggenheim Museum, New York

44 (p. 44)
Mz. 57. (Rosa.), 1920
[Mz. 57. (Pink.)]
Collage
18.2 x 14 cm
Kunsthaus Zürich

45 (p. 49)
Mzz. 62 Zeichnung teig, 1920
[Mzz. 62 Drawing Dough]
Collage
13.1 x 10.1 cm
Private collection, Stuttgart

46 (p. 47)
Merzz. 80. Zeichnung 130, 1920
[Merzz. 80. Drawing 130]
Collage
13 x 9.5 cm
Private collection, Stuttgart

47 (p. 46)
Mz 150 Oskar., 1920
[Mz 150 Oskar.]
Collage
13.1 x 9.7 cm
Kunstsammlung Nordrhein-Westfalen, Düsseldorf

48 (p. 48)
Merzzeichnung 154 zart., 1920
[Merzdrawing 154 Tender.]
Collage
17.8 x 14.4 cm
Galerie Kornfeld, Bern

49 (p. 50)
Mz 168. Vierecke im Raum, 1920
[Mz 168. Squares in Space]
Collage
17.8 x 14.3 cm
Private collection

50 (p. 50)
Mz 169 Formen im Raum, 1920
[Mz 169 Shapes in Space]
Collage
18 x 14.3 cm
Kunstsammlung Nordrhein-Westfalen, Düsseldorf

51 (p. 51)
Mz 170. Leere im Raum., 1920
[Mz 170. Voids in Space.]
Collage
18 x 14.4 cm
Private collection

52 (p. 58)
Merzzeichnung 203., 1920
[Merzdrawing 203.]
Collage
18 x 14.5 cm
Private collection

53 (p. 47)
Mz 143 Naturrein, 1920
[Mz 143 Unadulterated]
Collage
13 x 10.5 cm
Kunsthaus Zürich, promised bequest, Collection Erna
and Kurt Burgauer

54 (p. 79)
Zeichnung I 8 Hebel 1, 1920
[Drawing I 8 Lever 1]
Misprint, cut
13.3 x 10.7 cm
Estate of Kurt Schwitters

55 (p. 55)
Merzbild 29 A. Bild mit Drehrad, 1920 and 1940
[Merzpicture 29 A. Picture with Turning Wheel]
Assemblage, oil
85.8 x 106.8 cm
Sprengel Museum Hannover

56 (p. 79)
i-Zeichnung, 1920
[i-Drawing]
Misprint, cut
11 x 8.8 cm
Estate of Kurt Schwitters

57 (p. 54)
Siegbild, ca. 1920/25
[Victory Picture]
Assemblage
36.5 x 27.6 cm
Wilhelm-Hack-Museum, Ludwigshafen

58 (p. 56)
Merzbild 35 A, 1921
[Merzpicture 35 A]
Assemblage
22.2 x 16.8 cm
Archiv Baumeister, Stuttgart

59 (p. 70)
Merzbild 46 A. Das Kegelbild, 1921
[Merzpicture 46 A. The Bowling Picture]
Assemblage
47 x 35.8 cm
Sprengel Museum Hannover

60 (p. 57)
Ohne Titel (Dein treufrischer), 1921
[Untitled (Dein treufrischer)]
Assemblage, oil on cardboard
38.3 x 31 cm
Private collection, Brussels

61 (p. 59)
Mz 194, 1921
Collage
14 x 11 cm
Muzeum Sztuki, Lodz

62 (p. 59)
Mz 212. für Moholy-Nagy., 1921
[Mz 212. For Moholy-Nagy.]
Collage
18.4 x 14.6 cm
Collection Stella and Joe Kattan

63 (p. 60)
Mz 218., 1921
Collage
13.1 x 9.7 cm
Staatsgalerie Stuttgart

64 (p. 62)
Merzzeichnung 219, 1921
[Merzdrawing 219]
Collage
15.2 x 12.4 cm
Flick Collection

65 (p. 61)
Mz 228., 1921
Collage
13.4 x 10.7 cm
Private collection, Basel

66 (p. 63)
Mz 259 Zeichnung Campendonk, 1921
[Mz 259 Drawing Campendonk]
Collage
18.1 x 14.4 cm
Private collection

67 (p. 65)
Mz 271. Kammer., 1921
[Mz 271. Cupboard.]
Collage
17.8 x 14.5 cm
Kunstsammlung Nordrhein-Westfalen, Düsseldorf

68 (p. 64)
Mz 300 mit Feder., 1921
[Mz. 300 With Feather.]
Collage
16 x 13 cm
Private collection, Stuttgart

69 (p. 71)
Ohne Titel (Intarsienkasten SK / P für Sophie und Paul Erich Küppers), 1921
[Untitled (Inlaid Box SK / P for Sophie and Paul Erich Küppers)]
Wooden box, inlaid
23 x 23 x 16.7 cm
Kestner-Museum, extended loan from the Fritz Behrens Stiftung, Hanover

70 (p. 82)
Merzbild 435, 1922?
[Merzpicture 435]
Assemblage
13.4 x 11.5 cm
Carroll Janis, New York

71 (p. 69)
Mz. 395. Ein Erdbeben., 1922
[Mz. 395. An Earthquake.]
Collage
17.8 x 14.4 cm
Private collection

72 (p. 82)
Mz 408 Köln., 1922
[Mz 408 Cologne.]
Collage
21 x 16 cm
Private collection

73 (p. 80)
Mz 425. garnicht so billig., 1922
[Mz 425. Not so Cheap at All.]
Collage
11.7 x 9.1 cm
Carroll Janis, New York

74 (p. 76)
Mz 426 Zahlen, 1922
[Mz 426 Figures]
Collage
13.1 x 10.4 cm
Private collection, Courtesy Gallery Maurice Keitelmann, Brussels

75 (p. 77)
Mz 459. Zahlen., 1922
[Mz 459. Figures.]
Collage
13 x 10.7 cm
Private collection

76 (p. 78)
Mz 474 De schoenmaker., 1922
[Mz 474 The Shoemaker.]
Collage
17.7 x 13.8 cm
Estate of Kurt Schwitters

77 (p. 85)
Z. i. 20 Tafel Salz, 1922
[Z. i. 20 Table Salt]
Misprint, cut
11.7 x 12.8 cm
Tate Modern, on loan from Philip Granville, London

78 (p. 75)
Ohne Titel (Kleine schwarze Säule), 1922/24
[Untitled (Small Black Column)]
Sculpture, wood, painted
23 x 22 x 16 cm
Staatliche Museen zu Berlin, Neue Nationalgalerie, owned by the Verein der Freunde der Nationalgalerie

79 (p. 23)
Ohne Titel (Porträt Maria Oehlmann), ca. 1922
[Untitled (Portrait of Maria Oehlmann)]
Oil on wood or card
38.5 x 29 cm324
Private collection

80 (p. 80)
Ohne Titel (Holzkonstruktion), 1923
[Untitled (Wooden Construction)]
Relief, wood
36.8 x 54 x 10.8 cm
Philippe Woog

81 (p. 103)
Mz 601, 1923
Collage
40.4 x 34.8 cm
Estate of Kurt Schwitters

82 (p. 111)
Ohne Titel (Contramerk.), 1923
[Untitled (Contramerk.)]
Collage
13.3 x 11 cm
Deutsche Bank AG, Frankfurt/Main

83 (p. 97)
Merz 3. Merzmappe., 1923
[Merz 3. Merz Portfolio.]
6 Lithographs, portfolio
55.5 x 44.4 cm
Sprengel Museum Hannover

84 (p. 87)
Z. i. 28 Bild wie Galgen., 1923
[Z. i. 28 Picture like Gallows.]
Misprint, cut
16.6 x 13.3 cm
Estate of Kurt Schwitters

85 (p. 72)
Ohne Titel (Vertikal), 1923
[Untitled (Vertical)]
Sculpture, wood, painted
51 x 12.8 x 11.8 cm
Sprengel Museum Hannover, on loan from the
Sammlung Nord/LB in der Niedersächsischen
Sparkassenstiftung

86 (p. 98)
Mz ohne Apfelsinenhüllen, 1923/25
[Mz without Orangeskins]
Collage
16.2 x 13.2 cm
Spencer Collection, New York Public Library

87 (p. 100)
Ohne Titel (Mit Bindfaden), 1923/26
[Untitled (With Thread)]
Collage
17.8 x 13.9 cm
Sprengel Museum Hannover, on loan from the
Sammlung Nord/LB in der Niedersächsischen
Sparkassenstiftung

88 (p. 94)
Merz 1003. Pfauenrad, 1924
[Merz 1003. Peacock's Tail]
Oil on cardboard
72.7 x 70.6 cm
Yale University Art Gallery, Gift of Collection Société
Anonyme

89 (p. 96)
Ohne Titel (Bild mit Walfisch), 1924
[Untitled (Picture with Whale)]
Oil on canvas
80.4 x 60.5 cm
Städtisches Museum Abteiberg Mönchengladbach,
on loan from the Mönchengladbacher Sparkassen-
stiftung für Kunst und Wissenschaft

90 (p. 89)
Merz 1924,1. Relief mit Kreuz und Kugel, 1924
[Merz 1924, 1st Relief with Cross and Sphere]
Relief, oil
69.1 x 34.4 cm
Estate of Kurt Schwitters

91 (p. 104)
Mz 2014 kommt überhaupt nicht in Frage., 1924
[Mz 2014 completely out of the question.]
Collage
22.8 x 16.5 cm
Helmut F. Stern

92 (p. 104)
Ohne Titel (Wie Mädchen fallen), 1924/26
[Untitled (As Girls Fall)]
Collage
14 x 10.9 cm
Private collection, Europe

93 (p. 90)
1. weißes Relief, 1924/27
[1st White Relief]
Relief, wood, glass on wood, painted
66.5 x 48.7 x 28.7 cm
Sprengel Museum Hannover

94 (p. 93)
Ohne Titel (Ovale Konstruktion), ca. 1925
[Untitled (Oval Construction)]
Relief, wood, oil
116.5 x 75 cm
Yale University Art Gallery, Gift of Katherine S. Dreier
to the Collection Société Anonyme

95 (p. 98)
Ohne Titel (5 So Mo Die), 1925
[Untitled (5 So Mo Die)]
Collage
13.7 x 11.1 cm
Carroll Janis, New York

96 (p. 93)
Relief mit rotem Segment, ca. 1926
[Relief with Red Segment]
Relief, wood, painted
75 x 62.5 cm
Yale University Art Gallery, Gift of Collection Société
Anonyme

97 (p. 95)
Kathedrale, 1926
[Cathedral]
Relief, wood
39 x 17 x 7 cm
Staatliche Museen zu Berlin, Neue Nationalgalerie,
owned by the Verein der Freunde der Nationalgalerie

98 (p. 105)
Mz 1926,2. selbst oben. für Janssen 1936, 1926
[Mz 1926,2. self above. for Janssen 1936]
Collage
22 x 17.5 cm
The Mayor Gallery, London

99 (p. 90)
Merz 1926,3. Cicero, 1926
Relief, wood, painted
68.3 x 49.9 x 8.1 cm
Sprengel Museum Hannover, on loan from the
Sammlung Nord/LB in der Niedersächsischen
Sparkassenstiftung

100 (p. 100)
Mz 1926,20. chwi., 1926
Collage
13 x 10 cm
Private collection, Brügge

101 (p. 105)
Mz 1926,24. en Zoonen., 1926
Collage
8.9 x 6.9 cm
Estate of Kurt Schwitters

102 (p. 111)
1926,61. Sprengel., 1926
Collage
9.9 x 10 cm
Private collection, Lucerne

103 (p. 98)
Mz 26, 63. rein nichts., 1926
[Mz 26, 63. absolutely nothing.]
Collage
12.6 x 9.7 cm
Estate of Kurt Schwitters

104 (p. 86)
Zi 101. Begegnung., 1926
[Zi 101. Encounter.]
Misprint, cut
16.6 x 13.7 cm
Sprengel Museum Hannover, on loan from the
Sammlung Nord/LB in der Niedersächsischen
Sparkassenstiftung

105 (p. 107)
*Ohne Titel (Woll-kenkratzer, Anzeigenentwurf für
Handarbeitshaus Buchheister)*, 1926/28
[Untitled (Woll-kenkratzer, Design for an advertise-
ment for a craft shop, the Handarbeitshaus Buch-
heister)]
Collage
13.3 x 4.9 cm
Private collection, Courtesy Galerie Gmurzynska,
Cologne

106 (p. 66)
(SABA) Dem NeROH der Kunst, 1926/28
[(SABA) To the NeROH of Art]
Collage
14.7 x 11 cm
Staatliche Graphische Sammlung München

107 (p. 115)
Ohne Titel (Schwarze Merzzeichnung), 1928
[Untitled (Black Merzdrawing)]
Collage
27.5 x 22 cm
Staatliche Museen zu Berlin, Neue Nationalgalerie,
Private loan

108 (p. 108)
Ohne Titel (Schnurruhr von Hans Arp), 1928
[Untitled (Schnurruhr von Hans Arp)]
Collage
12.8 x 10.1 cm
Kunsthaus Zürich

109 (p. 109)
Ohne Titel (Fotogramm I), 1928
[Untitled (Photogram I)]
Photogram
17.9 x 13 cm
Öffentliche Kunstsammlung Basel, Kupferstich-
kabinett, gift of Marguerite Arp-Hagenbach 1968

110 (p. 109)
Ohne Titel (Fotogramm II), 1928
[Untitled (Photogram II)]
Photogram
17.7 x 12.9 cm
Angela Thomas Schmid

111 (p. 87)
Ohne Titel (ehemals: i-Zeichnung »Kreisen«), 1928
[Untitled (formerly: i-drawing 'Circles')]
Misprint, cut
30.2 x 21.5 cm
Estate of Kurt Schwitters

112 (p. 115)
29/19, 1929
Collage
12.2 x 9.5 cm
Private collection, Lucerne

113 (p. 112)
29/22 (Schatten des Nichts), 1929
[29/22 (Shadow of Nothingness)]
Collage
15.6 x 11.5 cm
Estate of Kurt Schwitters

114 (p. 113)
Ohne Titel (ereid.), 1929
[Untitled (ereid.)]
Collage
27.8 x 21.5 cm
Lisa Breimer

115
Ohne Titel (beim Steinhuder Meer?), ca. 1929
[Untitled (by the Steinhuder Meer?)]
Oil on cardboard
48.8 x 59.8 cm
Estate of Kurt Schwitters

116 (p. 118)
Merzbild P rosa, 1930
[Merzpicture P rose]
Assemblage
49.9 x 39.1 cm
Sprengel Museum Hannover, on loan from the
Sammlung Nord/LB in der Niedersächsischen
Sparkassenstiftung

117 (p. 114)
Das ist der Frühling für Hans Arp, 1930
[That is the Spring for Hans Arp]
Relief, wood, painted
61.5 x 51 cm
Pinacoteca Casa Rusca, gift from Hans and
Marguerite Arp

118 (p. 116)
Ohne Titel (Bild mit drehbarer Glasscheibe), 1930
[Untitled (Picture with Rotatable Glass Disc)]
Relief, wood, glass, painted
25.5 x 17.5 cm
Staatliche Museen zu Berlin, Neue Nationalgalerie

119 (p. 132)
Ohne Titel (9), 1930
[Untitled (9)]
Collage
13.1 x 10.2 cm
Collection Timothy Baum, New York

120 (p. 129)
Mz 30,38, 1930
Collage
13.6 x 11 cm
Collection Timothy Baum, New York

121 (p. 126)
Mz 30,40, 1930
Collage
12 x 9.4 cm
Estate of Kurt Schwitters

122 (p. 126)
Ohne Titel (H. Bahlsens Keks-Fabrik A.G.), 1930
[Untitled (H. Bahlsens Keks-Fabrik A.G.)]
Collage
17.9 x 11.8 cm
Kunsthaus Zug, deposited by the Stiftung Sammlung
Kamm

123 (p. 129)
Ohne Titel (Mit gelber Form), 1930
[Untitled (With Yellow Form)]
Collage
17.5 x 14 cm
Private collection, Deutschland

124 (p. 120)
Halbmond Ugelvik, 1930, 1931 and 1933
[Half-Moon Ugelvik]
Assemblage
65.7 x 53.7 cm
Private collection

125 (p. 128)
doremifasolasido, ca. 1930
Collage
29.4 x 23.3 cm
Private collection, Basel

126 (p. 125)
Schlanker Winkel, ca. 1930
[Slim Angle]
Sculpture, wood, painted
48.2 x 9.5 x 12.4
Estate of Kurt Schwitters / Galerie Gmurzynska,
Cologne

127 (p. 125)
Schwert, ca. 1930
[Sword]
Sculpture, wood, painted
82 x 9.5 x 9.5 cm
Estate of Kurt Schwitters / Galerie Gmurzynska,
Cologne

128 (p. 132)
Ein Beitrag zur Sanierung Deutschlands, 1931
[A Contribution to the Refurbishment of Germany]
Collage
15 x 10 cm
Private collection

129 (p. 116)
Ohne Titel (rot, grau, schwarz), 1931
[Untitled (red, grey, black)]
Collage
27.9 x 20 cm
Dr. & Mrs. M. Michael Eisenberg

130 (p. 124)
Monument über den Vater des Künstlers, 1931/35
[Monument to the Father of the Artist]
Sculpture, wood, painted
126.9 x 26.6 x 40.8 cm
Yale University Art Gallery, Gift from the Estate of
Katherine S. Dreier

131 (p. 152)
Ohne Titel (Alpenlandschaft?), 1932
[Untitled (Alpine Landscape?]
Oil on cardboard
24 x 32 cm
Estate of Kurt Schwitters

132 (p. 152)
Nervi, Frühlingsmorgen, 1932
[Nervi, Spring Morning]
Oil on cardboard
65.7 x 53.8 cm
Estate of Kurt Schwitters

133 (p. 122)
Merzbild 1933,2 »Umschuldung«, 1932–1934
[Merzpicture 1933, 2 "Umschuldung"]
Oil on canvas, Assemblage
74.4 x 60 cm
Sprengel Museum Hannover

134 (pp. 138, 139)
Merzbau (Reconstruction of the state ca. 1933),
1981–1983
Reconstruction after photographs, by Peter Bissegger
with advice from Ernst Schwitters
Walk-in space, various materials
393 x 580 x 460 cm
Sprengel Museum Hannover

135 (p. 140)
Ohne Titel, 1934
[Untitled]
Sculpture, wood, plaster
26 x 7 x 6.5 cm
Private collection, Courtesy Grosvenor Gallery,
London

136 (p. 140)
Das Schwert des deutschen Geistes, 1935
[The Sword of the German Spirit]
Sculpture, wood, painted
47.8 x 9.5 x 10 cm
Private collection

137 (p. 146)
Ohne Titel (Mit Apfelstück und grünen Blättern), 1936
[Untitled (With Piece of Apple and Green Leaves)]
Collage
20.8 x 15.2 cm
Estate of Kurt Schwitters

138 (p. 140)
Ohne Titel (Schmale Merzsäule), 1936
[Untitled (Narrow Merz Column)]
Sculpture, wood, plaster, painted
Ø 22.5 cm
Sprengel Museum Hannover, on loan from the
Sammlung Nord/LB in der Niedersächsischen
Sparkassenstiftung

139 (p. 153)
Landschaft mit Schneefeld: Opplusegga, 1936
[Landscape with Snowfield: Opplusegga]
Oil on wood
72 x 60 cm
Estate of Kurt Schwitters

140 (p. 147)
Ohne Titel (paa Krukke), 1936/39
[Untitled (paa Krukke)]
Collage
16 x 11.3 cm
Private collection, Salzburg

141 (p. 137)
Merzbild mit Kette, 1937
[Merzpicture with Chain]
Assemblage, oil on wood
72.7 x 49 cm
Collection von Bergmann

142 (p. 136)
Rote Linie, 1937
[Red Line]
Oil on wood
64.8 x 53.6 cm
Estate of Kurt Schwitters

143 (p. 147)
Frau und Mann, 1937
[Woman and Man]
Collage
19.4 x 15.8 cm
Öffentliche Kunstsammlung Basel, Kupferstich-
kabinett, gift of Marguerite Arp-Hagenbach 1968

144 (p. 149)
Amsterdam, 1937
Collage
17.5 x 13.7 cm
Private collection, New York

145 (p. 141)
Gedrehte kleine Plastik, 1937
[Small Turned Sculpture]
Sculpture, wood, plaster, painted
98 x 34 x 17.3 cm
Sprengel Museum Hannover, on loan from the
Sammlung Nord/LB in der Niedersächsischen
Sparkassenstiftung

146 (p. 154)
Ohne Titel (Hafen am Fjord), 1937
[Untitled (Harbour in the Fjord)]
Coloured pencil on paper
22.8 x 17.2 cm
Estate of Kurt Schwitters

147 (p. 154)
Dombaas, 1937
Coloured pencil on paper
15.8 x 21.9 cm
Estate of Kurt Schwitters

148 (p. 144)
Ohne Titel (Union), 1937/38
[Untitled (Union)]
Collage
16.9 x 13.6 cm
Estate of Kurt Schwitters

149 (p. 145)
Ohne Titel (Mit frühem Porträt von Kurt Schwitters),
1937/38
[Untitled (With an early portrait of Kurt Schwitters)]
Collage
22.7 x 18.1 cm
Sprengel Museum Hannover

150 (p. 141)
Ohne Titel (Für die Hand), 1937/40
[Untitled (For the Hand]
Sculpture, plaster, painted
6.6 x 21.6 x 13.3 cm
Sprengel Museum Hannover, on loan from the
Sammlung Nord/LB in der Niedersächsischen
Sparkassenstiftung

151 (p. 141)
Ohne Titel (Farbiger Halbmond), 1937/40
[Untitled (Coloured Half-Moon)]
Sculpture, plaster, painted
8.3 x 14.3 x 10.7 cm
Sprengel Museum Hannover, on loan from the
Sammlung Nord/LB in der Niedersächsischen
Sparkassenstiftung

152 (p. 143)
Ohne Titel (Merzbild mit Algen), 1938
[Untitled (Merzpicture with Algae)]
Assemblage
49.5 x 26.6 cm
Estate of Kurt Schwitters

153 (p. 137)
Ohne Titel (Das Hufeisenbild), 1938
[Untitled (The Horse Shoe Picture)]
Oil on wood
60 x 50 cm
Estate of Kurt Schwitters

154 (p. 146)
Ohne Titel (R DHUS), 1938
[Untitled (R DHUS)
Collage
27.8 x 20.8 cm
Galerie Jan Krugier, Ditesheim & Cie, Geneva

155 (p. 156)
Wasserfall bei Olden, 1938
[Waterfall near Olden]
Oil on wood
68.5 x 59 cm
Estate of Kurt Schwitters

156 (p. 155)
Ohne Titel (Norwegische Berglandschaft), 1938
[Untitled (Norwegian Mountain Landscape)]
Pencil on paper
20.9 x 27.8 cm
Estate of Kurt Schwitters

157 (p. 143)
Ohne Titel (Merzbild Alf), 1939
[Untitled (Merzpicture Alf)]
Assemblage
32.5 x 32.4 cm
Estate of Kurt Schwitters

158 (p. 136)
Ohne Titel (Zick-Zack), 1939
[Untitled (Zig-Zag)]
Oil on wood
33.5 x 27.3 cm
Estate of Kurt Schwitters

159 (p. 144)
Ohne Titel (Silbern), 1939
[Untitled (Silvery)]
Collage
20 x 15.7 cm
Estate of Kurt Schwitters

160 (p. 156)
Hjertö Kreuz, 1939
[Hjertö Cross]
Oil on wood
56 x 66 cm
Estate of Kurt Schwitters

161 (p. 155)
Strand, 1939
[Beach]
Coloured pencil on paper
33.7 x 26.6 cm
Estate of Kurt Schwitters

162 (p. 157)
Ohne Titel (Sehr dunkles Bild), 1940
[Untitled (Very Dark Picture)]
Assemblage, oil
47 x 38.1 cm
Collection Timothy Baum, New York

163 (p. 164)
pink collage, 1940
Collage
26.7 x 22 cm
Private collection, New York

164 (p. 194)
Ohne Titel (Porträt Rudolf Olden), 1940
[Untitled (Portrait of Rudolf Olden)]
Oil on canvas
89 x 89 cm
Konrad Losch

165 (p. 176)
Fredlyst with yellow artificial bone, 1940–1947
Assemblage
48.8 x 37.8 cm
Estate of Kurt Schwitters

166 (p. 160)
Ohne Titel (Bild mit Ring und Rahmen), 1941
[Untitled (Picture with Ring and Frame)]
Assemblage
78.9 x 68.4 cm
Estate of Kurt Schwitters

167 (p. 158)
PEN (For Young Faces), 1941
Assemblage
59 x 49.4 cm
Estate of Kurt Schwitters

168 (p. 160)
stillife with penny, 1941
Oil on cardboard
32.8 x 24.6 cm
Private collection

169 (p. 192)
Scenery from Douglas, 1941
Paint on plywood
32.5 x 24.5 cm
Estate of Kurt Schwitters

170 (p. 193)
Ohne Titel (Hausdächer in Douglas, Isle of Man), 1941
[Untitled (Roofs of Houses in Douglas, Isle of Man)]
Wax tempera on linoleum
36.5 x 43.4 cm
Estate of Kurt Schwitters

171 (p. 172)
Ohne Titel (Kathedrale), 1941/42
[Untitled (Cathedral)]
Sculpture, wood, painted
40 x 19.2 x 19.2 cm
Sprengel Museum Hannover, on loan from the
Sammlung Nord/LB in der Niedersächsischen
Sparkassenstiftung

172 (p. 166)
Ohne Titel (Die Puppe), 1942
[Untitled (The Doll)]
Collage
24.5 x 18.9 cm
Private collection, England

173 (p. 166)
Ohne Titel (D'Cilly), 1942
[Untitled (D'Cilly)]
Collage
32 x 18.7 cm
Private collection, Dorf Tirol

174 (p. 165)
Ohne Titel (Neatest Trick of the Month!), 1942/45
[Untitled (Neatest Trick of the Month!)]
Collage
42.5 x 53.3 cm
Richard S. Zeisler Collection, New York

175 (p. 158)
Ohne Titel (Merzbild 9), 1943
[Untitled (Merzpicture 9)]
Assemblage
50 x 40.2 cm
Estate of Kurt Schwitters

176 (p. 177)
Ohne Titel (Grasmere), 1942/45
[Untitled (Grasmere)]
Relief, wood, plaster, painted
35.3 x 27.3 cm
Colletion Calmarini, Milan

177 (p. 174)
Ohne Titel (Merzbild rosa-gelb), 1943
[Untitled (Merzpicture Pink-Yellow)]
Assemblage
34 x 26 cm
Estate of Kurt Schwitters

178 (p. 161)
Ohne Titel (Abstraktes Bild), 1943
[Untitled (Abstract Picture)]
Oil on canvas
63 x 75.5 cm
Private collection

179 (p. 184)
The Dux Picture, 1943
Collage
22.1 x 16.5 cm
Carroll Janis, New York

180 (p. 172)
Ohne Titel (for Ernst on 16.11.43 from Dada Daddy.),
1943
[Untitled (for Ernst on 16.11.43 from Dada Daddy.)]
Sculpture, plaster, wire
14.4 x 13.5 x 15.5 cm
Estate of Kurt Schwitters

181 (p. 172)
Speed, 1943
Sculpture, wood, plaster, painted
28.9 x 15.3 x 12.2 cm
Sprengel Museum Hannover, on loan from the
Sammlung Nord/LB in der Niedersächsischen
Sparkassenstiftung

182
Ohne Titel (Opening Blossom), 1943/44
[Untitled (Opening Blossom)]
Sculpture, plaster, painted
12.2 x 8.5 x 5.1 cm
Sprengel Museum Hannover, on loan from the
Sammlung Nord/LB in der Niedersächsischen
Sparkassenstiftung

183
Ohne Titel (Little Dog), 1943/44
[Untitled (Little Dog)]
Sculpture, plaster, wood
45.5 x 20 x 18 cm
Sprengel Museum Hannover, on loan from the
Sammlung Nord/LB in der Niedersächsischen
Sparkassenstiftung

184 (p. 175)
Ohne Titel (Merzbild mit Dose und Band), 1943/45
[Untitled (Merzpicture with Tin and Band)]
Relief, wood, plaster, painted
51 x 37.5 cm
Estate of Kurt Schwitters

185
Ohne Titel (Little Whale), 1943/45
[Untitled (Little Whale)]
Sculpture, plaster, polished and glazed
10.5 x 21.4 x 13.2 cm
Sprengel Museum Hannover, on loan from the
Sammlung Nord/LB in der Niedersächsischen
Sparkassenstiftung

186
Ohne Titel (Madonna), 1943/45
[Untitled (Madonna)]
Sculpture, corrugated cardboard, plaster, painted
57.8 x 13.3 x 15.6 cm
Sprengel Museum Hannover, on loan from the
Sammlung Nord/LB in der Niedersächsischen
Sparkassenstiftung

187 (p. 173)
Ugly Girl, 1943/45
Sculpture, wood, plaster, painted
27.5 x 31.1 x 24.7 cm
Sprengel Museum Hannover, on loan from the
Sammlung Nord/LB in der Niedersächsischen
Sparkassenstiftung

188 (p. 173)
Ohne Titel (Arabesque), 1943/45
[Untitled (Arabesque)]
Sculpture, wood, plaster, painted
35.5 x 11.3 x 10.5 cm
Sprengel Museum Hannover, on loan from the
Sammlung Nord/LB in der Niedersächsischen
Sparkassenstiftung

189 (p. 182)
Ohne Titel (The Hitler Gang – mit Schießscheibe),
1944
[Untitled (The Hitler Gang – with Target)]
Collage
34.8 x 24.6 cm
Estate of Kurt Schwitters

190 (p. 164)
Ohne Titel (Kreuzworträtsel), 1944
[Untitled (Crossword Puzzle)]
Collage
27.2 x 21.5 cm
Carroll Janis, New York

191 (p. 167)
Ohne Titel (Hommage au Sir Herbert Read), 1944
[Untitled (Homage to Sir Herbert Read)]
Collage
15.6 x 25.2 cm
Private collection, New York

192
Ohne Titel (Stehende Eins), 1944
[Untitled (Standing One)]
Sculpture, plaster, painted
15.3 x 11.5 x 6 cm
Sprengel Museum Hannover, on loan from the
Sammlung Nord/LB in der Niedersächsischen
Sparkassenstiftung

193 (p. 202)
Fant, 1944
Sculpture, wood, plaster, painted
29 x 11.5 x 11.5 cm
Sprengel Museum Hannover, on loan from the
Sammlung Nord/LB in der Niedersächsischen
Sparkassenstiftung

194 (p. 163)
Ohne Titel (Merzbild mit Koralle), 1944/45
[Untitled (Merzpicture with Coral)]
Assemblage
34.8 x 29.2 x 6 cm
Estate of Kurt Schwitters

195 (p. 168)
Ohne Titel (Mit zwei gelben Fallschirmen), 1945
[Untitled (With Two Yellow Parachutes)]
Collage
40.6 x 30 cm
Estate of Kurt Schwitters

196 (p. 163)
Ohne Titel (Kleines Merzbild mit vielen Teilen),
1945/46
[Untitled (Small Merzpicture with Many Parts)]
Assemblage
32.3 x 25.7 cm
Estate of Kurt Schwitters

197 (p. 200)
Ohne Titel (Verbogene Pyramide), 1945/47
[Untitled (Bent Pyramid)]
Sculpture, stone, plaster, painted
14.8 x 17.6 x 13.7 cm
Sprengel Museum Hannover, on loan from the
Sammlung Nord/LB in der Niedersächsischen
Sparkassenstiftung

198
Ohne Titel (Plastik mit Haken), 1945/47
[Untitled (Sculpture with Hook)]
Sculpture, plaster, wood, painted
10.5 x 14 x 15 cm
Sprengel Museum Hannover, on loan from the
Sammlung Nord/LB in der Niedersächsischen
Sparkassenstiftung

199 (p. 203)
Ohne Titel (Togetherness), 1945/47
[Untitled (Togetherness)]
Sculpture, stone, plaster, painted
17.8 x 7.5 x 7 cm
Tate Modern, private loan, London

200 (p. 196)
Ohne Titel (Garten im Lake District), 1945/47
[Untitled (Garden in the Lake District)]
Oil on wood
34.5 x 29.5 cm
Estate of Kurt Schwitters

201 (p. 197)
Ohne Titel (Landschaft – Abstraktion), 1945/47
[Untitled (Landscape – Abstraction)]
Oil on cardboard
33.3 x 45.2 cm
Estate of Kurt Schwitters

202 (p. 195)
Ohne Titel (Rydal Water), 1945/47
[Untitled (Rydal Water)]
Oil on canvas
55 x 44.5 cm
Private collection

203 (p. 169)
c 63 old picture, 1946
Collage
36.8 x 30.9 cm
Estate of Kurt Schwitters

204 (p. 223)
To Walter Gropius., 1946
Collage
14.5 x 11.9 cm
Bauhaus-Archiv, Museum für Gestaltung, Berlin

205 (p. 195)
Ohne Titel (Landscape from Nook Lane), 1946
[Untitled (Landscape from Nook Lane)]
Oil on card
36 x 25.3 cm
Private collection

206 (p. 194)
Ohne Titel (Porträt Dr. George Ainslie Johnston), 1946
[Untitled (Portrait of Dr. George Ainslie Johnston)]
Oil on cardboard
66.5 x 50 cm
Armitt Library and Museum, Ambleside

207 (p. 197)
Ohne Titel (Relief Konstruktion), ca. 1946
[Untitled (Relief Construction)]
Relief, wood, painted
13.9 x 16 cm
Private collection
328

208 (p. 202)
Chicken and Egg, Egg and Chicken, 1946
Sculpture, wood, plaster, painted
44.5 x 18.5 cm
Tate Modern, private loan, London

209 (p. 171)
47. 15 pine trees c 26, 1946/47
Collage
25.3 x 21 cm
Estate of Kurt Schwitters

210
Ohne Titel (Pebble-Sculpture), 1946/47
[Untitled (Pebble-Sculpture)]
Sculpture, stone, plaster, painted
7.3 x 14.4 x 10.5 cm
Sprengel Museum Hannover, on loan from the
Sammlung Nord/LB in der Niedersächsischen
Sparkassenstiftung

211 (p. 184)
yellow bits, 1947
Collage
22.7 x 18.6 cm
Estate of Kurt Schwitters

212 (p. 181)
*This was before H. R. H. The Late DUKE OF
CLARENCE & AVONDALE. Now it is a Merz picture.
Sorry!,* 1947
Collage
39.1 x 27.3 cm
Sprengel Museum Hannover, on loan from the
Sammlung Nord/LB in der Niedersächsischen
Sparkassenstiftung

213 (p. 191)
Mz x 22 Wantee, 1947
Collage
13.4 x 9.7 cm
Private collection

214 (p. 214)
47. 13 new, 1947
Collage
22.4 x 19.3 cm
Estate of Kurt Schwitters

215 (p. 215)
Ohne Titel (Duverger), 1947
[Untitled (Duverger)]
Collage
26.4 x 20.7 cm
Private collection, New York

216 (p. 185)
Mr. Churchill is 71, 1947
Collage
19.5 x 15.8 cm
Sherwin N. A. G., Leeds

217 (p. 187)
EN MORN, 1947
Collage
21.1 x 17.1 cm
Musée national d'art moderne, Centre Georges
Pompidou, Paris

218 (p. 214)
Out of red, 1947
Collage
19.4 x 15.8 cm
Öffentliche Kunstsammlung Basel, Kupferstich-
kabinett, Gift of Marguerite Arp-Hagenbach 1968

219 (p. 177)
red spot., 1947
Collage
11.5 x 8.7 cm
Galerie Brusberg, Berlin

220 (p. 178)
Ohne Titel (For Käte), 1947
[Untitled (For Käte)]
Collage
9.8 x 13 cm
Private collection

221 (p. 223)
Mz x 3 is deposited for Wantee 28.9.47, 1947
Collage
8 x 6.5 cm
Private collection

222 (p. 223)
Ohne Titel (WA), 1947
[Untitled (WA)]
Collage
26.8 x 21.7 cm
Estate of Kurt Schwitters

223 (p. 209)
47 12 very complicated, 1947
Collage
24.4 x 21 cm
Estate of Kurt Schwitters

224 (p. 180)
Mz X 5 Magistrats, 1947
Collage
20.3 x 16.5 cm
Private collection, Paris

225 (p. 222)
Ohne Titel (Y. M. C. A. Official Flag Thank You), 1947
[Untitled (Y. M. C. A. Official Flag Thank You)]
Collage on wood
30.4 x 27.2 cm
Abbot Hall Art Gallery, Kendal

226 (p. 167)
Für Carola Giedion Welker. Ein fertig gemachter Poët, 1947
[For Carola Giedion Welker. A done over poet]
Collage
20 x 17 cm
Private collection

227 (p. 188)
Green over yellow., 1947
Collage
16.5 x 13.5 cm
Estate of Kurt Schwitters

228 (p. 183)
dead cissors, 1947
Collage
17.5 x 14.5 cm
Private collection, Munich

229 (p. 208)
FRY'S, 1947
Collage
20 x 16.5 cm
Collection Calmarini, Milan

230
Two Forms in Rhythm, 1947
Sculpture, wood, stone, plaster, painted
7 x 15.5 x 11.5 cm
Sprengel Museum Hannover, on loan from the Sammlung Nord/LB in der Niedersächsischen Sparkassenstiftung

KURT SCHWITTERS
DOCUMENTS, MANUSCRIPTS, PUBLICATIONS, TYPOGRAPHIC WORKS

231
Anna Blume. Dichtungen, 1919
[Anna Blume. Poems]
Book
22.4 x 14.5 cm
Sprengel Museum Hannover, private loan

232 (p. 106)
Merz 1 Holland Dada, 1923
Booklet
22.3 x 14.2 cm
Sprengel Museum Hannover, private loan

233 (p. 106)
Merz 11 Typoreklame (Pelikannummer), 1924
[Merz 11 Type-set text advertisement (Pelikan Number)]
Booklet
29.1 x 22 cm
Sprengel Museum Hannover, private loan

234 (p. 106)
Hahne Peter (Merz 12), 1924
Booklet, lithograph, hand coloured
22.3 x 14.2 cm
Sprengel Museum Hannover, private loan

235 (p. 88)
Fotografien des Originalmodells der Normalbühne Merz, ca. 1924
[Photographs of the original model of the Merz Normal Stage]
4 photographs
5.5 x 8 cm
Kurt Schwitters Archive in the Sprengel Museum Hannover

236
Normalbühne MERZ, Nr. 98, July 1925
[Normal Stage MERZ, no. 98]
Manuscript (carbon copy), 3 sheets
Schwitters Archive of the Stadtbibliothek Hannover

237
Normalbühne = MERZ, Nr. 100, July 1925
[Normal Stage = MERZ, no. 100]
Manuscript, photograph, 3 sheets
Schwitters Archive of the Stadtbibliothek Hannover

238
Normalbühne. Nr. 121, 10.12.1925
[Normal Stage. no. 121]
Typescript, 3 sheets
Schwitters Archive of the Stadtbibliothek Hannover

239 (p. 106)
Die Scheuche (Merz 14/15), 1925
[The Scarecrow (Merz 14/15)]
Book
20.5 x 24.5 cm
Sprengel Museum Hannover, private loan

240
Kitsch und Dilettantismus, 19.12.1927
[Kitsch and Dilettantism]
Typescript, 1 sheet
Kurt Schwitters Archive in the Sprengel Museum Hannover

241
Merz 20 Kurt Schwitters (Katalog der Großen Merzausstellung), 1927
Booklet [exhibition catalogue]
24.5 x 16 cm
Kurt Schwitters Archive in the Sprengel Museum Hannover

242
Oben und unten (zweite Fassung). Nr. 1602, 1929
[Above and Below (Second Version). No. 1602]
Typescript (carbon copy), 34 sheets
Kurt Schwitters Archive in the Sprengel Museum Hannover

243
Ausstellung Karlsruhe Dammerstocksiedlung. Die Gebrauchswohnung, 1929
[Exhibition in the Dammerstocksiedlung in Karlsruhe. The Utility Flat]
Book
21 x 30 cm
Schwitters Archive of the Stadtbibliothek Hannover

244
Hannover, Städtische Drucksachen: Zoologischer Garten (1933), *Magistrat der Hauptstadt Hannover* (1931), *Schlacht- und Viehhof* (1934), *Verwaltung der städtischen Badeanstalten* (1934)
[Hanover, Official Printed Materials: Zoological Garden (1933), Municipal Council of the Regional Capital Hanover (1931), Abattoir and Stockyard (1934), Administration of the Municipal Swimming Pools (1934)]
4 letters on preprinted forms
29.5 x 21 cm
Schwitters Archive of the Stadtbibliothek Hannover

245
Ursonate, Merz 24, 1932
Booklet
21 x 14.7 cm
Schwitters Archive of the Stadtbibliothek Hannover

246
Hannover, Städtische Drucksachen: Sophienschule in Hannover, Zeugnis, 1932
[Hanover, Official Printed Materials: The Sophien School in Hanover, School Report]
1 sheet, printed
29.2 x 21 cm
Schwitters Archive of the Stadtbibliothek Hannover

247
Die Fabel vom guten Menschen, 10.6.1933
[The Fabel of the Good Person]
Typescript (carbon copy), 1 sheet
Kurt Schwitters Archive in the Sprengel Museum Hannover

248
Kleines Gedicht für grosse Stotterer, ca. 1934
[Little Poem for Big Stutterers]
Manuscript, 1 sheet
Kurt Schwitters Archive in the Sprengel Museum Hannover

249
Ich sitze hier mit Erika, 2.7.1936
[Here I sit with Erica]
Typescript (carbon copy), 29 sheets
Schwitters Archive of the Stadtbibliothek Hannover

250
Ambuamananzigel, 24.12.1937
Typescript, drawing, 1 sheet
Kurt Schwitters Archive in the Sprengel Museum Hannover

251
*Bericht über das Feuer im Atelier, Hutchinson Intern-
ment Camp, Douglas, Isle of Man,* 8.1.1941
[Report on the fire in the studio, Hutchinson Intern-
ment Camp, Douglas, Isle of Man]
Manuscript, 1 sheet
Schwitters Archive of the Stadtbibliothek Hannover

252
The Landlady, ca. 1942
Typescript, 1 sheet
Schwitters Archive of the Stadtbibliothek Hannover

253
Ann Blossom has Wheels, 1942
Manuscript, 1 sheet
Kurt Schwitters Archive in the Sprengel Museum Han-
nover

254
*Kurt Schwitters an Raoul Haussmann, mit Nieder-
schrift der Gedichte The furor of sneezing und Bal-
lade, sowie Klischee von seiner Skulptur Cicero,*
18.6.1946
[Kurt Schwitters to Raoul Haussmann, with copies of
the poems 'The furor of sneezing' and 'Ballade', as
well as a model of his sculpture Cicero]
Letter, 4 sheets
Schwitters Archive of the Stadtbibliothek Hannover

255
*Key for Reading Sound Poems, in: [PIN] Present Inter
Noumenal,* 27.12.1946
Typescript, 8 sheets
Schwitters Archive of the Stadtbibliothek Hannover

256
Kurt Schwitters an Hans Richter, 18.2.1947
[Kurt Schwitters to Hans Richter]
Letter, 2 sheets
Schwitters Archive of the Stadtbibliothek Hannover

257
*Kurt Schwitters an Christof Spengemann, mit letzter
Niederschrift des Gedichtes An Anna Blume,*
29.9.1947
[Kurt Schwitters to Christof Spengemann, with fair
copy of the poem 'An Anna Blume'] Letter, 2 sheets
Schwitters Archive of the Stadtbibliothek Hannover

258
ART, 1947
Manuscript, 1 sheet
Schwitters Archive of the Stadtbibliothek Hannover

ARTISTS FROM 1950 TO THE PRESENT

ABSALON

259 (p. 201)
Cellule No. 5, 1992
Wood, cardboard, white paint
400 x 240 cm
Kunstmuseum Liechtenstein, Vaduz

ARMAN

260 (p. 164)
Untitled, 1955
Stamp ink on paper on canvas
31.5 x 24 cm
Stedelijk Museum Amsterdam

261 (p. 164)
Priorité A, 1957
Stamp ink on paper
32 x 24.5 cm
Armand and Corice Arman

262 (p. 162)
Colère Suisse, 1961
Broken pendulum clock on wooden board
92 x 73 x 13 cm
Sprengel Museum Hannover

JOSEPH BEUYS

263 (p. 144)
Braunkreuz, 1960
[Brown Cross]
Collage, (ink with pen) on blue, faded paper (enve-
lope), glued to this: oil on printed newspaper, glued
to grey card
29.7 x 21 cm
Stiftung Museum Schloss Moyland – Sammlung van
der Grinten

264 (p. 145)
Spechtbild, 1961
[Woodpecker Picture]
Montage, cut card
26 x 18.3 x 3
Stiftung Museum Schloss Moyland – Sammlung van
der Grinten

265 (p. 146)
Kelch, 1962
[Chalice]
Card on card, glued
22.8 x 25.5 x 0.2 cm
Stiftung Museum Schloss Moyland – Sammlung van
der Grinten

266 (p. 145)
Namenliste 1, 1963
[List of Names]
Ink, oil, tin plate, glued on card
50.5 x 37 x 0.3
Stiftung Museum Schloss Moyland – Sammlung van
der Grinten

267 (p. 142)
Vitrine mit Kartoffelkraut und Fluxusstaubbild, 1962
and 1982
[Showcase with Potato Vine and Fluxus Dust Picture]
Potato Vine, bone, knife, earth, Fluxus dust picture,
1962, in wooden frame
202 x 233 x 61.5 cm
Private collection, Berlin

268 (p. 144)
Messer, 1965
[Knife]
Folded canvas with oil (Brown Cross), painted canvas
with pencil on brown card, mounted in object box
41 x 31 x 5.5 cm
Collection Maria and Walter Schnepel, Bremen

JOHN BOCK

269
*Dionysische Monologikus-Gelüste eines Schwacho-
maten,* 2000
[Dionysic Monologic-Lusts of a Weakomatum]
Mixed media
Various measurements
Collection of the artist, Courtesy Galerie Klosterfelde,
Berlin

GEORGE BRECHT

270 (p. 127)
Variation on Blair (ca. 1959) and Koan (1958), 1958/59
Assemblage
140 x 130 x 8 cm
Collection Feelisch, Remscheid

MARCEL BROODTHAERS

271 (pp. 130, 131)
La clef de l'horloge, 1957
16-mm-Film, b/w, sound, seven mins.
Maria Gilissen

CHRISTOPH BÜCHEL

272
Lieber Kurt, 2000
[Dear Kurt]
Mixed media
Various measurements
Collection of the artist

ANTHONY CRAGG

273 (p. 199)
Stack, 1975/2000
Mixed media
Various measurements
Collection of the artist

274 (p. 198)
Clear Glass Stack, 2000
Glass
Various measurements
Collection of the artist

FRANÇOIS DUFRÊNE

275 (p. 171)
Le Passirgranksagri passigriksa, 1960
Décollage on fibre board
137.5 x 174.5 cm
Sprengel Museum Hannover

ROBERT FILLIOU

276 (p. 119)
Werkzeugkreuz, 1969
[Tool Cross]
Tools and diverse materials
110 x 50 x 12 cm
Collection Feelisch, Remscheid

277 (p. 122)
Suspense Poem (L'Homme est solitaire), 1961
Montage, mixed media on wood
55 x 11 cm
Private collection, Krefeld

278 (p.118)
3 Weapons, 1968–1970
Blockboard, screw hook, knuckle-duster, diverse materials
46 x 46 x 13 cm
Collection Maria and Walter Schnepel, Bremen

279 (p. 124)
Object without Object, 1969
Wooden batten with screw hook, block of wood, with paper collage and felt-pen markings.
230 x 15 x 4 cm
Collection Feelisch, Remscheid

280 (p. 123)
Stuhl, 1969
[Chair]
Wood, synthetic, metal
68.5 x 43 x 40 cm
Museum am Ostwall, Dortmund

281 (p. 117)
PERMANENT CREATION – TOOL SHED – mobile version –, 1969 and 1984
Mobile tool shed, neon tube
280 x 220 x 420 cm
Collection Feelisch, Remscheid

282 (p. 119)
Research on Filmmaking, 1970
Blockboard, screw hook, wooden cube with traffic signs on metal foil
46 x 45.5 x 13 cm
Collection Maria and Walter Schnepel, Bremen

283 (p. 121)
Telephatic Music No. 20, 1982
20 music stands with mirrors
Various measurements
Sprengel Museum Hannover

GELATIN+D.MOISES

284 (p. 212)
ball crazy– –, 2000
Mixed media
Various measurements
Collection of the artists

RAYMOND HAINS

285 (p. 171)
Palisade, 1959
Wood, paper
90 x 100 cm
Krimhild and Jürgen Sparr, Kronberg/Ts.

286 (p. 170)
Untitled, 1961
Décollage, paper on tin sheet
200 x 100 cm
Sprengel Museum Hannover

RICHARD HAMILTON

287 (p. 190)
Let's explore the stars together, 1962/63
Collage, Indian ink, gouache on paper
102 x 122 cm
Staatliche Museen zu Berlin, Kupferstichkabinett

288 (p. 191)
Interior 1, 1964
Oil, collage on wood with integrated mirror
122 x 162 cm
Private collection

289 (p. 189)
Interior, 1964/65
Colour screen print
56.5 x 78.5 cm
Staatliche Museen zu Berlin, Kupferstichkabinett

THOMAS HIRSCHHORN

290 (pp. 218, 219)
Project: Schwitters' Home – Place of Pilgrimage
(not realised)

ALLAN KAPROW

291 (p. 110)
Kiosk, 1957–1959
Adjustable panels with lamps and diverse materials
158 x 134 x 243 cm
ART KIOSK, Brussels

292 (p. 112)
Meteorology, 1972
Ensemble
1 Object made of cardboard, plastic, mirror, wire, pipette, 62 x 31 x 40.5 cm
2 Shoe object, 11 x 11.5 x 30.6 cm
3 Tableau, consisting of a photograph by E. Wollek, Düsseldorf, 24.4 x 38.9 cm, and a sticker with text, 15.4 x 63 cm
4 Tableau with six photographs by E. Wollek, Düsseldorf, each 27 x 27 cm
5 Tableau with a photograph, a napkin with text and instructions
Collection Maria and Walter Schnepel, Bremen

EDWARD KIENHOLZ

293 (p. 179)
The Beanery, 1965
Assemblage
213.4 x 182.9 x 670.6 cm
Stedelijk Museum Amsterdam

LAURA KIKAUKA

294
INTERRUPTED INSPIRATION, 2000
Mixed media
Various measurements
Collection of the artist

ARTHUR KØPCKE

295 (p. 134)
Continue ..., 1958–1964
Edition of 150 in total, no. 4 of the luxury edition of 30, 1962
Green make-up case
30.5 x 36.5 x 21 cm
Contents:
1 Reading Work Piece on black card 24.7 x 34.7 cm, 72 sheets over-worked with felt-pen or collaged, one sheet of Plexiglas, one cover sheet
2 Booklet Arthur Køpcke – piece No 2 – Was ist das? [What is that?]
3 Gramophone record
4 Stuck book, signature: 4/30 A. Køpcke
5 Nickel spectacles
6 Alarm clock
7 Matchbox, signature: 4/30 A. Køpcke
8 Two empty tobacco packets
9 Wooden stick with mirror and sign
10 Powder picture, 34.7 x 24.5 cm
Collection Maria and Walter Schnepel, Bremen

296 (p. 133)
Reading Piece No. 33, 1964
Oil, paper on fibre board
55.8 x 46.4 cm
Staatsgalerie Stuttgart, Archiv Sohm

297 (p. 135)
Reading / Work Pieces, 1964
Collage, paint on fibre board
91 x 62 cm
Staatsgalerie Stuttgart, Archiv Sohm

298 (p. 134)
What's the Time, 1969
Clocks mounted on wood
16.5 x 60.5 x 18 cm
Staatsgalerie Stuttgart, Archiv Sohm

ROBERT MOTHERWELL

299 (p. 67)
Mallarmé's Swan, 1944
Gouache, chalk, paper on card
110.5 x 90.2 cm
Contemporary Collection of the
Cleveland Museum of Art

300 (p. 68)
Pierre Berès, 1974
Collage, acrylic on card
183 x 92 cm
Sprengel Museum Hannover

LOUISE NEVELSON

301 (p. 95)
Rain Forest Column XIX, 1959
Sculpture, wood, painted black
208.3 x 25.4 x 25.4 cm
Ron and Ann Pizzuti, Columbus (Ohio)

302 (p. 91)
Sky Cathedral III, 1959
45 boxes, wood, painted black
300 x 345 x 45 cm
Kröller-Müller Museum, Otterlo

303 (p. 92)
World Garden IV, 1959
Wooden shrine with door on hinges, wooden parts
nailed inside, painted
152 x 40 x 28 cm
Museum Ludwig, Cologne

NAM JUNE PAIK

304 (p. 148)
Gramophone Record Shashlik, 1963
Assemblage, radio, gramophone records
172 x 58 x 40 cm
Museum am Ostwall, Dortmund

EDUARDO PAOLOZZI

305 (p. 180)
Hi Ho, 1947
Collage
37.9 x 25 cm
Victoria and Albert Museum, London

306 (p. 184)
Refreshing and Delicious, 1949
Collage
38 x 27 cm
Sherwin N. A. G., Leeds

307 (p. 182)
Man Holds the Key, 1950
Collage
36.4 x 25.4 cm
Victoria and Albert Museum, London

308 (p. 186)
You Can't Beat the Real Thing, 1951
Collage
36 x 24 cm
Victoria and Albert Museum, London

309 (p. 181)
Evadne in Green Dimension, 1952
Collage
33.4 x 25.4 cm
Victoria and Albert Museum, London

310 (p. 182)
Metaphor Time (Hermaphrodite), 1960–1962
Collage
22 x 14.3 cm
Sherwin N. A. G., Leeds

NANA PETZET

311
*Sammeln Bewahren Forschen Abfallwiederver-
wertungssystem,* 2000
[Collect Preserve Research Waste Recycling System]
Domestic waste, recycled objects, repaired items,
photographs
Various measurements
Collection of the artist

ROBERT RAUSCHENBERG

312 (p. 82)
Untitled, 1957
Collage, oil on canvas
38 x 61 cm
Kunsthaus Zürich

313 (p. 81)
Diplomat, 1960
Combine Painting
125 x 67 cm
Museum moderner Kunst Wien, Stiftung Ludwig

314 (p. 84)
Navigator, 1962
Combine Painting
213 x 152 cm
Museum für moderne Kunst, Frankfurt am Main

315 (p. 83)
Cardbird II, 1971
Screen print, collage, assemblage on chipboard in
Plexiglas frame
151 x 96 cm
Sprengel Museum Hannover

LOIS RENNER

316 (p. 210)
Wimm, 1997
c-print, Plexiglas
120 x 150 cm
Collection of the artist

317 (p. 210)
Die Jugend, 1999
[Youth]
c-print, Plexiglas
225 x 180 cm
Collection of the artist, Courtesy Galerie
Kuckei + Kuckei, Berlin

318 (p. 211)
Playstation, 2000
c-print, Plexiglas
180 x 225 cm
Collection of the artist, Courtesy Kerstin Engholm
Galerie, Vienna

MIMMO ROTELLA

319 (p. 167)
Les conquérants, 1962
Photograph on canvas
89 x 130 cm
Sprengel Museum Hannover

DIETER ROTH

320 (p. 151)
*Bar Nr. 1, Basel – Toulouse – Holderbank – Wien
[Vienna],* 1983–1997
Assemblage
315 x 325 x 120 cm
Collection Maria and Walter Schnepel, Bremen

321 (p. 149)
Stummes Relief (erste kubistische Geige), 1984–1988
[Dumb Relief (first Cubist violin)]
Violin, violin case and violin bag, collage with small
objects, acrylic, spray paint
80 x 54 x 12 cm
Sprengel Museum Hannover

322 (p. 150)
Tischmatten, 1988/89
[Table Mats]
Assemblage
113 x 167 x 6 cm
Collection Feelisch, Remscheid

ANNE RYAN

323 (p. 101)
Untitled (# 43), 1948
Collage
19 x 16.5 cm
Joan Washburn Gallery, New York

324 (p. 102)
Untitled (# 3), 1949
Collage
14.2 x 11.7 cm
Joan Washburn Gallery, New York

325 (p. 101)
Untitled (# 234), 1949
Collage
19.1 x 14 cm
Joan Washburn Gallery, New York

326 (p. 99)
Untitled (# 516), 1949
Collage
42.5 x 34.9 cm
Joan Washburn Gallery, New York

327 (p. 102)
Untitled, 1952
Collage with fiber and paper
88.9 x 68.6 cm
Courtesy Michael Rosenfeld Gallery, New York

GREGOR SCHNEIDER

328
*u r 19, Liebeslaube, Rheydt 1995–96, aus dem Haus
u r*, 1995–2000
[u r 19, Love Arbor, Rheydt 1995–96, from Haus u r,
1995–2000]
Room, mixed media
Various measurements
Collection of the artist, Courtesy Galerie Konrad
Fischer, Düsseldorf / Luis Campaña Galerie, Cologne

329
Nacht-Video, Haus u r, Oktober 1996
[Night Video, Haus u r]
Black-and-white video
Collection of the artist, Courtesy Galerie Konrad
Fischer, Düsseldorf/Luis Campaña Galerie, Cologne

DANIEL SPOERRI

330 (p. 158)
Le réveil du Lion, 1961
Assemblage
76 x 90 cm
Sprengel Museum Hannover

331 (p. 159)
Le coin du restaurant Spoerri, 1968
Assemblage
270 x 300 x 150 cm
Museo Vostell Malpartida, on loan from the Junta de
Extremadura

JESSICA STOCKHOLDER

332
Gelatinous Too Dry, 2000
Mixed media
Various measurements
Collection of the artist, Courtesy
Gorney Bravin Lee Gallery, New York

TOMATO

333
Installation, 2000
Mixed media
Various measurements
Collection of the artists

CY TWOMBLY

334 (p. 74)
Untitled. Rome 1977
Sculpture, synthetic resin, painted
126.5 x 14 x 9 cm
Nicola del Roscio, Rome

335 (p. 74)
Untitled. Rome 1977
Sculpture, synthetic resin, painted
168 x 21.5 x 16 cm
Nicola del Roscio, Rome

336 (p. 73)
Untitled. Zurich 1978 (Cast Zurich 1991)
Sculpture, bronze
44 x 222.5 x 18 cm
Kunstsammlung Nordrhein-Westfalen, Düsseldorf

337 (p. 72)
Untitled. Rome 1959 (Cast Rome 1985)
Sculpture, synthetic resin, painted
67 x 34 x 26.5 cm
Nicola del Roscio, Rome

JACQUES VILLEGLÉ

338 (p. 168)
Passage Bayen 17e, 1959
Décollage
40 x 85 cm
Sprengel Museum Hannover

339 (p. 169)
Beaubourg Paris 3, 1960
Décollage
80 x 43.5 cm
Sprengel Museum Hannover

SOUND POETRY EVENTS

JAAP BLONK

340
Von Dada bis Blonk
18, 19, 20 and 22 August 2000
Voice Performance
Performer: Jaap Blonk

FRANZOBEL

341
Sony Monster lebt
[Sony Monster Lives]
26 September 2000
Reading and Videos
Performers: Franzobel – Carla Degenhardt

GERHARD RÜHM

342
Sprechtexte ein- und zweistimmig
[Spoken texts for one and two voices]
10 October 2000
Performers: Gerhard Rühm und Monika Lichtenfeld

ARTISTS' BIOGRAPHIES

ABSALON

Born in 1964 in Ashdod, Israel, Absalon arrived in Paris at the age of 23. At the time he was making small, white boxes from cardboard, wood or cork, containing white architectural miniatures. With these *Cellules (En silence)*, he started to participate in exhibitions of work by younger artists in France – in Lyon, Nice and Ivry-sur-Seine for example. His next series comprised his *Compartiments*, seemingly anonymous objects, uniformly covered in plaster. In 1989, in his *Propositions d'habitation* Absalon explored the idea of a space that fitted his own bodily dimensions exactly and which offered no comfort, nothing more than the basic requirements for survival. Between 1990 and 1993 he designed a total of six of these survival units, which he then constructed and showed at numerous exhibitions, including documenta IX in Kassel. These *Cellules* were intended to stand in public places, each in a different town, and the artist wanted to live in each for at least six months. With these severe spatial designs Absalon seemed less to be adopting an aesthetic stance than investigating possibilities for housing in the future. Through the confrontation between his white *Cellules*, exuding calm and stability, and the dirt and the noise of the city, the artist was criticising contemporary urban society in keeping with Mies van der Rohe's maxim: "Less is more". Since his premature death in Paris in 1993, his work has been shown in a number of group shows and memorial exhibitions; the first retrospective of his work took place in Bordeaux in 1998.
D. G.

ARMAN

Born 1928 in Nice as Armand Fernandez, Arman passed his baccalaureate in philosophy and mathematics in 1946. Having studied at the School of Art in Nice, the Ecole du Louvre and the Ecole Nationale des Arts Décoratifs in Paris, he had his first solo exhibition in Paris in 1956. Besides abstract paintings, this exhibition also included his *Cachets* (stamped works). These drew inspiration from Kurt Schwitters' i-drawings which Arman had seen in an exhibition in Paris in 1954. In 1959 he started to make his first object pictures, his *Accumulations* and *Poubelles* (rubbish bins), which were widely shown in Europe. Arman, Yves Klein – a close friend of his since 1947 – Martial Raysse, Jean Tinguely, Raymond Hains and César together founded Nouveau Réalisme in 1960. Around this time Arman developed his own unmistakable style, which he has remained true to ever since. In his assemblages of objects he heaps together the detritus of civilisation and consumer objects, creating a unique aesthetic of materials. Unlike Schwitters, Arman is less concerned with the aesthetic composition of these objects than with revealing the specific expressive qualities of the chosen items. In order to achieve this he resorts to a whole range of diverse methods: he destroys his objects, for instance by cutting them up (*Coupes*), smashing them or exploding them (*Colères, Combustions*), or, in his *Accumulations*, he displays a series of identical ordinary objects in showcases, thereby alienating them from their original everyday context. Some of the resulting *Accumulations* consist of items that bear the traces of everyday use, as in the collection of kitchen utensils in *Hommage à la cuisine française* (1960), while others use brand-new products, like the car-parts in the artist's collaboration with Renault plants in France (1967). In 1971, when polyester was discovered through rapid polymerisation, the artist found he was now able to permanently fix even the most sensitive organic matter, like the remains of a burnt violin or a trail of oil-paint squeezed out of a tube. Arman lives in New York, Vence and Paris.
D. G.

JOSEPH BEUYS

Joseph Beuys' notion of the 'extended concept of art' and of 'social plastic' are virtually impossible to define using conventional art terminology. Born in Krefeld in 1921, Beuys became known worldwide for his Actions and objects, which are inextricably linked with his participation in societal processes. Originally the young Beuys wanted to study medicine after he left school, but this was prevented by his being called up into the army in 1940. Once the war was over, he decided to study at the Academy of Art in Düsseldorf. In the four years he spent there, studying under Joseph Enseling and Ewald Mataré among others, he conducted intense research both into scientific topics and into the humanities. His artistic works from this period are highly stylised – although still relatively conventional – sculptural works, drawings and watercolours. They are more surprising for their links to mythological and anthropomorphic ideas. These works already contain many of the animal motifs that Beuys was to return to so often in later years. Between 1955 and 1957 Beuys suffered a severe mental crisis, which he himself described as a period of reorganisation. During these years of depression Beuys evolved his vision of mingling nature and culture, myth and science, all in one "whole" person. In 1961 he became a professor at the Düsseldorf Academy of Art; a year later, together with Nam June Paik, he began to take part in Fluxus Actions. However, it soon became clear that his projects were rather different from those of the other Fluxus artists. While Fluxus Actions were generally short and to the point, leaving a significant amount to chance, Beuys' Actions could last for days and were planned down to the last detail. In his work from 1960s onwards, Beuys generally kept to certain specially selected materials – fat, felt, wood, ashes, honey and sulphur – from which he developed a personal language of symbols. The difference between Beuys' Actions and those of the Dada-oriented Fluxus movement became abundantly clear in the Action *Der Chef*, which took place in Berlin in December 1964. In this Action, Beuys lay rolled-up in a felt blanket for eight hours in a specially prepared room. Every so often the completely motionless artist emitted sounds, which were transmitted to the public via a system of loudspeakers. The acoustic side of this Action underlines the close affinity between Beuys' work at this time and that of Schwitters. The work of the Hanoverian artist was familiar to Beuys: in his youth he had made collages that bear witness to Schwitters' influence, and he also knew the *Ursonate* which may have provided the model for the sequence of sounds in the Action *Der Chef*. The sounds that had gained their independence in the *Ursonate*, were imbued with a new evocative quality in Beuys' Action.

With his extended concept of art and notions of social plastic Beuys drew ever further away from the Fluxus movement, at the same time keeping his distance from other trends on the art scene. In his philosophically founded political praxis, which also embraced his visual works, he was striving for social goals such as the introduction of direct democracy through a plebiscite or free access to all educational institutions. In 1972, his occupation of the secretarial offices in the Düsseldorf Academy of Art, with 54 rejected candidates, prompted his dismissal from the Academy. In 1974, in response to the government's education policies, Beuys and the author Heinrich Böll founded the Free International University in Düsseldorf. In 1979 he stood as a candidate for the European Parliament on behalf of the Green Party. At the opening of documenta 7 in 1982, he planted the first of his *7000 Oaks* in Kassel; this marked the beginning of an Action that extended over years and was acclaimed at home and abroad. Joseph Beuys died in Düsseldorf in 1986.
D. G.

JAAP BLONK

It was free jazz that liberated the voice of the Dutch sound-poet Jaap Blonk. In his first vocal improvisations he imitated saxophone pieces. After that he extended his range to include poetry recitals. He is fascinated by the flexibility, the expressivity and the directness of the voice, even when no words are used. Born in 1953 in Woerden, and self-taught, Blonk's sound poetry operates somewhere between music and language. He writes sound poems and other texts, both for solo performances and for various musical ensembles, with whom he at times also performs. His stylistic range encompasses almost all kinds of music. In his compositions he creates endless new combinations of vocal and instrumental sounds, be it for his own thirteen-piece orchestra, Splinks, or for other line-ups. This voice artist has been involved in a wide variety of projects: he has performed, for instance, with the Netherlands Wind Ensemble and with the Ebony Band, and in 1999 he participated in Carola Bauckholt's music-theatre piece *Es wird sich zeigen...* at the Berlin Music Biennial. In Blonk's compositions an important part is played by improvisation and word-games. He notates his pieces as phonetic transcriptions, which are only to be taken as an indication of the actual vocal product. Blonk has already made a number of albums. His first recording, made in 1986, was a version of Kurt Schwitters' *Ursonate*. Jaap Blonk discovered his interest in Dadaist Actions early on, and today still performs sound poems from this period, such as Hugo Ball's *Seepferdchen und Flugfische* or his *Totenklage*. But he also includes texts by Ernst Jandl and Gerhard Rühm in his programmes. Blonk views sound poetry as an international language and performs the world over as well as working in primary schools and universities alike as a visiting teacher. For some years now, he has also taken an interest in the visual appearance of his scores, which have already been shown in a number of exhibitions.
D. G.

JOHN BOCK

The work of the Berlin artist John Bock, born 1965, derives from theatre and is closely linked with his Performances. Seen in isolation, Bock's grotesque installations – in which bicycles can just as easily crop up as cupboard walls, ladders, machines or other indefinable objects – seem like props from a stage play, for which 'absurd' might be a rather mild description.

Bock himself uses the term 'lectures' to describe his performances, which at times also include other actors. Yet the general thrust is always somewhat obscure, because although the artist (who studied economics before he studied art) does introduce theoretical discourse into his deluge of language, he also includes elements of puppet theatre or peasant theatre. Thus the whole can suddenly tip over into a sur-

real recitation of a poem or into a shaman-like sequence with overtones of Beuys. Or one of the figures is murdered for no apparent reason, upon which a commissar appears, in keeping with the style, yet disturbing.

In his highly energised performances, which can even include daredevil climbs, Bock always combines concepts that would seem to be mutually exclusive. He writes lengthy scripts, designs, costumes, works out constellations of objects and choreographies, only to improvise a large proportion of his performances. Sometimes the artist approaches his public very closely and aggressively, at other times he shifts his performance to the street, leaving the audience to watch events from inside, with his monologue relayed by microphones and loudspeakers.

Bock has worked in New York, Vienna, Venice and elsewhere. His performances, however, elude any expectations – although one cannot even be entirely sure of that, since some of his motifs are repeated. The fact that he frequently involves fruits or animals in his work, for instance, might be explained by the fact that he comes from the small north German village of Gribbohm.

John Bock plays his entertaining games just as much with the conditioning of the audience as with his own status as an artist. It can happen that he by mistake sticks an Otto Dix photo onto his own face and cries: "Otto Dix. He paints misery, and we like that. He's got to go. He's got to go." In just a few words Bock has touched on a number of themes all at once: unreflected art-consumption, voyeurism and fashionable psycho-babble. Of course he does not come to any conclusions on these themes. John Bock leaves that up to the visitors themselves, always assuming the high-spirited chaos leaves them with any serious inclination to do so.
Wot

GEORGE BRECHT
One of the first artists of the Fluxus movement is George Brecht. Born in 1925 in Halfway, Oregon, he studied with John Cage when the latter was teaching at the New School for Social Research. Like Robert Rauschenberg, in the early 1960s Brecht was making objects and assemblages from trash in the tradition of Junk Art. His first exhibition took place in the Reuben Gallery in New York in 1959, and he called it *Toward Events*. By the term 'Event', Brecht meant a "total experience that touches all the senses", and this notion has retained its importance for him ever since. In this respect he saw eye to eye with the Fluxus artists and their spokesman George Maciunas, and from 1959 onwards he took part in important international occasions like the Fluxus International Festival in New York. At these events he got to know Robert Filliou. Between 1965 and 1968 they lived and worked together in Filliou's house in the South of France. Besides a number of collaborative works, it was here that Brecht made his little medicine cupboards, typecases and boxes which he filled with everyday objects like toys, sports goods and small bottles. At first sight these have a certain affinity with Louise Nevelson's object boxes, although the latter have a more serious, rigorous, even mysterious air. Brecht's boxes on the other hand are more whimsical. In his assemblage of tipped-out trash he presents a segment of reality without passing comment on it, and binds a cord round the trash in order to give it a solemn, "museum-like" character. Like Robert Filliou, he does not see himself as an artist in the classical sense. Art seems to be

only one category amongst many that his work could be classified under. Brecht has spoken of the fact that he has been influenced by Zen Buddhism, Marcel Duchamp and John Cage, but he never talks about his work. He has lived in Cologne since 1972.
D. G.

MARCEL BROODTHAERS
Brussels was not only the birthplace of René Magritte, but also of Marcel Broodthaers (b. 1924). When the two met in 1945 for the first time, Magritte symbolically handed the younger artist his legendary bowler hat. At the time Broodthaers was working as a writer and poet, but also as a critic and journalist. In 1957 he published his first book, *Mon livre d'Orge*. In the same year he shot *La Clef de l'Horloge*, a short film lasting some seven minutes. The impulse behind the production was an exhibition of work by Kurt Schwitters in the Brussels Palais des Beaux-Arts in 1956. The film is Broodthaers' response to Schwitters' collages. Broodthaers regarded his experimental film as a *Poème cinématographique en l'honneur de Kurt Schwitters*, as he indicated in the subtitle. As so often in his case, the medium of film also served as an extension of language. Broodthaers saw himself first and foremost as a poet; it was not until 1963 that he started to work as a visual artist when he halfcovered 50 copies of his volume of poetry *Pense-Bête* in plaster, thereby creating an object. In 1964 the first exhibition of his work was presented in Brussels in the Galerie Saint-Laurent.

After that he continued to produce objects and sculptures – notably his compositions with shells or egg-shells – which gave this Belgian his particular reputation in the art world. Broodthaers understood his art as a metaphor, a parable in which title and painting, lettering and image complement each other. The visual language of René Magritte clearly has an influence in these matters, although Broodthaers' work is less Surreal than that of his role model, so that he could better point to certain social realities. In his view art could not exist without reality. In 1968, when he founded the fictive museum, *Musée d'Art Moderne, Département des Aigles*, his aim was to express his criticisms of the state's museums policy. The idea came to him when he was getting his studio ready for a visit from his friends. He set up a number of wooden boxes which he decorated with postcards showing art motifs from the 19th century. Finally he wrote the word 'Museum' in the windows of the studio. He later participated in documenta 5 in Kassel in 1972 with a similar project, his *Musée d'Art Ancien, Département des Aigles*. Following a protracted illness, Broodthaers died in Cologne in 1976.
D. G.

CHRISTOPH BÜCHEL
The Basel artist Christoph Büchel, born 1966, occupies rooms; not in the abstract-minimalist sense, but physically and for real. Büchel can almost always be certain of an intense reaction to his work.

He has become widely known for his imaginary domestic situations. In 1998, in the TBA Exhibition Space in Chicago, he built his piece *Home Affairs*, the home of an imaginary person who can never throw anything away. Immediately on entering the art-place visitors found themselves in an – admittedly carefully constructed – chaos of heaps of old newspapers, clothes, empty bottles, pizza boxes and other clutter. The kitchen and the toilet, equally packed, still served their original purpose and could be used.

A year later in Offenbach, Büchel installed the home of a person who can never finish anything. The puzzle on the floor, the letter in the typewriter, polishing the trophies, repairing the radio: at every turn in this room someone seems to have started something but then to have stopped short. Hints as to the mental state of the 'resident' are contained in countless details, all over the installation – under the bed, in the refrigerator, in the sink.

It is important to Büchel that visitors to his installations have direct contact with the work. The domestic situations, in which he likes to include switched-on television sets, are through-composed in an artistic sense, but not so alienated that the visitor would be led too far away from the basic idea of the psychogram being presented. In Chicago the artist accompanied his mise-en-scène of chaos with authentic photographs of apartments that had been compulsorily cleaned.

Not least because Büchel is uncompromising in the way he presents his situations, the visitor is forced to react to them, and to think about his/her own state of mind, as well as that of others too. It may be that the visitor will do this not unwillingly, for Büchel permits what is normally forbidden, namely that one should be able to take a voyeuristic – and if one wants, detailed – look at a complete stranger's private sphere. The work of art here is a deception, that one succumbs to no doubt with some discomfort but without putting up any very great resistance – which is not to say that Büchel never meets any resistance. On the contrary, at the 1998 Art Fair in Basel, one of his works was removed: the ironic (prize-winning) *Bandenwerbung* was evidently too realistic for the organisers of the Fair.
Wot

ANTHONY CRAGG
When Anthony Cragg was attending the Wimbledon School of Art in 1970, he regularly used to jump down from his tandem and pick objects up off the street. Born in Liverpool in 1949, he was fascinated by the stones and bits of wood he found, but also by industrial waste, be it glass, plastic or metal. In the mid-1970s he started to use these in his constructions: he would lay the objects on the floor or build them up to form his *Stacks*. His aim was to create pictures and objects that neither existed in nature nor in the world of technology. His use of organic matter, which also led him to experiment along the lines of Land Art, later increasingly gave way to a preference for industrial products. In his early works he was more interested in the creative process than in the end-result. If his London works had not been photographed it would be hard today to have any real idea of the early stages of his artistic career, since not a single work from between 1974 and 1977 has survived. A systematic documentation only started in 1977, when he began to become better known through numerous international solo exhibitions. At this time he was mainly making his wall and floor assemblages from coloured plastic pieces. Cragg always travelled to his exhibitions without any materials, because he used to collect these in situ, drawing inspiration from the atmosphere of the town. This way of working, which was part of the overall process, proved to be extremely strenuous and the artist constantly found himself facing incalculable problems. With time, therefore, Cragg included newly-purchased everyday objects in his stock of materials. In 1983 he returned to working in the studio. He acquired traditional sculptural skills,

such as casting metal, and devoted himself to composing single forms. Later he worked with materials such as plaster, wax or glass. In 1988 he became a professor at the Academy of Art in Düsseldorf. Anthony Cragg, one of the leading English sculptors of our time, lives and works in Wuppertal.
D. G.

FRANÇOIS DUFRÊNE

Born in Paris in 1930, Dufrêne started his artistic career writing sound poetry. In 1946, while he was still at school, he made his first contact with the Lettrists. This group was at the heart of the avant-garde at the time and its main focus was on drawing-like script compositions and visual poetry, which was combined with film, painting and music. Dufrêne's Lettrist poetry readings, above all in the Tabou and in the Maison des Lettres in 1950, brought him a certain degree of fame. In 1925 he presented his imaginary 'film' *Tambours et jugement premier* on the fringes of the Cannes Film Festival, a work with no filmic material and no screen, just a large number of poems.

Once Dufrêne had become acquainted with Raymond Hains and Jacques Villeglé, his artistic work began to take on new forms. He watched in fascination as the other two carried out their Actions, tearing down posters, but did not take part himself at first. Only after he discovered his own interest in the backs of the posters, did he start to use these 'found objects' as a basis for his own works. His so-called *Dessous d'affiches* were the 'reverse' of the poster-fronts mounted on canvas by Hains and Villeglé. All three artists continued with the principle of *décollage*, and formed the sub-group of *Affichistes* within the grouping of Nouveaux Réalistes established in 1960 by Arman, Yves Klein and Jean Tinguely with Pierre Restany.

In 1961 Dufrêne was represented in the exhibition *The Art of Assemblage* in the Museum of Modern Art in New York, which also included work by Kurt Schwitters and Marcel Duchamp. A year later he and Daniel Spoerri took part together in the *Festum Fluxcrum* in Paris, and Dufrêne also read from his own *Tombeau de Pierre Larousse*. Later in Milan he read an Italian version of the same work on the occasion of the tenth anniversary of the founding of the Nouveau Réaliste group. Dufrêne died in Paris in 1982.
J.F.

ROBERT FILLIOU

In 1958, the 32 year-old Robert Filliou, on the brink of a highly promising career as an economist, changed his job-description to "poet". Born in the village of Sauve in the South of France, he had studied Economics at the University of California and, in 1951, as part of his degree had visited South Korea, where he became interested in Zen Buddhism. After periods spent in Egypt, Japan and Spain he finally moved to Denmark, but spent a certain amount of time in Paris in 1959/60. There Daniel Spoerri put him in touch with numerous artists who were active in the French art-scene in the 1960s. During this time he wrote his *Suspense Poems* – poetry objects that were sent by post. The recipients were given instructions to arrange the objects as a kind of collage. Filliou presented the results in 1961 in his first exhibition in Copenhagen. From 1962 onwards he associated himself with Fluxus and participated in all their international exhibitions. Just like the Dadaists, the poet Filliou regarded visual art as only one activity among many. He preferred the term "permanent creation",

by which he meant life itself and which was also his definition of art. Taking the most banal of everyday items as his starting point, he sought to express the universal. He chose objects from his immediate surroundings – cardboard boxes, papers, threads and nails – creating works that combined language and objects. He himself did not judge a work of art by the manner or the quality of its making but by its capacity to create a poetic connection with reality.

In 1969 Filliou presented two of his most important works. Besides different versions of his *Permanent Creation Tool Shed* which embodied his concept, he also presented his *Création Fermanent, le Principe d'Équivalence*. This principle removes the distinction between 'well done', 'badly done' and 'not done', and thus wittily questions the traditional scale of Western values. In 1972 Filliou was represented at documenta 5. In 1982 he was awarded the Kurt Schwitters prize of the City of Hannover. In connection with this, the Sprengel Museum Hannover presented the first retrospective of his work in 1984. In 1985 he entered a Buddhist monastery in the Dordogne; two years later he died in Les Eyzies.
D. G.

FRANZOBEL

The Viennese artist Franzobel was born in 1967 as Franz Stefan Griebl in Vöcklabruck in Upper Austria; since 1991 he has regarded himself primarily as a man of letters. With his idiosyncratic language-experiments he addresses the most disparate of themes. Neither Lessing nor Josefine Mutzenbacher are safe from his literary attacks. Amongst other things, he has been awarded the first prize in the Klagenfurt Ingeborg Bachmann Competition, the Leonce-und-Lena Prize of the town of Darmstadt and the Kassel Literature Prize for Grotesque Humour.

He did also paint in the past, and he describes his style of painting as a "mixture of Jungen Wilden, perhaps a little darker, and a form of reduced photorealism". Yet he came to view the art business with increasing scepticism and finished with the visual arts just as he did with the theatre. Having originally been engaged "by chance" as a walk-on actor in the Viennese Burg Theater, he came to feel that stage life was vain and false. Nevertheless, Franzobel has not entirely turned his back on the visual media: he and his wife, Carla Degenhardt, make videos "without fancy technical gimmicks", which use both free invention and documentary snapshots, of St Peter's Square in Rome, for instance.

Franzobel is just as reluctant to name influences on his literary output: "It could be Nestroy or Wittgenstein or the Viennese Group." He loves to transform clichés and supposedly firmly-fixed values, transferring icons of high culture or scandal-ridden motifs into new, unfamiliar contexts. One time he may extract Franz Kafka from the usual tragedy that surrounds him, at another time he will alienate Goethe with the aid of a computer thesaurus programme. Or he writes an opera libretto about the gruesome story of the murderous Viennese nurses.

Franzobel enjoys alluding to the Dadaists and above all to Kurt Schwitters, whose humour, adaptability and musicality he appreciates – the same things that Schwitters himself particularly valued in his own readings.

However disrespectful Franzobel may be in his treatment of his verbal materials, he – like Schwitters – is not primarily concerned with deconstruction, but with creating new connections: "Pure destruction

would not be enough for me, precisely when one chooses a large form, you have to have some sort of control."
Wot

GELATIN+D.MOISES

The description "boy artists" that the four members of the group gelatin play with, already seems to make a certain kind of sense when one sees their "design sketches" for their installations. These look somewhat like children's drawings and seem to reflect the naive simplicity with which the members of gelatin regard their art. The installations and performances by these four artists from Austria – Ali Janka, Tobias Urban, Wolfgang Gantner and Florian Reitherzielen – aim to evoke extreme feelings. Often their works embody danger for the viewer or themselves. The determination that is needed if a person is to entrust him/herself to the work of art, is supposed to bring the viewer a sense of relief in the end which goes beyond the simple thrill. For the Sprengel Museum Hannover, the gelatin artists, together with David Moises, plan to construct a machine that will use air-pressure to shoot a golf ball through the so-called 'museum street' every twenty minutes; the ball will then be directed back into the machine by means of a sequence of metal plates. Besides danger, humour is also an important part of gelatin's projects. In *gelatins' Little Spanking Show*, which took place in a bar in Vienna in 1997, they hung naked and upside down, and allowed themselves to be spanked by a crowd of customers wielding leeks. They caused a sensation with their installation in the yard of the skyscraper PS 1 in New York. This consisted of a tower of furniture, roughly ten metres in height, which visitors could enter and which had a kiosk in its lower reaches. The group has intentionally removed the distinctions between artistic genres and categories; pop and trivia are put on a par with high culture. However, they would not want to equate their work with products of the culture of events and amusement. They see an affinity between their work and that of Kurt Schwitters in that they, like the Merz artist before them, are trying to step beyond the boundaries of what is socially acceptable in art. Born between 1967 and 1971, each is also active in his own right; they live and work in Vienna and New York.
D. G.

RAYMOND HAINS

In 1959, at the first Paris Biennial – which was dominated by *informel* paintings – Raymond Hains caused a scandal by presenting a section from a construction-site fence measuring three metres in height by seven metres in length. Entirely unaltered by the artist, the only aesthetic features of the fence were some left-over shreds of posters. Born in 1926 in Saint-Brieuc in France, Hains had originally wanted to be a photographer. On his night-time forays he used to spot walls with remnants of posters pasted over each other: at first he just photographed these, later he used them as materials. Looking back he commented: "I am a photographer who takes the motif home with him instead of photographing it." At first he was only accompanied by his friend Jacques Villeglé, whom he had met at the Ecole des Beaux-Arts in Rennes when he briefly studied sculpture there. In 1954 François Dufrêne joined them; he also showed torn-down posters at the Biennial. Hains had already attracted attention in 1948 with his first solo exhibition in the Galerie Colette Allendy, where he had shown photo-

graphs that he had alienated by means of certain technical processes. He called this form of post-treatment, "hypnogonoscopic", a word that he had constructed from 'hypnos' meaning 'sleep' and 'gonoscop' meaning a word-play.

Raymond Hains' work embraces all the different modernist media: besides availing himself of photography, abstract and figurative film, painting and installations, Hains is equally at home in the realms of pure concept art. Thus the frequently used epithet "poster-tearing artist" is wholly inadequate. One contributing factor in the scandal that Hains created at the Paris Biennial in 1959 was his criticism of contemporary painting, which had paved the way for the return of the idea of the artist-genius. As far as Hains was concerned, the most innovative images were to be found in reality. In 1960 the young art critic Pierre Restany organised a group exhibition in the Apollinaire Gallery in Milan, which included work by Hains, Yves Klein, Jean Tinguely, Arman, François Dufrêne and Jacques Villeglé. In October of that year these same artists, together with Daniel Spoerri, signed the 'Manifesto of Nouveau Réalisme'. A year later, in an exhibition entitled *Torn France*, Hains presented hitherto unexhibited torn posters from between 1950 and 1961, with which he made his views plain on the war in Algeria, amongst other things. Besides completely untouched fragments of posters, he also showed systematically worked layers of posters, so-called *décollages*. Having achieved international success with his posters in 1963, Hains once again turned more to other media, to photography for example.
D. G.

RICHARD HAMILTON
It seems that Richard Hamilton, born 1922 in London, has always been concerned to find the right mixture in his work. In his pictures he combines widely differing motifs, objects, techniques and styles. The link between classical painting and so-called popular art is already reflected in this American artist's training. He started to work in advertising at the age of fourteen, but then in 1938 decided to study painting at the Royal Academy School. After the outbreak of war he interrupted his studies in 1940 to attend courses in technical drawing, in order to work as a graphic artist in advertising and industry. When the war was over he returned to his original studies and in 1948 transferred to the Slade School of Art in London, where he spent the next three years. Hamilton's first works reveal his interest in Cubism and Futurism. In these works he explored the depiction of the movement of an object in space by means of multiple images. In 1952 he took up a teaching post at the Central School of Arts and Crafts in London where Eduardo Paolozzi was also teaching; that same year, Hamilton, Paolozzi and other artists and critics founded the Independent Group, whose members met to discuss topical issues such as the mass media and art, culture and progress. In 1956 Hamilton illustrated some of the group's thinking in his collage *Just what is it that makes today's homes so different, so appealing?*, which was originally intended as a poster for the Independent Group's exhibition *This is Tomorrow*. This amalgamation of disparate visual materials from magazines and journals provided an important impulse for British Pop Art, at the same time it prefigured Hamilton's preferred themes in his later work: the mass media, mass consumption, mass idols. After he had got to know the New York pop scene in 1963, photography acquired the same importance in his work as painting.

Hamilton also at times used printing techniques to combine painting and photography, or worked directly on the photographs, as in the collage *My Marilyn* of 1965. In his late period he tended increasingly to produce highly aesthetic, photographic works.
D. G.

THOMAS HIRSCHHORN
The Swiss-born artist Thomas Hirschhorn consciously avoids the question "How did he do that?" In order to remain on the same level as the viewer he uses materials that everyone knows and uses in their own lives, like cardboard, aluminium foil, wood or plastic. His *Cube* from 1992, for instance, looks at first sight like a crate made from roughly nailed pieces of wood. It frequently looks as though Hirschhorn (b. 1957) has just haphazardly collected together cheap materials, which are often otherwise only used as packing materials. And yet Hirschhorn is very conscious of the combinations he is making, which can also include advertisements or fragments of text: thus deeply disturbing motifs may be combined with the glittering world of advertising, status-symbols like Rolex watches or Mercedes stars may end up next to pieces of rubbish. By exploiting the associative qualities of his different 'pictorial elements', Hirschhorn manages to create a sense of coherence within his compositions, in which individual elements and the overall effect are carefully balanced. In his own words, Hirschhorn is fighting "against the injustice of the world"; he is not out to create new values, but to question the cultural values of our own time. In order to convey a sense of instability, transitional states and uncertain existences, he integrates perishable materials into his works. In his view, the artistic quality of a work – be it his own or someone else's – derives from the amount of energy that has been invested in the intention to communicate an idea and in the forming of the work. In this respect, he is particularly moved by Kurt Schwitters' Merzbaus, as well as by the work of Joseph Beuys and Robert Walser. Hirschhorn now lives in Paris and has participated in numerous major exhibitions. He contributed to *Skulptur. Projekte in Münster*, 1997, the berlin biennale in 1998, and in 1999 exhibited in the Museum of Contemporary Art in Chicago. However, the museum-context is not important to Hirschhorn, instead he is much more interested in presenting his work to as wide a public as possible. Thus his work may also be found in public places, in stairwells, out in the open or in front of his own house.
D. G.

ERNST JANDL
Despite everything, Ernst Jandl became one of the most important German-speaking writers. Often crossing accepted boundaries, his work demonstrated the many different ways of using language as material.

Jandl was born in 1925, the son of a bank official in Vienna. After studying German and English he qualified as a teacher and went on to write his doctoral thesis on Arthur Schnitzler. He taught in secondary education and published as a writer from 1952 onwards.

He described his approach as follows: "the aim of my work is to make functioning, living, effective, direct poems, guided – whatever their material and in whatever form they may appear – by what there is in me of direction and inclination, of joy and anger. what i want is poems that don't leave you cold."
Already in the early 1950s, Jandl's language-experiments did not leave his readers cold – they often pro-

voked white fury. Jandl, who was in close touch with Friederike Mayröcker and the Viennese Group (Artmann, Rühm, Wiener), met with a complete lack of understanding for his efforts to tread new and radical paths in literature. He threw himself into concrete poetry, where language and the written word were not intellectual reflection alone, but were also treated as graphic material, which not only visually supports or undermines the contents, but becomes 'contents' in its own right. In Jandl's own words, this was a directly pictorial approach: "creating objects from particular material – objects which do not exist other than as the result of such making."

Jandl enjoyed playing with hackneyed words or phrases and similar-sounding ideas, as in the book title *laut und luise* (the latter was his own mother's name; the title itself also evokes the phrase 'laut and leise' which would mean 'loud and quiet'). Gradually his unusual use of language met with increasing acceptance, and today certain works by Jandl have become classics, be it the question of whether one can "cofnuse . . . reft and light", or whether it is the mini-epic of *ottos mops*. It is in works such as these that not only the wit but also the musicality of Jandl's language becomes evident – for which Schwitters' literary work had provided a striking forerunner. Thus it is not surprising that Jandl also worked with the Vienna Art Orchestra and the North German Radio Big Band. And logically enough, in amongst his numerous awards and honours, such as the Georg Büchner Prize and the Grand Austrian State Prize, the list also includes the prize awarded by the German gramophone critics. In this artist's work the audio-experience is often as important as the reading experience.

Ernst Jandl always went down new paths. Just when people had become accustomed to him playing with language and juggling with words, he took them by surprise with his volume *selbstporträt des schachspielers als trinkende uhr* [self-portrait of the chess-player as a drinking clock]: autobiographical poems filled with despair, discouragement and mercilessly comical self-laceration. In his poems, prose, radio plays and dramatic scenes, Jandl has shown not least how close comedy and tragedy may be to each other. Ernst Jandl died in his home town in June 2000.
Wot

ALLAN KAPROW
Allan Kaprow, born 1927 in Atlantic City, is regarded as one of the most important Happenings and Environment artists. From 1945 until 1952 he studied architecture, painting and art history in New York. In his first exhibition, in 1952, besides paintings he also showed diverse collages and assemblages. The striking feature of these works is the way they extend the range of materials that may be combined in a composition, for they also include 'non-painterly' materials and items, such as tin foil, straw, canvas and sometimes even food. Following in the footsteps of Kurt Schwitters, Kaprow evolved so-called Junk Art. Later, in analogy to the notion of Action Painting, he coined the term 'Action Collage' when he found he was making works that were different from his older collages in the sheer speed of their making. After studying music for two years with John Cage (from 1956 to 1958), Kaprow started to create environments, which also involved members of the public. With his Action *18 Happenings In Six Parts* in 1959 he established 'the Happening' both as a term and as an art form: he did so by adding a new dimension – time – to the environment.

A major theme in Kaprow's work concerns the conditions and consequences of medial and mass communication. Thus, in 1962, he made Words – an environment in the form of a book that one could walk right into. Viewers found themselves in the midst of an overwhelming mass of words from newspapers, lines of poetry, love stories and so on. The public were allowed to add to this flood of information, either in the form of scribbles or by contributing scraps of paper they had already written on and had brought with them. Kaprow also linked the visual effect with acoustic perception: thus visitors could hear sounds and fragments of words from all kinds of sources. In the 1970s Kaprow started to replace the by now over-used term 'Happening' with 'Activities', by which he meant ritualised, inter-personal connections. In 1969 Allan Kaprow was appointed to a Chair at the California Institute of Arts; in 1974 he moved to the University of California in San Diego.
D. G.

EDWARD KIENHOLZ

"All our little human tragedies can be read in our rubbish" – this comment by Edward Kienholz is a clear indication of the themes and materials that were to be central to his work for many decades. Born 1927 in Fairfield, Washington, Kienholz never studied at an art school. He acquired his manual skills at a young age on his parents' farm; after graduating from high school in 1945, he first earned his living with various temporary jobs – a car salesman, a carer in a clinic for nervous diseases, a window-dresser, manager of a dance band and as a vacuum cleaner salesman.

Around 1953, Kienholz started to make collages, which he mounted on plywood bases. Later these became figurative, as in George Washington in Drag, 1957. In 1961 he began to produce assemblages and Tableaus, as he called his large-scale installations. In all of these works he incorporated objects that he found in the streets or spotted in flea-markets. However, he did not use them in the sense of Marcel Duchamp's ready-mades or Kurt Schwitters assemblages, but always with specific reference to a real person or to a particular social milieu.

In 1961, Kienholz's work was seen in the Museum of Modern Art, New York, in the exhibition The Art of Assemblage, which presented an extensive overview of collage and assemblage in the 20th century. This exposure in the company of Pablo Picasso, Kurt Schwitters, Marcel Duchamp and Joseph Cornell marked Kienholz's breakthrough on the international scene. With large-scale environments such as Roxy's, 1960/61, The Beanery, 1965, or The Portable War Memorial, 1968, Kienholz was constructing installations that were as compelling as they were spectacular. Each was based on a theoretical concept which was extremely important to the artist, as may be seen from his Concept Tableaus, which are in fact written records of his ideas for works.

In 1973, on the invitation of the DAAD, Kienholz visited West Berlin. The city fascinated him to such an extent that it became his second home and he henceforth divided his time between Berlin and Hope, Idaho. The work-complexes that he subsequently produced reflect this new situation in that they address German history: the divided city of Berlin in Still Life, 1974, and National Socialism in Volksempfänger, 1975–1977. In 1972 Kienholz met his later wife Nancy Reddin. From 1981 onwards he named her as his co-producer of all the works made since 1972. Kienholz died in 1994 in Hope, Idaho.
J.F.

LAURA KIKAUKA

When Laura Kikauka's parents left her their old farmhouse in Markdale, Canada, they had no idea that between 1986 and 1997, the 18-room house would become a tourist attraction, providing accommodation for numerous events and workshops. Kikauka had always been a little different; she never imagined having a "regulated" job. Born 1963 in Canada, in 1980 Kikauka was awarded a scholarship by the Art Gallery, Ontario. The following year she experimented at the Ontario College of Art with holography, video, audio and computer technology. She creates very unorthodox, humorous sculptural works and objects, which draw on the absurdities and irony of everyday life. Her creativity has its roots in an extreme passion for collecting. It is virtually impossible for her to get rid of anything, she has to live with things to explore their effect over time. Thus she deposited her entire collection of everyday trash at her parents' farm. Gradually the house turned into a kind of museum for the detritus of prosperity. Kikauka arranged the crammed-full rooms thematically, i.e. there was a pink room or a turquoise room, for instance, each with objects only in that colour. "Collected together in one room the things lost their ugliness," says Kikauka, who takes particular delight in adding technical extras to her found objects, like movement-detectors that react when a person walks into a room. In the Funny Farm, as she called this farmhouse near Toronto, there was also a completely empty white room, where visitors could recover from the deluge of materials in the other rooms. In 1992, Kikauka and the Canadian composer Gordon Monahan moved to Berlin. The city proved to be an inexhaustible treasure trove for the 'collectoholic' from Canada. Anything "made in the GDR" – whether electrical equipment from hospitals, glass bowls or milk-cans was collected and processed. In her shopping action Spätverkauf in 1995, the artist set herself up behind a counter in the foyer of the Volksbühne Berlin under the slogan Shop til you drop, in order to pass on surplus items from her collection to anyone who might be interested. Dressed in garish outfits, she presents herself as a component in her own Gesamtkunstwerk, like the Funny Farm East in Berlin, an off-shoot from the original Funny Farm in Canada, or in the BHG Schmalzwald in Berlin, a kind of pub, where the multi-media artist presents arrangements of worn-out everyday objects and stage props, but also herself appears and serves drinks.
D. G.

ARTHUR KØPCKE

In the 1960s, when Nouveau Réalisme and Fluxus dominated the art world, most probably no-one imagined that of all places Copenhagen would become one of the centres of these new movements. It was Arthur Køpcke, or 'Addi', as his friends called him, who drew artists like Daniel Spoerri, Jean Tinguely, Dieter Roth, Robert Filliou and Joseph Beuys to the Danish capital. He was the driving force behind their exhibitions and events, and never missed the major Fluxus Actions outside of Denmark. Køpcke, born in Hamburg in 1928, had moved to Denmark in 1953. He had been deeply affected by the experience of war, during which his home town was destroyed and his mother lost her life. Summing up Køpcke's attitude to Germany, his friend Beuys once said, "When it came to Germany, all he loved was the language, but that above all else." In 1958 Køpcke opened a gallery in Copenhagen. This did not prove to be a commercial success, but it did become an international meeting place for artists, giving off sparks and signals that reached far beyond Scandinavia. Having already incorporated paper-cuts into his pictures in the early 1950s, Køpcke started to produce collages and assemblages around 1960. In the entrance to the allotment cabin, that he and his wife Tut Aase lived in, there were mounds of old materials, like discarded tickets, dented cans and parts of old bicycles: all raw materials for his work. In 1961, for instance, he made a series of compositions using everyday objects, which he unified by painting them all with silver paint. The Tachiste and Expressionist influences on his early work – which clearly go back to the painters around Asger Jorn – now retreated increasingly into the background, while language took on ever greater significance. In 1963 he started on his series of 129 Reading-Work-Pieces, which demonstrate the combined effect of verbal and visual communication. These works also show that the artist was less interested in a perfect end-product than in the idea and the genesis of the work itself. Køpcke wanted to rally the viewer into taking an active part in the work, into decoding his work. This approach links him with many of the Fluxus artists. Arthur Køpcke died in Copenhagen in 1977.
D. G.

ROBERT MOTHERWELL

Robert Motherwell was born in 1915 in Aberdeen, Washington, and throughout his life experimented with an extraordinary range of pictorial possibilities. As the author of numerous essays and as the editor of the important series Documents of Art, he also played a crucial role as a theorist in the dissemination of Abstract Expressionism in North America. His publications also include the anthology The Dada Painters and Poets, published in 1951.

Motherwell was one of the very first Abstract Expressionists, whose academic background nevertheless set him apart from most of the other Abstract Expressionists. In 1936 he completed his studies in philosophy at Stanford University, two years later he travelled to France, where he encountered the art scene for the first time in his life. He then added to these first impressions by studying art history and archaeology in New York under Meyer Shapiro who was an active proponent of abstract art. During this time Motherwell met several European Surrealists living in exile in the United States, including Max Ernst, Yves Tanguy, Marcel Duchamp und Matta. In 1941 he travelled to Mexico with the latter, where he then decided to pursue a career as a visual artist himself. He acquired various graphic skills and made a serious study of Surrealism – in particular of psychic automatism – which strongly coloured his own work.

When Peggy Guggenheim asked the painter in 1943 if he could make some collages for an exhibition, he started to work on collage techniques. In collage he discovered an artistic form which also allowed the abstract painter to incorporate realistic fragments into his work. The dynamics of some of his collages are reminiscent of Kurt Schwitters' works, while the colours in others recall pictures by Henri Matisse. Following this, Motherwell studied works by Georges Braque and Pablo Picasso, as well as Matisse's late collages of scissor-cuts. He died in Provincetown, Massachusetts, in 1991.
D. G.

LOUISE NEVELSON

Louise Nevelson was born on 23 September 1899 in Kiev; in 1905 her family emigrated to Rockland, Maine.

Nevelson studied at the Arts Students League in New York and in Munich with Hans Hofmann. At the same time her work was also influenced by her dance-studies with Ellen Kearns, her interest in the cultures of South America and by alchemy. While her early terracotta and bronze pieces bring to mind thoughts of Henri Laurens, Jacques Lipchitz or Constantin Brancusi, in the 1940s Nevelson turned her attention to Surrealist assemblages, spatial collages and moving sculptures, into which she incorporated found objects with anthropomorphic and Cubist forms. Her breakthrough came in the late 1950s with her large sculptural wall-pieces such as *Sky Cathedral III*, 1959, and her architectonic environments. Fundamental to her assemblages was her exclusive use of wood as a material, be it as pieces of waste wood, vegetable crates, bits of driftwood or lathe-turned fragments. In addition to this, her works are characterised by geometrical structures and her practice of applying the same colour to all her materials before using them. Drawing on the alchemical teachings on the transformation of matter, Nevelson worked in three colours: black (from 1953 until 1960), which stands for the experience of death, white (from 1959 until 1960), as a symbol of purity and cleansing, and gold (from 1960 until 1964) representing the level of immortality and highest perfection. In contrast to Marcel Duchamp or Robert Rauschenberg, who emphasise the everyday character of 'their' found objects, in Nevelson's works the nature and the original function of the objects is concealed by their first being painted. The box that frames and contains the work always forms the basic structure of her works. At the same time, for the artist this cube represented the interface of time and space, a fourth dimension, which cannot be perceived by the eye but which can only be grasped by the mind. After the late 1960s Nevelson also integrated Plexiglas into her works. The major themes in her work were always travel and transformation, life and death, light and shade. Louise Nevelson died in New York in 1988.
J. F.

NAM JUNE PAIK

In 1965 Nam June Paik made a prophecy: "In the same way that collage techniques have replaced oil painting, the cathode ray tube (TV) will replace the canvas. One day artists will be working with capacitors, resistances and semiconductors, in the same way that they use brushes, violins and trash today."

The foundations of the work of this pioneer of video art were in fact in music. Born in Seoul, Korea, in 1932, Paik was already studying piano and composition by the age of 14 and completed his training in Japan with a dissertation on Arnold Schoenberg in 1956. He continued his musical career in Germany, and at the most important festival for avant-garde music, the International Summer Courses for New Music in Darmstadt, he met John Cage, who was to have an enduring influence on Paik's artistic work.

His early musical compositions already contained elements of Performance. Paik challenged his audience both visually and acoustically, for example by tipping a piano over in *Hommage à John Cage*, 1959, or by smashing violins in *One for violin (solo)*, 1962. With these shocking Actions Paik made a central contribution to the international Fluxus movement.

Besides this, Paik was interested above all in changing perceptions in the media age. As early as 1963 he was already starting to integrate televisions into his installations. Paik liked the idea of using elec-

tronics to 'paint' on the television screen, thereby countering the flood of images from the television stations with pictures of his own. In 1965 the scope of his artistic activities was greatly extended by the invention of the portable video camera. In 1969 he and his Japanese colleague Shuya Abé developed a video synthesiser, with which he could artificially create new images and change existing forms, colours and sequences.

Video tapes, video installations and video sculptures now became Paik's preferred modes of expression – some in collaboration with the American cellist Charlotte Moorman, for whom Paik created a considerable number of video objects, like *TV-Bra for living sculpture*, 1969, or *TV Cello*, 1971, intended to integrate sensuality and sexuality into concert performances.

Paik's video installations were in fact collages of images that questioned Western media society. He was in full agreement with his friend Joseph Beuys that art has a social function to fulfil. At the same time his repertoire of expression was always original, and his objects retained their humour and deftness: thus he was perfectly capable of building an entire family of robots from televisions, antennae and loudspeakers. Nam June Paik lives and works in New York and Wiesbaden.
J. F.

EDUARDO PAOLOZZI

Whether sculpture or collage, drawing or screenprint, ceramics or textile design: Eduardo Paolozzi is at home in many different genres. Born 1924 into an Italian family in Edinburgh, Paolozzi now lives in London.

During his time in Paris, from 1947 to 1949, Paolozzi met many artists including Alberto Giacometti, Tristan Tzara, Hans Arp, Constantin Brancusi, Georges Braque and Fernand Léger. He discovered important sources of inspiration in Surrealism, Dada and Jean Dubuffet's Art Brut. Paolozzi's work also shows the influence of Max Ernst, in particular in his incorporation of mechanistic elements. Marcel Duchamp's ready-mades also left their mark on his work. In 1949 Paolozzi started to experiment with screen printing. In 1950 he produced *Mr. Cruikshank*, a bronze head with visible seams that had been cast from a dummy used for scientific testing. The motif of the head taken apart and put back together again emerges repeatedly in Paolozzi's work. Later on he made sculptures of mythological, religious themes from scraps he had collected. Firmly convinced that destruction and transformation are necessary parts in the act of artistic creation, Paolozzi spoke of the "metamorphosis of waste".

1952 saw the formation of the Independent Group in London, a loose grouping of creative minds from a number of different spheres. In his now famous epidiascope lecture, Paolozzi showed his *Bunk* collages, in which he employed trivial icons – comic figures, the covers of cheap magazines, adverts, consumer products – well before Andy Warhol in the USA. He acquired his materials between 1947 and 1950 from former members of the American armed forces. Magazines like *Esquire*, *Life*, *Look* and *Cover Girl* provided material – as banal as it was fascinating – from the seemingly unattainable, glittering world of the United States. Paolozzi's lecture met with criticism from his colleagues. Still beholden to a questionable ideal of 'high art', they were unable to recognise the marked influence of Pop Art themes, like science fiction or car

design, on the individual and the collective consciousness.

Paolozzi's work is many-faceted in the extreme. It ranges from sculptures, many made for public places, right through to 'technological' pictorial abstractions in immensely powerful colours. Paolozzi has frequently participated in documenta and the Venice Biennale, where he received an award in 1960 for his sculptural work. He has lectured and held professorships in London at the Royal College of Art, in Hamburg, Cologne and Munich.
Wot

NANA PETZET

Collect – Preserve – Research [in German: "Sammeln – Bewahren – Forschen (SBF)"]: these three-step instructions, which significantly also describe the task of any museum, refer to the system for dealing with garbage that the artist Nana Petzet developed in 1997. As a promising response to the questionable effectiveness of the Dual System, SBF requires first and foremost responsibility and systematic collection on the part of the individual. The daily cleaning, drying and sorting of one's own garbage in special storage places plays a basic part in the life of the SBF enthusiast. He/she can only be seriously interested in articles whose packaging can be transformed into useful or useless things in terms of preserving valuable materials. Following that, as he/she productively sets to work at home, there are no limits to his/her imagination or manual ingenuity. Creative fruits of such acts of preservation are objects with the unmistakable charm of recycled goods: domestic life is enriched by paper baskets made from plastic bags, a picture frame made from cigarette boxes or a room-divider, sewn together from roughly 300 milk cartons. Nana Petzet offers a glimpse into her own model household, which is at the same time also a place for research and teaching.

Born 1962 in Munich, the artist appears in her experimental set-ups and laboratory situations parodying the solemn airs of the expert. As far back as 1987 in her performance *Rational Scientific Art*, she already put forward the notion that science is art. In subsequent projects she experimented with artificial ageing processes. Elsewhere she devoted her attention to research into basic questions of physics or to an experiment designed to join elements from quantum physics and macroscopic phenomena. Petzet's lectures and texts adopt the objective tone of the natural scientist: pseudo-data and diagrams, analysis and strategies for solutions seem so convincing that even the simplest, critically disbelieving objections are not raised. What, for example, happens when – within the SBF recycling system – all those committed households are filled to overflowing with their lovingly crafted objects? So SBF turns out to be no more than a stunning logical sham-solution to a pressing problem.

Taking the theory of Junk Art ad absurdum, with her SBF concept Petzet questions the shelf-life of certain values as well as the shifting of value systems. In doing so she takes a stand against the historic opposition between art and non-art. In an age when there is talk on all sides of the aestheticisation of science, in a humorously revealing manner Petzet throws up critical, epistemological questions. Nana Petzet lives and works in Hamburg.
A. R.

ROBERT RAUSCHENBERG

One artist who uniquely embodies the elan of the 1950s and 60s is the American, Robert Rauschen-

berg. He is able, in his own unmistakable manner, to create extraordinary works from an amalgamation of performance, politics, painting, sculpture, film and technology. Rauschenberg was born in 1925 in Port Arthur, Texas. Having broken off a degree in pharmacy and after serving in the Navy, in 1947 he enrolled at the Kansas City Art Institute in Missouri. Following a short study trip to Paris – where he met his future wife, the artist Susan Weil – in 1948 he transferred to Black Mountain College in North Carolina, where he studied for two years, in part under Josef Albers. In college he sealed important friendships with artists such as Cy Twombly, Robert Motherwell, Merce Cunningham and John Cage, in whose *Theater Piece No. 1* he took part in 1952. From rural North Carolina, Rauschenberg finally moved to New York. There he attended the Art Students League in 1952, and took courses with Morris Kantor and Vaclav Vytlacil. His own career really began with the large-scale, monochrome white pictures that he showed in 1951 in his first solo exhibition in the Betty Parsons Gallery. In 1952, during a year-long trip to North Africa and Italy with his friend, the painter Cy Twombly, he made his first *Dirt Paintings*. In these Rauschenberg combined disparate materials, often fusing plants and other small three-dimensional elements by means of a glassy resin. At the same time he also made rough-hewn wooden boxes and objects, in which he incorporated materials such as stone, bone, or metal objets trouvés. Once he was back in New York he continued with his similarly structured *Elemental Sculptures*. The *White Paintings* from 1951 were followed by the *Black Paintings* and the *Red Paintings* from 1953 onwards, with an intensity of colour that went far beyond the artist's otherwise predominantly uncolourful experiments. Even in the earliest stage of his artistic career, between 1949 and 1954, it was clear that Rauschenberg was drawing on an immense wealth of ideas: many developments in his later career go back to this time. As though at a run, he passed through important stations in European modernism. Rauschenberg's works are as much influenced by the psychic-gestural expressivity of Action Painting as by the symbolic power of the objects he is dealing with. These two influences are found again in his spectacular *Combine Paintings* and in his free-standing, three-dimensional *Combines*, which he started to make in 1953: everyday objects and trash are combined with traditional paint substances and transformed by Rauschenberg into pictures. Tachist trails of paint unite the heterogeneous materials to form a whole in which the everyday objects develop their direct effect as quotes from reality. One source of inspiration for these pieces may have been the works by Kurt Schwitters that were on show in the Museum of Modern Art in 1948 and in the Sidney Janis Gallery in 1953/53.

Around 1960 Rauschenberg took fragments of reality such as newspaper photos and texts and increasingly incorporated them into his works by means of screen prints, transfers or rubbings, rather than integrating them directly. In 1970 he left New York and moved to Captiva Island, Florida, where still lives today whenever he is not travelling.
D. G.

LOIS RENNER

It is by no means easy to follow an interview with Lois Renner. Born in 1961 in Salzburg and now living in Vienna, he delights in changing perspectives. His efforts to avoid being pinned down are equally evident in his art, an individualistic mixture of painting, sculpture and photography. "I have to cling to photography with just eight of my ten fingers so that I have the remaining two to paint with", explains Renner who studied with Gerhard Richter and who, in his own words, "came down from college as a painter".

In his work Renner focuses on processes of artistic creation and artistic work in general and on the status of painting in particular. In Vienna the artist has built a much reduced model of his Salzburg studio. He then takes photographs of his model, all one-offs: highly unsettling works because on one hand they show a comprehensible basic situation, which on the other hand is constantly being disturbed. For the architecture can become unhinged and lose its usual purpose. Helplessly the eye wanders across it, without finding any clear point of reference, across proliferating constructions that at times are somewhat reminiscent of Schwitters' *Merzbau*. In addition, items in their original size can find their way into the perfectly formed miniature structure, which completely confuses all its proportions. Moreover, we do not always see the artist's world as we would want to see it: we spot a resplendent painting, but it is out of focus and partly cut-off, in the corner of the picture, or the visitor only sees the back of the easel. The fact that Renner likes to include appropriated famous pictures in his assemblages, by Rubens for instance, by no means lessens the irritation.

"With my art I would like to both strengthen the desire for painting and its reality and to test our faith in photography. I am making a kind of test picture," declares this idiosyncratic artist who is constantly crossing boundaries, and who is always prepared to put public perceptions of reality up for debate.
Wot

MIMMO ROTELLA

Independently of the Paris *Affichistes*, Mimmo Rotella was experimenting at much the same time in Italy with décollage. It was only in 1958 when Pierre Restany, the initiator of Nouveau Réalisme, told him in his studio in Rome of the parallel developments in France, that Rotella heard about what Raymond Hains and Jacques Villeglé had been doing since 1949 and that they were later joined by François Dufrêne. Rotella was born in 1918 in Catanzaro, in Calabria. He initially studied painting in Naples; between 1941 and 1951 he spent most of his time in Rome. In 1951, the year of his first solo exhibition, in the Galleria Chiarazzi, Rotella was awarded a scholarship by the Fulbright Foundation, which allowed him to study for one year at the University of Missouri. Even before he set off for the United States he was already exploring a wide range of artistic topics. Besides phonetic poems, the *Epistaltici* that he had been making since 1949, he also produced photographs, photomontages, assemblages from diverse objects and the first precursors of his later décollages. The stagnation in painting, which he became aware of in the United States, sparked off a crisis for him in 1952/53. During this time he worked with great intensity on his sound poems. In 1954 Rotella produced his first torn posters, which may be compared with the early works of the *Affichistes* in Paris. Rotella, for his part, pasted posters directly onto the canvas, generally also adding rips and tears of his own. Occasionally he also used the backs of the posters as pictorial elements, in a manner similar to Dufrêne's method. Both Dufrêne and Rotella composed sound poems, which in itself points to the link between phonetic poetry – where the sound is broken into pieces – and the torn posters – where the form is ripped apart. In 1958 the Italian artist's purely abstract décollages gave way increasingly to works with figurative tears. Now particularly actors on film posters, but also well-known politicians like John F. Kennedy were found a place in his pictures. In 1961 Rotella joined the Nouveaux Réalistes and in 1964 he moved to Paris. Two years earlier he had already shown work in France for the first time. In Paris he stopped making décollages, but in the 1980s returned to his work with torn advertising posters, which he then applied to various supports before working on them yet further. Since 1980 he has lived in Milan and Nice.
D. G.

DIETER ROTH

Born in Hanover in 1930 to German-Swiss parents, Dieter Roth's œuvre is immense and incommensurable. This is due partly to the sheer extent of his output, but also to his preference for working with foodstuffs, integrating their decay into the artistic process. Already as a schoolboy – living in Zurich from 1943 onwards – his talent for drawing was evident, as was his love of unusual materials. Thus his first attempts at printing were carried out on beaten-flat tin-cans. Roth acquired sound technical skills from his apprenticeship as a graphic artist (1947–51 in Bern) and from courses in lithography at the School of Arts and Crafts.

Roth's work always rested on graphics as its artistic foundation, although he was already adding to this in the 1950s with painting – smeared and poured – or extending it into assemblage. In this respect his position coincided with that of artists such as Robert Rauschenberg or his friends Daniel Spoerri and Richard Hamilton. His first book objects and stamped pictures, which he started to make in 1957, show the influence of concrete and constructive art. Similarly the roots of his literary work also go back to concrete poetry.

In 1960 Roth's work started to change: processes of decay – leading to mildew, mould and rot – now became a topic and were positively encouraged by his choice of materials. Roth pressed sausage and soft cheese onto paper, made screen prints using chocolate and filled window frames with herbs and spices. Countless serial sculptures from sugar and chocolate were built up into towers. At the same time Roth was also filling loose-leaf files with huge collections of *Flat Rubbish*, 1976.

Roth only rarely exhibited his work. His attitude to the art market may be understood as a gesture of refusal. His work is inextricably bound up in the course of his own life; drawing and writing offered him a form of existential support. In the artistic process he could overcome his anxieties and illnesses. This personal approach to his work is also evident in the diaries, which he started to keep in 1966; the forty volumes appeared between 1970 and 1977 as his *Gesammelte Werke* [Collected Works]. Dieter Roth died in Basel in 1998. His self-observations made with a video camera were shown as large-format installations in the 1999 Venice Biennial.
J. F.

GERHARD RÜHM

For Gerhard Rühm the boundaries between the various artistic media are there to be crossed. Born 1930 in Vienna, with Cologne now as his adopted home, this man of letters and visual artist started his career by studying music (piano and composition). The son of a double-bass player with the Vienna Philharmonic,

he initially studied privately with the twelve-tone composer Joseph Matthias Hauer, and studied Eastern music during a stay in Beirut.

Even so, this account of Rühm's many-sided creativity does not do him justice, for he has always been interested in mixed forms in the arts. Thus he has often used music or visual art to address language, creating sound poems and visual texts and subjecting words and text to a variety of techniques involving montage, alienation and permutation.

In the mid-1950s, Gerhard Rühm, Friedrich Achleitner, H. C. Artmann, Konrad Bayer and Oswald Wiener came together to form the Viennese Group, and proceeded to upset post-war cultural life with their dialect poetry, verbal collages and appropriations of material from grammar books and light fiction.

Right from the outset Rühm has taken language as a material to its extremes. His dialect poetry is often more meaningful for its sound than for its content, and similarly in his stage works, the language often takes precedence over the structure of the plot. In his experiments with concrete poetry Rühm dissected the language into its individual letters. Rühm finds his initial material as readily in Shakespeare as in press reports or scientific texts.

Rühm has also produced 'pure' musical compositions or visual works, such as his pen and ink drawings in a sparse style that is reminiscent of the Far East. Yet he also combines these two realms when he draws sign-like forms on manuscript paper which, although unplayable, seem to take on an acoustic dimension besides their visual meaning. In view of all this, it is hardly surprising that Rühm's live performances do not necessarily take the form of conventional readings, for in them he effortlessly combines language games, automatic drawing and projections with elements of drama and music.
Wot

ANNE RYAN
The path to artistic creativity is not always straight and smooth. Anne Ryan, born 1889 in New Jersey, devoted the first half of her adult life mainly to being a housewife. A mother of three, she first explored the possibility of writing. Having separated from her mentally unstable husband she then lived for some years on Mallorca before moving to New York at the age of 49, where she opened a restaurant.

Amongst her neighbours there were many painters, including Jackson Pollock. Ryan started to paint, too, and put her apartment at Stanley William Hayter's disposal for his drawing lessons; his students notably included Marc Chagall and Jacques Lipchitz.

Now Ryan started to experiment with wood-cut techniques; the key experience in her development as an artist came in January 1948 when she visited Kurt Schwitters' first solo exhibition in Rose Fried's Pinacotheca Gallery. Her daughter Elizabeth McFadden later remembered that day: "Mother went from one collage to another in a passion of delight. She knew instantly and completely that she had found her métier. [...]. We went home and before she put water on for supper, she was at her work table making collages." Ryan then devoted the next six years until her death in 1954 to making collages, in the process emancipating herself very quickly from her role model Schwitters. Paper and fabrics became her preferred materials. In a fine balance of colours and textures the different compositional elements came together as equals, with letters or stamps at times appearing here and there. In contrast to Schwitters' output, in Ryan's

work there few hints of a commercialised world. The associations set up by her works generally evoke individual issues and that particular moment in time: for instance Ryan may combine remnants from Victorian clothing with new fabrics or with fabrics that are on the point of disintegration through having been washed so frequently. Another important element in her works proved to be the hand-made papers by Douglas Howell who had learnt the medieval art of paper-making in Florence.

Anne Ryan's collages are unique: Cubist dynamics, total abstraction and a high level of emotion come together in her works.
Wot

GREGOR SCHNEIDER
Imagine you arrive at the outwardly unremarkable *Haus u r* in Rheydt, innocently looking for somewhere to rent. The landlord Gregor Schneider takes you through the freshly redecorated rooms. The walls are white. Doors, windows, ceiling, floor – the house is filled with the feeling of ordinary everydayness. A person could move in here, after all the rooms do seem to be lived in. In one there are bits and pieces to do with work, in another there is a mattress or a table set for a meal. Admittedly the furnishings make a rather sparse, improvised impression but some people just don't have the time to do up their homes properly. But this feeling of normality soon gives way to a sense that this house is far from run-of-the-mill. If you go into the small kitchen and draw back the curtain, moving gently in the breeze to see why it is still so light outside, it turns out that the window is fake and what seemed like sunlight is in fact a spotlight – and a ventilator is causing the 'breeze'.

Born 1969 in Rheydt, Schneider stages human habitation as a living nightmare; he completely confuses this and subjects it to his own rules. Through years of adding and rebuilding, he has created a now wholly impenetrable labyrinth of layers of walls, shafts and rooms. Since 1985 the artist has been working here entirely according to his own devices. Schneider counters the artistic assessment of the work as a finished product by pointing instead to the simple wear and tear on his own strength. He builds rooms in rooms and walls in front of walls, thereby isolating himself both socially and spatially. Most of the rooms are completely sound-proofed. If one steps behind the set of one of the 'false' rooms, for example by sliding a wall open, one finds oneself in yet another labyrinth, in another zone of isolation. In these in-between spaces, Schneider stores mysterious objects. For exhibition purposes he reconstructs individual rooms from his house or reshapes rooms in galleries and museums by adding new walls, as in Haus Lange in Krefeld in 1994.
D. G.

KURT SCHWITTERS
Kurt Schwitters was born in Hanover in 1887. Having first attended the School of Arts and Crafts there, he then studied from 1909–14 at the Academy of Arts in Dresden. From 1911 onwards he participated in exhibitions, initially showing representational paintings. The idea of 'MERZ', Schwitters' most important contribution to contemporary art, first came about in 1918. The term 'MERZ' (one syllable from the name 'Commerz- und Privatbank', which appeared in one of his first assemblages, the *Merzpicture* of 1919) was used by Schwitters – not least setting himself apart

from Dada – to refer to all his wide-ranging artistic activities: he made Merz drawings (collages), Merz pictures (assemblages) and Merz sculptures; in the mid-1920s he also started work on his *Merzbau*, a walk-in collage extending over several rooms. In 1923 he started to publish his own series, the *Merz* magazines. Besides participating in numerous solo and group exhibitions, Schwitters also put on Merz evenings throughout Europe with readings and performances of his poems, prose texts and his *Ursonate*. In 1924 he founded the Merz Advertising Centre, and increased his activities as a typographer. In 1927 he even called himself MERZ – an expression of his logical, multi-disciplinary concept designed to achieve an art-form that creates "relationships, preferably between all the things in the world" (1924). A resident of Hanover, Schwitters was in lively contact with numerous international avant-garde artists (including Hans Arp, Raoul Hausmann, Hannah Höch, Nelly and Theo van Doesburg, Paul Klee, Vilmos Huszár, Tristan Tzara, El Lissitzky) and with the circles around the journal *Der Sturm* and the Sturm gallery, where he regularly showed work from 1918 onwards. He was also in touch with the Berlin Dadaists, the artists from de Stijl in Holland and the Constructivist Internationals. He was a co-founder of the artists' association *die abstrakten hannover* and the *ring neuer werbegestalter* as well as being a member of the Deutscher Werkbund and, in the 1930s, of the Paris groups *Cercle et Carré* and *Abstraction-Création*. From 1932 onwards Schwitters was a frequent visitor to Norway, where nature offered him refuge and recuperation from the political uncertainties of the time. When his son Ernst fled to Oslo in 1936, Schwitters soon followed. He never returned to Germany, where his art was reviled as 'degenerate' after 1933, and his work in public ownership was destroyed. In exile he produced numerous representational works, above all landscapes and portraits. But these were not merely a source of income, for throughout his life Schwitters produced representational works in parallel and apparently in contradiction to his abstract œuvre. So far his representational works have only received marginal recognition.

When German forces entered Norway in 1940, Schwitters fled again, now to England. After an initial period in internment camps and a time in London, he finally moved to the Lake District in 1945. Both in Oslo and in the Lake District, the now seriously ill artist embarked on new Merzbaus. In England he received financial support from the Museum of Modern Art, New York. Schwitters' house in Hanover was destroyed during an air-raid in 1943, and with it the *Merzbau* and many of the works he had had to leave behind. Virtually forgotten by the art world, Schwitters died from heart failure in Kendal in 1948.
I. S.

DANIEL SPOERRI
Spoerri's name is inextricably linked with Eat Art, which he himself invented. Born in 1930 as Daniel Isaac Feinstein in Galati, Romania, his family emigrated to Switzerland in 1942. Spoerri initially trained in classical ballet and from 1954–57 he was lead dancer at the Stadttheater in Bern, but he also worked as an actor, director, publisher, poet and exhibitions maker. While movement played a central role in his early works, in 1959, with his edition *MAT (Multiplication d'Art Transformable)* Spoerri started to explore works of art and the possibility of multiple reproductions. In 1960 he joined forces with the Nouveaux Réalistes –

Yves Klein, Jean Tinguely, Arman, César, Christo, Raymond Hains and Jacques Villeglé – who sought to overcome the subjectivism of *informel* painting and to return to reality by procuring their materials in kitsch shops and flea markets, from scrap dealers and rubbish heaps. Spoerri, for his part, came up with his *Trap Pictures*, for which he glued random found items to a solid base. It was in 1960 that he first glued down the remains of a meal on a hotel table – the beginning of a whole series of *Tableaux pièges*. The first of Spoerri's *Trap Picture Actions* took place in 1963 in the Galerie J in Paris: at a specific moment, all the guests invited to the meal had to drop their forks, and Spoerri set to work with his glue. After this, the table-tops with the glued-down leftovers were hung on the gallery walls. In the 'Restaurant Spoerri', which was opened in Düsseldorf (in the Burgplatz) in 1968, guests could, if they wanted, have their tables fixed in this manner after they had eaten. One corner of the restaurant became a work in its own right, known as *Le coin du Restaurant Spoerri, 1968*.

Eating as a ritual and a celebration reached a highpoint in his grand banquets, as in his *Hommage à Karl Marx* in 1978 when Spoerri was appointed to a Chair at the College of Art and Design in Cologne, in the *Astro-Gastro* to mark the 175th anniversary of the Munich Academy in 1983, and in the one-month long *Attrape-Tripes* Festival in Burgundy in 1980.

Spoerri later moved away from the notion of capturing a piece of unaltered reality: he added a new dimension to the *Trap Picture* by including autobiographical elements, ironic allusions and games of deception, as in the *False Trap Pictures*, the *Détrompe-l'Œils* or the *Dis-Illusionment Pictures*, the *Labyrinths* and the *Trap Pieces*. In 1966, during his year-long stay on the Greek Island of Symi, the artist also began to investigate the magic potential of objects. Now his assemblages started to include meat-grinders, helmets, chopping-knives or animals' skulls, which combined to create powerfully expressive, at times aggressive sculptures. Spoerri lives and works near Bern in Switzerland.
J. F.

JESSICA STOCKHOLDER

"I never know for sure why I choose certain materials," says Jessica Stockholder. "I am interested in putting materials together so that they speak for me." Stockholder, born 1959 in Seattle and now living in Brooklyn, has no inhibitions when it comes to making these choices: her installations, which at times take on gigantic cimensions, can include wood, concrete or tinplate; lamps, furniture or refrigerator doors; oranges, underwear or Walkmen.

As she herself says, having started as a painter, she did "not stop making pictures and then start to make sculptures. I still paint, only now my pictures are also sculptures at the same time." Components such as colour, form and surfaces point to painting, while space, volume and mass are clearly sculptural features.

These works certainly do not boast easily interpreted contents of a narrative or symbolic kind. While one cannot deny the associations evoked by the red-coloured mattress that Stockholder used in her *Instellation in My Father's Backyard*, 1983, – thoughts of sleep, sex and blood come to mind – nevertheless the shape of the mattress also picks up on rectangular forms in the surroundings and the colour corresponds to the red of the berries in the tree growing right next to the installation. The work *Recording Forever Pick-*

led,1990, is built up from contrasts, which create a kind of surreal domestic situation. Next to a concrete table there is a seat with a collection of stuffed-full rubbish bags and a wooden construction that is vaguely reminiscent of shelving. There are some clear colour accents; thus part of the floor is painted yellow, complementing the violet nuances on the backs of the pieces of wood.

The artist herself has made the connection between her works and those of Allan Kaprow, whose *Kiosk* (1957–59), with its combination of fruit, collaged elements, light bulbs and broken mirrors creates a similar multi-layered balance of disarray and structure.

Stockholder's works function more via sensual perception than intellectual analysis. Viewers have no choice but to open themselves in an entirely subjective manner to these works with their touches of monumentality and their numerous details. In terms of the works' dimensions and contents, a whole variety of approaches and viewpoints are thinkable; thus each individual who succumbs to the wealth of associations inherent in these works, will arrive at his or her entirely personal experience of Stockholder's art.
Wot

TOMATO

T/O.m/TO is the name of a beta-hormone apparently found in the brains of people who tend to go into daydreams and experience a feeling of weightlessness – tomato, a nine-person group of British artists, has taken its name from this hormone. These designers, musicians, directors and artists joined forces in 1991 in order to work in the way that they themselves wanted to, free of the constraints that operate in advertising agencies and journalism. The result was the phenomenon tomato, a collective of artists who want to extend and influence human perceptions, and who make use of all the available media – film, photography, spatial installations, graphics, music and words. The groups' works appear in books and magazines, in advertising slots on television, in museums by day and in clubs by night.

In their studios in Soho in London, tomato produce concentrated images using film and photographs, either by treating the materials electronically or by recombining them. The original image is altered to such an extent in this process that it is no longer recognisable. This alienation leads to images that seem to lie beyond our normal consciousness, the sort that float through our minds when we daydream; or they portray thoughts and ideas that no camera or photographic equipment could ever capture. Words and music also play an important part in tomato's works, which is hardly surprising in view of their role-models who go from the philosopher Ludwig Wittgenstein, the artist Joseph Beuys, the writer James Joyce to the band Oasis. Two members of tomato, working as Underworld with the DJ Darren Emerson, produced the hit album *Second Toughest of the Infants*.

Which of the nine members of the team work on individual projects is not as important as the project itself, for tomato wants to be understood as a collective. Thus tomato is not an advertising agency in the usual sense although they do produce advertising spots, as in 1993 for the firm Nike. The artists do not put together a concept for the client nor do they offer any readymade solutions; instead they work freely according to their own convictions and judge the quality of their work by the intensity of the pleasure it gives them. For their exhibitions they design and create rooms, partly in combination with music videos.

The exhibition logo *MERZ* and the layout for this catalogue have both been designed by tomato.
J. F.

CY TWOMBLY

Born on 25 April in Lexington, Virginia, Cy Twombly is regarded as an artistic loner. In his own highly individual way – which some critics and members of the public take to be disrespectful – Twombly has addressed the great themes of cultural history. His interest in European culture was first awakened in his art lessons with Pierre Daura, who introduced him to the history of classical art and contemporary movements alike. While he was studying at the School of the Museum of Fine Arts in Boston, Twombly was specially intrigued by Expressionism, Dada and Surrealism. It is clear to see the influence of Kurt Schwitters and Alberto Giacometti in the assemblage-sculptures which Twombly made from simple, found objects and painted uniformly white. These white sculptures, with their simply arranged objects, became an important constant in Twombly's work. He then continued his artistic training at the Art Students League in New York and in Black Mountain College in North Carolina under Robert Motherwell. His days as a student came to an end with his first trip to Europe and Africa in the company of his friend and artist-colleague Robert Rauschenberg.

Twombly's work as painter is notable for its large, relief-like, sculptural pictures with their abstract, gestural lineatures. His scribbled lines, that occasionally bring to mind thoughts of childish attempts to write, hover somewhere between abstraction and recognisable signs and symbols. Isolated words like AMOR or OLYMPIA crop up after Twombly's move to Rome in 1957, and are influenced by the traces of modern graffiti that Twombly found on historic buildings and ancient walls. His early work is partly characterised by its lack of strong colours.

From 1960 onwards Twombly started to address masterworks from the history of art, such as Raphael's *School of Athens*. This phase, in which mythological themes play a large part, gave way in 1967 to images connected with movement and time, and which owe as much to Leonardo da Vinci as to Marcel Duchamp. In the late 1970s, Twombly once again produced white, and black, sculptures, whose forms are reminiscent of flowers, chariots and boats – with which Twombly, as so often, takes up themes from ancient cultures and their symbols. From 1990 onwards flowers also become an important motif in the paintings of this artist, who divides his time between Italy and the United States.
J. F.

JACQUES DE LA VILLEGLÉ

"In the mind of the poster-collector, the art of décollage is an invitat on to leave behind the world of bourgeois, official reality, the tyranny of propaganda and advertising, and to enter the poetic world of dreams and imagination." Jacques de la Villeglé became known the world over for his own particular form of urban field-research, the "art of torn posters".

Born 1926 in Quimper, now living in Paris and Saint-Malo, Villeglé very soon started to work with objets trouvés such as pieces of wire and snippets of text. In 1949 he began to focus mainly on posters on the sides of buildings and on fences in Paris: pasted over each other, tugged at by passers-by, softened by the rain – posters announcing films, posters with advertisements or put up by political parties. Detached

from the hoarding, pasted on canvas and transferred into a new context in terms of contents and aesthetics, the resulting pictures constituted a seismographic record of society.

Villeglé worked together with Raymond Hains, who had previously only photographed the layers of posters on hoardings, and who compared the two activities: "The difference is the same as between a proposal of marriage and the wedding."

While the art of torn posters does have its roots in Dada and in Duchamp's concept of the ready-made, it does not, however, primarily have any socio-critical or polemic intentions. Already related to easel painting in terms of form, Villeglé's works display a whole range of similarly painterly effects, from confusingly hovering, superimposed, at times doubled writing, with the eyes trying in vain to read in the usual direction, through to powerful compositions with a section of a Woody Allen head or a garish comic strip drawing, or graffiti-like elements.

At the same time Villeglé's torn posters may be taken to exemplify a socio-historical situation. The contents and themes of the printed matter, that Villeglé often worked in several variations, relate directly to a certain time and a certain place.

In 1960 Villeglé and Hains were amongst the artists who founded the group of object-artists, the Nouveaux Réalistes, around the critic Pierre Restany. Its members included François Dufrêne and Mimmo Rotella, who also worked with torn posters. However, the latter both only used the posters for their aesthetic qualities: Dufrêne for instance was mainly interested in the colours and textures of the backs of the posters. By contrast, Villeglé and Hains minimised their interventions in the found posters, mainly only finishing off rather too timid attempts by passers-by to tear down the posters. "They always messed around with them a bit", remarked their artist-friend Daniel Spoerri, "Hains always picked off little bits. Villeglé was probably the precisest."
Wot

The authors of the artists' biographies:

J. F.: Julienne Franke
D. G.: Daniel Görbing
A. R.: Annett Reckert
I. S.: Isabel Schulz
Wot: Jörg Worat

AUTHORS' BIOGRAPHIES

DIETMAR ELGER
Born 1958. 1973–1984: studied Art History, History and Literature at the University of Hamburg. 1984: PhD on the *Merzbau* of Kurt Schwitters. 1984–1985: secretary to Gerhard Richter in Cologne. 1985–1988: curator and deputy director at the Museum am Ostwall Dortmund. Since 1989: Keeper for painting and sculpture at the Sprengel Museum Hannover. Monograph on the *Merzbau von Kurt Schwitters* (1984, second edition 1999). 1997–1999: guest lecturer at the Fachhochschule Hannover. Numerous exhibitions and publications on 20th century art. *Catalogues raisonnés* on Gerhard Richter (1986) and Felix Gonzalez-Torres (1997).

ISABELLE EWIG
Born 1968. Studied Art History in Paris at the École du Louvre and at the Université Sorbonne-Paris IV. 1993–95: working at the Musée national d'art moderne, Paris, on the retrospective and exhibition catalogue *Kurt Schwitters*. 1997–1998: working at the Musée de Grenoble on the exhibitions *Le sentiment de la montagne* and *Le sentiment de la montagne. Visions contemporaines*, as well as coordinating the catalogue. Since 1998: teaching at the Université Sorbonne-Paris IV. Diverse articles, lectures, translations and contributor to the *Catalogue raisonné Herbert Zangs*. 2000: completion of PhD on Kurt Schwitters.

JUSTIN HOFFMANN
Born 1955, lives in Munich and Zurich. Degree in Art Pedagogy and Art History. Critic for the journals *Kunstforum*, *springerin*, *frieze* and the *Süddeutsche Zeitung*. Author of the book *Destruktionskunst. Der Mythos der Zerstörung in der Kunst der frühen sechziger Jahre* (1955). Freelance curator since 1988, organising exhibitions and events in the Munich area. Since 1997: curator at the Shedhalle in Zurich. Joint-editor with Marion von Osten of the book *Das Phantom sucht seinen Mörder. Ein Reader zur Kulturalisierung der Ökonomie* (1999).

INES KATENHUSEN
Born 1966. Degree in History and German at the University of Hanover. 1997: PhD on *Kunst und Politik. Hannovers Auseinandersetzung mit der Moderne in der Weimarer Republik* (1998: Prize awarded by the Stiftung der deutschen Städte, Gemeinden und Kreise zur Förderung der Kommunalwissenschaften.) 1993–1999: lecturing at the Centre for Applied Languages and 1997–99 in the Department of History at the University of Hanover. 1999: lecturing at the Hochschule für bildende Künste, Braunschweig, and on the staff of the Institute of Political Science at the University of Hanover. Contributor to exhibitions and symposia, amongst others at the Historisches Museum Hannover, the Niedersächsisches Landesmuseum and the Sprengel Museum Hannover. Publications on municipal history in the 19th and 20th century, focusing particularly on the politics of art and culture.

ULRICH KREMPEL
Born 1948. 1967 onwards: studied German, Art History, Philosophy and Journalism at the Ruhr University in Bochum. 1975: PhD on *ROSTA-Fenster und ihre Stellung in der sozialistischen Bildersprache*. 1977–1980: teaching at the universities in Duisburg, Essen, Osnabrück, Kassel. Since 1980: curator at the Kunsthalle Düsseldorf, at the same time lecturing from 1982 onwards at the Staatliche Kunstakademie in Düsseldorf. 1986: Exhibitions director at the Museum Folkwang Essen. 1988: Director of the exhibitions department in the Kunstsammlung Nordrhein-Westfalen, Düsseldorf. Since 1993: Director of the Sprengel Museum Hannover. 1996: Honorary Professor at the Hochschule für Bildende Künste in Braunschweig.

ANETTE KRUSZYNSKI
Born 1957. Studied Ancient Philology, Italian, Art History, Psychology and Medicine in Heidelberg, Berlin and Hamburg. Periods of study in London and Rome. PhD on 16th century emblematics. Traineeship at the Staatsgalerie Stuttgart. Teaching at the Heinrich Heine-University, Düsseldorf. Since 1986: curator at the Kunstsammlung Nordrhein-Westfalen, Düsseldorf. Exhibitions and publications above all on 20th century art.

SUSANNE MEYER–BÜSER
Born 1963. Studied Art History and German at the University of Osnabrück. 1992: PhD on painted portraiture in the 1920s. 1993–1994: working at the Centre Georges Pompidou, Paris, on the exhibition project *La Ville*. 1994–1996: traineeship in the Sprengel Museum Hannover. Teaching at the University of Hildesheim. Since 1996: freelance curator for various institutions, including the Von der Heydt-Museum Wuppertal, kunstraum münchen and the Sprengel Museum Hannover. Publications: *Bubikopf und Gretchenzopf. Die Frau der 20er Jahre*, Museum für Kunst und Gewerbe Hamburg 1995; *Garten der Frauen. Wegbereiterinnen der Moderne in Deutschland. 1900–1914*, publ. together with Ulrich Krempel, Sprengel Museum Hannover 1997; *TALK. Show – Die Kunst der Kommunikation in den 90er Jahren*, publ. together with Bernhart Schwenk, Von der Heydt-Museum Wuppertal 1999.

KARIN ORCHARD
Born 1961. Studied Art History, History and Literature in Hamburg, Edinburgh and London. 1988: PhD on androgyny in 16th century art. 1984–1991: traineeship at the Hamburger Kunsthalle, working amongst other things on the exhibitions *Zauber der Medusa. Europäische Manierismen* (for the Vienna Festival, 1987) and *Europa 1789. Aufklärung, Verklärung, Verfall* (1989). Since 1991: curator at the Sprengel Museum Hannover, responsible amongst other things for the exhibitions *Die Erfindung der Natur. Max Ernst, Paul Klee, Wols und das surreale Universum* (1994) and *BLAST. Vortizismus – Die erste Avantgarde in England 1914–1918* (1996). Since 1994: Director of the Kurt Schwitters Archive in the Sprengel Museum Hannover, joint editor of the *Catalogue raisonné Kurt Schwitters*. Publications on art in the 16th century and in the 20th century.

GERHARD SCHAUB
Born 1938 in Kassel. Studied German and English in Heidelberg, Hamburg and Exeter (England). 1970: PhD 1980: Habilitation 1970: Academic Assistant 1975: Assistant Professor 1985: Professor of Modern German Literature at the University of Trier. Publications on 19th and 20th century German literature and various authors, including Clemens Brentano, Georg Büchner, Hugo Ball and Kurt Schwitters; on the latter: *Kurt Schwitters: »Bürger und Idiot«. Beiträge zu Werk und Wirkung eines Gesamtkünstlers. Mit unveröffentlichten Briefen an Walter Gropius* (1993); *Kurt Schwitters und die »andere« Schweiz. Unveröffentlichte Briefe aus dem Exil* (1998); *Schwitters-Anekdoten. Versammelt und mit einer Einleitung von Gerhard Schaub* (1999).

ISABEL SCHULZ
Born 1960. Studied Art History, Literatur, Folklore and Aesthetic Education in Bonn and Hamburg. 1992: PhD on Meret Oppenheim, traineeship in the Westfälisches Landesmuseum Münster. 1994–1996: member of staff at the Zeitgeist-Gesellschaft Berlin. Since 1996: on the staff of the Kurt Schwitters Archive in the Sprengel Museum Hannover (*Catalogue raisonné Kurt Schwitters*). Selected publications: *Künstlerinnen. Leben, Werk, Rezeption*, Frankfurt 1991; *Edelfuchs im Morgenrot – Studien zum Werk von Meret Oppenheim*, Exh. cat., Munich 1993; *Sachkunde – Alltagsdinge in der Kunst*, Kunsthaus Hamburg 1993; *Kurt Schwitters, Werke und Dokumente. Verzeichnis der Bestände im Sprengel Museum Hannover* (ed. with Karin Orchard), Hanover 1998.

INDEX OF NAMES

PHOTO CREDITS